YOUNG
MICHELANGELO

YOUNG MICHELANGELO

THE PATH TO THE SISTINE

JOHN T. SPIKE

THE VENDOME PRESS

NEW YORK

First published in the United States of America in 2010 by
The Vendome Press
1334 York Avenue
New York, N.Y. 10021
www.vendomepress.com

A MARK MAGOWAN BOOK

EDITOR: Jacqueline Decter
DESIGNER: Patricia Fabricant
PHOTO EDITOR: Tiffany Hu

ISBN 978-0-86565-266-8

Printed in the United States of America
Second printing

 Library of Congress Cataloging-in-Publication Data

Spike, John T.
 Young Michelangelo : the path to the Sistine : a biography / by John T.
Spike.
 p. cm.
 Includes bibliographical references and index.
 ISBN 978-0-86565-266-8
 1. Michelangelo Buonarroti, 1475-1564—Childhood and youth. 2.
Artists—Italy—Biography. I. Michelangelo Buonarroti, 1475-1564. II.
Title. III. Title: Path to the Sistine.
 N6923.B9S52 2010
 709.2—dc22
 [B]
 2010015813

CONTENTS

AUTHOR'S NOTE

THIS BOOK IS A PORTRAIT OF MICHELANGELO AS A YOUNG MAN burning to attract attention. Drawing on top of his master's drawings and improving them, challenging the older students in the sculpture studio of San Marco, he never doubts his superior gift. He goes to Rome to claim the credit for sculpting a Cupid deceptively sold as an antique. Given a chance to redeem himself, he sculpts a Bacchus reeling from drink. After its rejection, the young man pours his heart into the *Pietà*, polishing it for a year, and then comes home to Florence. There the *David* waits for him trapped inside a ruined block. He is a sculptor and, lest anyone forget, always signs his letters "Michelangelo scultore."

Michelangelo late in life took an active interest in his own story, underwriting a biography by Ascanio Condivi in 1553. Condivi and the two editions of Giorgio Vasari's *The Lives of the Artists*, 1550 and 1568, are the crucial sources, yet they come with the drawback of pandering to their subject, the world's most powerful artist. When relying on their sole authority, as often happens, I have taken pains to identify their declarations as historical hindsight rather than facts. Similarly, the old man's poetry and letters and statements to diarists like Francisco de Holanda are not allowed to speak for the young Michelangelo. We cannot know the young man's thinking, but it is possible to know something of the people and events on his mind. The costly art of sculpture demanded that he cultivate patrons to support him. Even from his earliest encounters, Michelangelo was extraordinarily adept at gaining the confidence of powerful men and women, many of whom we shall meet when he does. During this stage of his life, Michelangelo does not change, he learns.

In 1508, when our story ends, he has been called back to Rome to paint the book of Genesis in the Sistine Chapel. The *Moses* does not yet exist, nor the *Night, Day, Dusk,* and *Dawn* in the Medici Chapel, nor, of course, the dome of St. Peter's. Michelangelo will change while painting the Sistine ceiling, as the frescoes clearly show. Twenty years after that, other changes will mark the onset of his antediluvian old age. During his lifetime he will sculpt

the Pietà two more times, and the three works will have nothing in common except that only he could have made them.

This book was made possible by the research of many great scholars, whom I wish to thank in the open air, not only buried in the footnotes. The opening of the Buonarroti family archives in Florence in the nineteenth century ushered in the modern epoch of studies. It is safe to say that a recent work by a single scholar, *The Wealth of Michelangelo* by Rab Hatfield, 2002, will have a similarly transformational effect. Professor Hatfield has laboriously transcribed the ledgers of Michelangelo's bank accounts in Florence and Rome, comparing the totals to the artist's letters and biographers, down to the last baiocco. Much of my reading of Michelangelo's character is based on this data, which shows that he was intensely involved in growing his money, which he earned in large amounts, far more than he ever admitted. His father's interference in his financial affairs, rather than cause for resentment as tradition has supposed, was in fact a shared concern and at the very heart of their relationship.

ACKNOWLEDGMENTS

IN WRITING THIS BOOK I HAVE HAD THE INDISPENSABLE ASSISTANCE of my wife, Michèle Spike, and our son, Nicholas Spike, who offered countless improvements and gave me a lift when the light was invisible at the end of the tunnel. My publisher, Mark Magowan, has been an unfailing supporter of the highest standards for this book: for his constancy, he deserves its dedication.

My researches for this book were undertaken in Florence at the Archivio di Stato, Casa Buonarroti, the Kunsthistorisches Institut, and the Berenson Library of Villa I Tatti of Harvard University. In the United States I used the excellent facilities of the New York Public Library, the Frick Art Reference Library, the Hirsch Library of the Museum of Fine Arts, Houston, and the Swem Library at the College of William & Mary in Virginia.

At Vendome Press, I feel special gratitude to Jacqueline Decter, my excellent editor, who treated my prose with the utmost kindness.

I shall always be grateful to Francesco and Oletta Lauro for their friendship and encouragement through the long years of writing this book.

It is pleasant to acknowledge the substantial assistance I have received from colleagues and friends, with sincere apologies to anyone omitted in the haste of these late moments. I would like to thank Alessio Assonitis, Mgr John Azzopardi, Babette Bohn, John Bugeja Caruana, Francesco Buranelli, Jean Cadogan, Keith Christiansen, Aaron De Groft, Philip Elisasoph, Peter Falk, Capt. Anne Flammang, Marco Fossi, Thomas and Nancy Galdy, Jorge Guillermo, Gregory and Margaret Hedberg, Bryan and Jennie Ho, Paul Joannides, Jim and Priscilla Kauffman, David Madden, Alessandra Marchi, Margaret Mims, Cesare and Betty Nadalini, Arnold Nesselrath, Feliciano Paoli, John Varriano, Mgr Timothy Verdon, Louis Waldman, Wendy Watson, George White, Alice and Helmut Wohl, Abbot Michael John Zielinski, and, finally, my mother.

CHAPTER ONE
IN THE BEGINNING
FLORENCE
1475–1489/90

On the seventh day the Creator rested. Sunday being a day of obligation, a young man brought around a horse and waited. Riding to church was allowable to one so old he could hardly lift his head. Michelangelo was eighty-eight. The narrow street wound down the hill, bringing them to an open ground fringed by ruins. A great arch half-buried in the dirt commemorated a long-forgotten war.[1]

In the year of Our Lord 1563, the Roman Forum was by turns a graveyard of Christian saints, a quarry of tumbledown architecture, and a scratchy pasture where an animal market was held on Thursdays and Fridays.[2] For those who cared to turn its pages, the Forum was a book with but a single lesson: at the end of time no stones will be left standing—human genius can go to hell. It was a proposition Michelangelo believed intensely. "Once our eyes were fully whole, with a light within each cavern; now they are empty, black and frightful. This it is that time has brought."[3]

The little brown horse, led by his two servants, set its hooves on the hardpan road laid down by the Farnese pope of recent memory.[4] Travertine paving stones from the pagans' Via Sacra lay strewn about, like the playing pieces of careless giants. Now the road was sacred for the apostles Peter and Paul, who had walked it in chains, and in deference to the chapels wedged like hornets' nests in the porches of shattered temples.

On this first Sunday of October, four months of life were left to Michelangelo. He ruminated on his work-in-progress, a marble group of

Jesus, Mary, and Nicodemus. It was a final attempt to carve his own tomb, but he could not resolve it. There was barely time enough now to strip it down to the lacerated core that would be his testament, the *Rondanini Pietà*.

The old man went to mass at Santa Maria Nova at the opposite, eastern, end of the Forum. The crumbling church was centuries old, rising unsteadily on the foundations of the pagan Temple of Rome and Venus: the Latin palindrome *Roma/Amor*. Near here St. Peter terrified the imperial Romans by causing the sorcerer Simon Magus to fall from the sky.[5] Two slabs dipped with the impressions of the apostle's praying knees were embedded in a wall of the sacristy.

Michelangelo preferred to worship in a church devoid of any sign that he or Bramante or Raphael had ever worked in Rome. The old man much admired a fresco by Masaccio's contemporary Gentile da Fabriano, who had the gift, he said, of painting like his name: *gently*.[6] Few traces remain of the interior Michelangelo loved. Before its baroque revamping, Santa Maria Nova was a time capsule of the early Middle Ages. Its breadth was spanned by the *Triumph of the Cross*, a mosaic drenched with the mystical wine of Christianity.[7] In the center, Michelangelo saw a Greek cross with four equal arms signifying the four ends of the earth and, by implication, the immensity of God. Seven Hebrew candelabra symbolized the seven days of Creation. The old man knew two things for certain: the soul thirsts for an absent source and the story of its ascent begins in Genesis.[8] The gilt and shimmering mosaic showed solemn prophets crowned by palms and the four Evangelists' symbols: an angel, a lion, an ox, and an eagle. Golden letters spelled out the message in rhymed Latin couplets:

GLORIA SACRA CRVCIS FIT NOBIS SEMITA LVCIS
QUAM QUI PORTAVIT NOS XPS AD ASTRA LEVAVIT

The Glory of the Holy Cross Has Become a Path of Light to the World and Christ Who Carried It Has Raised Us to the Stars[9]

• • •

AFTER THE MASS, DON MINIATO PITTI APPROACHED AND INTRODUCED himself. He was an Olivetan abbot who had just come down from Florence. His face, though not handsome, was alive with curiosity and a hint of quizzical humor. He took the liberty, he said, because his father and Michelangelo

had been friends many years before.[10] Indeed, they had been friends, and the old man knew exactly who the abbot was: Luca Pitti's grandson.

At the apogee of his wealth in the mid-fifteenth century, Luca Pitti had bought a tract of land on the Boboli hillside on the south side of the Arno River. There he commissioned Filippo Brunelleschi to design a palace of such enormous dimensions that its windows would be "larger than the doors of the Palazzo Medici."[11] Luca's ambitiousness was such that he brazenly pitted himself against the elder Cosimo de' Medici, whose position after 1434 was well nigh incontestable. Cosimo's impressive mansion, designed by Michelozzo, was just then rising on the Via Larga on the north side of the Duomo. Both palaces were constructed of *pietra forte*, the strong brown limestone of Florence. After Brunelleschi's death, Pitti had his architects exaggerate the rusticated blocks to make his house look more like a fortress.

The Palazzo Pitti became a symbol of resistance: the headquarters of the *Partito del monte*, as though the Boboli were a mountain, not a hill.[12] Cosimo warned his rival, saying, "I do not try to fly, for fear of falling."[13] Luca would not listen. After Cosimo's death, he made his move, but the plot against Cosimo's son and successor, Piero the Gouty, failed. When Luca's complicity was discovered, his only option was to withdraw from public life or forfeit his life.[14]

Luca Pitti went humiliated to his grave in 1472, leaving his palace unfinished and his heirs mired in the limbo reserved for Florentine patricians out of favor with the Medici regime. There they languished during the years that Michelangelo di Lodovico Buonarroti Simoni, born in 1475, and Miniato Pitti, born in the 1490s, were boys growing up in the city.

The restoration of the Florentine Republic in 1498 ushered in a late summer of rekindled hope for the anti-Mediceans, including the Pitti. In or around 1504, while Michelangelo was at work on a statue of civic liberty—the *David*—he took time off to present Bartolomeo Pitti, Miniato's uncle, with a robust bas-relief of the Madonna and Child. The *Pitti Tondo* was later inherited by Don Miniato, who gave it, with priestly modesty, to a friend.[15] He might more prudently have retained it.

Overwhelmed by debts, the Pitti were constrained at last to sell their palace to the all-consuming Medici. In 1549 Cosimo I moved his court from the Palazzo Vecchio, the "old palace," to the spacious premises of Luca Pitti's broken dream. This event was still recent when Don Miniato came up after Sunday mass to introduce himself to the sinewy little man with furrowed brow and deep-set eyes.

Sixty years after the *Tondo* came into this world, Don Miniato Pitti was an elderly churchman nearing retirement[16]—and Michelangelo was still alive. In fact he was hungry for news from Florence, which he had not seen in thirty years, since the Medici had retaken the city as vassals of the German emperor Charles V. Don Miniato and Michelangelo chatted agreeably for half an hour: the cleric dressed in a white Olivetan habit, the artisan caked in sweat and dust. A few days later, on October 10, Don Miniato described the meeting in a letter to their mutual friend Giorgio Vasari.[17]

> I asked him how old he was. He said he was eighty-eight years old and that at the time of the Pazzi case he was carried in his father's arms. He remembered when Jacopo de' Pazzi was cast into prison after his capture in the Casentino, where he had fled after the outrage was committed. He walks bent over and has difficulty raising his head. And yet he still continues to work at carving stone, staying in his home. This is what is necessary to say now about Michelangelo.[18]

The old man's memory was built on bedrock. Nearly ninety, he recalled being held up to see Jacopo de' Pazzi, the richest man in the neighborhood, torn limb from limb. Since Jacopo was already dead, it was the humiliation of the battered corpse that Michelangelo remembered seeing on May 17, 1478, two months after his third birthday.

The catastrophe known as the Pazzi conspiracy erupted during a late April visit to Florence by Raffaele Riario, the pope's seventeen-year-old grandnephew and the freshest face among the cardinalate. For some time, Pope Sixtus IV (Francesco della Rovere) had made no secret of his ill will toward the Medici, whose interests persistently conflicted with his own. The pope dismissed the Medici as managers of the papal accounts and engaged the banking house of their competitors, the Pazzi family. Like the Medici, the Pazzi were discerning patrons of the arts, having employed Brunelleschi to design their family chapel in the cloister of Santa Croce. However, the Pazzi family tree, traceable back to their valorous service in the Crusades of 1099, was incomparably more respectable than the overweening Medici's.[19]

Piero the Gouty was succeeded by his sons, Lorenzo—the future Magnifico—and his younger brother, Giuliano de' Medici. Although only in his twenties, and not an elected official, Lorenzo was, to all intents and purposes, lord and master of Florence. The usurpation of government by an upstart dynasty was as galling to the Pazzi as it had been to Luca Pitti.

With Luca's unfortunate example staring them in the face, the Pazzi opted for harsher tactics.

On April 16, 1478, Sunday morning, the Florentine cathedral was packed with the Medici and their allies, Cardinal Riario's retinue, and a hidden covey of assassins. Precisely what happened and when has been disputed, but Vespasiano da Bisticci, a reliable witness, says, "At the elevation of the Host, Giuliano was assaulted and killed, and Lorenzo slightly wounded."[20] The Pazzi conspiracy was predetermined to fail, he goes on, because "it was contrary to the will of God that such an execrable and wicked crime should happen in His temple."

Giuliano perished at once beneath nineteen knife thrusts. As the assassins closed in on Lorenzo, Francesco Nori, a Medici loyalist, stepped in front to take the fatal thrust in his own breast. His beautifully sculpted monument still stands against a column in Santa Croce. Lorenzo managed to escape, amid the screams and confusion, to the north sacristy, collapsing inside as his friend Poliziano slammed shut the heavy bronze doors against the Pazzi swords in hot pursuit.

The young Cardinal Riario fled panic-stricken into the other sacristy.[21] The first fury spent, the Medici regained control. "Afterward," Vespasiano says, "more than five hundred were either killed or executed. The cardinal was taken to the palazzo, where he received honorable treatment, and everything was done to save him from the hands of the people who would have made an end of him." Lorenzo concluded that the youth was blameless and spared him—not so the archbishop of Pisa, who had hastened to the Palazzo della Signoria to take control of the government and for his trouble was hanged from one of the windows. After returning to Rome, Riario stayed away from Florence for the rest of his life, concentrating his attention on collecting antiquities and building an immense palace. Thus he lived to intervene eighteen years later at a crucial juncture in Michelangelo's life.

Not one of the conspirators escaped. Old Jacopo de' Pazzi, transformed in a single hour from eminence to outlaw, rode through the streets with an armed guard, knocking on doors and calling out the Florentines to rebel, but nobody listened.[22] Seeing that all was lost, Jacopo fled in confusion to the Casentino mountains. Two days later he was recognized and seized by the farmers of Monte Falterona. Brought back to Florence in chains, he too was hung from a rope on the Palazzo della Signoria.

Two weeks passed. On May 15, the people's sense of outrage boiled over again. An angry mob broke into the Pazzi crypt at Santa Croce, disinterred Jacopo's body, and dumped it in a shallow ditch outside the city walls. Two

days later, another mob dug him up again, dragging the cadaver through the streets until they reached the entrance of the Palazzo Pazzi. Fastening the corpse's neck to the iron ring, they pounded the door, shouting out, "Knock again!"[23] Then they carried the body to the Rubiconte Bridge and dropped it in the flooded river. Fished out downstream, the mangled body was beaten with sticks and thrown back in, the riotous crowd loudly singing, "Master Jacopo's swimming in the Arno."[24]

> It was an awful instance of the instability of fortune, to see so wealthy a man, possessing the utmost earthly felicity, brought down to such a depth of misery, such utter ruin and extreme degradation.[25]

Even Machiavelli was impressed.[26] Niccolò Machiavelli was nine years old at the time and already at school, so his recollection was more nuanced than three-year-old Michelangelo's. The Machiavelli and the Buonarroti belonged to the same circle of *ottimati,* or respected families, who were not in the loop of Medici power. Niccolò's father, Bernardo, was a literary man who had a small income from rents, which he kept carefully recorded in a diary. The Machiavelli lived on the opposite side of the Arno from the Buonarroti, in the Via del Borgo between the Ponte Vecchio and the Palazzo Pitti. Both families had the use of a chapel in the Franciscan church of Santa Croce. Otherwise their paths had no particular reason to cross until, as young men, Machiavelli and Michelangelo shared a commitment to the Florentine Republic restored by Piero Soderini in 1498. Despite his willingness later to work for the Medici, Machiavelli's bitter reward for civic service would be exile. If Michelangelo, clutched in his father's arms, drew any lesson from the Pazzi conspiracy, it was a mortal fear of politics.

• • •

MICHELANGELO'S MOTHER AND FATHER CAME FROM PATRICIAN families that had long filled offices in the republican government of Florence. Francesca de' Neri was a Rucellai, one of the best families, on her mother's side. His father, Lodovico di Lionardo Buonarroti Simoni, was descended from a long line of council members and *gonfalonieri,* or standard bearers. Lodovico, a "good and religious man, somewhat old-fashioned,"[27] transmitted his obsessive interest in the family dignity to his son.[28]

They traced their good name back to one Simone di Buonarrota, of whom we know little except that in 1295 he was a member of the powerful council of One Hundred Wise Men.[29] His descendants revered his memory.

> Messer Simone then, of the family of Canossa, coming to Florence as Podestà in the year 1250, was deemed worthy of being made a citizen, and head of a sestiere or sixth-part of the town, because the city, which today is divided into quarters, was then divided into six parts. The Guelph party were in power in Florence and he, who had been Ghibelline, became a Guelph, because of the many benefits he received from that faction.[30]

Old and famous, Michelangelo dictated this genealogy to his pupil Ascanio Condivi in 1553; Vasari had just published a more modest version that needed correcting.[31] Like many family heirlooms, though, Michelangelo's ancestral claims do not hold up well under scrutiny. No gentleman corresponding to this Simone of Canossa is listed among the *podestà*, or magistrates, of the thirteenth century. Condivi's linkage of this Simone to the lineage of Matilda of Canossa is even more farfetched. The great Tuscan countess died childless; her only heir was the Roman Church. Matilda, moreover, was the staunchest pillar of the Guelph, or papal, party; had she had descendants, they would not have arrived in Florence bearing Ghibelline (imperial) credentials.

None of these circumstances gave pause to Michelangelo, who, by 1520, will have no difficulty obtaining the corroborating evidence. The Count of Canossa, though no relation to the fabled Matilda, will be pleased to exchange letters welcoming the artist of the Sistine Chapel into the family. Though trivial, the episode is telling nonetheless. Michelangelo habitually generated letters, drawings, poems, and business papers, making his one of the most documented lives ever lived. Not by chance, Raphael portrays him in the *School of Athens* neither sculpting nor painting, but slumped over a desk, wearily writing.[32]

Although Renaissance biographies are usually posthumous, emulating the ancients, Michelangelo first saw his life published by Vasari, and then orchestrated Condivi's reply in 1553.[33] In 1568, four years after Michelangelo's death, Vasari brought out an expanded version that reads like a dialogue with the old man's ghost.

All sources agree that Michelangelo was born the second son of a respected family fallen on hard times. Their former prosperity, whatever

its source, had dried up fifty years before his birth. The Buonarroti Simoni resided in and helped administer the Santa Croce quarter, the traditional center of the lucrative wool industry, as the survival of street names such as Corso dei Tintori, or Dyers' Street, attests. For two hundred years they had been elected representatives of the Arte della Lana, the politically powerful Wool Guild, and they retained the right to membership provided they could pay the dues.[34] As far back as the sketchy records can take us, though, Michelangelo's forefathers were always employed in government and municipal service. [35]

Before surnames came into common usage, Florentine names were typically patronymic: *Simone di Buonarrota* means "Simon the son of Buonarrota." The Florentine church of San Simone is near Santa Croce, which may explain the family's connection with this Christian name. *Buonarrota*, which means "good wheel," is a name chosen for its auspiciousness. *Rota* is Dante's word when he writes, "Therefore let Fortune spin her wheel. . . . "[36] Fortuna survived under Christianity, not as a goddess but as one of God's agencies.[37] Machiavelli devotes some striking pages to fickle fortune's power to bestow success or ruin on human affairs.[38]

Simone di Buonarrota, Michelangelo's ancestor of the late thirteenth century, initiated the custom of bestowing his father's name on the first-born in every generation. Thus his son was Buonarrota di Simone di Buonarrota. Through the Trecento and into Michelangelo's Quattrocento his forebears maintained the tradition as tenaciously as a dynasty in a novel by Gabriel García Márquez.

The family attained its golden age during the second half of the Trecento through the efforts of Simone di Buonarrota (di Simone di Buonarrota), who died in 1372.[39] An exemplary citizen of the world's first capital of capitalism, this Simone was entrusted with offices as crucial as the administration of the municipal grain supply. Florence had difficulty feeding itself; famine was a constant concern. He served three times as a prior of the Signoria, the uppermost governing council. In 1392 his son Buonarrota di Simone di Buonarrota (di Simone di Buonarrota) became a captain of the Guelph party, the sanctioned political apparatus. Buonarrota's three sons carried the family banner into the new century. They were Simone, Michele, and Lionardo; the last was Michelangelo's grandfather. Lionardo held the rudder as the family sank to near extinction.

By the early Quattrocento, Florence had passed the peak of its economic hegemony. The city's preeminence in culture, not to mention civic pride,

was such, however, that the fact went unnoticed. The outward mechanisms of republican government were retained after Cosimo de' Medici's assumption of control in 1434, but from that day forward power and wealth were concentrated in the hands of the most astute and the most ruthless. It was said that Cosimo wielded taxes like a "dagger."[40] The collapse of the wool industry took its toll on the patriciate. Jacopo Acciaiuoli's case was typical. In 1427 he reported to the tax authorities that his cloth factories were "locked up and unrented, and for more than eight years I have received no income from them."[41]

Many old, respected families, including Michelangelo's forebears, finding themselves unable to compete against money-lending enterprises grown into multinational conglomerates, fell back on government service. They kept their heads above water by living off the produce and wine of their farms, the rental revenue from houses they owned, and the fees they received for filling the jobs that the cumbersome Florentine bureaucracy continually churned out. After 1434, however, the Medici reserved the best appointments for their favorites.

The desperation of Michelangelo's ancestors emerges from an episode in the private memoirs of the merchant Antonio Rustichi. One day during the 1420s, Rustichi was quietly seated on a bench in front of a neighbor's house when Simone di Buonarrota assaulted him, absolutely without provocation, or so he protested. As improbable as that sounds, Simone was now liable to serious punishment. To escape incarceration, he had to return, weeping, to Rustichi's house and there apologize in front of witnesses that he had been "possessed by a devil."[42]

Simone's stars were unpropitious. In 1428 his premature death, without issue, snapped the chain of five consecutive generations of Simones and Buonarrotas. His brother Lionardo was hit by the backlash. Michelangelo's grandfather became trapped in a vicious cycle of tax arrears that disqualified him for the offices that would have allowed him to pay his taxes.[43] Father of two sons and four daughters, Lionardo lacked the cash for dowries. He was ultimately ruined when obliged, at his eldest daughter's marriage, to give his son-in-law the family's house in Piazza dei Peruzzi.[44] The other daughters made marriages to husbands of inferior social status. There was no surer sign that a family's exit from the patriciate was imminent.[45] At his death in 1459, Lionardo's sole legacy to his sons, Francesco and Lodovico, was a small farm in Settignano and a once-proud surname— Buonarroti Simoni.

. . .

BORN IN 1444, LODOVICO DELAYED MARRIAGE UNTIL HE WAS OF AN age that would permit him to accept government posts as soon as he paid off his taxes—which he did with his new wife's dowry of 416 florins. Francesca, the daughter of Neri di Miniato del Sera, was sixteen years old at their marriage in 1472. A year later, Lodovico was appointed to the socially prominent council of the XII Buonomini, or the Twelve Good Men. The couple's first son, Lionardo, was born a year later and named after his grandfather. On the last day of September 1474, Lodovico Buonarroti began a six-month term as *podestà*, or magistrate, of Chiusi and Caprese, two small towns perched in the mountains to the east of Florence.[46] In each village of roughly 1,500 farmers and shepherds, the temporary *podestà* lived in a stout stone house from which he would adjudicate the locals' incessant disputes over grazing rights and family properties. Lodovico was given a lump-sum budget of 500 lire to cover his compensation and the expenses of two notaries, three servants, and a horseman during his assignment from September 30, 1474, until March 29, 1475.[47]

His wife, Francesca, elected to accompany him into the mountains, climbing twisting mountain roads on horseback. It was a risky undertaking for a woman pregnant with her second child, but there were reports of the plague that year and many city dwellers took refuge in the countryside.[48] During the dark morning hours of March 6, 1475, Francesca gave birth to a boy who was baptized Michelangelo.[49]

The Casentino is a rugged place to be born in winter. It was the wild remoteness of those mountains—nearer to Arezzo than Florence—that convinced St. Francis to place his retreat atop the rock of La Verna. Michelangelo did not instruct Condivi to name the village in which he was born, only that his father was the magistrate of both Chiusi and Caprese. It was not an important distinction to a Florentine accidently born away from home, but Vasari's error, naming Florence as the place, had to be corrected. Vasari's second edition follows Condivi, pointing out the proximity of these towns to the rock of La Verna "in the diocese of Arezzo where Saint Francis received the stigmata."[50]

The given name Michelangelo was new in the family. It might arguably have been chosen in honor of his father's uncle Michele, recently deceased in 1471.[51] The modification into Michelangelo was significant. The cult of St. Michael Archangel was deeply rooted in the Casentino by St. Francis, who

preached sermons about the archangel who accompanies souls as they stand before God. It was during Francis's fast for forty days in the wilderness at La Verna during the "Lent of St. Michael" that he experienced the mystical wounds of the stigmata.[52] Chiusi, attached to the slope of La Verna, was one of many settlements in this region that had a church dedicated to the Archangel Michael. If the child's birth was difficult or hazardous, the name could have been chosen out of gratitude for a miraculous deliverance.

A tradition first reported in 1700 by Michelangelo's heirs claimed that the journey on the ridge road connecting Chiusi and Caprese nearly proved fatal for Lodovico's nineteen-year-old wife and unborn child.[53] It was said that Francesca's horse stumbled; she fell and was dragged along the ground.[54] According to others, the mishap induced the birth of the baby that very night by the side of the rutted track. These stories belong to the legends that grew up around Michelangelo, some even during his lifetime. Early on he was placed among the select who made miraculous escapes as infants: Hercules, Jesus, and countless saints.[55]

In 1548 Michelangelo, by then an old man of seventy-three, was brooding about his birthday. He wrote to his nephew Lionardo in Florence to say, "I would ask you to send me my *nativitào* [birth record], as you once sent me another time, but I misplaced it, from a book of our father."[56] It must have been the day and hour of his birth that interested him, because a few years later Condivi gives these exactly, ascribing the Master's "high and noble genius" to the conjunction of the planets Mercury and Venus in his horoscope.[57] The outlines of the zodiac were understood by everyone in that age. Though the Church had demoted the stars from divinity status, the heavenly constellations retained their power to influence character, subject of course to free will and the grace of God.[58] As a Pisces, the child was born in the sphere of Jupiter, the supreme planet. This birth sign carries with it a freedom from earthly attachments and the capacity to see deeply into spiritual matters. As persons given to abstract thinking, Pisces run the risk of becoming loners.

After Lodovico Buonarroti's half-year as *podestà* expired, he and Francesca returned to Florence, and put the child to nurse with the wife of a stone carver in Settignano, "three miles from the city . . . a place abundant in stone and everywhere filled with quarries of blue-gray sandstone continuously mined by stone cutters and sculptors, most of whom were born in that place."[59]

The child may have remained at Settignano for an additional year or so, as Lodovico was soon called away to a posting of four months as keeper of the

castle in Facciano, a remote location in the Romagna region.[60] Michelangelo would later tell Condivi:

> It was no wonder the chisel gave him so much gratification for it is known that the nurse's milk is so powerful in us that often, by altering the temperature of a body that has a certain natural propensity, it may introduce another quite different one.[61]

And to Vasari, he said, with a grain of Florentine salt:

> Caro Giorgio, if I have any intelligence at all, it has come from being born in the pure air of your native Arezzo, just as also I imbibed from the milk of my nurse the mallets and chisels I use for carving my figures.[62]

A marble plaque at the crossing of Via Bentaccordi and Via Anguillara marks the site of Michelangelo's childhood home, which was later rebuilt. From there, Via Bentaccordi continues north, tracing the curved wall of the amphitheatre built in classical times, when Florence was a Roman colony. The other end of this vanished coliseum once covered part of Piazza Santa Croce, a favorite staging ground for the glorious pageants the Medici organized "to give the people something to take their minds off State affairs."[63]

The family rented rooms so that they could remain in the neighborhood despite the loss of their grandfather's house thirty years before. Here Michelangelo was living in 1478, when he witnessed the destruction of the Pazzi, until that day the neighborhood's richest family. He was a three-year-old child in a small, dark dwelling shared by his parents; his brothers Lionardo and Buonarroto (just one year old); his father's brother Francesco and Francesco's wife, Cassandra; and his seventy-two-year-old grandmother Alessandra.

• • •

A STONE'S THROW FROM THE BUONARROTI HOUSE WAS THE STINCHE, the debtor's prison, which occupied an entire city block and was surrounded by a ditch-like moat. Its south side ended at the church of San Simone. The prison's rough walls, unbroken by windows, rose to a height of fifty feet, and

in one place, where an old tower was incorporated, sixty. The Stinche took its name from a rural castle of the Cavalcanti family, whose unlucky survivors were brought here and imprisoned after being routed by the Neri in 1304. Many distinguished Florentines, weighed down by debts, were involuntary residents over the years.[64] The rumors of its harsh conditions struck a kind of Dickensian dread in the heart of every passerby.

Florentines coped with the prison's menacing presence as they were wont to do, by making bitter jokes, like this one ascribed to Poliziano:

> A certain Bragiacca had been imprisoned for thirty years, when someone asked him his age. Thirty, he replied. Oh! What are you saying? You were already thirty when they brought you in! To which Bragiacca said, Well, Christ, you can't say I've been alive these thirty years in the Stinche![65]

Any errand to the north of the Buonarroti house required passing by the Stinche, a visible, reproachful reminder of the Florentine paternal admonition, "Always remember, my sons, that your expenditure should never exceed your income."[66] Michelangelo's father was unstinting in his dispensation of such advice, which he practiced himself by spending nothing, since most of the time he had no work.

In 1481, when Michelangelo was barely six, his mother died. It is a loss never disclosed by his biographers and of which Michelangelo never spoke.[67] Francesca died at age twenty-six, presumably of complications in the delivery of Michelangelo's last and youngest brother, Sigismondo. In her nine years of marriage, she gave Lodovico five sons. Her strenuous success as a Florentine's wife was bought at the expense of her life.

Of the five boys, ironically, only one raised a family. The eldest, Lionardo, a weakly man, became a Dominican friar. This unheard-of vocation for a first-born son bespeaks the limitations of his character and of his father's purse.[68] Then came Michelangelo, two years younger. The third son of Lodovico and Francesca was born in 1477 and auspiciously named Buonarroto: he alone would marry. Buonarroto was Michelangelo's favorite brother and his principal correspondent after their father's death.[69] The fourth son, Giovan Simone, was the family scapegrace: undutiful to his father, he wandered hither and yon, causing his older brother much trouble.[70] Of Sigismondo, the fifth son, little is known, save that he left home to become a soldier of fortune.[71] Eventually he gave up and settled down in Settignano to the life of a peasant

dietro i buoi (behind the oxen), as Michelangelo disapprovingly phrases it in a letter of December 4, 1546, to their father.

Within a year of his wife's death, Lodovico married another woman of good family, if modest means. Twelve years later, in 1497, Lucrezia di Antonio di Sandro degli Ubaldini da Gagliano passed away without leaving any discernible trace in the family apart from a nettlesome obligation to repay her dowry to her relatives. Michelangelo's responses to his mother's death and to the arrival of a stepmother are not known; that a child of his age, suddenly deprived of his mother, could have been untroubled is hardly conceivable. Yet his fondest memories were reserved for his Settignano wet nurse.

Noting the child's intelligence, Lodovico determined to invest in educating Michelangelo for a profession, perhaps in law. At about age seven, the boy was sent to study grammar at the school of Francesco da Urbino, a teacher solely remembered for this one reluctant pupil. Florentine boys were grounded in the basic accounting and drafting skills required by a mercantile society. By the end of the fifteenth century, considerable importance was also assigned to classical and modern literature. Virgil's *Aeneid* and Bible stories headed the list of readings, followed by the stoic philosophers Boethius, Seneca, and Cicero. For Italian practice, Dante was de rigueur. The poet appealed not only for his immortal rhyme, but also for his dexterous skewering of his Florentine enemies, all of them still vividly recalled. The Latin primer of preference was called the *Donatello*, an abridgment of the *Ars grammatica* composed in the fourth century by Aelius Donatus.

Michelangelo learned to write in a clear hand and with an exceptional command of his mother tongue. He was a taciturn child. It may be that Francesco da Urbino only taught his charges to read and write in the Italian vernacular, for Michelangelo complained in later life that he knew little Latin.[72] As an old man, Michelangelo confessed to Condivi that he had neglected his lessons.

> The very heavens, as much as his own desire, pulled him irresistibly
> to art, so that he could not stop himself from drawing, whenever he
> could steal a moment, and from seeking the company of painters.[73]

Appraising himself as the active object of cosmic forces was typical—one wonders when he acquired the habit. Vasari, before coming under Condivi's influence, framed this early phase of awakening in a family context.

Because Lodovico was poor and burdened with a large family, he put his other sons to work at various trades, keeping with him only Michelangelo, who, as a child and on his own, drew all over sheets of paper and on the walls.[74]

These early sketches were still in existence in the middle of the eighteenth century, at least in the family's opinion. A. F. Gori, a Florentine erudite, describes one shown to him by the Cavaliere Filippo Buonarroti, a descendant of Michelangelo's uncle Francesco, drawn in black chalk on a staircase wall in the Settignano farmhouse. Still intact, it represents in firm, vigorous strokes a man with his right arm raised and his head down.[75]

• • •

ONE OF THE OTHER BOYS IN THE SANTA CROCE DISTRICT, FRANCESCO Granacci, was training as a painter. He and Michelangelo became best friends. Francesco lived with his older brother Marco, a baker, in Via Ghibellina on the other side of the horrid Stinche.[76] By 1484 or so, while Michelangelo was drawing in his grammar books, Francesco had already obtained local celebrity as the model for the child depicted in Filippino Lippi's revision of Masaccio's *St. Peter Raising the Son of Theophilus* in the Brancacci Chapel.[77] Francesco appears in the center foreground, completely nude, kneeling in the midst of a scattering of bones meant to simulate a graveyard.

Granacci was five or six years older than his new friend. Indeed, the two were unalike in almost every way. A handsome, amiable adolescent, Granacci had the gift of putting people at their ease. He enjoyed bringing friends together. Young Buonarroti didn't mingle easily. He was of middling height and undernourished, his body tending to nerves and bones instead of flesh and fat.[78] His eyes were too deeply set and his forehead too broad to be good-looking. The most important difference, at least from his father's point of view, was that Granacci's father, Andrea, and his two brothers were simple tradesmen, selling mattresses and second-hand furniture. Four streets distant from the Buonarroti, the bustling, middle-class Granacci were, as far as someone as old-fashioned as Lodovico was concerned, denizens of a different world.

Granacci was stunned, in his easygoing way, by Michelangelo's brilliance. The boy was no more than ten and yet instantly understood

everything Francesco could tell him about art—and then pressed for more. Before too long, Michelangelo had Granacci smuggling drawings for him from the workshop of Domenico Ghirlandaio and his brother Davide. He was an extraordinarily strong-willed boy, which makes one wonder about Condivi's claim that Lodovico and Uncle Francesco "held art in contempt . . . and beat him severely for it. They were so ignorant of the excellence and nobility of art that they thought it shameful to give it shelter in their house."[79] The story has a vehemence worthy of Michelangelo's imagination.

Indeed, his denials, as Condivi transcribes them, of an association with Ghirlandaio were refuted by Vasari, who had researched the contract of his apprenticeship.

> 1488. I record this first day of April that I, Lodovico di Lionardo di Buonarrota, have placed my son Michelagnolo with Domenico and Davide di Tommaso di Currado [Ghirlandaio] for the next three years to come according to these agreements and terms: said Michelagnolo must stay with the aforesaid persons for the stipulated time in order to learn how to paint and to do in this activity that which the aforesaid shall command. Said Domenico and Davide must pay him for these three years the twenty-four florins that have been agreed—six florins the first year, eight florins the second year, and ten florins the third year, making in all the gross sum of ninety-six lire.[80]

At the tender age of thirteen Michelangelo inaugurated a lifelong pattern: he entered into a contract that would be broken at his convenience. Sixteen days after the agreement was signed, the Ghirlandaio brothers handed over two gold florins to their new apprentice and the less interesting sum of twelve lire, twelve soldi, to his father. Despite his father's dour warnings about money, convincing people to give it to him proved to be remarkably easy. From that day forward, Lodovico worked in the employ of his brilliant son, although he was either unaware of it or unwilling to admit it.

In those days word reached Florence from Imola in the north that Cardinal Raffaele Riario's uncle, Girolamo Riario, the count of Imola, had been stabbed to death by assassins either allied with Lorenzo de' Medici or seeking to gain his favor.[81] Thus died the last survivor of the Pazzi conspirators, ten years after the outrage. Riario's body was thrown out the

window of his palace onto the street. His widow, Caterina Sforza, raced to safety in the city's fortress. Within minutes she and her youngest child were trapped inside by a besieging mob. But she would not surrender, not even as the crowd hurled threats to kill her two sons who had been taken prisoner. From the ramparts, the countess refused to yield, calling down to the populace that the day would come when the babe in her arms would claim vendetta. As for her, lifting her skirts to expose her sex, she would make more sons.

• • •

THE GHIRLANDAIOS WOULD NOT HAVE CONSENTED TO PAY AN apprentice—indeed, they would have adhered to the custom of receiving payment to train him—unless the boy was capable of helping. Only recently has it come to light in an overlooked document that Michelangelo was running errands for the Ghirlandaios as early as June 28 of the preceding year (1487).[82] Perhaps it was on a trial basis (although neither Lodovico nor Michelangelo was wont to donate services). The Ghirlandaio brothers were committed to two important commissions: six months after promising Giovanni Tornabuoni in September 1485 to decorate the choir of Santa Maria Novella, Domenico signed a contract with the directors of the Ospedale degli Innocenti to make an altarpiece for their chapel. The Innocenti was the orphanage designed by Brunelleschi with a long loggia along one side of Piazza SS. Annunziata.[83] The altarpiece, considered one of Domenico's masterpieces, was completed straightaway, and a boy was sent over to collect the installment payment of three large florins. Though only twelve, Michelangelo was already trusted to handle money.

Domenico stood at the head of his atelier and "was esteemed not only in Florence but throughout Italy as one of the best masters then living."[84] He belonged to the elite contingent brought from Florence in 1480 to fresco the walls of the Sistine Chapel in Rome. The new papal chapel had been built by Lorenzo's nemesis, pope Sixtus IV, which increased Lorenzo's delight in this demonstration of Florentine primacy in the arts. When the duke of Milan needed painters for a prestigious assignment, he was convinced that only a Florentine would do.[85] The duke's agent wrote back an interesting report on the four best choices.

Sandro Botticelli, an excellent painter both on panel and on wall.
His things have a virile air and are done with the best method and
cohesive proportion.

Filippino, son of the very good painter Fra Filippo Lippi: a pupil
of the aforesaid Botticelli and son of the most outstanding master
of his time. His things have a sweeter air than Botticelli's; I do not
think they have as much skill.

Perugino, an exceptional master, and particularly on walls.
His things have an angelic air, and very sweet.

Domenico Ghirlandaio, a good master on panels and even more so
on walls. His things have a good air, and he is an expeditious man
and one who gets through much work.

In conclusion, the agent summed it up.

All these masters have made proof of themselves in the chapel
of Pope Sixtus IV, except Filippino. All of them later also in the
Spedaletto villa of Lorenzo il Magnifico, and the palm of victory
is quasi ambigua [almost in doubt].[86]

Leaving the verdict open was a gallant gesture if one considers that by
this time Botticelli had completed the *Primavera* and the *Birth of Venus,* the
supreme expressions of the three graces idolized at the Magnifico's court:
beauty, eroticism and mystery. Perhaps the duke's agent was trying to mini-
mize the disappointment should it prove impossible to lure Botticelli from
Florence. Praise for the artist's "virile air" is difficult to comprehend since we
tend to read Botticelli as the author of the most sinuous, seductive lines ever
drawn. The list credits Ghirlandaio for his "good air," which sounds respect-
able, and for his organizational skills in completing many projects. Small
wonder, then, that he and his new apprentice were soon enmeshed in a clash
of personalities.

• • •

MICHELANGELO ENTERED A WORKSHOP IN THE THROES OF A GREAT work. The wealthy Tornabuoni had agreed to pay for the renovation of the choir in Santa Maria Novella, replacing the frescoes by Orcagna, which were streaked and damaged by water pouring down from the roof. Ghirlandaio's new fresco paintings, in soothing tones of purple, gray, green, and brown, were to cover the steep walls on the left and right sides of the Gothic apse from top to bottom. He envisioned the lives of the Virgin Mary and John the Baptist unfolding in the streets of Florence, and in its better houses, with the participation of Florentine beauties and celebrities dressed in Renaissance costume.[87] Among the witnesses to Mary's Visitation to her cousin Elizabeth we see the exquisite Giovanna Tornabuoni, at that time the most beautiful woman in Florence. In other panels we find portraits of all the Tornabuoni men, women, and children, along with the Medici and their learned friends the philosopher Marsilio Ficino and the poet Angelo Ambrogini, better known as Poliziano. Ghirlandaio himself is there, as well as his brothers. No doubt the assignment came to them because of their aptitude for portraiture, a new genre of painting that Michelangelo, for his own reasons, would never practice.

Posterity, like the Milanese duke's informant, is inclined to praise the skillful execution of these frescoes while decrying their emotional blandness. For John Ruskin, the Victorian critic, they fall short because "if you are a nice person, they are not nice enough for you; and if a vulgar person, not vulgar enough."[88]

Life as one chanced to find it—the real, physical, perspiring world—was not a subject for art according to Michelangelo's instinctive conception of it, even as a child. At this time, though, he made an exception. While Ghirlandaio was momentarily called away, Michelangelo took his pencil and drew the whole battery of intricate scaffolding, ropes, and apparatus on which the boys were diligently working in Santa Maria Novella. Perhaps the talk in the air that morning had been about the artist-engineer Leonardo da Vinci, who had gone to Milan to design war machines for Ludovico Sforza, called Il Moro (The Moor). Everything was drawn so precisely that Domenico, when he saw the paper, blurted out astonished, "This youngster knows more than I."[89]

Michelangelo, aged thirteen, appears to have agreed with this appraisal, even literally. His comportment toward his master pegs him squarely among those geniuses whose powers precipitate problems. As part of their training, Ghirlandaio required his apprentices to copy his preparatory studies. Without disclosing his intentions, Michelangelo took one of these drawings

from a fellow pupil and drew on top of it, running his thick strokes over the master's lines, "correcting their defects, and so well that no objection could be offered."[90] Improvisation by apprentices fell far outside the normal curriculum. Vasari confirms this story of Condivi's, adding, almost incredulously:

> Consider the courage of the youth who was daring enough to correct his master's things. I have this drawing still, as a relic, having received it from Granaccio; and in the year 1550, I showed it in Rome to Michelangelo, who recognised it and was glad to see it, saying modestly that he knew more of the art when he was a boy than now he was old.[91]

Ghirlandaio's annoyance was beginning to show. Michelangelo assumed it was envy, recalling an episode involving a remarkable book of drawings "representing shepherds with their flocks and dogs, landscapes, buildings, ruins, and other things."[92] As befits a Florentine master of his stature, Domenico had collected more than a hundred studies of classical motifs in an album, perhaps the one that later found its way into the Spanish Royal Collection under the title *Codex Escurialensis*. When Michelangelo asked to borrow the book, Domenico refused.

Condivi reports another anecdote of the apprentice's interest in valuable drawings. After joining the workshop, Michelangelo's draftsmanship progressed by leaps and bounds. It happened, finally, that someone lent him a drawing of a head to copy and when he was finished, he returned his copy to the owner instead of the original. He was curious to see if his work was on a par with a full-fledged master's. In fact, the deception was not discovered until all the boys started talking and laughing about it. This made everyone gather for a comparison between the two sheets. No one could detect even the slightest difference, "for besides the perfection of the drawing, Michelangelo had smoked the paper to make it appear of the same age as the original."[93] This triumph sent his reputation soaring. Thus authorized by Condivi, Vasari confirms that the boy counterfeited many drawings by different old masters, aging the papers with smoke and various tricks.

> He did this only in order to learn from the originals of those artists whose excellence he admired and desired to surpass.[94]

Ghirlandaio's reluctance to lend him drawings was not so strange.

Some months went by and Michelangelo, though not yet fourteen, felt ready to attempt a first picture. Somehow his friend Granacci had laid his hands on a marvelous engraving by Martin Schongauer. The subject was St. Anthony carried aloft by a swarm of devils furiously beating him with sticks. The raw energy of the German print was unlike anything he had seen in Ghirlandaio's studio. Michelangelo set out to copy it on a wood panel using pigments and brushes supplied by Granacci. He even stopped by the fishmongers' to study the iridescence of scales and fins. Everyone who saw the painting went away astonished.

Michelangelo would have heard how Leonardo da Vinci, twenty-two years his elder, had early demonstrated his genius by painting a dragon after copying the wings and snout of a bat and a lizard.[95] He figured he would do no less. He had, besides, a family interest in the subject as a result of his great-uncle's unfortunate brush with demons.

There had been a vogue for naturalism in Florence since May 1483 and the arrival from Bruges of the *Portinari Altarpiece*. Tommaso Portinari, a Medici banker, had commissioned *Adoration of the Shepherds*, a huge triptych with life-size figures, for the church of the hospital of Santa Maria Nuova near the Duomo. The artist was Hugo van der Goes, one of the great masters of Flanders. Florentine painters were deeply impressed by the painting's fidelity to nature, impartially rendering the shepherds' grimy faces and the Virgin's symbolic flowers with the same acute observation.

Ghirlandaio took pride in pointing out that the boy's remarkable painting was made in his workshop. It was an innocuous observation, yet sixty years later Michelangelo still seethed with resentment at what he regarded as a brazen attempt to claim the credit.[96]

How long this war of nerves might have carried on, and with how many casualties, is anybody's guess. It must have been with a mutual sigh of relief that the two of them heard that Lorenzo de' Medici was looking for talented young artists to train as sculptors in the garden of San Marco.

THE GARDEN OF THE MEDICI

FLORENCE

1489/90–APRIL 1492

THEY HEARD THE VOICE OF LORENZO WALKING IN THE GARDEN. Twenty years had come and gone since the lord of Florence had enclosed this plot of land on the Piazza San Marco, 150 paces to the north of his palace. The Magnifico planted tall trees in the midst of the garden, built a loggia, and then filled the terraces and paths with antique statues, bas-reliefs, and marble fragments.[1] "And not only were these things pleasant to the sight, but they became a school and academy for young painters and sculptors."[2]

In the Laws, the divine Plato praises education that enhances the whole personality as opposed to mere professional skill.[3] When Lorenzo was young, his grandfather Cosimo the Elder had him tutored in accord with this philosophy. The garden at the edge of Florence was his modern re-creation of the Athenian groves where Plato lived and taught. Within its walls his companions and guests breathed the sultry, sensuous air of antiquity.

Only a handful of artists were admitted. Vasari lists them all, but, owing to their diversity, it is not clear what they did there.[4] Lorenzo's intention was never to supplant the tradition of workshops, but rather to cultivate the most promising talents. About 1480, when Leonardo da Vinci was already in his twenties, the Magnifico summoned him, "gave him provisions and set him to work in his garden on the Piazza of San Marco in Florence."[5] Leonardo was a proven painter by then, but he used the access to study the horses represented on the classical bas-reliefs.[6]

One morning in 1489 or 1490, instead of going to the Ghirlandaio studio at Santa Maria Novella, Francesco Granacci and his young friend Michelangelo Buonarroti turned right at the cathedral and walked up the Via Larga, past the Palazzo Medici, until they came to the garden.[7] There they saw Pietro Torrigiani fashioning some figures in clay under the approving eye of old Bertoldo di Giovanni, Donatello's last pupil. It was an awesome moment, so utterly different from the drudgery in the workshop belonging to the garland maker's sons.[8]

Pietro Torrigiani came from a respectable family, like the Buonarroti Simoni, with the difference that the Torrigiani were prosperous businessmen—vintners by trade. Now eighteen, Pietro enjoyed vaunting his superiority over the other lads at San Marco. He was poised to begin a distinguished career. Even Vasari, though he disliked Torrigiani for the harm he did to Michelangelo, admits that "he worked clay in a very beautiful manner."[9]

Michelangelo looked at Pietro's clay models, carefully turning them over in his hands. He would have to do as well, just as he had improved upon Ghirlandaio's drawings. "Do you not know that in a race the runners all compete, but only one receives the prize?" So St. Paul admonished the Corinthians. "Run in such a way that you may win it." Florentines were known for their competitiveness; he had it in his veins.

Condivi, the scribe of Michelangelo's old age, passes over this episode, perhaps because it concedes that the detested Torrigiani had talent. We know the story through Vasari: though he had never modeled clay, "upon seeing Pietro's figures in the round, Michele Agnolo immediately made some to rival them."[10] The magnificent Lorenzo, walking in his garden in the cool of the day, was impressed.

An astute judge of character, Lorenzo could not have failed to notice the incongruities in fifteen-year-old Michelangelo di Lodovico Buonarroti Simoni. Florentines of his age and upbringing usually had a smattering of Latin; Lorenzo's own son Piero was quoting Virgil when he was seven. Yet this boy knew only Dante and the Bible. In a city where money meant everything, the lad was stubbornly proud of his impecunious family.[11] There were rough edges to his personality, but he cared not that merchants' sons wore finer coats and had more meat at supper.

Eyes are windows opening onto the soul. Young Buonarroti's eyes were peculiar: "small, the color of horn, with bluish yellow flecks."[12] They gave him an air of aloofness. When Michelangelo challenged Torrigiani, it was his *sì bello spirito* that impressed Lorenzo—his remarkable strength

of character.[13] Instead of distracting himself with merrymaking and flirta-tions—the usual pastimes of youth—Michelangelo lusted only for art. As an irascible old man he complained to a pupil that Condivi's biography should have emphasized more how he'd never neglected his work to play love songs on the lyre.[14]

Michelangelo's transfer from Ghirlandaio to the Magnifico cost him a severe beating from his father, or so Condivi insists, but whether the pusil-lanimous Lodovico even attempted it is improbable. His father could not command him. A proud resistance to a son's resolve to work with his hands is precisely the response that Michelangelo would have wished from him. Granacci stood up for his young friend, pointing out to Lodovico the differ-ence between a sculptor and a stonemason.[15]

• • •

AFTER THE MURDER OF GIULIANO, THE JOYOUS OPTIMISM OF THE Medicean court had never returned.[16] Failing to assassinate Lorenzo, Pope Sixtus IV determined to destroy him. As early as May 12, 1478, Alfonso, duke of Calabria and the son of the king of Naples, had been called to Rome to prepare a war against Florence. By early July the Neapolitan troops under the duke's command had crossed into Florentine territory. The advance into Chianti was timed to coincide with the papal excommunication of Lorenzo, which took force on July 21. Ringed by enemies, Florence found herself in serious difficulty. By mid-November her dependent towns of Poggio Imperiale, Castellina, and Colle had fallen. A failure at arms, Lorenzo was trapped in a predicament with no apparent escape. The sole advantage remaining to him was his own extraordinary personality. In November 1479 Lorenzo informed the Signoria of his intention to surrender his life and liberty to the perilous mercy of Ferrante, king of Naples:

> As I am the person aimed at by our enemies, I may, by delivering myself into their hands, perhaps be the means of restoring peace to my fellow-citizens. . . . And perhaps it may be the will of God that, as this war was begun by the blood of my brother and of myself, it may now by my means be concluded. All that I desire is that by my life or my death, my prosperity or my misfortune, I may contribute towards the welfare of my native land.[17]

The autumn voyage from Pisa to Naples was made in fair weather, which Lorenzo accepted as a happy augury for his mission. Better still, the Neapolitans poured out to catch a glimpse of the famous Magnifico, a dashing youth even if his face was coarse. Lorenzo delighted the populace with his liberality, giving handsome dowries to poor girls and paying ransoms for a hundred galley slaves. With his life hanging by a thread, Lorenzo was wagering all for all. Even the malicious King Ferrante was worn down by his prisoner's charm. A treaty was drawn up in defiance of the pope's unappeasable demands for Lorenzo's surrender to Rome. The prince returned to Florence safely and at peace.

This miracle undid the Magnifico's opponents; thereafter he ruled as he pleased. The vestiges of republican government were maintained, but in name only. The great families, if they refused to fall in line, were humiliated. An army of spies kept Lorenzo informed about the citizens' most private affairs.[18] "Florence could not have had a better or more delightful tyrant," writes Guicciardini, always an acute observer.[19] Machiavelli, also an eye-witness, writes that his personality "combined the uncombinable."[20]

Lorenzo's ruthlessness in affairs of state was veiled by the glittering refine-ments of his court. He gathered around him the greatest men of letters of the age, who found in him a charming, unstinting Maecenas. "In a villa overhang-ing the towers of Florence, with [Marsilio] Ficino, [Cristoforo] Landino, and [Angelo] Poliziano at his side, he delighted his hours of leisure with the beautiful visions of Platonic philosophy, for which the summer stillness of an Italian sky appears the most congenial accompaniment."[21] A philosophy that renounces worldly concerns and urges the contemplation of pure ideas is bound to appeal to a man who suppresses political debate.[22] But the influ-ence of Lorenzo's circle extended well beyond the borders of Florence.[23]

In 1462 Cosimo de' Medici had deposited his Greek manuscripts in his villa at Careggi and commissioned Ficino to translate Plato and the other sources of Platonic thought.[24] The son of Cosimo's physician and a youth of twenty-nine, Ficino responded to this calling as if born to the task. His translations of all the dialogues of Plato were completed in 1468; a year later, he wrote his famous commentary on Plato's *Symposium*, which he titled *De amore*, "On Love." Ficino's great contribution was to identify Love as the operative force in Creation. He read the *Symposium* as St. Augustine read Genesis—as if its plot were the Incarnation. Over the next three decades he produced an unending stream of translations, letters, and commentaries. Although an academy in name only (in homage to Plato), the villa at Careggi became the meeting place, and thus the enduring symbol, of the scholars,

writers, and thinkers around Ficino who shared his aspiration to incorporate the ancient wisdoms within Christian practice.[25]

A vivid sketch of the tranquil life led by the philosophers in the villas placed at their disposal has come down to us in a letter Poliziano wrote to Ficino in the spring of 1490, inviting him to visit during the approaching summer:

> I hope when it is very hot in the month of June, and you direct your steps towards your Careggi, that you might think of coming to our country refuge in Fiesole. We enjoy quantities of water and in this valley the sun is never too hot. And there is always a pleasant breeze. From the little farm . . . one can see and admire Florence. Quite often Pico comes to visit me from his Querceto, unannounced, and he takes me with him for a delightful dinner, simple in its frugality, but elegant and always enriched by pleasant conversation and by the peacefulness of the setting. The wine here would certainly be as good as the food, perhaps better. In fact I always compete with Pico himself for the prize of the best wine.[26]

On such quiet evenings in the hills of Tuscany, these gentlemen found it easy to imagine that Lorenzo was the philosopher king of Plato's *Republic*. Proximity to the Magnifico, if nothing else, allowed Michelangelo to observe that a man of sufficiently strong will can make himself a living myth—and myths have power.

Caught between state affairs and the leisured society of his court, Lorenzo delegated too much autonomy to the incompetent manager of the Medici bank, Francesco Sassetti.[27] The family's operations in Bruges, Paris, and London were crippled by bad loans to insolvent foreign sovereigns.[28] The loss of the papal accounts wounded the Medici like the thrust of a knife. Lorenzo il Magnifico was indubitably "a man born for greatness," as Poliziano tells us in elegant Latin.[29] But he was also—in Machiavelli's down-to-earth vernacular—"miserable at business."[30] The family tactic of ruling unofficially as private citizens meant that Lorenzo could not easily raid the municipal coffers.[31] The popular pageants and jousts in Piazza Santa Croce were not resumed. The best sculptors, Verrocchio and Leonardo da Vinci, went to other cities to execute public monuments. Suddenly there was not enough money in Florence.

There were other troubling portents. By the time Michelangelo came to the garden, in 1489 or 1490, Lorenzo, though just entering his forties, was

already stricken with gout, the liver dysfunction that had killed his father, Piero, and his grandfather Cosimo. It was Fortune's cruel irony to inflict a hereditary illness on a family protected by Sts. Cosmas and Damian, the brother physicians—*medici* in Italian. Lorenzo made a brave face of his distress so as not to alarm the populace, not to mention his creditors. Yet his hedonistic hymn to the wine god Bacchus, composed in 1490, is laced with presentiments of mortality.

Lorenzo's zeal to export philosophy complicated his affairs. In December 1486 the rising star of his court, Count Giovanni Pico della Mirandola, printed and circulated nine hundred *Conclusiones*, or philosophical statements, which the young man proposed to defend in public debate. He also penned an introductory oration, *On the Dignity of Man*. In Pico's revision of the Genesis story, until God made man, the Creation was a hollow victory. "The Artisan desired that there be someone to reckon up the reason of such a big work, to love its beauty, and to wonder at its greatness."[32] All things were given their essence; only man has the power to change it. "Thou," Pico's God tells Adam, "art the molder and maker of thyself; thou mayest sculpt thyself into whatever shape thou dost prefer."[33]

Although ostensibly Christian, Pico's theology draws heavily on Orphic hymns, Egyptian astrology, and the Hebrew Cabala. Magical proof of Christ's divinity was not a message welcome in Rome, especially during a papacy that was burning witches in Germany and would soon send Tomás de Torquemada to inflame the Spanish Inquisition.[34] Innocent VIII had succeeded Sixtus IV in 1484. Neither the pontiff nor his Curia was inclined to entertain the speculations of a precocious twenty-three-year-old with a reputation for romantic escapades.[35]

The verdict was quickly delivered. Seven of Pico's tenets were judged heretical; six others, highly suspicious.[36] Still keen on arguing, Pico rashly published a defense, to which Innocent responded with an order for his arrest. The young count fled to France, but in February 1488 he was taken by papal officers and incarcerated in the castle of Vincennes. It took all of Lorenzo's influence, and much money, to free his protégé and bring him home.

But the damage was done; the pope had been alerted to Lorenzo's reputation for encouraging the worst as well as the best qualities of his friends. In October 1489, when Pico della Mirandola showed no signs of desisting in his theologizing, Innocent sent Lorenzo an ominous warning by way of a letter to the Florentine ambassador:

That person [Pico] is looking to make a bad end; one day he could be burnt or eternally condemned as has happened to others. These matters of the faith are both sensitive and prohibited. I cannot tolerate such interventions. Write to Lorenzo: if he wishes him well, have him write works of poetry, and not theology, because such are more suitable. The Count lacks the firm foundation a theologian needs; his ideas are wrapped in doubts and sophistries as opposed to the true reasonings approved by the Holy Church.[37]

This new menace came when the young count was still reeling from the disastrous reception of his nine hundred theses. He had never imagined that his idealistic attempt to reconcile Christianity with "the truth of all the ages" would bring him to the brink.

Yearning for guidance in that dark year of 1489, Pico recalled his meeting in Reggio a few years earlier with Fra Girolamo Savonarola, a brilliant friar with ascetic tendencies. In April Lorenzo wrote to the Dominicans, at Pico's urging, requesting Fra Girolamo's return to the convent of San Marco. The Medici were deeply interested in San Marco, which was rebuilt by Cosimo de' Medici at the time of the Council of Florence in 1439. It became a center of learning and piety, endowed with a humanistic library and embellished by the devout frescoes of Fra Angelico. The church, which stood across the Via Larga from Lorenzo's garden, has been frequently altered and modernized since then, and there is little now to remind us that it was here on August 1, 1490, that Savonarola began to expound on the Apocalypse.[38]

• • •

IN THE GARDEN THERE WAS A CACHE OF MARBLE BLOCKS INTENDED for Lorenzo's library, or so Condivi says, though it makes little sense that building materials should have been stored in the midst of his prized antiquities. The biographer goes on to say that Michelangelo made friends with the stonecutters, who lent him their tools.[39] Perhaps they did more than that, for otherwise how he learned to carve and polish stone is a mystery. Bertoldo was primarily a modeler of wax and clay for casting in bronze and was anyway on the verge of departing this life. This is one of the gaps in Michelangelo's story that he was content to leave as such.

Among the ancient sculptures in the garden was the "head of a Faun, in appearance very old, with a long beard and a laughing face, although the mouth could hardly be seen because of the injuries of time."[40] This *Faun* was perfect for Michelangelo's purposes. He could mask his inexperience by elaborating another master's invention. It was the same tactic that had worked so well with his painting of a German engraving.

Bertoldo gave him permission to attempt his first marble. Copying the *Faun* fit in with Lorenzo's long-standing interest in recycling classical subjects. Not many days had passed before Lorenzo walked up to look in on the young Buonarroti's progress.

He found the boy busily polishing the head. Incredibly, the *Faun* was almost finished.[41] Michelangelo had worked on it secretly day and night. The quality of the workmanship from one so young, who "had never before touched marble or chisels," struck Lorenzo as nothing short of amazing.[42] He marveled at the ingeniousness of the details the boy had inserted in places where the original was rubbed or broken. Michelangelo had sculpted a lascivious laugh on the satyr's lips and opened the mouth to show his wild teeth. Every detail was calculated to please his new lord, even the choice of subject. Faunus was the Roman counterpart of Pan, the feral ruler of ancient Arcadia and patron of pastoral poetry, Lorenzo's own art.

The Magnifico had recently received *The Court of Pan* by Luca Signorelli, an outstanding master. The meaning of this painting of goat-footed Pan enthroned in the midst of beautiful youths, male and female, has never been deciphered. Yet it seems imbued with the erotic yearnings of Lorenzo's friends as surely as Botticelli's *Birth of Venus* and *Primavera* allegorize their Neoplatonic pretensions. Though the fondest of fathers, and respectful toward his Roman wife, Clarice Orsini, Lorenzo was "marvelously committed," Machiavelli tells us, "to the affairs of Venus."[43] Few men have been as keenly alive to beauty—carnal as well as spiritual—or as uninhibited by morality. Writing later under the constraints of the Counter-Reformation, Vasari cautiously says only that Signorelli's masterpiece represented "some nude gods."[44]

After many compliments, Lorenzo decided to tease him slightly, as one does with children, saying,

> Oh! You have made this Faun very old, and yet left him all his teeth. Don't you know that old men of that age are always missing some?[45]

Lorenzo made other jocular comments, but Michelangelo was no longer lis-
tening. Wrapped up as he was in his own carefully plotted intentions, the
joke sailed over his head. He felt mortified: how could he have overlooked
something so obvious? Michelangelo's *Faun* was not a copy exercise; it was
meant to show his tongue-in-cheek understanding of the classical ethos of
Lorenzo's garden. His father's sobriety and Ghirlandaio's industry had not
prepared him for this sophisticated banter. When Lorenzo responded with a
satirical joke, Michelangelo panicked. Condivi relates what happened next:

> It seemed a thousand years to Michelangelo before the Magnificent
> went away so that he could correct the mistake; and when he was
> alone, he removed an upper tooth from this old man, drilling the
> gum as if it had come out with the root, and the following day he
> awaited the Magnificent with eager longing. When he had come
> and noted the boy's willingness and single-mindedness, he laughed
> very much; but then when he weighed in his mind the perfection
> of the thing and the age of the boy . . . he resolved to help and
> encourage such genius and to take him into his household; and said,
> "Inform your father that I would like to speak to him."[46]

Arriving home, Michelangelo immediately communicated Lorenzo's
command. His father, divining why he was being summoned, made ready to
go, persuaded as well by Granacci, though he complained, once again, that
his son was being led astray.

The first stones of the Palazzo Medici, to which father and son now made
their way, were laid in 1444, the year of Lodovico's birth. Lodovico had seen
with his own eyes the tangible proof of Medicean power: the cutting through
and replacement of the old, meandering streets north of the cathedral by a
broad, straight street, the Via Larga, which would be more fitting in front of
the massive block that would be their palace.[47] The two Buonarroti Simoni,
father and son, passed through the portal and entered an arcaded courtyard
with the steepest walls they had ever seen in a private house. Above the
arches all around were sculptured medallions depicting scenes—mainly of
Bacchus and his satyrs—copied from antique gems and cameos in Lorenzo's
possession. Far above their heads the square sky appeared, as if viewed from
the bottom of a well.

They came face to face with the astonishingly lifelike statue of *David*,
portrayed as a beautiful adolescent nude, and adorned with Dionysian

tresses. One of the city's artistic masterpieces, the bronze had been fashioned by Donatello for Cosimo de' Medici, now called *Pater Patriae.*

The archways on the far side of the cortile allowed a glimpse of the palace garden with its profusion of antique statues, heads, capitals, and entablatures. On either side they saw two classical statues of the satyr Marsyas—one in white marble, the other in *rosso antico.*[48] Ovid tells the story as a lesson in artistic hubris. Goaded by vanity, Marsyas challenged the divine Apollo to a music contest. After his defeat, the presumptuous satyr was flayed alive. In the *Paradiso,* Dante writes of Marsyas losing his skin as if it meant not death but the freeing of his spirit.[49]

Finally, father and son were ushered into a reception chamber, where the boy's future was discussed. There, amid the wall hangings, bronzes, gems, majolica, and countless curiosities collected by three generations of Medici rulers, not to mention dazzling panels painted by Paolo Uccello, Piero del Pollaiuolo, van Eyck, and Fra Angelico, Lorenzo asked Lodovico to entrust his son into his care.[50] There would be a stipend of five scudi a month (an extraordinary sum to pay for the privilege of improving the prospects of a boy).[51] Unable to deny the most powerful man in Florence, and no doubt overwhelmed by the surroundings, Lodovico made the best of it, graciously replying, "Not only Michelangelo, but all of us, with our lives and our best faculties, are at the service of Your Magnificence."[52] With that settled, Lorenzo asked Lodovico about his own affairs. Summoning up his dignity, the elder Buonarroti said:

> I have never practiced any profession, but I have always lived on my modest income, looking after those few possessions left to me by my ancestors, seeking not only to maintain them but also endeavoring to increase them as much as possible by my diligence.[53]

"Very well," Lorenzo told him, "look about you and see if there is not something in Florence that will suit you. Make use of me, for I will do the best I can for you." And so dismissing him, the Magnifico gave Michelangelo a good room in his own house, "providing him with all the conveniences he desired."[54]

Michelangelo had Condivi relate not only this encounter but the ensuing one, a very curious kind of memory for a son to preserve. Not long afterward, a position opened in the customs office. Lodovico returned to the palace to make his application, saying, modestly, "Lorenzo, I can do nothing but read and write; the comrade of Marco Pucci in the Dogana has died. I should like to have his place. I believe I shall be able to carry out the duties properly." The

position brought eight scudi a month, a barely sufficient income for a head of household. Lorenzo, who assumed the man would ask him for more, was surprised. Smiling resignedly, he placed his hand on the other man's shoulder and told him he would always be poor.[55]

• • •

THE BOY OWED A GREATER DEBT TO DOMENICO GHIRLANDAIO than he admitted. His earliest drawings show the imprint of the older master's graphic style, the first sight of which had so inspired him.[56] Despite the competitive pressure of such contemporaries as Verrocchio, Botticelli, Lorenzo di Credi, and Leonardo da Vinci, Ghirlandaio had found his own way. His drawings are not as beautiful as theirs, but they are effective. The short, abrupt strokes are laid down in parallel hatchings and in various directions, according to the fall of light across different textures. The studies were indispensable when he had to capture silky pleats and corrugated faces in colorful pigments.

Even as a child, Michelangelo's use of parallel shading was more controlled than Ghirlandaio's. The great distinction, though, is one of temperament: Michelangelo makes the human body appear as solid and weighty as it is in actual life. Fleeting effects of light and surface mean little or nothing to him, nor does the illusion of distant spaces—which explains his refusal to consider himself a painter.[57]

Bertoldo wanted to teach the promising newcomer according to the tried and true methods. The boy would be given free access to Lorenzo's collection, which included drawings, cartoons, and models from the hand of Donatello, Brunelleschi, Masaccio, Paolo Uccello, Fra Angelico, and other masters native and foreign. "Indeed, these arts cannot be learned except by long study and by copying good works. And he who has not had this opportunity, though he may be greatly talented, will be long in attaining perfection," or so Vasari assures us, and he was one who copied much.[58]

The daily influx of artists of every age to study the Masaccio frescoes transformed the Brancacci Chapel into an art academy. Vasari singles out in Masaccio's scene of St. Peter performing baptisms, "a very fine nude figure, shown shivering among those being baptized, numb with cold, executed with the most beautiful relief and the sweetest style. This is a figure which both older and modern artisans have always held in the greatest reverence

and admiration."[59] Of the ten or so drawings that can be reliably dated to Michelangelo's student days prior to his departure to Rome in 1496, two subjects are from the Brancacci Chapel and one from Masaccio's *Sagra* in the adjacent cloister. Another is a figure in Giotto's *Ascension of St. John the Evangelist* fresco in the Peruzzi Chapel in Santa Croce. Michelangelo's concentration on these two masters was inevitable, for each in his day was unequaled in the rendering of stately forms. Giotto was a hundred years ahead of his time, with but a short-lived following; Masaccio, in Berenson's brilliant formulation, was "Giotto reborn" in the fifteenth century.[60]

Several of his early drawings represent the heads of satyrs, the same theme as his sculpted faun. His fascination with wickedly mocking creatures—the classical personification of the rampant id—never left him. As long as he drew, he made doodles of them, the way Leonardo sketched ugly old men. Perhaps they made these drawings to exorcise inner demons; whereas Leonardo was famously vain about his beautiful features, Michelangelo was tormented by his disfigured nose. As he would later confess in a poem, "my face makes hers more beautiful . . . so that I'm mocked even more for being ugly."[61] His poems are also haunted by concupiscence, the sin that, for fauns, is second nature.

Michelangelo wielded a barbed tongue, or possibly it was now he developed one. Satirical ripostes were a Florentine art form: Poliziano compiled a list of hundreds of *Detti piacevoli*. Even the title, "Pleasant Sayings," is ironic, for the few that are not insulting are instead salacious. Donatello's infatuations with the boys in his studio are recounted more explicitly than with a wink.

The liberties taken by, or permitted, artists of genius is another leitmotif. Even in the Trecento, Poliziano tells us, Giotto vaunted his self-assurance in the presence of sovereigns. King Robert of Naples, who had called the artist to his service, was visiting his studio on a very hot day, and remarked, "Giotto, if I were you I should leave off painting for a while." "Yes," was the reply, "if I were you I should."[62]

Donatello was similarly irreverent toward the high and mighty. When the Patriarch Giovanni Vitelleschi formally complained that Donatello had ignored a command to come and work for him, the crusty master responded "Tell the Patriarch that I am not going to go, because I am a patriarch in my art, just as he is in his."[63] Such stories were told of the great painters of antiquity, so it is not surprising that Michelangelo picked up the habit. Vasari records several of his sardonic quips, such as his retort when told that a certain artist, though otherwise mediocre, had painted a marvelous ox: "It is easy for artists to paint their own portrait."[64]

Within a few months, the youth had acquired the same privileges granted to Bertoldo only after a lifetime of faithful service: a room in the Palazzo Medici on Via Larga and the keys to the garden. Michelangelo repaid this trust by being more studious than the others and never missing an occasion to display his "proud spirit."[65] He pored over Masaccio's frescoes in the Carmine, drawing copies that were openly admired by his followers.[66] Baccio da Montelupo, another sculptor at San Marco, became a close friend. Torrigiani endeavored to get along with him, but to no avail, as he later recounted to Cellini:

> Buonarroti and I used, when we were boys, to go into the Church of the Carmine to learn drawing from the Chapel of Masaccio. It was Buonarroti's habit to banter all who were drawing there, and one day, when he was annoying me, I got more angry than usual, and, clenching my fist, I gave him such a blow on the nose that I felt bone and cartilage go down like biscuit beneath my knuckles; and this mark of mine he will carry with him to his grave [67]

Condivi tells Michelangelo's side of the story:

> When he was a boy, a man called Torrigiano de' Torrigiani, a brutal and arrogant person, with a blow of his fist almost broke the cartilage of Michelangelo's nose, so that he was carried home as if dead. However, that Torrigiani who was banished from Florence for this, came to a bad end.[68]

It was the custom at Lorenzo's table not to stand on ceremony. Those who were present at the beginning of a meal were encouraged to take their places close to his, and were not obliged to change them, no matter who came in afterward.[69] "Thus it often happened that Michelangelo was seated above Lorenzo's own sons,"[70] as well as the distinguished "men of letters" who frequented the Palazzo Medici in the last decade of the fifteenth century. Michelangelo recognized them from their portraits in Ghirlandaio's frescoes.

Theirs was a constellation of minds not easily matched in brilliancy by any other age. In order of seniority, there were the stars discovered by old Cosimo: Cristoforo Landino, the commentator on Dante; Marsilio Ficino, the translator of and commentator on Plato, Plotinus, and St. Paul; and Vespasiano da Bisticci, bibliophile and biographer. They had been Lorenzo's

tutors. His contemporaries and intimate protégés—Pico della Mirandola, the precocious theologian, and Angelo Poliziano, the poet and translator of Homer—burned as brightly. The court of Lorenzo was a perfectly crafted universe on the edge of dissolution.

Michelangelo's arrival coincided with Ficino's completion of a treatise on medicine and astrology, *Three Books on Life* (1489), which concludes, "The activity which from tender years you do, speak, play-act, choose, dream, imitate . . . is the thing for which the heavens and the lord of your horoscope gave birth to you."[71] Had Lorenzo asked Ficino to chart his protégé's horoscope, they would have found it filled with difficulties.[72] As a Pisces, Michelangelo was chiefly ruled by mighty Jupiter; however, the only planet above the horizon at the time of his birth was Saturn, the orb conducive to moodiness and secrecy. Indeed, Michelangelo's horoscope had four other planets casting shadows over his family's prosperity and his own hopes of inheritance.[73] Lorenzo had said as much to Lodovico when he settled for too little. A negative position of Venus, the planet ruling love, in relation to powerful, brooding Saturn, foretold a passionate personality that would receive "no pleasure from love nor successful results from its desire."[74]

On Michelangelo's day of birth, March 6, 1475, Mars was in the third house, nearly ascendant in the heavens. In Ficino's system of astrology, this location predetermined belligerence and, alas, an erosive envy of others' accomplishments. Strained relations with Torrigiani, not to mention Ghirlandaio, seemed to be in his stars. In consolation, fiery Mars held out the prospect of fame, if young Buonarroti Simoni were willing to dedicate the "greatest toil."[75] Sculpture combines choleric exertion with image making and is thus a Martial activity.[76] A battle, such as Poliziano recommended he attempt, is the ultimate Martial subject.[77]

• • •

DURING THE LAST TWO OR THREE YEARS OF LORENZO'S LIFE, WHEN Michelangelo was in constant proximity to the most learned men of the time, his mind was awakened. "The Magnificent would send for him many times a day and would show him jewels, carnelians, medals, and other things of great value as he knew the boy had high intelligence and judgment."[78] The intaglio gems were adorned with the signs and hieroglyphs of the ancient wisdoms. Sixteen years old, and intent on learning how to sculpt, the boy was

not yet equipped to be the confidant of metaphysicians. But Poliziano had a theory on art—expressed in terms of poetry, the highest of the arts—and Michelangelo was interested in that.

Poetry cannot be understood, the theory goes, without prior knowledge in many fields, including philosophy, medicine, law, and philology—and a mere smattering will not do.[79] Only daily immersion over the course of years will suffice. Of course Poliziano was speaking of himself. He invoked as support his friend Pico della Mirandola. Their readings in the early church fathers led them to the discovery that the deepest truths of the Old Testament lay concealed beneath the surface of its narratives and genealogies. So it was, they reasoned, that the Egyptians placed sphinxes outside their sanctuaries to guard their secrets from impious eyes.[80] Hadn't Augustine alluded to "hidden mysteries" in his *Confessions?* And didn't Paul reveal to the Galatians, "These things are an allegory," and to the Corinthians, "The letter kills, but the spirit quickens"?[81]

The implications were enormous. It would take time to absorb them all— years even just as the poet was claiming. But what first struck Michelangelo was the inadequacy of Ghirlandaio's approach. People whose opinions mattered, like Poliziano and Lorenzo, required art that went deeper than superficial appearances. Art had to touch the *spirit*.

The most estimable painters and sculptors, he was told, were set apart by knowledge. Otherwise art was merely manual labor—exactly as his father and uncle had protested. Having no money, his father tried to cling to appearances lest his family be associated with "the rank scum that pursues the mechanic arts," as Petrarch so edifyingly puts it in his *Family Letters*.[82]

As a schoolboy Michelangelo had memorized Dante's verse, "Once Cimabue held the field, now Giotto receives the cry, so that the other's fame grows dim."[83] It had seemed a normal statement about competition, but there was more to it. The humanists in Lorenzo's circle spoke of Giotto as a man of "great understanding even apart from the art of painting, and one who had experience in many things. Besides having a full knowledge of history, he showed himself so far a rival of poetry that keen judges consider he painted what most poets represent in words."[84] As a fledgling copyist Michelangelo was captivated by Giotto's frescoes in his own church, Santa Croce. To reach that level, he now was told, an artist needed hands that were *docta*, as well as *dextera*.[85]

Giotto was a recurrent topic at Lorenzo's table at the time of Michelangelo's arrival. Working behind the scenes, the Magnifico had managed to persuade

the cathedral's building works, called the Opera di Santa Maria Fiore, to install a Giotto memorial. Honoring artists on a par with military heroes was a humanistic innovation initiated at Brunelleschi's death in 1446. As the architect of its magnificent bell tower, Giotto's association with the Duomo was as fixed in Florentine minds as Brunelleschi's was for his great dome. The portrait bust was sculpted by Benedetto da Maiano between September 1489 and August 1490.[86] Poliziano composed a Latin inscription in which old Giotto speaks in sonorous cadences inspired by Plato and the God of Moses.

> I am that man by whose deeds
> painting was raised from the dead,
> my hand as ready as it was sure.
> Nature lacked what my art lacked.
> No one was allowed to paint anything
> better or more completely.
> Do you admire a beautiful tower
> resounding with sacred sound?
> By my design this tower
> also reached for the stars.
> But I am Giotto, why cite such deeds?
> My name alone is worth a lengthy ode.[87]

. . .

RENAISSANCE SCULPTURE TRACES ITS ANCESTRY TO 1401, WHEN the Arte di Calimala, the wealthy guild of the cloth importers, organized a public competition for the commission to execute bronze doors for the Baptistery of Florence. The ancient doors in Rome were very much in the air. Two expert goldsmiths, Lorenzo Ghiberti and Filippo Brunelleschi, submitted cast plaques representing the Sacrifice of Abraham. Though each was superb, Ghiberti's was preferred.

Bitterly disappointed, Brunelleschi took himself to Rome, thus making the first recorded artistic pilgrimage to that open-air academy of classical ruins. His friend Donatello accompanied him. Together they made drawings of everything they saw, including almost all the Roman buildings, estimating their heights from the foundations to the cornices and recording their notations. Donatello was keen to learn the proportions and motifs for his

sculptures, but Brunelleschi, without confiding in his friend, had resolved to become an architect. We have these details from Antonio Manetti, a humanist at Lorenzo's court. The two Florentines paid diggers and porters to excavate around the foundations of buried buildings, "since no one else did this thing nor understood why they did it. No one gave any thought to the ancient method of building, nor had for hundreds of years."[88] The phrase has dual value as a capsule definition of *Renaissance*.

If Brunelleschi provided the intellect for the creation of Renaissance sculpture, Donatello supplied the heart. He was the first to combine a faithful presentation of the human form with an acute and penetrating portrayal of character. Sculpture before Donatello was peopled by emblematic personages as inert emotionally as a coat of arms. As a young sculptor of great expectations, surrounded by literary men and aristocracy, Michelangelo was constantly reminded from all sides that the greatest sculptor of the century now nearly past was indubitably Donatello.

The furnishings in the Palazzo Medici comprised a Donatello museum of statues and plaques in every size and description. Bertoldo's room, as we know from inventories, was located in the servants' quarters and did double duty as a storage space for pictures and sculptures—presumably Michelangelo's was the same.[89] There is no better way to learn about a work of art than to hold it in your hands and observe its infinite transformations between daylight and candlelight. The large-scale works by Donatello included the standing figure of *David* in the courtyard and the powerful, almost roughly so, bronze relief panels intended for the pulpits of San Lorenzo. Unfinished at the master's death in 1464, these tumultuous compositions resemble the furious carvings on the side of a sarcophagus. After their respectful completion by his pupil Bertoldo and his assistant Bartolomeo Bellano, the San Lorenzo bronzes were retained in the Palazzo Medici and not installed in the church until later.

Donatello was the only artist with whom Michelangelo ever consented to be compared. The accounts of his admiration became the stuff of legend. Pausing to appraise Donatello's *St. George* standing vigilant with his shield in a niche on the façade of Orsanmichele, Michelangelo was heard to quip, "Forward, march!"[90] Regarding Donatello's *St. Mark*, in another niche on the Orsanmichele façade, he used to say, "One was compelled to believe an apostle who looked like that."[91]

They had many points of contact between them, including temperament, but most important was the comfort Michelangelo took from Donatello's

attitudes toward the antique. In contrast to Lorenzo's love of archaeological replicas, Donatello had adapted or discarded from the ancients as he saw fit. This explains the extraordinary originality of his bronze *David*. Vasari writes of a Florentine collector, Don Vincenzo Borghini, who placed drawings by Donatello and Michelangelo on facing pages in his album. Their ornamental borders were inscribed with two Greek mottoes: "The Spirit of Donatello was revived in Buonarroti," and "Or Buonarroti's Spirit first appeared in Donatello."[92]

Michelangelo had another trait that Donatello might have encouraged, though it was probably innate. From the moment that Michelangelo leaves off copying and invents his own compositions, his personality is such that he is "bound," as Kenneth Clark puts it, "to identify his emotions with ideas."[93] The *Madonna of the Stairs,* for example, treats the age-old theme of the Madonna and Child in ways that are astonishingly unconventional, and yet the carving suggests that it represents the boy's first independent conception.

The piece abounds in snippets from recognizable precedents, as if it were a student project assigned by his master Bertoldo: This is a valuable slab of white marble. Use it to make a low-relief sculpture of the Madonna in the manner of Donatello. Be sure to include antique motifs as well.

The Donatellian qualities of the *Madonna of the Stairs* begin with its execution in *rilievo schiacciato* (shallow relief). This trial effort is in fact Michelangelo's only known sculpture in that technique. In many places, the stone is hardly touched while the forms are drawn with incisions. The stairs and wooden railing are a Donatellian motif taken from the *Feast of Herod* that was part of Lorenzo's collection.[94] Allowing accidental overlappings of the frame or of the halo is another kind of borrowing from the earlier master.

Having done his homework, and proven it by a display of footnotes, the sixteen-year-old proceeded to ignore the point of the exercise. Donatello excelled in the creation of illusory courtyards and arcades teeming with figures. It took a peculiarly independent personality to envision a bas-relief, in Donatello's style, that would make a case for *non*-perspective. The blocky stairs climb straight up like a ladder: instead of creating space, as diagonals would, they cut it off. If we assume that the boy hanging over the banister is but a short distance behind the Madonna, we do so despite Michelangelo's conscious effort to entangle their figures in every way. Upon completion, Michelangelo brought it home, perhaps out of frustration because his patrons did not retain it, or perhaps in obstinate triumph because he had confounded their expectations.[95]

Emotions become ideas. Mary's giant form dominates everything. She holds her child in her huge hands and wraps him up protectively.[96] The infant Jesus buries himself in her bosom, hiding his face. They are surrounded by the raucous carrying on of a pack of boys.[97] The idea that the infant shrinks in fear from some wild boys is as familiar in emotional terms as it is absolutely unthinkable in a work of Christian art. Withholding the face of God would be a profoundly touching metaphor of despair if that were the intention—we cannot be certain because it is unique to the *Madonna of the Stairs*.

What Child is this? Michelangelo gives us a baby Jesus who has the muscled shoulders of a diminutive Hercules.[98] His arm is twisted behind his back in a sign of passivity or weakness. Classical sculptors used the same gesture to show Hercules slumped exhaustedly after his heroic labors. Ghirlandaio kept a drawing of one such statue in the album he had denied to Michelangelo.[99] Perhaps we are to understand that, when the time comes, the Child will rise and avenge himself on the wicked boys, just as Hercules crushed his adversaries. It is not a theme found in Scripture. Nor are there any precedents for sculpting a Madonna with the customary pose and distant gaze of a portrait on an ancient funerary stele or plaque.[100] Christian art abounds with presentiments of the Child's death, not his mother's. It almost seems as if young Buonarroti's rendering of the Madonna and Child draws upon his own infancy.

• • •

Savonarola's sermons in San Marco attracted such large crowds that on Ash Wednesday, February 16, 1491, he was obliged to move to the Duomo of Florence, the most important pulpit in the city. Warming to his subject, the friar's piercing voice rolled over the hushed heads of the throng like thunder. Once Pico was present at the preaching of Genesis 6:17, "Behold I will bring the waters of a great flood upon the earth, to destroy all flesh wherein is the breath of life." Listening to those words, the count felt a cold shudder run through him, and his hair stood on end.[101] Years later, Michelangelo still heard Savonarola's voice ringing in his ears. His older brother Lionardo joined the friar's acolytes.

Lorenzo il Magnifico was probably glad at first to have a preacher of such celebrity in his city, but his enthusiasm cooled when Fra Girolamo began to lay bare the evils that stalked the streets. "All things are full of impiety and evil, of usury and robbery, of blasphemy and crime, of hypocrisy and falsehoods.

Here virtues are made vicious, and vice takes virtue's place. Shall I say more? There is none that doeth good—no not one."[102]

On April 6 Savonarola preached a sermon on civic justice before the governing Signoria. Many took it for a veiled attack upon the Medici regime. He spoke openly of the iniquitous distribution of wealth between the Medici favorites, whom he called the *primati*, and the have-nots, the *disperati*. Pico, incredulous, tried to warn him off before things got worse: "You're jousting, and you cannot win."[103]

But of course he continued. In July his Dominican brothers at San Marco elected him prior of their convent. Afterward Fra Girolamo did not pay the customary visit to Lorenzo de' Medici, who was not only the friary's benefactor but also the representative of the Florentine Republic. Taking notice of the slight, Lorenzo remarked with a smile, "Here is a stranger come to my house who does not deign to speak with me."[104]

The prince's attempts to pacify the irascible friar were firmly rebuffed. Five leading citizens were sent to intervene, ostensibly on their own initiative. Savonarola shocked them by saying, "Go and tell Lorenzo de' Medici to make penitence for his sins, that God wishes to punish him and his friends."[105] To other visitors, who brought the rumor that Lorenzo intended to expel him from the city, Savonarola replied with a terrible prophecy: "Tell him that I am only a stranger here, and he a citizen; I, however, will remain and he depart."[106]

Though the two men embodied entirely different concepts of life and thought, Lorenzo, to his credit, respected an adversary whose "great reputation for holiness"[107] he could see was well founded.[108] Patience was also urged on him by his literary friends, especially Pico, who, despite initial skepticism, had been won over by Savonarola's eloquence. The Magnifico had every reason, besides, to assume that he could rein in a charismatic preacher. Quarrelsome Italy was basking in an unaccustomed peacetime entirely due to his own diplomacy; within a decade Lorenzo had re-created himself from papal scapegrace to the *ago della bilancia,* the needle of the balance, and was universally admired by other princes, great and small.

Perhaps in response to the change of climate, Lorenzo expanded his poetic repertory by writing, for the first time, a sacred drama in vernacular speech. His *Representation of St. John and St. Paul* was presented, accompanied by Enrico Isaac's music, on February 17, 1491. He gave parts to each of his children to play and took one himself.[109] Set in the palace of the emperor Constantine, the drama opens with an angel promising "many examples of

different fortunes"—as if the Bible were a tragedy written by Sophocles.[110] The events in question include several that Lorenzo personally would have wished for: a miraculous cure, a rousing victory, and the punishment of a false prophet.[111]

Failing health induced Lorenzo to retreat whenever possible and for longer periods to his rural villas. Between May and September 1491 he stayed several times at his favorite, Poggio a Caiano, where the woods were full of pheasants and peacocks wandered the terraces.[112] He and Poliziano dedicated their most beautiful pastoral verses to this lush terrain. Lorenzo was anxious to see finished his new villa, which, designed by Giuliano da Sangallo in a grandiose neo-antique style, had been under construction since 1485.

The design of the remarkable frieze over its portico was entrusted to Bertoldo.[113] Executed in a glorious glazed terra-cotta, the white figures march across the blue background in time to a hidden music. The mysterious procession appears to symbolize the journey of the soul through and beyond the natural rhythms of life, work, and days.[114] In unseasonable December, Bertoldo went to Poggio without Lorenzo, no doubt to coordinate some detail of the decorations. While there he suffered a painful angina attack that left him bedridden. On December 28 Lorenzo wrote impatiently for news, but it was too late. Bertoldo died the next day, to Lorenzo's great distress, for he loved him as much as any member of his family.[115] The funeral mass for Bertoldo was held at San Lorenzo on January 3, 1492, with the Medici household in attendance.[116]

From mid-February to the end of March, Lorenzo experienced a reprieve from his health troubles, which allowed him to enjoy some of his usual pastimes. He was particularly intrigued by the arrival of an emissary from Rome bringing news of a curious discovery. Among the treasures preserved in the Roman church of Santa Croce in Gerusalemme was a reliquary that held the *Titulus,* or tablet, from the Cross of Christ. This ancient case had recently been opened after many centuries. It was revealed, as Lorenzo was immediately informed, that the Greek and Latin inscriptions of "Jesus of Nazareth King of the Jews" were written from right to left to conform to the Hebrew.[117] The significance of this revelation was carefully weighed. In Lorenzo's house, at the end of the fifteenth century, language was considered both a vehicle and a source of philosophical truth.

• • •

In the same house lived Poliziano, a most learned and clever man, as everyone knows and his writings fully testify. Recognizing in Michelangelo a superior spirit, he loved him very much and, although there was no need, he continually urged him on in his studies, always explaining things to him and providing him with subjects. Among these, one day he proposed to him the Rape of Deianira and the Battle of the Centaurs, telling the whole story one part at a time. Michelangelo set out to do it in marble in mezzo-rilievo, and he succeeded so well that I recall hearing him say that whenever he sees it again, he realizes what a great wrong he committed against nature by not promptly pursuing the art of sculpture, judging by that work how well he could succeed. . . . This work of his can still be seen in his house in Florence, and the figures are about two palmi [40 cm] high.[118]

Listening to Poliziano translate the classics for his benefit was a memory to reinforce with Condivi's pen. Apart from his stature as a poet, Poliziano had taught the classics to Lorenzo's sons, accompanying the eldest, Piero, to various monuments in Rome in 1488. During the trip he made some observations about antique sculpture that reminded him of a passage in Pliny's *Natural History*, namely, that ancient sculptors sometimes left parts of their works unfinished as if to show that art, being the endeavor of human hands, can approach but never obtain perfection. A year later, in 1489, Poliziano wrote down this idea, just in time for it to leave a lasting impression on Lorenzo's newest protégé.[119]

The *Battle of the Centaurs* is as compelling an illustration as art has ever offered of a world in the throes of sensual madness. Half man and half horse, the centaur was the mythological embodiment of bestial behavior. Centaurs lived in the mountains and forests of Thessaly and their food was raw flesh. Drinking only excited their natural propensity for brawling and raping. Ovid and other ancients speak of the centaurs' battles against their unlucky neighbors, a people called the Lapiths, and against Hercules. Michelangelo told Condivi, sixty years later, that the woman being dragged across the scene is Hercules's beloved Deianeira. But there is no sign of Hercules. Indeed the *Battle* gives the impression that the young man's last intervention on the relief was to chisel off four inches at the top, leaving a coarsely scored ramp of stone. What remains is a seething maelstrom of men, women, and centaurs.

Declining to separate the men from the monsters is a compelling way of showing that lust, drunkenness, and murderous wrath result in chaos.[120] It is a corollary of the Platonic thought that all matter, including our bodies,

is base and irrational.[121] That such was on Michelangelo's precocious mind is evident from his remarkable insistence on identifying his combatants with the very stone from which they were formed. Though carved in middle to high relief, the figures retain attachments at so many points that they appear to emerge from the underlying marble. Michelangelo's *Battle* is often compared to Bertoldo's *Battle of the Horsemen*,[122] a bronze relief in antique style that had a place of honor over a mantelpiece in the Palazzo Medici, and it may well have inspired the choice of subject, if not its refined technique.[123] Michelangelo has looked back in time beyond Bertoldo to a muscular age of working marble: the Gothic forerunners and contemporaries of Giotto. There are obvious connections between his *Battle* and Giovanni Pisano's *Massacre of the Innocents,* carved on a pulpit in Pistoia about 1301. The youth has emulated the boxy frame, including even the ledge at top, which he later repented and chiseled away. The Pisano family of sculptors revived the massive forms of Roman sarcophagi; Michelangelo goes a step further and makes his rocks and battlers' close-cropped heads seem "born of the homogeneous mass of the stone," as de Tolnay puts it so aptly.[124] Even granting that the *Battle of the Centaurs* is an immature work, it is the infancy of a Michelangelo.

Having portrayed Mary's contemplative gaze on high in the *Madonna of the Stairs,* Michelangelo turned his attention in his centauromachy to the lowest extreme of the cosmic scale. In the Platonic scheme of things, human nature is an unstable combination of body and soul. To put it bluntly, our souls are imprisoned inside bodies that are continually prey to the lure of carnal satisfaction, and suffer decay, corruption, and death. The immortal soul yearns for reunion with God, the Creator of all, the One, the Beautiful, and the Good. To be worthy of the ascent, the soul must renounce the delusions of the body and focus its gaze on the divine Idea. "Hardly had he finished this work when Lorenzo died."[125]

In early April 1492, Lorenzo's condition took a drastic turn for the worse, from which he realized he would not recover. Seeking quiet, he withdrew to his villa at Careggi, which was near enough to the city for his friends to come see him. It was in this villa that annual dinners had been held in honor of Plato's birthday on November 7.[126] In 1464, as Cosimo lay in his final illness, he bade Ficino come at once to explain to him Plato's *On the Highest Good*—and not to forget his Orphic lyre.[127] Now Lorenzo planned his own departure in accord with his grandfather's.

On April 5, at the third hour of a cloudless night, the huge lantern atop the cupola of Santa Maria del Fiore was suddenly struck by lightning and split

almost in half. One of its marble arches and many other pieces of marble came crashing down on the north side of the cupola. Tons of stone broke through the roof of the church, making a great hole in the pavement.[128] Fortunately the church was empty at that hour and no one was injured. When Lorenzo heard the news, he asked where the lantern had fallen. And when he was told, he said: "That means I shall die, because it fell towards my house."[129]

Pico della Mirandola and Poliziano were called to Careggi for final discussions. Despite the pain, Lorenzo's last hours on April 8 passed in dignity and calm. A silver crucifix covered in pearls and gems was brought so that Lorenzo could kiss it. Savonarola was summoned to administer the extreme unction, which was done without rancor, or so Poliziano recalled.[130] Others said that Savonarola first commanded the dying man to repent his sins, which Lorenzo did, and then to surrender his fortune to the Florentines, at which, the rumor went, Lorenzo turned his face away and died without absolution.[131]

To the people it did not matter. The city was seized by public grief. Even those who had not loved Lorenzo lamented the evils that were sure to come.

THE GENERATIONS

FLORENCE · BOLOGNA · FLORENCE

APRIL 1492–JUNE 1496

Regarding his sons, Lorenzo de' Medici was heard to say, "One was good, one was clever, and one was a fool."[1] The good son was Giuliano, his youngest. Mild in appearance and of fragile health, Giuliano was three years younger than Michelangelo and as yet a child. Giovanni de' Medici, the second son, was clever. He and Michelangelo were contemporaries, both born in 1475, but they had little in common. Giovanni had been groomed from infancy to lead his family into the highest echelons of the Church.[2] He was but seven when he took vows; scarcely a year later the king of France gave him his first abbacy. Abbacies bestowed by the king of Naples and Ludovico Sforza in Milan followed in rapid succession. Giovanni's ecclesiastic titles read like the honor roll of his father's alliances.

Above all, Lorenzo wanted for his second son the cardinal's hat that only the pope, the newly elected Innocent VIII, could grant. A strategic marriage was arranged between Giovanni's sister Maddalena de' Medici and Franceschetto Cibò, the pope's son born before his ordination. The tactic worked. In March 1489, thirteen-year-old Giovanni de' Medici was secretly appointed to the cardinalate with the stipulation that he first study canon law at Pisa for three years. If Lorenzo, or the pope, died in the meantime, the accord was not binding. On March 10, 1492, three years to the day, Giovanni de' Medici was raised to the purple in a ceremony held at the ancient Badia on the way to Fiesole. The next day Cardinal Giovanni went to hear mass in the Duomo in the midst of the jubilant citizenry. The

Signoria "presented him with 30 loads of gifts carried by porters, being silver plate, basins, ewers, dishes and all the silver utensils that can possibly be used by a great lord."[3] Three weeks later the Magnifico was dead. Pope Innocent VIII died in July.

In his last days, Lorenzo sent Giovanni a letter of paternal advice. As "you are the youngest cardinal, not only in the Sacred College of today, but at any time in the past, when you are in assembly with other cardinals, you must be the most unassuming, and the most humble."[4] The future would tell whether Giovanni, intelligent but sensually self-indulgent, could be so astute.

Piero, the eldest son, was an arrogant fool. A contemporary portrait shows him as a sturdy young man with haughty, lowered eyes.[5] Spoiled by privilege, Piero took for granted the reputation and preeminence for which his forefathers had strived so hard. In 1488, at age seventeen, Piero married Alfonsina Orsini, a Roman cousin on his mother's side; the event was celebrated in Naples in the manner reserved for royalty.[6] Lorenzo did his best to give Piero some seasoning. In 1489 a popular religious festival staged annually at the Carmine church was placed under the boy's direction; the result was an egregious flop.[7] Though Piero's defects were clear to everybody, Lorenzo was too devoted a father to deny his son his birthright.[8]

These are the generations of the Magnifico. Ironically, the heir who held out the most promise, Giulio de' Medici, was not his own begotten son, but his brother's bastard. Giulio was born to Fioretta, a girl of the backstreets—some said near Borgo Pinti—only days before the Pazzi murdered his father in the cathedral. The infant was brought to Lorenzo, who had not known of his existence. Christened Giulio in his father's honor, he too was taken into the family.

Without their father, the Medici sat at table according to rank and the conversation turned to hunts and finery. Though brilliantly educated, Piero had not his father's passion for philosophy and the arts. Michelangelo knew enough not to count on him. As soon as possible without giving offense he moved back to his father's cramped house in Via Bentaccordi.

• • •

Only Lorenzo had known how to keep in check the rival powers of Italy, and everywhere his loss was treated as a calamity. When the word reached Naples, King Ferdinand exclaimed, "This man has lived long

enough for his own glory, but too short a time for Italy."[9] The pope cried out, "The peace of Italy is at an end!"[10] All eyes were on Piero de' Medici, whose age was the same—twenty-one—as his father's had been when he assumed the reins of governance.

Four days after their father's death, Cardinal Giovanni wrote apprehensively to Piero:

> My dearest brother, now the only support of our family; what I have
> to communicate to thee, except my tears, I know not; for when
> I reflect upon the loss we have sustained in the death of our father,
> I am more inclined to weep than to relate my sorrow. What a father
> we have lost! How indulgent to his children! Wonder not then that I
> grieve, that I lament, that I find no rest. Yet, my brother, I have some
> consolation in reflecting that I have thee, whom I shall always regard
> in the place of a father. Do thou command—I shall cheerfully
> obey. . . . Allow me, however, my Piero, to express my hopes that
> in thy conduct to all, and particularly to those around thee, I may
> find thee as I could wish—beneficent, liberal, affable, and humane;
> by which qualities there is nothing but may be obtained, but may
> be preserved. Think not that I mention this from any doubt that I
> entertain of thee, but because I esteem it to be duty.[11]

The letter brims with tactfulness, passing in a few lines from filial commiseration to political solidarity to a final restrained plea for Piero to emulate their father's liberality. It was a futile hope, for instead of Medici shrewdness, Piero's mind was filled with the aristocratic pride of his Orsini mother, Clarice, and wife, Alfonsina. He was incapable of viewing himself as other than the hereditary prince of Florence. It was soon rumored that he would indeed bestow the title upon himself.[12] Surrounding himself with sycophants, Piero was keen to enjoy his turn at the helm.

But storms of discord were fast approaching. Indeed, Savonarola was openly proclaiming them in terrifying sermons on the Old Testament and the castigations of plague, flood, and famine that would surely strike the wicked Florentines. "Repent, O Florence, while there is still time," Savonarola cried out to packed congregations.[13] Savonarola had foretold the death of Lorenzo, and behold, Lorenzo was dead. Now the friar had visions of a "Sword of the Lord" suspended over the sinful city, the specter of foreign armies raping, killing, and looting.[14]

The impending evils were accelerated by the death of Innocent VIII that summer,[15] then exacerbated seventeen days later by the elevation to the throne of Cardinal Vice-Chancellor Rodrigo Borgia, who took the name of Alexander VI.[16] This pope, with his notorious children Cesare and Lucrezia Borgia, by different mistresses, has been written about in more biographies and lurid novels than almost any other. Alexander VI had grown fabulously rich in the service of his church; his election through open bribery of key cardinals came at the expense of the ambitious Giuliano della Rovere, the cardinal of San Pietro in Vincoli and nephew of Sixtus IV. The two had been deadly enemies since the 1470s, when they shared a mistress, leading to rumors that Cesare Borgia was not Rodrigo's son at all, but della Rovere's.[17] The Borgia pope combined extraordinary intelligence with insidious cunning. These instruments were at the service of what Guicciardini describes as his "obscene behavior, insincerity, shamelessness, lying, faithlessness, impiety, and insatiable avarice"—among other such epithets.[18]

Poor Piero de' Medici was in over his head, and his immaturity was exposed at the very first crisis. Ludovico Sforza, the regent of Milan, was openly courting the favor of France, presumably in its designs on the throne of Naples. Sforza, known as Il Moro (the Moor) for his dark complexion, had scandalously refused to surrender control of the city when the rightful duke, his nephew Gian Galeazzo Sforza, reached his majority. Instead, Gian Galeazzo and his family were kept in gilded confinement in the castle of Pavia. These actions disgusted Ferrante, king of Naples, who was related to Gian Galeazzo's wife. King Ferrante thus sent Piero de' Medici a proposal for a secret alliance against Milan with an improbable plan of dividing the spoils. Without consulting the leading citizens as his forefathers would have done, Piero accepted the poisoned apple. Ludovico's spies in Florence soon informed him of this treachery, and thereafter any serious communications between them was impossible. The friendship laboriously maintained by Lorenzo as a bulwark against the encroachment of either Milan or Naples vanished in an impetuous moment. Sforza immediately sent word to France that the Milanese would pose no obstacle to the French king, Charles VIII, should he cross the Alps with an army.

• • •

"For many days," Michelangelo, sunk in depression, was "unable to do anything."[19] His mourning was understandable, but lying prostrate on his bed day after day in the spring of 1492 looked like the onset of something chronic. As one born under the influence of Saturn, Michelangelo was vulnerable to bouts of excessive black bile, the dreaded humor of melancholy.[20] Feeling paralyzed by his emotions would become the negative pole of his creative energy. The young man could console himself with Aristotle's famous observation, "Why is it that all men who are outstanding in philosophy, poetry, or the arts are melancholic?"[21]

If the seventeen-year-old thought he was finished with the Medici, he was being uncharacteristically shortsighted. Meanwhile, he had his own dysfunctional family to deal with. We never read of his stepmother, Lucrezia, but Lodovico was the kind of father who constantly scolded his children about their duty. It is easy to imagine Lodovico's hysteria at the recent turn of events. Scarcely two years after abandoning a well-paid apprenticeship to join the upstart Medici, his most gifted son was home again with little to show but two stone carvings. The Magnifico had retained the *Faun*, which, in effect, he had purchased, but not the *Centaurs* or the *Madonna of the Stairs*. To make matters worse, Lodovico's oldest son, Lionardo, had gone off to enter a Dominican convent in Pisa.[22]

The next two years are dark to us, illuminated only in flashes. Devastated by a death, Michelangelo chose this moment to investigate the intricate inner workings of the human machine.[23] The Church prohibited the mutilation of bodies, yet everybody knew, or said they knew, that Antonio del Pollaiuolo had dissected corpses.[24] How else could he have obtained his astonishing knowledge of tendons, bones, and muscles? If the report were true, Michelangelo would have heard it from the artist's own champions, Lorenzo and Ficino. A sculptor, painter, and architect, Pollaiuolo was sent to Rome in 1484 to execute the tomb of the detested Sixtus IV, at last deceased. Even before he left Florence, Pollaiuolo had clinched his reputation as a master anatomist with an engraving of seven naked men armed to the teeth and strained in every nerve. What the Florentines lacked in finesse compared to German engravers, they more than compensated for with verve. The *Battle of the Nudes* was a tour de force of male anatomy that was admired by Dürer, far away in Nuremberg.[25] Michelangelo consulted it while thinking about his *Centaurs*, though more for the subject than for the figures: both works depict the evils of irrational ire.[26] Since the 1460s the male nude had been the quintessential subject of Florentine art. Though ten years absent in Milan,

Leonardo da Vinci was renowned for his knowledge of anatomy. It was not in Michelangelo, as we have seen, to concede advantages to other artists.

The youth went to call upon the prior of Santo Spirito, a distinguished Augustinian friar named Nicholaio di Giovanni Lapo Bichiellini.[27] Santo Spirito was the most important religious establishment on the opposite side of the Arno. Its buildings held schools, hostels for the poor, a hospital, and a library that preserved the classical manuscripts bequeathed by the poet Boccaccio.[28] These had been read and discussed in the cell of Fra Luigi Marsili, Petrarch's friend, at the end of the previous century.[29] Florentine humanists were especially devoted to the order's founder, St. Augustine of Hippo.[30] How could they not revere a church father who had cut his teeth on Plato?[31] Marsilio Ficino had constructed his *Platonic Theology: On the Immortality of the Soul,* a magnum opus of eighteen books published in 1482, on a foundation of three thinkers: Plato, Plotinus, and Augustine—the only Christian in the trio.[32]

Santo Spirito was thus a kind of hospice for inquiring minds. Even so, Prior Bichiellini was extraordinarily accommodating to a mere apprentice. Being a Medici protégé clearly helped. Lorenzo's favorite preacher, Fra Mariano da Genezzano, belonged to this order.[33] In May 1491 Fra Mariano delivered a public rebuttal to Savonarola in a sermon that was attended by Lorenzo, Pico della Mirandola, and Poliziano.[34] Lorenzo was a major benefactor of Santo Spirito, lending his favorite architect, Giuliano da Sangallo, to design the octagonal sacristy, which was still under construction. Piero, meanwhile, was following in his father's footsteps, agreeing at once to underwrite the sacristy's vestibule, which was to be covered by a coffered vault in classical style.[35]

Prior Bichiellini provided the youth with a room and the disposition of cadavers in the hospital's mortuary. In gratitude, Michelangelo carved a wooden crucifix as a donation to the church. This much we glean from Condivi, whose words Vasari then repeats, with only a perfunctory mention of the sculpture, in 1550. It seems odd that Vasari has no praise for Michelangelo's earliest work in public view.

Other circumstances suggest that the genesis of the Santo Spirito crucifix was more complex than the old man confided to Condivi. Santo Spirito, one of the city's noblest churches, had just been completely rebuilt. Designed by Brunelleschi as a twin to San Lorenzo, the church had burned to the ground in 1471, set ablaze by Easter candles displayed for the visit of the duke of Milan. The reconstruction of Brunelleschi's adaptation of a classical Roman

basilica with graceful Corinthian columns took sixteen years. Michelangelo had watched it going up his whole life. Now paintings were being obtained from the city's leading masters for its thirty-eight altars. The result was the agreeable effect, still enjoyable today, of a gallery of Florentine modern art frozen around 1480. Sandro Botticelli's altarpiece was later removed by the Bardi family and is now in the Gemäldegalerie in Berlin, but fine examples by Francesco Botticini, Filippino Lippi, Cosimo Rosselli, and others have stayed put.[36] An ambitious artist would leap at the chance to place his work among them—donating one, if need be. The crucifix was Michelangelo's chance to crown the decorations: set high on the choir screen behind the high altar, it was visible to every worshiper in the church.

It so happened that two of the sculptures Michelangelo knew best were wooden crucifixes. One, by Donatello, belonged to the Franciscans of Michelangelo's own parish, Santa Croce. The other, by Brunelleschi, was at Santa Maria Novella, where Michelangelo had wasted his time, or so he thought, watching the Ghirlandaio brothers paint frescoes. Well before they became legends—some eighty years earlier—Donatello and Brunelleschi were young, opinionated, competitive friends. Upon seeing Donatello's crucifix, Brunelleschi, never one to mince words, chided his comrade for sculpting a crude peasant—a *contadino*—on the cross instead of the Christ. "Take some wood then," Donatello shot back, "and try to do it yourself." So Brunelleschi did, but in secret. Donatello was carrying eggs back from market on the day he saw the finished work—and dropped the basket. "To you it was granted to make Christs," he stammered, "and to me *contadini*."[37]

It was a satisfying punch line for a favorite story—Vasari tells it twice—as it divides the realm of sculpture between two Florentines. Michelangelo, seventeen, was left with no choice; he too would have to try it. Not the slightest hint as to how or where he learned the necessary skills is on record. No doubt there were many who, like Granacci and the marble cutters at the garden of San Marco, felt gratified in assisting genius.[38] In hushing up these episodes later, the old Michelangelo will be like the ancient Greeks, who held that "a man's inborn glory makes him mighty; he who learns from being taught is a twilight man, wavering in spirit."[39]

In November 1962 a German art historian named Margrit Lisner nervously visited the Florentine office of art restoration. She came to ask an important favor of the director and noted scholar, Umberto Baldini. Lisner had been compiling an exhaustive survey of every Tuscan wooden crucifix made before 1600. Given the large number of churches and the limited

documentation of sculpture, it was a daunting task. She had already located and catalogued hundreds of old crucifixes, but one in particular had seized her imagination. She had come upon it—dusty and neglected—in a corridor leading to the kitchen of the Santo Spirito monastery. To her expert eye, the wooden beams of the cross were modern replacements, no older than the nineteenth century. The figure of Christ was rather different. Slightly under life size, its age and quality were unmistakable despite a crude cover of over-painting. Instead of the traditional posture, symmetrical and frontal, the body seemed to turn in response to an inner spirit. It would be necessary to clean the sculpture in order to understand what it was. Indeed, this was Lisner's request; she suspected that she had found Michelangelo's wooden crucifix, which had been missing for more than two hundred years.[40]

Happily, the cleaning was immediately authorized. And the results were exciting. Beneath a thick coat of yellow-brown paint and several layers of whitewash, the sculpture was in fine condition. The carving of the flesh was indescribably more sensitive than it had first appeared. As the forms emerged, Lisner gazed in awe, almost forgetting, she said, that it was merely wood.[41] The original polychrome painting was delightfully intact, including details such as the final strands of hair falling on the shoulders so as to enhance the softness of the Savior's locks. Professor Baldini published the results of the restoration, confirming Lisner's intuition to the extent that material science is able. The wood, polychromy, and method of construction are characteristic of a Tuscan crucifix of the late Quattrocento, but ultimately, it is the depth of poetic feeling that is the test of Michelangelo's authorship.

How a masterpiece can be lost without leaving the premises is an interesting question. Working backward through the documents, Lisner deduced that the crucifix went off view early in the seventeenth century, at the time when the choir screen was taken down as part of a grandiose remodeling of the church's high altar. Why no place was subsequently found for it remains an enigma to which there may be a clue in its last sighting, a footnote in a 1760 reprint of Vasari's Lives.[42] Here we read that the crucifix—out of sight inside the monastery—lacked the "great, proud style of Michelangelo's later works." Then a hundred years of silence passed until Gaetano Milanesi went in vain to look for it in 1878 as part of his research for his nine-volume annotated edition of Vasari's Lives. He found two crucifixes in the church, neither of them by Michelangelo. No one told him of another one in a back room—after several whitewashings, no one paid it any mind. The Santo Spirito crucifix did not resemble Michelangelo's "great, proud style," which explains how

its existence could have been forgotten, indeed why some experts remain unconvinced of its attribution, and perhaps also why, curiously, the crucifix is widely illustrated but very rarely examined.

One suspects that as early as Vasari's reticence in 1550, or even earlier, the Santo Spirito crucifix was a work of art that did not please. We may find this hard to understand, if only because we have grown inured to the effect of art, which we tend to assume is momentary at best. Michelangelo lived when the authority invested in sacred art was at its zenith. No doubt the Santo Spirito crucifix aroused perplexities, and was ultimately deemed safer in storage, because in it Michelangelo reveals more than in any other work how deeply he had dipped his cup into the intoxicating conversation at Lorenzo's table.

"It has a distinctively Augustinian quality," an old priest remarked to me one day when I had gone to see the crucifix in its new hanging in the sacristy of Santo Spirito.[43] He was referring to its unblemished perfection. The Savior's delicate body looks hardly marked by the Passion trauma. His eyes are gently closed as if in sleep. "Death, where is thy sting?" St. Augustine's philosophical cast of mind was oblivious to the slings and arrows of mere mortality. For Santo Spirito, Michelangelo carved a crucifix for Augustinian friars desirous to contemplate the higher, *absolute* truth of God.

> God is beautiful, beautiful in heaven and on earth . . . beautiful
> in the arms of his parents . . . beautiful in leaving this life and in
> retaking it; beautiful on the Cross, in the tomb, and in heaven.
> Listen to the psalms and let not the weakness of the flesh distract
> your eyes from the splendor of his beauty.[44]

Michelangelo knew the psalms too, and they were clear: "Thou art more beautiful than the sons of men: grace is poured into thy lips.[45]

In an hour, one can easily walk from Santa Croce on the east edge of the city to Santa Maria Novella in the west and then across the Arno at the Carraia bridge to arrive at Santo Spirito in the south. It would not leave nearly enough time, though, to do justice to the three Renaissance crucifixes that are always on view while the churches are open. The old story is true: Donatello gave Christ the heavy, sad face of a laborer. Of course he meant no offense. His crucifix is a powerful, precocious statement of the human-ists' conviction that man, despite his imperfections, is God's most marvelous creation.[46] Brunelleschi's Crucified also suffers, but through noble features.

The muscles and tendons in his chest and legs are rendered with more care than any artist had ever taken. Here, earlier in the fifteenth century, began the Florentine love affair with science. One would think, comparing their sculptures, that Brunelleschi, rather than Michelangelo, had just completed intensive lessons in dissection.[47]

There is more to Brunelleschi's crucifix than meets the eye—there are the elements addressed to the mind. "God disposes all things in number, measure and weight" was a favorite passage in St. Augustine; it means that the world is constructed according to a secret plan, which the Renaissance set out to rediscover with the aid of geometry.[48] After searching for clues in the proportions of the Roman architect Vitruvius, Brunelleschi sculpted a Christ whose height from head to toe is exactly the same as the span of his arms.[49] Eight decades later, about 1492, Michelangelo did the same.[50]

This was also the time that Leonardo da Vinci made a famous drawing of a "Vitruvian man," arms outstretched, inscribed inside a square and a circle.[51] At the close of the fifteenth century many were seized by an exciting feeling that truth was yielding to inquiry and new worlds waited over the horizon. Lorenzo's philosophers asked whether they couldn't improve upon Vitruvius. In 1489 Pico della Mirandola published his *Discourse on the Seven Days of Creation*. In its conclusive paragraph he unveiled a mystical division of the body into three parts: "How beautifully and how perfectly [they] correspond to the three parts of the world! The brain, source of knowledge, is in the head; the heart, source of movement, life, and heat, is in the chest; and the genital organs, the beginning of reproduction, are located in the lowest part [from the navel to the feet]."[52] This is dry stuff unless one shares the Laurentian love of mysteries. How marvelous if the human body, as Pico says, were a secret map of the whole world as God planned it! Self-confidence is the Renaissance emotion.

Somehow Michelangelo molded these visions of Augustine, Brunelleschi, and Pico into a semblance of God incarnate in flesh and blood. Strictly speaking, the head is too large for the body, but wisdom requires a prominent brow. The chest is graceful, as love is. And, finally, the abdomen twists strongly as if to display the supple thighs and the nestled, rather virginal, genitalia.[53] The ambitious young sculptor knew how to use a spiral position to divide the body into three elements, if that's what was wanted.[54]

Our age of specialization tends to restrict theology to priests, philosophy to professors, and art to artists. We naturally ask whether a work of art can encompass thought beyond the illustration of a story or the summoning of a

feeling.[55] In Medicean Florence it was just the other way around. Conveying insight was the distinction of a great artist. Masaccio had the gift, as did Fra Angelico, Leonardo, and Botticelli. Michelangelo shows it even in his baby steps guided by Poliziano. And Raphael, born in 1483, will have it too (much to Michelangelo's disgust). "People sometimes wonder why the Renaissance Italians, with their intelligent curiosity, didn't make more of a contribution to the history of thought." Kenneth Clark posed the question and answered it. "The reason is that the most profound thought of the time was not expressed in words, but in visual imagery."[56]

Whereas Donatello and Brunelleschi sculpted men on their crosses, Michelangelo imagined Christ as a youth his own age—or younger. At Santo Spirito he responds not only to the other great crucifixes but also to Donatello's adolescent *David* in the Medici courtyard. The youthful body of his Christ is as lifelike, and as lovely, but with a crucial difference: it is unmistakably chaste. Heavenly forms, Ficino decided, are "pure, complete, effective, free from passions, and peaceful." He could as well have been speaking of this crucifix.[57]

The love of human beauty was the initial step toward the love of God's own splendor—so Augustine says.[58] A beautiful human body was thus a glimpse of divine perfection. Ficino refined the argument to specify the beauty of young men as the cause of "platonic love"—the spiritual love between two men—which is ignited by the apprehension of the other's beauty.[59] "Love is only unworthy of its aim when it desires the fair body for itself, and not for this higher ideal which it awakens in us."[60] His own sensitivity to virile beauty was, he was at pains to clarify, "platonic and honest, not like Aristippus [the notorious Epicurean] or lascivious."[61] By all accounts Ficino, who took holy orders, lived a virtuous and abstemious life. His moral letters are uplifting in their unshakable faith. Yet in the heated love letters he showered on his young favorite, Giovanni Cavalcanti, Ficino stretches the Platonic ideal to its breaking point.

It would not be easy, in fact, for most persons to distinguish an impassioned affection for young men, which Ficino justifies and in fact recommends, from the forbidden love that was denounced from the time of Dante onward and that Savonarola was attacking directly and obsessively. And herein lies perhaps the perplexity encountered by Michelangelo's portrayal of an exceedingly youthful Christ. To some eyes, as a few scholars have quietly acknowledged, the beauty of this sculpture evokes the Greek cult of adolescent beauty that was openly celebrated in Lorenzo's circle.

This concept of beauty is remote from our eyes. Florentine artists, thinkers, and aristocrats, however, had in mind such stories as how the great Pericles, at dinner on the night before a battle, passed the time in a discussion, with another general, of the best words to describe the delicate blush on a boy's cheek.[62] Though not yet twenty, Michelangelo not only understood the idea but was already capable of rendering it in sculpture.

Sexual relationships between men and adolescents were sufficiently common in Florence to require the establishment of a section of the police, the Office of the Night, dedicated to their suppression.[63] These officers kept careful records that suggest that the act of sodomy was frowned upon by society in general without carrying a stigma of "sexual orientation." The concept had not yet come into existence. When Florentine preachers inveighed against it, as they periodically did, they tended to group it with social problems such as gambling.

The city's demographics probably contributed to the frequency of sodomic encounters: only one in four young men between the ages of eighteen and thirty-two was married; in contrast, girls and young women were either married by their mid-teens or locked up at home while waiting. On April 7, 1492, that is, the day before Lorenzo's death at Careggi, the twenty-five-year-old son of a prominent family, Niccolò di Braccio Guicciardini, wrote a terrified letter about Savonarola's threats, saying, "God has sent us this scourge [flagello] so that we would repent of our sins, especially sodomy, which he wants to be done away with . . . or these streets will run with blood. . . . May God help us."[64]

Whether the "socratic love" exalted by Plato in the *Symposium* actively encouraged the frequency of sodomy among Florentine intellectuals and artists is an issue that had been openly debated in the city for decades.[65] Artists were particularly susceptible, perhaps because boys worked as the models and servants in their bottegas. Donatello's predilections in this wise were openly made fun of in Poliziano's book of jokes. Leonardo da Vinci was formally accused of sodomy by the police in 1476, while he was in Verrocchio's employ. The charge was leveled against Poliziano on April 3, 1492, among other occasions.[66] Botticelli would be denounced to the Night Officers in 1502.[67]

Like Hercules at the crossroads, or Adam, Michelangelo was faced with a choice. A passion for beauty, mortal and divine, possessed his soul. Whether he would pursue this love abstemiously, following Ficino's almost impossibly difficult example, or promiscuously, as Poliziano is reputed to have done, he

could not know. That the conflict between the alternatives tormented him like a thorn in his flesh is certain.

· · ·

SUCH ARE THE GAPS IN MICHELANGELO'S FORMATIVE YEARS THAT we hear scarcely anything about the whole of 1492 and 1493. Apart from the prior of Santo Spirito, he later would not say who helped him at this critical juncture. A lad in his situation would normally have sought an attachment with a workshop in which he could earn some money. This he seems not to have done, for no master ever claimed the credit for teaching Michelangelo how to sculpt. That he felt himself ready to work independently after only two years' informal training in Lorenzo's garden is most remarkable. Leonardo da Vinci spent years assisting Verrocchio before branching out on his own. Yet that was the part old Michelangelo took for granted while dictating to Condivi a portrait of himself as an eighteen-year-old unconcerned with patrons or payment.

Donating a crucifix that cost him months of labor was a noble gesture in return for a kindness. But it rather strains credulity to read that his other major project of this time was likewise undertaken on his sole initiative. "When he had recovered, he bought a large block of marble that had for years been lying in the wind and rain. Out of it, he carved a Hercules, four braccia [233 cm] high, that was ultimately sent into France. Whilst he was working at this statue there was a great snowstorm in Florence, and Piero de' Medici, who occupied the same position as his father but not with the same grace, being young, wanted a statue of snow made in the middle of his courtyard. He remembered Michelangelo, sent for him, and had him make it."[68]

Commissioning a sculpture of snow could be a metaphor for Piero's futile life, but the story as told is unfair. After serious digging in the Florentine archives, scholars have recently proved what was already suspected: the *Hercules* was made at Piero's behest.[69] After all, it was unheard of for painters or sculptors to work without specific commissions—and advances for materials—at a time when the art market did not yet exist. And the only possible place at his disposition for working such a block (since he had no workshop of his own) was the garden of San Marco. Piero failed to pay for the statue, however, which probably explains why Michelangelo deleted him from its history.

The Medici were to blame, moreover, for the statue's removal from Florence during the siege of 1529. The *Hercules* was sold out of the Palazzo Strozzi and taken to Fontainebleau in France. Vasari, who was eighteen years old during those dark days, could not recall it and did not have any record of it, knowing only that "it was considered an admirable thing."[70] The statue disappeared when the Fontainebleau gardens were destroyed in the eighteenth century. Opinions differ as to which drawings or statuettes might contain a resonance of Michelangelo's first freestanding marble statue, which was a direct precursor of his *David*.[71] Its disappearance means that we do not know if Michelangelo's interpretation was expressive in a Donatellian way or if it emulated the emotional coolness of classical statues of this hero.

As a traditional symbol of courage, rectitude, and the active life, Hercules was an almost inevitable choice of subject for a young ruler, and especially Piero de' Medici, who took pride in his physical strength. The story appealed as well to classically minded Florentines from Coluccio Salutati, the humanist chancellor, to Ficino, for its lesson that men of superhuman excellence could become gods.[72] Lorenzo was like a mighty Hercules in ways his son could never be. In Greek mythology, Hercules is the archetype of the conflicted hero, interspersing his victories over monsters with bouts of madness and sensual abandon. Finally, poisoned by the blood of a centaur, Hercules threw himself in agony onto a flaming pyre. From that apotheosis, the Olympian gods lifted him up to immortality.

On January 20–21, 1494, the snow fell continuously through a day and night. It was the severest snowstorm in the city that the oldest Florentines could remember, lasting from the Ave Maria one morning until the Ave Maria of the next.[73] The cold had been oppressive all month, unleashing pestilential fevers in the frigid houses and claiming lives, including that of Domenico Ghirlandaio, who was greatly mourned.[74] Looking out on the prodigious drifts, Piero de' Medici decided to make light of a potentially disastrous situation. Savonarola's prophecies had the populace sensitized to the hidden significance of every event out of the ordinary. Michelangelo was summoned through waist-high snow to the palace, where Piero bade him to mold a statue in the courtyard.[75]

The memory of history's most remarkable snowman would have been lost had old Michelangelo not related it to Condivi, who connects this trivial episode with the young Michelangelo's return to the Medici household. He was given the same room as before and his former place at table. The old man

distinctly remembered as well that his father, Lodovico, "now became more friendly to his son, and dressed him in finer clothes, seeing that he was almost always in the society of great persons."[76] Meanwhile, it allowed Piero to boast of having in his house two rare men, Michelangelo and a Spanish valet, who, besides being marvelously handsome, was so swift of foot that a horse at full gallop could not overtake him.[77] The blatant absurdity of the comparison, dutifully transcribed by Condivi, gives the lie to the old man's insistence that he bore no grudge against Piero.[78]

· · ·

THE YEAR 1494, "A MOST UNHAPPY YEAR FOR ITALY," BEGAN BADLY and became progressively worse, "opening the door to innumerable horrible calamities."[79] On January 25 King Ferrante of Naples died suddenly of pneumonia, yet another victim of that harsh winter. Piero's secret alliance had pinned Florentine hopes on the resourcefulness of a king whose place was now taken by his less capable first-born son, Alfonso. It was a perfect opportunity for Charles VIII, the *Cristianissimo*, to make plain his intentions, already formulated some months before, to descend upon Italy and march against Naples. He already had the blessing of Il Moro in Milan; now the king of France sent ambassadors to Florence and Rome to negotiate safe passage for his army through their territories. Despite long years of friendship between Florence and France, Piero de' Medici gambled that the menace would evaporate in time and stubbornly stuck to his new alliance with the Neapolitans. He was holding the reins of uncontrollable forces, like Phaeton driving his father's chariot.

On Ash Wednesday, February 12, Savonarola ascended the pulpit of San Lorenzo to deliver the first sermon of Lent. For two years, since the Advent season of 1492, the Dominican friar had repeatedly preached visions of a sword suspended over a prostrate Italy and of a foreign conqueror, "a Cyrus," who would cross the mountains bringing devastation.[80] The interceding events had shown the lightning behind his thunderous prophecies. Throughout Lent he explicated the Book of Genesis as an allegory of an Ark in which few souls would be saved from the impending Flood. Though Piero had the temerity of youth, France was the most populous and the wealthiest kingdom in Europe, "perhaps since the time of Charlemagne."[81] Florence, by contrast, had no standing army and had not fought a battle in fifty years. No wonder the Florentines

were on edge. In March Charles VIII transferred to the south of France, establishing headquarters in Lyons. Seeing that the invasion was looming, the cardinal of San Pietro in Vincoli left Rome, where he feared assassination at the hands of the pope, and rushed to Lyons in April to urge the king to convoke a council to depose Alexander VI on the grounds of simony.

To add to his woes, Piero's own house was divided. There were two other prominent Medici in Florence, the grandsons of Cosimo the Elder's brother and banking partner, and thus his cousins. The younger branch of the family had preserved its money while their famous cousin, Lorenzo il Magnifico, had spent most of his. Indeed, during his guardianship of the two boys, Lorenzo and Giovanni, who were but thirteen and nine when their father, Pierfrancesco, died in 1476, Lorenzo had freely deducted from their inheritance. As soon as they were of age, they successfully sued the Magnifico for compensation in the form of valuable properties, including the fortress of Cafaggiolo.[82]

But the complexities of their relationship with Piero did not end there, for in evident ways Lorenzo and Giovanni di Pierfrancesco de' Medici had more of their godfather's qualities than his flesh-and-blood son. First of all, the two brothers, who jointly managed their own affairs, were politically astute, whereas Piero was heavy handed. They loved books and were steeped in Platonic philosophy; Piero preferred more chivalric entertainments, such as sports.[83] Finally, they were heirs to the Magnifico's passion for art. Two of Botticelli's masterpieces, the *Primavera* and the *Minerva and a Centaur,* hung in Lorenzo di Pierfrancesco's private chambers in his house on the Via Larga between the Palazzo Medici and the San Marco garden.[84] The *Birth of Venus* was also in the brothers' collection.

It has been suggested that Botticelli composed the *Primavera* in honor of Lorenzo di Pierfrancesco's marriage in 1482 with inspiration from a famous letter by Marsilio Ficino entitled *Prospera in fato fortuna,* "Good Fortune Is in Fate."[85] Ficino likened Lorenzo to the Moon and counseled him toward prudent contemplation of gifts given by God through the planets: judgment through Jupiter, reason through Mercury, love through Venus.[86] That Ficino addressed such a complicated astrological discourse to a twenty-year-old is proof of the young man's philosophical bent. By 1494 Botticelli had been working for more than ten years on a series of Dante illustrations commissioned by Lorenzo di Pierfrancesco. It was through Botticelli that Michelangelo knew this brother and would come to depend on his protection. The cousins' unconcealed contempt for Piero made them unbearable to him. One day at a dance, Piero

erupted and struck Giovanni di Pierfrancesco.[87] That blow signaled the end of Piero's limited powers of self-restraint. On April 29 he had the Signoria confine his cousins indefinitely to their estates three miles outside the city. Their offense was not stated in the deliberation, but rumors circulated that the brothers were secretly negotiating with King Charles or possibly Ludovico Sforza.[88] They withdrew, infuriated, to their villa of Castello on May 14.[89] Botticelli's contemporary painting *Calumnitas* is believed to allegorize their indignation at the accusation.[90]

The fate of nations and men hung in the balance while the summer festered with horrific signs and portents. "In many places in Italy the sacred images and statues openly sweated. Everywhere monsters of men and other animals were being born. Many other things beyond the usual course of nature happened in various locales, whence the people were filled with an unbelievable dread, frightened as they were by the fame of French power."[91] July came and went, and the French remained immobile in Lyons, brooding over the invasion without daring to take the decisive step. Born in 1470, Charles VIII was one year older than Piero de' Medici and equally inexperienced. Physically, they were opposites: the Most Christian King was several inches short of regal stature, with ill-formed limbs. His bulging white eyes and thick, always open lips were very unpleasant to see. His speech was slow and halting.[92] Giuliano della Rovere, cardinal of San Pietro in Vincoli, "then and formerly and subsequently the fatal instrument of the misfortunes of Italy," as Guicciardini succinctly puts it, prodded the awkward youngster to action with pointed remarks about the royal honor.[93]

The French artillery could not be carried through the mountains except by the pass at Mont Genève, near Grenoble, and thus it was there that the king crossed into Italy. The tortuous passage would have cost him dearly had any Italian wished to impede it, but these invaders were invited. On September 3 Charles entered the Italian town of Susa at the head of Breton archers, Gascon infantry, and thousands of Swiss and German pikemen. He was welcomed by the marchese of Saluzzo, who escorted him to Turin to be showered with honors by Duchess Bianca of Savoy. On September 9 the French army reached Asti, where Charles was immediately visited by Ludovico Sforza and his wife, Beatrice. After several days of festivities, the king came down with a fever, suspending his advance for almost a month.[94]

Word of Charles's descent into Piedmont reached Florence on the heels of other grievous news. On September 6 a force of three thousand men sent north by Naples had been decimated at Rapallo, near Genoa, by Swiss and

Genoese foot soldiers under French command. The Neapolitans had sailed out of Livorno, a Florentine port, with provisions supplied by Piero de' Medici. The savage Swiss slaughtered the Neapolitans as they surrendered, and sacked the city, killing many townsmen, until they were finally stopped in a desperate counterattack by their own comrades-in-arms, the Genoese. Atrocities of this kind were rare in Italian warfare, which was mainly waged by mercenaries intent on taking prisoners for ransom and averse to making lasting enemies, never knowing under whose colors they might be marching next. The French were playing by different rules.

The proud Florentines were appalled that as a result of a private citizen's actions, they were on the verge of war with their traditional protectors. Even the city's symbol, a lily, was the fleur-de-lis bestowed by the French crown. Florence had no army in the field, and no one would lend Piero the money to mount a defense of its borders. The Medici bank was on its last legs; this part of his inheritance had been spent by his father. As Piero's authority melted away, the people placed their trust in Fra Girolamo Savonarola, for only he had foreseen the imminent calamities.

Such was the mood in the city on September 21, as a false rumor circulated that Charles had entered Genoa, plundering as he came. The date happened to be Savonarola's own birthday, and he had arranged to preach in the Duomo, the civic pulpit. Month after month the friar had persisted in recounting the Genesis story of God's vengeance on wicked humanity. The densely packed audience sat suspensefully in the immense cathedral until there was silence. A voice rang out: "Ecce ego adducam acquas diluvii super terram!" (Behold, I, even I, shall bring a flood of waters upon the earth!) In the pews, Pico della Mirandola felt a shiver run up his spine.[95] Michelangelo remembered these sermons his whole life. Savonarola triumphantly completed the text, "And every thing that is in the earth shall die."[96]

Within the week, as if to underscore where the sword would fall most heavily, Poliziano took gravely ill. On September 29 he died.[97] The brilliant, witty Agnolo Poliziano, a poet who read Greek as an average man reads a letter, the Magnifico's intimate friend and Piero's private tutor, was gone. Some said maliciously that he had contracted a disease from a young man; others said the fires of an unrequited passion had consumed him from within.[98] By all accounts, the crisis had breached the walls of the Medici palazzo. No one was safe.

A certain Cardiere, a lute player at Piero's court, now confided to Michelangelo a most alarming secret. The ghost of Lorenzo de' Medici,

wearing black rags over his gaunt and naked body, had appeared to him in a dream. The specter had commanded the terrified Cardiere to tell Piero that he would soon be driven from his house, never to return again.[99] Michelangelo urged Cardiere not to delay in delivering the message to Piero. But the musician was loath to act. A few days later Lorenzo de' Medici appeared again to Cardiere—and struck him in the face for ignoring his command. This time Michelangelo convinced the lutanist to go at once to find Piero at his villa in Careggi, about two miles from the city. Cardiere was halfway there when he met Piero on the road, returning to the city. In a rush the poor man blurted out everything he had seen and heard. Piero, true to form, "laughed it off and, alerting his attendants, made them mock him with a thousand jeers." Piero's chancellor, who later became Cardinal Bibbiena, said to Cardiere, "You must be out of your mind. Do you think that Lorenzo loves you more than his own son? Would he not appear to him, if this were true, rather than to anyone else?"[100]

As one whose name respected Fortune's wheel, Buonarroti was alert to portents.[101] He quietly made up his mind to run away. Two days later he headed north on the Bologna road. It was the first week of October, and the French were marching into Tuscany—he would be safe in neutral Venice. Michelangelo must have had some money because he brought two companions along with him. Condivi does not name these friends; Cardiere and Granacci are sometimes mentioned as possibilities. Word of his flight got out fast. Adriano Fiorentino, a pupil of Bertoldo, received a letter from his brother, "You should know that Michelangelo, the sculptor from the garden, has gone to Venice without saying anything to Piero, who was returning home. I think Piero has taken it very badly."[102] Michelangelo's departure mattered. That he considered himself in danger if the Medici collapsed is extraordinarily revealing. Other artists might have seen their place as ancillary—not he.

Whatever he expected to find in Venice was not there after all, for he turned on his heels and left in less than a week. The three Florentines retraced their steps to Bologna in search of better prospects. Pietro Torrigiani had found good employment there after his expulsion for flattening Michelangelo's nose. Torrigiani was by now in Rome; fortunately, Baccio da Montelupo, a true friend from the garden, was working in Bologna.[103]

The mood in Bologna was almost as fraught as in Florence. The city was crawling with spies, sent from everywhere, to find out if Giovanni Bentivoglio, the lord of the city, would send an army in aid of Piero de' Medici. Foreigners

were required to identify themselves at the city gate and wear a red wax seal on their thumbnail.[104] Somehow Michelangelo and his friends ran afoul of this new law and were summarily arrested. As they could not pay the fine, which Michelangelo distinctly recalled being the hefty sum of fifty Bolognese lire, they were bound for prison. As chance would have it, Giovan Francesco Aldrovandi, a member of the Council of Sixteen and a former *podestà* in Florence, was present in the license office at this decisive moment.[105] As one of Bentivoglio's most trusted advisors, there was little that escaped his attention. Learning that Michelangelo was a sculptor, Aldrovandi had him set free. Indeed, he invited him to his house, an indication that the youth's fame had preceded him. "Michelangelo thanked him, excusing himself because he had with him two friends whom he did not want to part from, nor did he want to inflict their company on him." To which the gentleman replied, "I too will come with you and wander all over the world, if you will pay my way."[106] This quip, more ironic than usual for Condivi, suggests he had the help of a good editor.[107] It is also a characteristic example of Michelangelo's vivid memory for money matters.

Persuaded by these and other words, Michelangelo bid his friends goodbye, "giving them what little he had."[108] His new host, Aldrovandi, was immediately called away to attend the funeral of Gian Galeazzo Sforza, who had died in Pavia on October 22. Aldrovandi led the Bolognese delegation to the funeral, which was conveniently combined with a ceremony in which Ludovico Sforza received the title he had previously usurped. It was widely and implausibly rumored that his nephew's death had been provoked by "immoderate coitus." But most thought as the French did, namely, that Gian Galeazzo had been slowly poisoned by his own uncle. This was after all the golden age of arsenic.

Under Ludovico's watchful eye, Charles VIII had paid an emotional visit to Gian Galeazzo Sforza on his deathbed; the fact that they were cousins was a regrettable complication, but the king concealed his suspicions from his Milanese ally. The French proceeded from Pavia to Piacenza, always accompanied by Ludovico Sforza, who, it seems, was afraid to let them out of his sight. Il Moro was terrified now by the destructive force he had unleashed. North Italy held its breath to see which route Charles would take to cross the Apennines. He could choose to cross Emilia to Forlì, availing himself of the safe passage offered by Caterina Sforza, the widow of Girolamo Riario, or his army could turn south at Parma and pass through Pontremoli. He took the latter route, encouraged by communications of cooperation from Lucca and Siena.

To make matters worse, as far as the Florentines were concerned, Alexander VI suddenly issued a brief authorizing the *Cristianissimo* to cross Roman lands on his way to conquer Naples.[109] The pope had allowed Piero to count on his resistance, but expediency changed his mind. Thus the king sent his envoys to make the same demand of Florence, threatening drastic consequences in the event of a refusal. Temporizing frantically, Piero kept the envoys waiting five days before sending them away without a response.[110] Immediately rumors were heard that the king was swearing he would let his soldiers pillage Florence; the populace was saying it was mad not to give the safe-conduct.[111] On October 29 Charles underscored his intentions by attacking the first Florentine outpost in his path, a tiny fort at Fivizzano. Every one of its inhabitants was killed. The road now led to Sarzana, a fortified town in a strategic position on the sea. The French besieged the fortress called Sarzanello with every prospect of another massacre. Reinforcements were sent from Florence, but the troops were intercepted and wiped out.

Now Piero took the decision that sealed his doom. Without seeking counsel from anyone, he rode in secret to throw himself on Charles's mercy, openly imitating his father's *colpo di scena* in 1478. But the situations were not the same, nor were the men. Having resisted, if ineptly, Piero had spent the good will that his city could otherwise have brought to bear on its old ally. Nor was he aware that his inimical cousins had cut his legs out from under him. Though confined to their villas, Lorenzo and Giovanni di Pierfrancesco were very much in the thick of events, sending emissaries to assure Charles of their support. Lorenzo knew the king personally because Piero had had the lack of foresight in 1493 to make him his envoy to France.

Piero's mission was not "attended by the same good fortune" as his father's.[112] The two arrogant young men, Charles and Piero, each of them playing at rulers, finally met face to face. Desperate to save his city from the unthinkable, Piero immediately handed over Sarzana, Pietrasanta, and Sarzanello—the fortresses that guarded Florence from attack from the west.[113] And a few days later, he gave away the seaport cities of Pisa and Livorno. All this was done without consulting the Signoria and without obtaining any decree by the magistrates, as his forefathers had always done. There was also the matter of a huge loan, amounting to more than 100,000 florins. Piero appeared to be bartering the public bounty for a private ambition: the king's support for his rule as absolute prince. According to a sixteenth-century history, he was "driven to do this thing chiefly by his wife and the Orsini family."[114]

On November 5, while Piero remained a guest in Charles's camp, the king's messengers arrived in Florence and went about the city marking the houses for their quarters. Machiavelli called it a war won "by a piece of chalk."[115] Another eyewitness, the apothecary Luca Landucci, wrote in his diary how the Frenchmen "came indoors and entered all the rooms, marking one for such and such a lord, and another for such and such a baron."[116] Suddenly terror was tinged with indignation; Piero got wind of the people's displeasure and rushed back on November 8.

The next day was Sunday. As the bells were ringing for afternoon vespers, Piero was summoned to the palace of the Signoria, where he was asked to enter without his armed men. When he refused, the door was closed in his face.[117] A crowd began to gather in the piazza. Before an hour had passed, the square was filled with citizens and district leaders crying loudly, "Popolo e Libertà!" (The People and Liberty!) Piero decided to enter the piazza on horseback surrounded by his men, but very few came to take his side. Meanwhile the young cardinal Giovanni de' Medici walked toward the piazza accompanied by soldiers, crying out "Popolo e Libertà" like the others, and declaring that he had separated himself from his brother. But the crowds on the piazza menaced him with their swords and he turned back at Orsanmichele, "not without danger." Piero returned dispiritedly to his house only to learn that the Signoria had declared him a rebel.[118] That night the Magnifico's eldest son left his house and went toward the Porta San Gallo, the northern gate, which he had asked his brother Giuliano to stand by and keep open past the usual hour. They fled the city, carrying with them much of value, but nothing compared to the treasure they now abandoned.

> Thus Cardiere's vision or diabolical delusion or divine prediction or powerful imagination, whatever it was, came true. This is truly remarkable and worth recording, and I have related it just as I heard it from Michelangelo himself."[119]

Cardinal Giovanni stayed behind, showing himself at the window in prayer, but soon it became evident that the Florentines were mustering the courage to storm Cosimo's palace on the Via Larga. To escape, he put on a rough Franciscan robe and pushed his way anonymously through the mob to San Marco. From there he too slipped out the Porta San Gallo and caught up with his brothers on the road to Bologna. Within hours the crowds began to break into houses, including Cardinal Giovanni's, and the garden of San

Marco, but they did not succeed in plundering the Palazzo Medici on the Via Larga, which was protected by armed guards posted by the Signoria.[120] Alfonsina Orsini and her attendants were still closed inside: the gravest consequences would have ensued had anything happened to her. Besides, the collections were too precious to lavish on a mob. At midnight, the Signoria intervened more broadly, forbidding the pillaging of any more houses, on pain of death.[121] The Medici were declared outcasts and banned for life from Florence—indeed, with heavy prices on both Piero's and Giovanni's heads. Every Florentine family in exile—the Neroni, the Pazzi—was now officially recalled. The sentences against Lorenzo and Giovanni di Pierfrancesco de' Medici were repealed as the illegal action of "tyrants."[122]

Piero's beleaguered train reached Bologna late the next day. Giovanni Bentivoglio lodged them in a palace for a few days, while reproving them for their fainthearted defense of everything their father had fought and paid for.[123] The Medici brothers planned to proceed to Venice and there make their plans to recapture power. Before departing Bologna, they were surprised to find a former member of their household comfortably ensconced in the Palazzo Aldrovandi.

Nothing now impeded Charles's advance. An embassy of leading citizens, including Savonarola, was sent out to arrange the conditions of his entrance into Florence. Savonarola's worst predictions had all proved true—he must have felt grimly satisfied—yet now it was up to him to save the city. When the Florentines were ushered into their royal audience, the friar astonished one and all by loudly hailing the young king as "the Minister of God, the agent of God." By proclaiming Charles the city's deliverer, Savonarola beguiled the king into sparing it from the sack.

On November 17 Charles, splendidly clad in black velvet with a mantle of gold brocade, rode into Florence astride a regal mount, as though he were the liberator of a city under siege.[124] At his side was Giuliano della Rovere, the bellicose cardinal of San Pietro in Vincoli. The leading citizens waited in the Duomo to receive him. When he emerged from the church, Charles remounted his horse and rode on to the palace of Piero de' Medici, amid the public's cries of "Viva Francia!"[125] It was reported that his first request was to view the fabled Medici treasures, but he was told that prior to his expulsion Piero had transferred the most valuable pieces of furniture, sculpture, vases, cameos, and gems to hiding places that were only gradually being discovered in monasteries and houses around town.[126] Little noticed in the jubilation, Count Giovanni Pico della Mirandola passed that same day into eternity. The

cause of death was unknown, inciting the usual suspicions of poison. In following his friend Poliziano to the grave, Pico made the same request for burial in San Marco robed in the habit of St. Dominic. Savonarola brought the robes to his bedside. Fair-haired and strikingly beautiful, Pico was but thirty-two. Of this *uomo quasi divino*, as Machiavelli calls him, it had been prophesied that he would die in "the time of lilies."[127] And though it wasn't Easter, Pico had died on the day that Florence was occupied by the royal banners of France, emblazoned with golden lilies.[128]

• • •

MICHELANGELO, MEANWHILE, WAS BECOMING A WONDER. HE AND Aldrovandi got on well, no doubt because his host "honored him highly" and "delighted in his genius."[129] We do not know how the twenty-year-old displayed his promise. Michelangelo's exterior was unremarkable, a top-heavy head set on a wiry frame. His voice was high and thin, yet he projected an irresistible self-confidence. He was of course a formidable draftsman. Regrettably, none of his drawings from this year survived intact. In the evenings in his palace in Via Galliera the Bolognese nobleman availed himself of his guest to hear the verses of "Dante, Petrarch, and sometimes Boccaccio," as Condivi says, read aloud in their flinty Tuscan cadences. In the happier times of 1488, Aldrovandi had served as *podestà* in Florence, an office that made him a welcome guest at Lorenzo de' Medici's court.[130] In spite of the use of Latin in all writings of serious import, Lorenzo placed the Italian vernacular on a level with the classics—a remarkable departure from humanist prejudices. During his stay with Aldrovandi, Michelangelo discovered that his experiences amid the poets and performances in the Palazzo Medici more than compensated for his meager formal schooling. While reading his patron to sleep, Michelangelo began to memorize the poems of Dante and Petrarch.

One day Aldrovandi accompanied his guest to one of Bologna's most venerated sanctuaries, the church of San Domenico. Entering the immense Gothic building, they saw the *arca,* or tomb, of St. Dominic, the thirteenth-century founder of the order that bears his name. The marble coffin containing the saint's bones was encased within a monument that was as yet unfinished because the sculptor, Niccolò dell'Arca, had died the previous March. Four marble statuettes were lacking: three standing saints on the eaves of the

attic, and, below, a kneeling angel holding a candlestick. Aldrovandi asked Michelangelo if he had the heart to undertake this work, and the young man replied, "Yes."[131] He was to provide the last pieces of a work that had occupied the city's foremost master for twenty-five years. Michelangelo gravitated as if by magnetism to situations that would draw the sharpest scrutiny, situations that others might have gone out of their way to avoid. Though he could claim the prestigious mantle of Florentine sculpture, the Bolognese locals were understandably jealous.[132]

Condivi informs us that Michelangelo received eighteen ducats for his figure of St. Petronius, the city's patron saint, and twelve for the angel. This was good payment for statues less than two feet in height. They can still be seen on the tomb today. True to form, Michelangelo's interest in conforming his sculptures to the others was very slight. His angel should have balanced a lovely one by Niccolò dell'Arca on the opposite side of the altar. But compared to Niccolò's lyrical conception, Michelangelo's angel looks more like one of the Lapiths from his battle relief, if somewhat better behaved. It has a late-antique ruggedness closer in spirit to St. Dominic's original sarcophagus, which was carved in high relief about 1265 by Nicola Pisano and Tuscan assistants. Michelangelo appears to have intended a kind of Florentine snub to Niccolò's Bolognese version of Renaissance style.[133]

The St. Petronius, in contrast, is a rare example of our young man playing it safe, openly taking guidance from a prominent local precedent, Jacopo della Quercia's statue over the central portal of the cathedral of San Petronio.[134] Della Quercia died in Bologna in 1438; as an example to follow, he had the advantage of being Tuscan, from Siena. Both figures of mitred bishops hold models of the city, identified by Bologna's famous leaning towers. Like della Quercia, Michelangelo exaggerated the contrapposto of the legs in an effort to inject expression into a formalized pose. The saint's head is unusually mute; it may be that he modeled it after a classical statue in order to evoke Petronius's noble Roman birth in imperial Milan during the fifth century.[135] When viewed in place, several feet above eye level, the face acquires a commanding expression. No doubt Michelangelo designed his statue in accordance with this particular perspective.[136]

A third statue, representing St. Proculus, is by far the most interesting of the young man's contributions to the arca.[137] Condivi does not mention it even though at the time of his writing Michelangelo's authorship was still fresh in Bolognese memories.[138] St. Proculus was a local martyr with a remarkable story.[139] An imperial officer, Proculus bitterly resented the cruel persecutions

of his fellow Christians in Bologna, circa 304. Arranging an evening meeting with Marinus, the emperor's emissary and high executioner, Proculus pulled out an axe he had hidden under his cloak and drove it into Marinus's head. Afterward he confessed to the crime and was beheaded, placing him among the small number of those who served their faith through murder. Tyrannicide was a contemporary theme, however, and Michelangelo made the most of it. His furrowed brow and restless stance are a portrait in fury rarely seen on the shrine of a saint. His right hand, scholars think, originally brandished the fatal axe, but in 1572 the statue was knocked over and broken while the tomb was being cleaned, and the axe was lost and not replaced.

"Conscious that he was wasting time" (or so Vasari assumes), Michelangelo hastened back to Florence after an absence of just over a year. During their occupation, the French had behaved as well as could be expected from an underpaid corps of soldiers, but they were unpopular for allowing the Pisans to slip away from Florentine control. Charles made matters worse by repeatedly speaking in support of Piero de' Medici. These were fighting words, as far as the Florentines were concerned. All sides breathed a sigh of relief in late November 1494, when the French moved south, taking their convulsions with them.

When Pope Alexander VI balked at his demands, the Most Christian King resorted to a show of force. On the last day of that momentous year, the French army rolled into Rome, which was undefended. "Oppressed by incredible anxiety and dread," the pope took refuge in the Castel Sant'Angelo. Alexander had cause for fear. His enemies, led by the implacable cardinal of San Pietro in Vincoli, daily implored the king to dethrone a pontiff "so full of vices and so abominable in the eyes of the world."[140] But Charles had neither the intention nor the inclination to offend the papacy—and besides, his privy council was dominated by persons "whom Alexander had rendered benevolent by means of gifts and promises."[141] An agreement was reached in January 1495 whereby the pope was freed in exchange for the investiture of the kingdom of Naples and the custody of several strategic fortresses. Naples fell to the French without resistance on February 24, 1495.

Thus Charles VIII achieved his aims; unfortunately for him, this moment would be the pinnacle of his life and fortunes. As soon as the French artillery had rumbled out of sight, the insidious pope activated the betrayal he had prepared, joined by that other opportunist, the duke of Milan. By March 31 they had consolidated with Venice into an Italian league that enjoyed the tacit support of Spain and Germany. The league's ostensible purpose was

to combat the Turkish threat, but no one was deceived. Suddenly the Most Christian King found himself at the southern end of the peninsula with no safe route home. Time was of the essence. On May 20 Charles began his retreat, marching northward. Thanks to a combination of luck and Italian indecisiveness, the depleted French were able to drag their artillery through the Cisa pass, north of Pontremoli, before the Mantuans could seal it off. The army that had marched the length of Italy in triumph now stumbled, starving, into Asti on July 15.[142]

That same month the contents and furnishings of Piero de' Medici's house were put on public auction inside Orsanmichele, the grain market transformed into a richly sculpted shrine.[143] The Signoria had confiscated his possessions under the very legislation that Cosimo the Elder had enacted in 1434 to plunder his political exiles, the *falliti fuggiti*.[144] The quantity of luxurious items was so great—"velvet bedcovers embroidered in gold thread, paintings, pictures and many beautiful things"—that the auction was resumed in August and again in November.[145] On December 9 the Signoria ordered that the two bronze statues by Donatello, the *David* and the *Judith*, which had stood in the court and in the garden of Piero's palace, respectively, should be removed to the Palazzo della Signoria.[146] As far as we know, Michelangelo was on hand to witness the transformation of private property into public domain.

· · ·

HE FOUND FLORENCE UNDAMAGED—AND UTTERLY CHANGED. The sight of the incomparable gardens, palaces, and churches of Brunelleschi, Michelozzo, and Alberti, the altarpieces of Botticelli, and the sculptures of Donatello was a tonic after a year of Bologna's red clay bricks. And yet everything was different. It wasn't merely that the Medici were absent; it was the disappearance of their neo-pagan ethos. "Nor was there a single woman who dared go out not modestly dressed," writes Landucci in his diary, proud that his boys were among the hundreds Savonarola had sent into the streets to guard against vanity.[147] Gamblers and sodomites were publicly targeted by the *frate* (friar) of San Marco. In one brief year, Florence had replaced a despot with a zealot.

Fra Girolamo Savonarola headed only one of several factions in the city. But his was the most public and the most vociferous; its members were derisively called the *piagnoni*, the "whiners." A new government was chosen

after Piero's expulsion. Its offices were filled mainly by members of the same families that had served the Medici. Savonarola seized upon the incongruity of the situation, dedicating his Lenten sermons in 1495—while Michelangelo was still in Bologna—to the urgency of a radically new approach. The *frate* astutely allied himself with the people at large, and successfully moved the parliament toward the creation of a Consiglio Maggiore (Great Council) that would number no fewer than a thousand citizens.[148] The populace, which was already won over by the confirmation of his prophecies, responded warmly to his nostalgia for the republican liberties of the fourteenth century. People of all walks of life abandoned families and friends to take holy vows and enter the convent.

Everyone was touched by Savonarola's denunciation of selfishness and hypocrisy, but not everyone agreed that a priest should govern in the name of Christ. Though the *frate's* strident voice was the city's most compelling, many others were raised against it. The Franciscans promoted one of their own preachers in rebuttal. Many in the clergy were appalled by Savonarola's hostility toward the pope. For his part, Alexander VI was losing patience with the friar's refusal to bring Florence into the League of Venice, especially since he claimed to speak for God. The rich and aristocratic families were divided into factions that opposed the *frate* for different reasons: the *Arrabbiati* wished to restore the old government by oligarchy; the *Palleschi* openly longed for a Medici return.[149] Every day rumors came and went of suspicious sightings of Piero de' Medici in Siena, where Charles VIII had left a garrison; or in the company of the pope's son, Cesare Borgia; or nearby in Cortona or Perugia; and so on. He seemed to prowl the perimeters of his lost realm, drumming up allies for an assault.

On November 6, 1495, the garden of San Marco was sold to Giovanni Bentivoglio, lord of Bologna. The public auction was advertised in advance and six parties made offers. The garden was the only piece of confiscated Medici real estate that would find a foreign purchaser, raising the possibility that Bentivoglio secretly acted on Piero's behalf.[150] Or it may be that Michelangelo's powers of persuasion were somehow involved, for of all the interested parties he alone had an immediate use for a sculpture studio. In fact, where else could he carve the marble *Young John the Baptist* that Lorenzo di Pierfrancesco had requested?

Lorenzo di Pierfrancesco, his brother Giovanni, and Ficino were the only remnants of the old brain trust. The storm is proof of the pilot: during the crisis Lorenzo di Pierfrancesco had proved himself a master politician—not for

nothing had Ficino, when he was Lorenzo's tutor, addressed him as *Laurentius minor.* Though only thirty-two, Lorenzo obtained one of the twenty coveted places among the *Accoppiatori,* the members of the executive committee, who were required to be forty or older. Once dipped in the stream of the Magnifico's lavish epoch, these sons of Pierfrancesco de' Medici could not share in Savonarola's austerity, but they managed not to oppose it publicly. Along with their friend Bernardo Rucellai, another politically savvy aristocrat, they recognized that the government was unstable. Their strategy was to stay out of harm's way and wait to pick up the pieces.[151] Meanwhile, Lorenzo and Giovanni changed their surname to Popolano (of the people) and removed the Medici coat of arms from the façade of their house.

Fra Savonarola was the sworn enemy of ostentation, not of art per se, but the effect was the same. Overnight the leading painters had few significant commissions; the sculptors, even fewer. The workshops resorted to various strategies to stay afloat. Now that fresco cycles of the rich and famous were unthinkable, the Ghirlandaio workshop, headed by Davide, expanded its sideline in stained-glass windows and mosaics. The Ghirlandaios had lost market share to an enterprising Umbrian, Pietro Vannucci, called Perugino. Perugino streamlined his workshop into a reliable factory of high-quality, made-to-measure altarpieces. In 1494 or 1495 he brought in an outstanding prospect, Raphael Santi, the orphaned son of the painter to the duke of Urbino. The eleven-year-old boy soaked up his master's lessons like a sponge. Perugino was engaged on his *Crucifixion* fresco for the Cestello church, near the Carmine, when Michelangelo came home at the end of 1495. The following spring, as soon as the fresco was finished, Perugino accepted commissions away from Florence, taking young Santi with him to Fano in the Marches and then to Perugia.[152]

Only the fabulously wealthy Filippo Strozzi was spending money, investing a fortune to build the massive palace that looms over Via Tornabuoni. In a few years he would buy Michelangelo's standing *Hercules* for the courtyard. Strozzi had Filippino Lippi and Benedetto da Maiano, the elderly sculptor, on long-term contracts to decorate his chapel in Santa Maria Novella. No one was in a hurry to unveil in front of Savonarola the extravagantly neo-antique motifs Filippino had picked up in Rome.

Thus it was that Filippino Lippi's masterpiece of these years, the *Adoration of the Magi,* was destined for a church at a discreet distance from the city, San Donato a Scopeto.[153] The Three Wise Men was Cosimo de' Medici's signature theme, unforgettably painted by Benozzo Gozzoli as an equestrian parade of

portraits in the Palazzo Medici chapel and by Botticelli as a family reunion in Santa Maria Novella in the mid-1470s. As Botticelli's best pupil, Filippino was an inspired choice to paint the story yet again, this time with the portraits of the at-long-last-vindicated rival cousins: Lorenzo, Giovanni, and even their deceased father, Pierfrancesco de' Medici. The altarpiece is signed and dated to the day, March 29, 1496.[154]

Not that Botticelli was out of the picture; by now he was working exclusively for Lorenzo il Popolano. The interminable illustrations to Dante's *Inferno* were going ahead, reaching a total of ninety-one large "miniatures" by the end of the decade.[155] One has to look eastward in the history of art to find a parallel case of a master occupied for years on a work intended for the private contemplation of his maecenas. In 1495 and 1497 Lorenzo called Botticelli to his villas of Trebbio and Castello to paint wall decorations that, alas, have not survived. Some see Savonarola's influence in Botticelli's stark late paintings, but with the approach of the half-millennium, 1500, apocalypse was in the air. No doubt he was grateful for the protection of a patron who understood him. At thirty-two, Il Popolano had already lived through several lifetimes.

It would have been surprising, then, had Michelangelo gravitated toward anyone else. Condivi's reference to the *San Giovannino* gives the impression that the idea was Lorenzo's. The statue was quickly finished, and just as rapidly lost, that is, within the next half-century. We know even less of its appearance than of the appearance of the *Hercules*. John the Baptist, patron saint of Florence, was a politically correct choice of subject and should not have attracted controversy.

Michelangelo needed money. Sculptors always do because their materials are expensive. But there was something else. He came back from Bologna completely self-sufficient. The thirty ducats he brought with him were far more than his father or brothers would earn anytime soon. This meant, of course, that the family was now counting on him. Although more than sixty surviving letters testify to Lodovico's status as *pater familias*, he abruptly disappears from Condivi's biography at this point, despite having recited one of its most vivid parts. Henceforth, his second son would have to pay for home and hearth.

One day, while Michelangelo and Lorenzo di Pierfrancesco were commiserating over the lamentable state of the market for contemporary sculpture, Il Popolano let drop a remarkable proposition. The problem, as they both recognized, was that living sculptors were assumed to be inferior to

their ancient counterparts. Michelangelo, of course, was the exception to the rule. If the twenty-year-old were willing, Lorenzo had contacts in Rome who could sell his latest sculpture, *Sleeping Cupid,* for nearly as much as an antiquity. Whether the *Cupid* was made before or after Lorenzo proposed this deception is a moot point disputed between Condivi and Vasari.[156] What matters is that the plan went off like clockwork. Within weeks, Michelangelo had pocketed thirty ducats.

Even better, in June 1496 a gentleman came to visit him in his studio. He told the sculptor that his name was being mentioned in Rome as a most promising talent. Could Michelangelo provide him with a drawing or some other demonstration of his talent that the gentleman could take back to an important collector? Catching on, though still not saying anything, the twenty-one-year-old took a pencil and flawlessly drew a hand—the same hand, in fact, as on his marble *Cupid.* At once his visitor, who was probably Jacopo Galli, revealed that he had been sent by Cardinal Raffaele Riario. The cardinal of San Giorgio, as he was titled, had been appalled to discover that the *Sleeping Cupid* in his collection was a Florentine fake—not antique at all. And to think that he had paid a price of two hundred ducats! Distraught, to say the least, Michelangelo departed at once for the Eternal City.

CHAPTER FOUR
SACRED AND PROFANE LOVE

ROME
JULY 1496–JULY 1500

FOR THE PILGRIM MULTITUDES, ROME WAS THE NEW JERUSALEM
and the gateway to heavenly grace. For Savonarola, preaching from the pul-
pit, Rome was a modern Sodom sunk in sinfulness.[1] Michelangelo, arriving in
the summer of 1496, would see for himself. Thus far, the first week of his first
visit had been passed in the society of moneylenders and a cardinal as rich
as Croesus. He describes the situation in a letter to Lorenzo di Pierfrancesco
in Florence.

Yesus. On the 2nd day of July 1496.

Magnificent Lorenzo etc.,

This is to let you know that we arrived safely last Saturday
and at once went to call upon the Cardinal of San Giorgio, to
whom I presented your letter. He seemed pleased to see me and
immediately desired me to go and look at certain statues; this took
all day, so I could not deliver your other letters. Then on Sunday, the
Cardinal went to his new house and sent for me. I called on him,
and he asked me what I thought of the works I had seen. In reply
to this I told him what I thought; and I certainly think he has many
beautiful things. Then the Cardinal asked me whether I had courage
enough to attempt some beautiful work of my own. I replied that I

could not do anything as fine, but that he should see what I could do. We have bought a piece of marble for a life-sized figure and on Monday I shall begin work.

Last Monday I presented your other letters to Paolo Rucellai, who provided me the money I needed, and likewise to the Cavalcanti. Then I gave the letter to Baldassare [del Milanese] and asked him for the bambino, saying that I would refund his money. He told me very curtly that he would sooner break it into a hundred pieces, that he had bought the bambino and it was his. He said he had letters showing how he had settled the matter with the person to whom it had been sent, and he would not now give it up. He complained bitterly about you, saying that you had maligned him. Some of our Florentines sought to arrange matters between us, but they could do nothing. Now I am counting on acting through the Cardinal, for thus I am advised by Baldassare Balducci. You shall be informed as to what ensues. That's all for this letter. I commend myself to you. May God keep you from harm.

Michelagniolo in Roma[2]

Recovering the *Sleeping Cupid* was proving more difficult than they had foreseen. After ascertaining that the cardinal of San Giorgio bore him no grudge, Michelangelo had gone to see Lorenzo il Popolano's bankers in Rome, Paolo di Pandolfo Rucellai and the Cavalcanti family. They gave him enough money to buy back the *bambino* (baby), as he called it, but Baldassare del Milanese refused to cooperate. As head of Roman operations for a well-connected family of financiers, Baldassare del Milanese knew his rights.[3] His friend Lorenzo had maligned him, he said. The thirty ducats he had paid was an excellent price for a marble *bambino*. Whose business was it if he turned it over for two hundred? Access to the cardinal of San Giorgio was worth that much and more.

At thirty-five, Raffaele Riario, cardinal of San Giorgio, was in the prime of life.[4] The Pazzi traumas of April 1478—when Giuliano de' Medici was murdered in front of his eyes, and he himself was nearly hanged—were seared into the collective memory, but he for one had recovered nicely. When he was twenty-one, his uncle Sixtus IV handed him the chancellery, the papacy's second-richest office. Thus fortified, Cardinal Riario was unaffected as pontificates came

and went, free to indulge his passion for the classics and do all he could to overtake Florence in art and letters. Boldly, for a prince of the Church, Riario was eager to revive the theater, sponsoring the first public performance since Roman times of Seneca's tragedy *Hippolytus*. He underwrote the scholarship and paid for the publication of ancient texts, most notably the *De Architectura* of Vitruvius.[5] With due reverence for the Christian martyrs, the pagans were altogether more sophisticated. Riario lavished money on antique marbles and was immensely proud of having two colossal statues, a *Demeter*, now in the Vatican rotunda, and a *Melpomene*, the tragic Muse, now in the Louvre. His cousin the cardinal of San Pietro in Vincoli, the pope's bitter enemy and currently in exile, kept in his garden a striding *Apollo* that was even finer.[6]

Cardinal Riario was temporarily renting a small, elegant palace in the densely populated area between the Ponte Sant'Angelo and the north end of the Piazza Navona.[7] The count of Imola, Girolamo Riario, another cousin, had built the palace in 1488 at the height of his political fortunes. A few months later, Count Girolamo was assassinated, presumably for his part in the Pazzi plot, although the Medici were not the only ones who wished him dead. Michelangelo went to call at the Palazzo Riario as soon as he arrived in Rome on Saturday afternoon, June 26. He was ushered in bearing a letter signed by a man whose brother, Giovanni di Pierfrancesco, was just then initiating a love affair with the owner of the palace—Caterina Sforza Riario, Girolamo's widow.[8]

After exchanging amenities, the cardinal of San Giorgio sent Michelangelo around to see his sculpture collection. There Michelangelo contentedly passed the remaining hours of that long June afternoon. They arranged to meet the following day at the cardinal's "new house," a massive rectangular block in its final stages of construction to the south of the Navona. It was the custom for wealthy cardinals to construct spectacular palaces in the vicinity of their titular churches. Having paid for the printing of Vitruvius's ancient treatise on architecture and Leon Battista Alberti's modern revision of it, Riario was eager to put these theories into practice, taking advantage of sixty thousand ducats won gambling at dice with Franceschetto Cibò, one of the pope's sons.[9] The plan entailed the destruction and reconstruction of San Lorenzo in Damaso, the venerable early Christian basilica, inside his huge new house, the present-day Palazzo della Cancelleria.

On Sunday, after quizzing Michelangelo and being satisfied with his replies, Cardinal Riario revealed his intention to give the young man a marble block to carve a statue for his collection. Despite its rejection, the *Sleeping Cupid* had become the cornerstone of a new relationship. Elated,

Michelangelo set out to find a block of statuary marble. In two days he was ready to start cutting. As to his subject, though, his letter says nothing to arouse Lorenzo's curiosity, only that it would be a "life-sized figure."

Meanwhile, Baldassare del Milanese had more tricks up his sleeve. While Michelangelo was meeting the cardinal on Sunday, the clever banker sent the *Cupid* over to the Palazzo Sforza Cesarini in the Via Banchi Vecchi. Interested parties were invited to go and view the marvel, which he persisted in calling antique. Count Antonio Maria Pico della Mirandola, the philosopher's cousin, rushed over the same day. Pico's sister-in-law Isabella d'Este paid him to keep an eye out for important antiquities. By Monday, when Michelangelo was busy with Lorenzo's bankers, Count Pico was already writing his avid patroness in Mantua:

> [I]t is a putto that reclines asleep, supporting itself on one hand.
> It is intact about three spans long and very beautiful. The owner
> wants two hundred for it.[10]

Del Milanese was sticking to his price, but one wonders how long its fictitious provenance would last with Michelangelo in town. For the moment, the formidable marchesa was not intrigued (and a month later, Pico wrote her again to explain that the cupid was not antique after all, though it was "so perfect that many people believe it is"[11]).

Placing it in the hands of Cardinal Ascanio Sforza put it beyond the reach of almost anyone, including possibly Riario.[12] Sforza, the brother of Ludovico il Moro, had cast the decisive vote in the papal conclave of 1492 that had elevated Rodrigo Borgia to the papal throne as Alexander VI. In gratitude, the pope bestowed on Sforza his palace, the office of vice-chancellor, and four mules laden with gold and silver.

On Monday, going around to the bankers and then to Baldassare del Milanese, Michelangelo was amazed to discover this fait accompli. The Florentine colony in Rome included twenty-five banking houses in the vicinity of the Palazzo Riario, so there was no shortage of associates and friends of his patron to whom he could appeal. He found only one person who listened sympathetically. Baldassare Balducci came from Michelangelo's Santa Croce neighborhood; he became Michelangelo's banker and they began a friendship.[13] But even Balducci agreed that no one but Cardinal Riario had the power to intervene. In the meantime, Michelangelo decided not to inform Lorenzo about the *bambino*'s change of address.

He sent the letter in care of Sandro Botticelli, who would always know how to find their mutual protector. For safety's sake, il Popolano was living in his villa at Trebbiano outside the city.[14] Florence was more volatile than ever now that Savonarola was in control. Roving bands of children filled the streets singing hymns and chiding the populace to respect the friar's reforms. There may have been as many four thousand boys between the ages of six and nine, six thousand between ten and fourteen.[15] In a sermon preached on June 24, the *frate* took the Florentines to task for their sumptuous modes of dress.[16] It was a foreshadowing of things to come. With the situation heating up, no one's position was inviolable. Both Lorenzo and his brother, Giovanni di Pierfrancesco, were quietly planning their escapes. Giovanni was in the Romagna, delegated to purchase wheat from Caterina Sforza Riario, and falling in love with her. A secret marriage meant he would share her estate. Lorenzo il Popolano was organizing an extended absence across the Alps in order to inspect some property in Flanders.

<center>• • •</center>

THE DECADENT COURTS OF THE IMPERIAL ROMANS AND THE Renaissance Borgias have been compared innumerable times, most brilliantly by Oscar Wilde in *The Picture of Dorian Gray*. Wilde unwinds an unnerving skein of names belonging to Michelangelo's contemporaries:

> Over and over again Dorian used to read this fantastic chapter of the Roman emperors, and the two chapters immediately following, in which ... were pictured the awful and beautiful forms of those whom Vice and Blood and Weariness had made monstrous or mad: ... [Cesare] Borgia on his white horse, with Fratricide riding beside him, and his mantle stained with the blood of Perotto; Pietro Riario, the young Cardinal Archbishop of Florence, child and minion of Sixtus IV, whose beauty was equalled only by his debauchery.... Giambattista Cibo, who in mockery took the name of Innocent [VIII], and into whose torpid veins the blood of three lads was infused by a doctor; ... Dorian Gray had been poisoned by a book. There were moments when he looked on evil simply as a mode through which he could realize his conception of the beautiful.[17]

Alexander VI was not the first pope to acknowledge his children openly—that distinction belongs to his predecessor, Innocent—but he made his family the fulcrum of his policies. "His only care was to seize on all means that might aid him to increase his power and advance the wealth and dignity of his sons; on no other subject did he ever seriously bestow a thought," was the drastic opinion of the Venetian ambassador.[18]

Nepotism, however, was the mildest of the Borgias' crimes. The pope's sons, Juan and Cesare, and their famously alluring sister, Lucrezia, were equal heirs to Rodrigo's sensuality and ruthlessness. Juan Borgia's return to Rome from his duchy in Gandia in May 1496 was celebrated by a triumphal procession, the likes of which had not been seen since imperial days. Juan's wife, Sancia, a Spanish noblewoman, was rumored to have been possessed in turn by his younger brother, Cardinal Cesare, and his father, the pope. Another rumor making the rounds was that Cesare desired to see Riario poisoned so as to possess his lucrative office. In the air, too, was a brooding bad blood between the Borgia brothers. Cesare had never disguised his envy of his brother's military career. As strange as it may have been for Cardinal Rodrigo to name a second son for a pagan emperor, with every passing day it seemed more fitting.

The man who would be the most feared in modern history was born to Rodrigo Borgia's favorite Italian mistress in September 1475. Cesare Borgia was thus a young man of the same age as Giovanni de' Medici, born in December, and Michelangelo, born the previous March. Though Cesare had no natural inclination to the cloth, his father groomed him for a cardinal's hat, as Lorenzo il Magnifico had done for Giovanni. Cesare Borgia and Giovanni de' Medici were wary classmates at Pisa until Lorenzo's death and Rodrigo's election in 1492. Before raising Cesare to the purple in 1493, Alexander first soothed the College of Cardinals by disseminating a fabricated story of his legitimate birth. This unsavory episode of 1493 appalled Savonarola and echoed throughout Christendom.

Alexander VI had attempted to deal with Savonarola, secretly offering him the cardinalate in exchange for his silence, but the rebellious friar seemed hell-bent on defiance. Fifteen thousand people were attending his sermons, at which he almost always mentioned the corruptions of Rome.[19] Between May 8 and July 3, 1496, he preached seventeen sermons, not just on Sundays and feast days, but even some daily masses.[20] Having used the pulpit to accomplish the enactment of a new municipal constitution, Savonarola was inextricably involved in the city's politics, although he had no seat in the

council. His vision of good government was electrifying, but divisive. "God alone will be thy king, O Florence, as He was king of Israel under the old Covenant.... Thy new head shall be Jesus Christ."[21]

In his Lenten sermons on Amos, he had compared the prophet's condemnation of the *vacche*, or "fat cows," of Samaria—i.e., the lascivious women—to the "ten thousand concubines" of Rome, to whom the "heads of the church, priests, friars, went by night," and then "celebrated the Sacrament the following morning." Indeed, "the bull who keeps these cows," he continued, "is wanton and proud and always keeps them in sight, and woe to any other bull who comes near."[22] The Borgia coat of arms depicted a bull. Even the pope's private apartments, freshly painted by Pinturicchio, were emblazoned with this symbol in the midst of a scandalous profusion of astrological and pagan ornaments. When pressed to cease his attacks on the pontiff, Savonarola replied that he had never singled out any priest in particular—but everyone knew of whom he spoke.[23] The "fat cows of Samaria" are cited in Amos's fourth chapter, which contains a prophetic warning: "I have destroyed some of you, as God destroyed Sodom and Gomorrah, and you were like a firebrand plucked out of the fire."[24]

· · ·

ON JULY 18 THE LIFE-SIZED "MARBLE OUT OF WHICH THE FIGURE will be made by the hand of Michelangelo"[25] was duly paid for, together with a refund of the few ducats spent on the journey from Florence and stable fees for his horse. Cardinal Riario's accounts were held by Baldassare Balducci, who handled the disbursements with remarkable promptness. The cardinal treated the sculptor with every courtesy. The work was showing good progress: a month later, on August 23, Michelangelo was given through Balducci an impressive first payment of fifty large gold florins. Balducci and his brother Giovanni had made their careers through their close association with Jacopo Galli, a merchant banker of noble blood who moved easily in the upper echelons of society.[26] He was a model of discretion, an aesthete, and deeply committed to helping the young artist. Cardinal Riario was but one of the cardinals who sought Galli's advice on all sorts of matters, not only financial. On August 24 another four ducats were sent to Michelangelo in the house of Jacopo Galli. This is the first known reference to Michelangelo's privileged residence in the banker's own house.

Galli owned an *isola,* or block, of adjoining houses, a corner of which looked out across the piazza where San Lorenzo in Damaso had stood, until its recent removal, since the year 395. The medieval streets around it were jammed with stalls and passersby. The interior enclosed a patch of grassy ground and any number of alcoves and stables that could accommodate a sculptor who wished to chisel stone at all hours of the day and night. A cultivated man, Galli collected classical marbles for his garden, though nothing too grand. He was careful to encourage the cardinal's interests, not compete with them.

It was Galli whom Riario had sent to Florence to find the sculptor of the fraudulent *Cupid,* and he who realized that Michelangelo was a genuine talent. Buonarroti was now twenty-one, so his youth was not remarkable, but he possessed an intensity that convinced others to take him seriously. The decision to bring the youth into the cardinal's orbit must have been favorably influenced by his neo-antique statue of Hercules of colossal dimension. By the same token, Michelangelo's good relations with Santo Spirito also helped, for Riario was the cardinal protector of the Augustinian order. Some study would be needed to arrive at an invention up to the cardinal's demanding standards, but Galli was equipped to be a sounding board and a reference library. Michelangelo was in his element.

Michelangelo would later complain to Condivi that Cardinal Riario had no taste in modern art and gave him no work, but that would be in 1553, when he had the luxury of writing a smoother version of events. Things were going well in this initial honeymoon moment. How could they not? In a matter of days he had made himself the protagonist of a Roman revival of the Greek intellectual climate of Florence. On September 19 Riario sent him two barrels of wine, a congenial, customary gift, though tempting to interpret as an allusion to the subject of Michelangelo's work in progress, a marble *Bacchus.*

There were only two shadows, it seems, on the face of this limpid Roman year. It surely galled him that Pietro Torrigiani, the sculptor who had smashed his nose, was gainfully employed by the inner circle of the Borgia papacy. After being exiled from Florence, Torrigiani had gone to Bologna and then settled in Rome. Very quickly his work came to the attention of Andrea Bregno, a distinguished sculptor and architect, who was overseeing the redecoration of San Giacomo degli Spagnoli, the church of Alexander VI's own nation, Spain. The other disappointment was the definitive loss of his *Sleeping Cupid.* Within a few months it had been acquired by Cesare Borgia and sent to Guidobaldo da Montefeltre, the duke of Urbino. Cesare

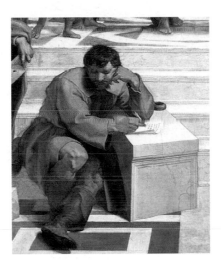

Raphael, *The School of Athens*, 1509–10, fresco, detail (portrait of Michelangelo).
Stanza della Segnatura, Vatican Palace.

1. Palazzo Medici 2. Duomo 3. Palazzo
della Signoria 4. Santa
Croce

5. Rubiconte
 Bridge

6. Palazzo Pitti

The Catena map of Florence (copy),
ca. 1480. Museo di Firenze Com'era.

Leonardo da Vinci, *The Hanged Body of Bernardo Baroncelli, Pazzi Conspirator,* 1479, drawing. Musée Bonnat, Bayonne.

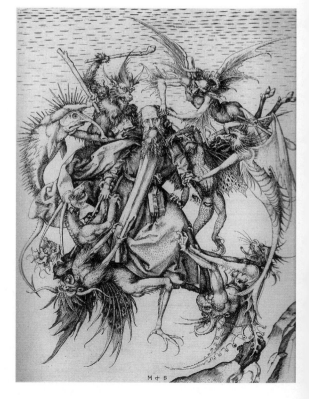

Martin Schongauer, *The Temptation of Saint Anthony,* ca. 1470–75, engraving. The Metropolitan Museum of Art, New York.

ABOVE LEFT: Domenico Ghirlandaio, *Lorenzo il Magnifico* (second from left), 1482–85, fresco, detail. Sassetti Chapel, Santa Trinità, Florence. ABOVE RIGHT: Domenico Ghirlandaio, (from left) *Marsilio Ficino, Cristoforo Landino, Angelo Poliziano, Gentile de' Becchi*, 1485–90, fresco, detail. Tornabuoni Chapel, Santa Maria Novella, Florence. BELOW: The Villa Medici at Careggi.

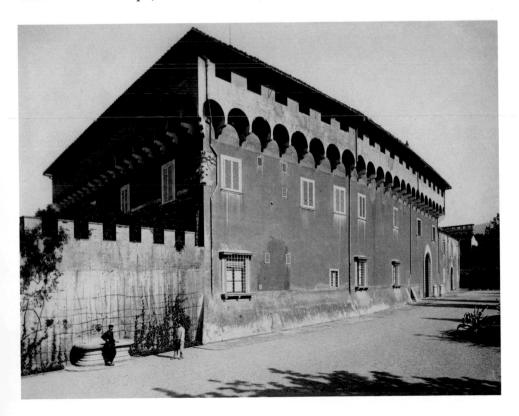

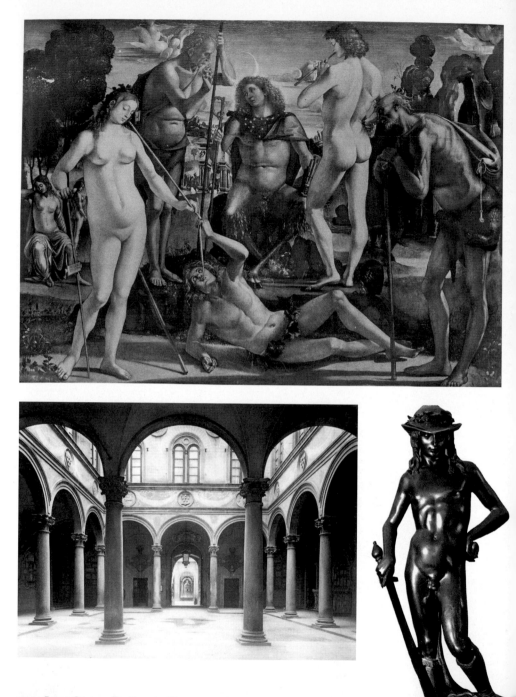

TOP: Luca Signorelli, *Court of Pan,* ca. 1490, canvas.
Kaiser Friedrich Museum, Berlin, destroyed by fire in 1945.
ABOVE: Courtyard, Palazzo Medici, Florence.
RIGHT: Donatello, *David,* ca. 1430–35, bronze.
Museo Nazionale del Bargello, Florence.

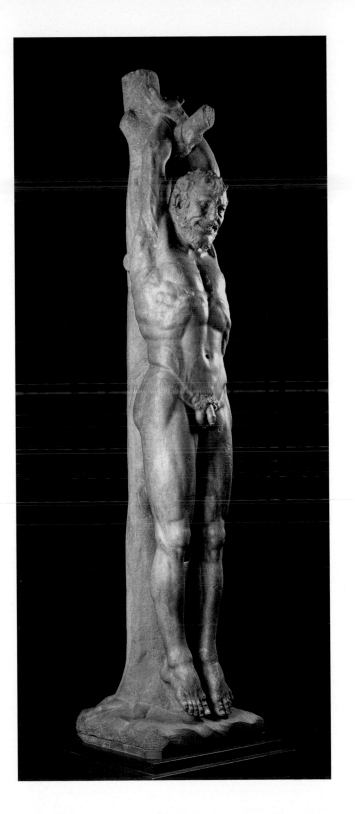

Roman, *Red Marsyas,*
or *Marsyas Flayed,*
marble. Collection
Cosimo de' Medici,
Uffizi, Florence.

ILLE EGO SVM PERQVEM PICTVRA EXTINCTA REVIXIT
CVI QVAM RECTA MANVS TAM FVIT ET FACILIS
NATVRAE DEERAT NOSTRAE QVOD DEFVIT ARTI
PLVS LICVIT NVLLI PINGERE NEC MELIVS
MIRARIS TVRREM EGREGIAM SACRO AERE SONANTEM
HAEC QVOQVE DEMODVLO CREVIT ADASTRA MEO
DENIQVE SVM IOTTVS QVID OPVS FVIT ILLA REFERRE
HOC NOMEN LONGI CARMINIS INSTAR ERAT
OB AN MCCCXXXVI CIVES POS B M MCCCCLXXXX

ABOVE: Benedetto da Maiano, *Giotto Memorial,* 1489–90. Duomo, Florence.
BELOW: Masaccio, *Baptism of the Neophytes,* 1425–26, fresco, detail. Brancacci Chapel, Florence.
OPPOSITE: Michelangelo Buonarroti, *Two figures, after Giotto,* after 1490, drawing. Louvre, Paris.

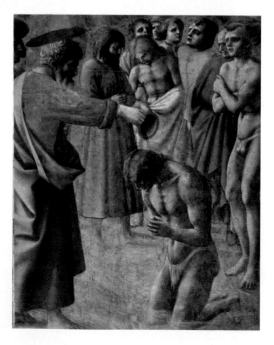

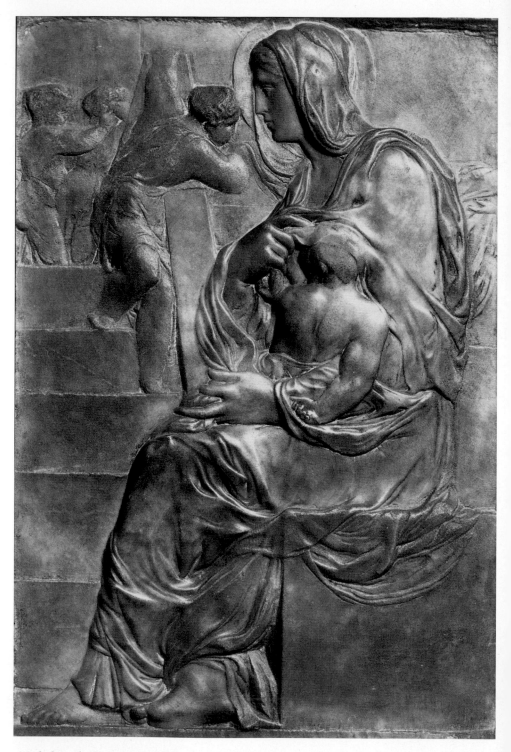

Michelangelo Buonarroti, *Madonna of the Stairs*, 1490–92, marble. Casa Buonarroti, Florence.

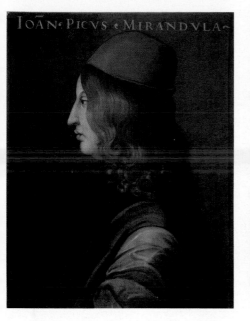

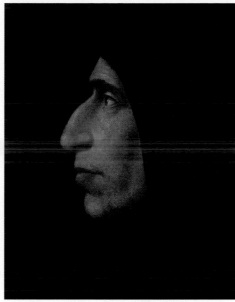

Cristofano dell'Altissimo, *Portrait of Pico della Mirandola,* second half of the 16th century, oil on wood panel. Uffizi, Florence.

Fra Bartolomeo, *Portrait of Girolamo Savonarola,* ca. 1498, wood panel. Museo di San Marco, Florence.

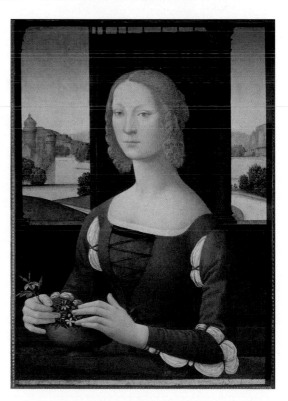

Lorenzo di Credi, *Portrait of Caterina Sforza,* ca. 1487. Museo di Forlì, Italy.

Michelangelo Buonarroti, *Battle of the Centaurs*, 1490–92,
marble. Casa Buonarroti. Florence.

RIGHT: Gherardo di Giovanni, *Portrait of Piero di Lorenzo de' Medici,* 1488, miniature. Biblioteca Nazionale, Naples. BELOW: Antonio del Pollaiuolo, *Battle of the Nudes,* ca. 1465–75, engraving. The Metropolitan Museum of Art, New York.

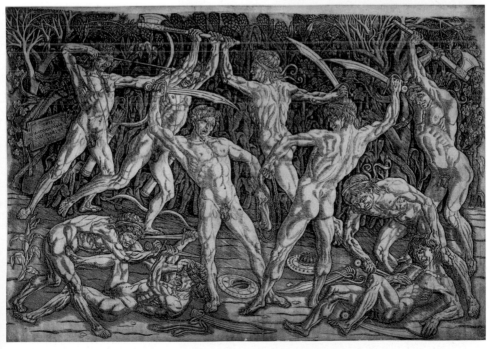

ABOVE LEFT: Donatello, *Crucifix,* ca. 1412–13, wood. Church of Santa Croce, Florence.

ABOVE RIGHT: Leonardo da Vinci, *Vitruvian Man,* ca. 1487, drawing. Gallerie dell'Accademia, Venice.

LEFT: Filippo Brunelleschi, *Crucifix,* ca. 1410–15, wood. Church of Santa Maria Novella, Florence.

OPPOSITE: Michelangelo Buonarroti, *Crucifix,* 1492–93, wood. Church of Santo Spirito, Florence.

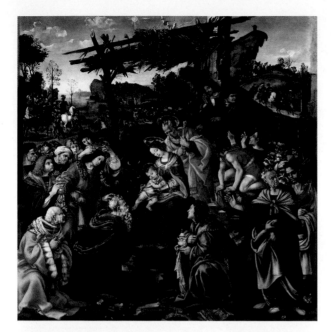

LEFT: Filippino Lippi, *Adoration of the Magi,* 1496, oil on panel. Uffizi, Florence. At left: Lorenzo di Pierfrancesco being crowned and Giovanni di Pierfrancesco holding the chalice.

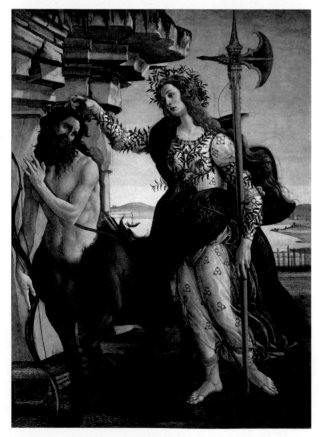

ABOVE: Michelangelo Buonarroti, *St. Proculus,* 1494, marble. San Domenico, Bologna.

LEFT: Sandro Botticelli, *Minerva and the Centaur,* ca. 1485, tempera on wood panel. Uffizi, Florence.

Borgia had no known interest in the fine arts, so one must suppose the gift was part of his strategy of "flattering and then surreptitiously murdering the various ruling families of Romagna and Tuscany."[27]

The statue of Bacchus was completed the following spring in the interval between a second payment of fifty large gold florins on April 8 and a final settlement in the same amount on July 3, 1497. The total of 130 gold florins represented what his father would have earned in six years in the customs job he had obtained from Lorenzo de' Medici.[28] It was a considerable sum to pay any sculptor, though less, in fact, than Riario had paid for the supposedly antique *Sleeping Cupid*. On July 1, 1497, Michelangelo wrote his father, Lodovico, about his plans for coming home. "I have not yet been able to arrange my affairs with the Cardinal and I don't wish to leave here until I have been satisfied and remunerated for my labors." [29] Though the tone is noncommittal, the content is unmistakable: he is waiting to be paid, after which Riario will have no further use of his services. Was something wrong with the *Bacchus*?

Condivi's comments on the statue are the most important because they were read and approved by Michelangelo himself in 1553. After asserting its fidelity to its subject, Condivi underscores its moral rectitude, notwithstanding its pagan inspiration.

> Galli, a Roman gentleman of fine intelligence, had him make in his own house a marble Bacchus ten palmi in height whose form and appearance correspond in every particular to the description of the ancient authors. The face of the youth is joyful and the eyes, squinting and wanton, are like the eyes of those who are too much possessed by the love of wine. He holds a cup in his right hand, as if about to drink, and gazes at it like one who takes pleasure in that liquor which he invented. For this reason, Michelangelo has wreathed his head with a garland of vine leaves. On his left arm hangs a tiger skin, the beast dedicated to him as one that delights in grapes. Michelangelo represented the skin instead of the animal to signify that he who allows his senses to be overcome by that appetite for that fruit and its liquor, ultimately loses his life to it. In his left hand, he holds a bunch of grapes, which a lively and nimble little satyr at his feet is slyly eating; the satyr seems to be about seven years old, and the Bacchus eighteen. [30]

The theme is essentially the same as the *Centaurs*, with drunkenness replacing bloodlust as a vice that reduces men to beasts. The feral satyr is attached to him like an attribute. Vasari, though, reads the *Bacchus* in an entirely different key; his opinion may not coincide with Michelangelo's intentions, but is interesting as a response from an informed contemporary.

> In this figure it is clear that Michelangelo wanted to attain a
> marvelous combination of various parts of the body and most
> particularly to give it both the slenderness of the young male
> figure and the fleshiness and roundness of the female: it was such
> an astonishing work that it showed Michelangelo to be more
> skilled than any other modern sculptor who had ever worked
> up to that time.[31]

Condivi ignores the pagan god's androgynous sexuality while Vasari thinks of nothing else. This dissonance is perhaps a symptom of whatever it was that induced Riario to disassociate himself as rapidly as possible. Given the cardinal's neo-antique tastes for all things rational and harmonious, he probably objected on the same grounds as the poet Shelley four centuries later.

> The countenance of this figure is the most revolting mistake
> of the spirit and meaning of Bacchus. It looks drunken, brutal,
> and narrow-minded, and has an expression of dissoluteness the
> most revolting. . . . On the other hand, considered merely as a
> piece of workmanship, it has great merits. The arms are executed
> in the most perfect and manly beauty; the body is conceived
> with great energy, the lines which describe the sides and thighs,
> and the manner in which they mingle into one another, are of
> the highest order of boldness and beauty. It wants, as a work of
> art, unity and simplicity; as a representation of the Greek deity,
> it wants everything.[32]

This was the problem: the cardinal had commissioned a statue to place in the arcade of his grand new courtyard, which was designed to serve as both a theater and a sculpture gallery. Dionysius, the Greek antecedent of Bacchus, was a multiple personality, given to debauchery yet credited by Aristotle with the invention of tragic drama and by Plato as the source of poetic inspiration.

Mystical interpretations of the wine god's "divine frenzy" were the daily bread of the Florentine Neoplatonists; Michelangelo knew them by heart. So did Riario, who as a teenager was already receiving advice in letters from Ficino. Such themes allowed the humanists to put a decent Christian polish on the naked classical marbles they adored. But Michelangelo's *Bacchus* was unmistakably not a Dionysius. Inexplicably, he had declined to observe the polite conventions. The *Bacchus* he delivered was not the inventor of tragedy; nor was he a worthy rival to noble Apollo, who commands the poetic muses. If Michelangelo was thinking of theater at all, it could only be of the biting mockery of the satyr comedies that the Greeks used as codas to their tragic trilogies. If he was thinking of Plato, it can only be of the beautiful and staggering Alcibiades as he appears in the *Symposium*: a thinly veiled symbol for Dionysius who bursts into the party, breaking up the pretentious conversation and openly flaunting himself.[33]

It was hardly a piece for a cardinal under the pope's surveillance to keep at home. Michelangelo was paid off and his *Bacchus* was left to languish at Galli's house.[34] In 1534, long after Riario and Galli had passed away, a Dutch artist would draw it standing amid the marble fragments in the garden, missing its right hand, its penis broken.[35] When Vasari finally speaks up in 1550, he naturally credits the commission to Galli, owner of the *Bacchus*'s only home. Michelangelo will let the error pass and allow Condivi to jibe the cardinal for missing his chance.[36] In July 1497, though, their sole idea was to save themselves from embarrassment.[37]

• • •

Michelangelo's first year in Rome was Savonarola's last year of power. After urging the enactment of a new populist constitution, the friar had placed the city in the hands of God. But even a government guided by prophecy had to withstand the Renaissance test of fire that was its foreign policy. Savonarola staked everything on Florence's special relationship with Charles VIII, king of France. "Lilies must flower with lilies," he said, making the most of their heraldic ties.[38] He sent five letters to Charles demanding that he restore Pisa to the Florentines. The friar knew that his own fate was inextricably connected to the outcome of the Pisan war.

The port of Pisa, newly freed from Florentine dominion, was a seductive apple in the eye of European potentates. In autumn 1496 Maximilian,

the Holy Roman Emperor, descended into Italy at the behest of Ludovico Sforza, who was busily spinning plots as always. This time the invasion was intended to weaken the power of France. The Pisans opened their gates to Maximilian, offering him the palace they had confiscated from their Medici overlords. The emperor then sent letters warning Florence that if she did not join his league, which included Venice and the Borgia pope, he would attack Livorno, nearby on the Tyrrhenian coast. Livorno was the only possession lost by Piero that Charles had restored. Piero de' Medici had buckled under the pressure, which his citizens redoubled by their alarm, but Savonarola did not intend to change a policy dictated by God. "My Florentines have a faith made of wax," he said, "which melts at the first touch of heat."[39] With their troops engaged in skirmishes on the Pisan plain and no warships to dispatch, the Florentines' sole recourse was prayer. As in times of plague and famine, a procession was organized to bring a venerated icon of the Madonna from its sanctuary in Impruneta.[40]

The first word of the imperial assault on Livorno reached Florence on October 30, simultaneously with the arrival of the Impruneta tabernacle. The men of Livorno had struck first, going out of their city to surprise the Germans' camp, killing about forty soldiers and capturing their artillery. A fleet sent in haste from France had entered the harbor and routed the league's ships, including that of the emperor, who was almost drowned. As details trickled in, the Florentines understood that their devotional procession had been rewarded. "It can easily be seen that such a sign is a miracle," Landucci exclaims, "showing God's aid to the Florentines; for the Emperor immediately abandoned his enterprise, after having come all the way from Germany to take possession of Pisa, which the Pisans had offered to him. And now in a single day this conflagration was extinguished. It was a miracle like those in the Old Testament."[41] Validated from on high, Savonarola's strength reached its zenith with the salvation of Livorno at the end of 1496.

But the aftershocks of disastrous harvests were beyond the powers of Fra Girolamo to control. While the mercenaries engaged against Pisa sat out the winter, famine stalked the countryside. During the early frigid months of 1497 Landucci writes of threatening plague, the spiraling price of bread, and "men, women and children falling down in the streets exhausted from hunger."[42] This year Savonarola's Augustinian enemies at Santo Spirito devoted the Lenten sermons to attacking his claims to prophecy.

A curious event took place on the last day of Carnival, February 7, 1497.[43] Going door to door throughout the city, the young people under Savonarola's

command urged the Florentines to give up their playing cards and dice, mirrors, cosmetics, lascivious paintings, drawings and books, and every other kind of luxury and frivolity. These objects were carried to the Piazza della Signoria and piled up in a pyramid more than fifteen meters high. After the friar said morning mass, his listeners marched, singing hymns, in a long procession to the square. The pyramid was ignited in flames to the uproarious accompaniment of trumpets and religious songs. This was the first bonfire of the vanities; it would be repeated the following year.

Fifteen thousand people continued to attend the friar's sermons, and yet many were against him. Some feared that Savonarola would transform the city into a convent. Others questioned whether an army of children was an appropriate method for policing the public morality. The governing *Signori* were alarmed by the friar's conflicts with the pope; they knew the damage a papal censure would cause the city.[44] Although the majority of the population counted themselves among the friar's supporters, who were called the *frateschi* or, pejoratively, the *piagnoni* ("whiners"), the city was splintered into opposing civic factions.

His opponents were setting traps. Having failed to threaten Fra Girolamo into obedience or to buy him with a cardinal's hat, Alexander VI quietly reorganized the Dominican order in Tuscany. Enemies of Savonarola, some of them turncoat friends, were appointed to the senior positions of authority. They now bided their time. On the secular front, in March the aristocratic families that had benefited from Medici rule and longed for its return—the party of the so-called *Palleschi*—successfully elected their leader, Bernardo del Nero, to the high office of gonfaloniere.[45] Del Nero was also a staunch ally of the pope.

Thus it happened that in the spring of 1497 Piero de' Medici's efforts to enlist supporters for his return began for the first time to yield fruit. Accustomed as they were to rumors of Piero's threatening presence in the outlying towns, on April 25 the Florentines were startled to hear that he had amassed a large body of solders and was marching on the city from the direction of Siena. Three days later his force of two thousand men, moving briskly with a purpose, was sighted as it passed by Castellini in Chianti. That evening Piero called a halt at the monastery of San Gaggio, barely outside the fortified gate Porta Romana. He was convinced that his approach would incite the Florentines to rise up and open the doors for him. Instead he found the gate barred and stoutly defended by the city militia. Four hours later, when the situation did not improve, Piero led his men away. The people felt pity for

the prince's futility. "It was considered a most foolish thing for him to have put himself in such danger, for if we wished, we could have captured him; if the alarm bell had rung outside, he would have been surrounded. As it was, he returned to Siena, not without fear."[46]

Thwarting the hapless Piero gave a boost to the Savonarolians, but not for long. Public protests, at first apparently spontaneous, became frequent enough to acquire significance, such as the malicious dumping of dirt inside the pulpit of Santa Maria del Fiore on Ascension Day, May 4, when the friar was scheduled to preach.[47] The following day the council of *Signori* unexpectedly voted that no order of friars could preach without their permission, underscoring whom they had in mind by abruptly removing from the cathedral the wooden benches erected for Fra Girolamo's boys. A rumor that the pope had secretly summoned him to Rome was in the air but nothing more was heard.[48] On St. Barnabas's day, June 11, the Palio horse race was staged after a lapse of several years. Landucci's diary entry reflects his mixed feelings about this, "This Signoria decided no longer to pay attention to the friar's warnings, saying: Let us cheer up the people: are we all to become monks?"[49] The apothecary recorded a remarkable succession of entries on consecutive days, June 18, 19, and 20.

> 18 June. An ex-communication for Fra Girolamo came from the Pope this morning and was posted in Santo Spirito, Santa Maria Novella, Santa Croce, in the Badia, and at the Servi . . . it declared that the said frate had not obeyed a certain brief which had been sent as far back as November of 1496 summoning him to the Pope; and if he did not obey the ex-communication, no one was to give him aid or support, and no one must go and hear him, nor go to any place where he was, on pain of their own ex-communication.

The next two entries are comparatively laconic.

> 19 June. We heard that a son of the pope had been murdered and was thrown into the Tiber.

This was Juan Borgia, duke of Gandia, by all accounts murdered by his brother, Cardinal Cesare. Pope Alexander was reportedly driven in his grief to the brink of madness.

20 June. Fra Girolamo published an epistle in protest, by which he justified himself in some people's opinion.[50]

"Many refused to go to Savonarola's preaching for fear of the consequences, saying 'just or unjust, it is to be feared.' I myself was one of those who did not go." So said the diarist Landucci, though he had been a sympathizer.[51] The Dominican superiors, hand picked by the pope, moved systematically to purge the friar's followers from the order's convents throughout the region. One of the friars compelled to flee was Fra Lionardo di Lodovico Buonarroti Simoni, who went to ask his brother for help.

Michelangelo wrote their father on the first day of July: "Fra Lionardo returned here—to Rome—and said that he had been obliged to flee from Viterbo and that he had had his habit taken away and wished to go home. So I gave him a gold ducat which he asked of me for the journey, but I expect you know about this, as he must have arrived there by now."[52]

· · ·

JACOPO GALLI WAS IN CONTROL AND AS CONFIDENT AS EVER. If genius comes in different forms, his was for smoothing over difficulties. Twice now he had averted fiascos caused by Michelangelo's imprudence. The *Bacchus* affair was even worse than the *Sleeping Cupid* because it involved Galli personally. "Noble and wise," as Condivi calls him, Galli instinctively understood that the best way to limit damage was to act as if everything had gone according to plan. He hid the *Bacchus* in plain sight, surrounding it with antiquities, and never looked back. Rome was brimming with opportunities for sculptors, whereas Florence currently had none, so Michelangelo gratefully stayed on.

The workshop in Galli's compound was an ideal location to receive prospective clients—and exiles, as it turned out. First his brother Fra Lionardo came to find him, and then, unexpectedly, Piero de' Medici, fresh from the debacle at the portals of Florence. In Rome, Piero could console himself at his brother Giovanni's house, where Florentines met to exchange the latest news from home. Piero dreamed of bringing a new Michelangelo sculpture to Florence just as his father would have done, but Cardinal Giovanni represented the family's future, exactly as their father had foreseen. By August 19, 1497, Piero's plan had already come to naught, leaving Michelangelo with a familiar bitter taste.

I undertook to do a figure for Piero de' Medici and bought the
marble; and then never began it, because he hasn't done as he
promised me. So I'm working on my own and doing a figure for
my own pleasure. I bought a piece of marble for five ducats,
but it wasn't a good piece and the money was thrown away;
then I bought another piece for another five ducats, and this
I'm working for my own pleasure. So you must realize that I,
too, have expenses and troubles.[53]

He was writing his father about finances, so he allowed himself to
dramatize slightly. Telling his impoverished father about losing five ducats on
a faulty block was almost a form of boasting. He stays quiet about the thirty
ducats Piero gave him before going off.[54] Thanks to Riario, Michelangelo had
plenty of money.

He alludes to a new work that is perhaps the adolescent *Cupid* he made
for Jacopo Galli around this time. The work was seen in Galli's house and
praised in 1556 by a famous visitor from Bologna. Ulisse Aldrovandi saw "an
Apollo entirely nude with a bow and quiver at his side and a vase at his feet:
this statue like the *Bacchus* is by Michelangelo."[55] It was cut from finer marble
than the *Bacchus*—glistening white Carrara. A beautiful boy strides forward,
his head thrown back as he reaches with both hands for an arrow. Because the
figure lacks wings, Aldrovandi took it for Apollo, but there is little doubt of its
identity as the life-size *Cupid* that both Condivi and Vasari place in the Galli
house. Long lost from view, the Galli *Cupid* was recognized in 1996 on public
view in the vestibule of the French Embassy's cultural center on Fifth Avenue
in New York. Its previous sighting had been in a Christie's auction in 1902.[56]
It was overlooked for several reasons, but primarily because of its mutilated
condition. Since its depiction in red chalk by the eighteenth-century French
artist named Ango, the *Cupid* had lost its arms, legs, and supportive vase.
It was also difficult to judge because the work it most resembles, the Santo
Spirito *Crucifixion*, is itself specific to a moment. These are early works in
which Michelangelo, under the spell of Neoplatonism, presents the beautiful
adolescent body as a metaphor of divinity.

Like the crucified Christ, the *Cupid*'s age is indeterminate because he
represents a superior state: Love. *Cupid* is a Florentine boy with tapering
thighs and a peculiarly Michelangelesque urgency; the head, arms, legs mov-
ing in different directions all at once; the torso twisted; the instinctive power
of his feral nature heightened by the lion's paw in which he carries his arrows.

Sensual love and wildness were somehow linked in the young man's mind. For Galli, Michelangelo had sculpted not a Sacred Love, but a Profane one to go with the libidinous *Bacchus* in his garden.

• • •

MICHELANGELO HAD TAKEN ON AN ASSISTANT OF ABOUT HIS own age, perhaps initially to help him manage the heavy *Bacchus*, but Piero d'Argenta soon made himself indispensable as a jack-of-all-trades. His name suggests that his family came originally from Argenta, a small town near Ferrara, but his early biography is largely a blank. It was most likely at this point in Michelangelo's first Roman sojourn that he designed a painting, *The Stigmatization of St. Francis*, which was placed in a chapel in San Pietro in Montorio, where it remained on view without attracting much comment until its disappearance in the late seventeenth century. In 1550 Vasari ascribed it to Michelangelo's own brush, in tempera, but in 1568 he changed his mind, crediting it, intriguingly, to a painter employed as a barber by Cardinal Riario. Perhaps this was d'Argenta.[57] Why Michelangelo did not do it himself is not clear, for he had not entirely abandoned painting.

On June 27, 1497, Michelangelo withdrew a trivial sum from his account "to buy a wood panel on which to paint."[58] What became of this panel is not known. Three *carlini* seems insufficient for anything but the smallest board, so it is unlikely that the painting in question was the composition known since the middle of the nineteenth century as the *Manchester Madonna*.[59] Once celebrated, and then almost universally snubbed, the National Gallery's painting is ultimately too remarkable to ignore.[60] If indeed by Michelangelo, it must be a product of this betwixt-and-between moment in his formation. The subject is the Madonna and Child with the young St. John, which the artist has embellished with four attractive youths masquerading as angels. The unfinished panel displays an uneasy détente of three styles: Ghirlandaio's technique, especially vis-ible in the cross-hatchings on the Madonna's mantle, a Botticellian lan-guor, and Michelangelo's sculptural urge to cram the figures into a shallow space, as though sculpted in high relief rather than merely painted. The Madonna and the child Baptist anticipate the Mother and Child of the *Bruges Madonna*, which is a marble. The *Manchester Madonna* was aban-doned after the artist was fairly far into the work. The two angels on the

right side were nearly completed, and he was laying in the first greenish underpaint of two more angels on the left, when suddenly, it seems, he noticed, or perhaps his patron noticed, that their lissome figures were stealing attention from the Madonna.[61]

In August his favorite brother, Buonarroto, came all the way to Rome to appeal for Michelangelo's intervention with a dissatisfied creditor. Michelangelo had imperceptibly and naturally assumed the primogeniture that was his by right since his brother Fra Lionardo had withdrawn from the world when he took orders.[62] Filial responsibility was ingrained in his definition of self. Thus far, his sculptures had not garnered the acclaim he expected, but Rome was full of money. In March he sent nine large gold ducats to his father in Florence. Out of work in a time of rising prices, Lodovico was running up debts, and this is why Buonarroto was sent to see his brother.

> He tells me that the merchant, Consiglio, is giving you a lot of trouble, that he won't come to any agreement and that he wants to have you arrested. I advise you to come to an agreement and pay him a few ducats on account; and whatever you agree to give him, let me know, and I'll send it to you, if you don't have it. Although I have very little money, as I've told you, I'll contrive to borrow it, so that you will not have to take it out of the Monte fund, as Buonarroto said. Don't be surprised if sometimes I have written so irritably. Often I get wrought up by the sort of things that happen to people away from home. Whatever you ask of me I will send you, even if I have to sell myself as a slave. [63]

He was eager to shoulder the mantle of "eldest son." The problem was in controlling his father's expectations. He concludes the letter affectionately.

> Buonarroto arrived safely and put up at the inn, where he has a comfortable room and will not want for anything for as long as he wishes to stay. I don't have the means to keep him with me because I live in the house of other people, but suffice it that I will not allow him to want for anything. I am well, as I hope you are.
>
> Michelagnolo in Roma [64]

In the margin, Lodovico wrote: "He says he will help me to pay Consiglio."[65]

Buonarroto returned to Florence, where he was working for the Strozzi in their textile warehouse in Via Porta Rossa. Michelangelo wrote soon afterward to tell him that the banker Francesco Strozzi was authorized to pay him two ducats, perhaps to pass on to the disgruntled Consiglio. "Try to apply yourself, as I told you to. Explain to Lodovico both what I told you and what I advise. That's all." [66] In the end, Lodovico did not quite follow his advice, but the family pattern of appealing first and always to Michelangelo was established. Lodovico may have incurred some debts in connection with the passing away of his second wife, Lucrezia degli Ubaldini da Gagliano, on July 9. The city was besieged by pestilent fevers that summer. None of Michelangelo's extant letters contains a word of condolence to his father.

Michelangelo did not have long to wait before Galli provided a suitably ambitious task. The banker was a confidant of an elderly cardinal who, feeling his mortality, wanted to make arrangements for his tomb. Jean de Bilhères-Lagraulas, also known as Jean de Villiers de La Groslaye, abbot of Saint-Denis, came to Rome in 1491 as the ambassador of Charles VIII. Bilhères served impressively, and during the interregnum following the death of Pope Innocent he was appointed governor of Rome by Cardinal Riario. Alexander VI named him cardinal of Santa Sabina in September 1493, although Bilhères retained the title of his royal abbey, Saint Denis, and the Italians knew him as the cardinal of San Dionigi. By the summer of 1497 Bilhères had come to realize that Rome would be his final resting place. He chose to be buried in St. Petronilla, an ancient mausoleum adjacent to St. Peter's, later converted into a chapel under the protection of the French crown.

Michelangelo was eager to begin at once, and he was determined to go himself to Carrara and select the stone on the mountain. The marble he had found in Rome had been either mediocre, like the *Bacchus,* which shows noticeable veins, or unusable, like the piece on which he had recently lost five ducats. Evidently, Florentine stonemasons took greater pride in their product, if the high quality of his two early reliefs is any indication. Michelangelo informed Galli that the cardinal would have to advance a large sum of money toward the acquisition of a prime block. The money was in place by November 18, when Michelangelo withdrew twelve ducats to buy a dapple gray horse to carry him north. On the same day Cardinal Bilhères gave him a letter of introduction to the *Anziani* of Lucca (the banking city nearest to the quarries) in which he requests the Elders' assistance for "Michelangelo, son of Lodovico, the Florentine sculptor" in procuring a marble from which he was to carve a "Pietà in marble with the Virgin Mary in clothes and the dead Christ nude

in her arms."[67] Jacopo Galli was personally supervising every detail; this time there would be no ambiguity about the subject.

One assumes that Michelangelo went directly to Carrara from Rome and then returned to Florence for Christmas. Whatever his itinerary, he was in Florence on December 29, 1497, to receive twenty ducats in cash from Francesco Strozzi and confirmation that 130 ducats were deposited for him in the Buonvisi bank in Lucca. This was far more money than the block of marble, no matter how fine, could possibly cost, eight ducats being a more reasonable sum. He must have had it in mind to acquire additional blocks for other works, although it is not clear whether he or the cardinal would be paying for them.[68] His precipitous departure bearing the cardinal's money caused Galli some concern, as Piero d'Argenta communicated to Buonarroto in a letter of January 13, 1498.[69] As the guarantor of this affair, Galli expected to be kept informed.

The new year 1498 dawned unusually cold. "Know that in these days we have had snow up to our arse and we've been drowning in it,"[70] Piero d'Argenta complained from Rome. In Florence the Arno froze.[71] The quarrymen at Carrara worked undeterred by holidays or frigid weather. Fortune—or expert experience—smiled on Michelangelo, for someone led him almost at once to the Polvaccio quarry, where a block was ready for extraction. The *Pietà* would require a monolith of white statuary marble not less than three braccia high, three braccia wide, and two braccia deep (180 x 180 x 120 cm; 6 x 6 x 4 feet). The source of Michelangelo's success was a stonecutter from Settignano who appears in two payments as "maestro Michele scharpellino." This was the beginning of a close working relationship—or is it possible that Michele di Piero Pippo, to give his full name, was one of the Settignano stone carvers who gave Michelangelo a chisel and stones to practice on in the garden of San Marco?[72] By February 9 the block was already rough hewn and ready for transport. Michelangelo withdrew funds to pay for the saddle and harness of the horse that would pull the cart down from the Carrara quarry and to the coast, where the marble would be loaded onto a boat. A month later Michelangelo was back in Rome, where he saw Piero de' Medici on or around March 22 in order to return the down payment for the sculpture he had not begun.[73]

Unfortunately, as soon as Michelangelo left Tuscany, his freight stopped moving. The block had made no visible progress by April. The cardinal's secretary wrote in frustration to the gonfaloniere of Florence seeking his intervention with the marchese of Carrara, Alberico Malaspina. We do not

know if Malaspina was the cause of the delay or the only authority who could expedite the shipment.[74] The marble finally reached the port of Rome in the middle of June 1498. Upon its safe arrival many accounts came due, and Michelangelo kept the Balducci bank busy making at least six withdrawals to cover the final payments to the Carrara laborers, the sea transport by Simone *marinaio,* the Roman porters, and the stones themselves, of which he had brought an entire cargo in addition to that for the *Pietà.*[75] The journey had taken nine months of concentrated effort. As late as August 22, 1498, Michelangelo was instructing his father to pay maestro Michele for his work in Carrara. The previous day he had paid six months' advance rent on a separate space in which to work.[76]

Everything hinged upon the marble; otherwise it would not have been necessary for Jacopo Galli to prepare a new accord with Cardinal Bilhères on August 27, 1498. As drafted by Galli, the contract for the *Pietà* is a legal document that makes a cultural statement. From Michelangelo, he sensed the importance of the moment. Michelangelo's own copy is intact and merits reproducing in its entirety.

> August 27
>
> Be it known and manifest to all who shall read this present writing that the Most Reverend Cardinal di San Dionisio has agreed that Maestro Michelangelo, statuary of Florence, that the said Maestro shall at his own proper costs make a Pietà of marble, that is to say a draped figure of the Virgin Mary with the dead Christ in her arms, the figures being life-size, for the sum of four hundred and fifty gold ducats in papal gold, to be finished within the term of one year from the beginning of the work. And the Most Reverend Cardinal promises to pay the money in the manner following: that is to say, in primis, he promises to pay the sum of one hundred and fifty gold ducats in papal gold before ever the work shall be begun and thereafter while the work is in progress he promises to pay to the aforesaid Michelangelo one hundred ducats of the same value every four months in such wise that the whole of said sum of four hundred and fifty gold ducats in papal gold shall be paid within a 12 month period, provided that the work shall be finished within that period. If it shall be finished before the stipulated term his Most Reverend Lordship shall be called upon to pay the whole sum outstanding.

And I, Iacopo Gallo, do promise the Most Reverend Monsignore, that the said Michelangelo shall complete said work within one year and that it shall be more beautiful than any work in marble to be seen in Rome today, and such that no master of our own time shall be able to produce a better. And I do promise the aforesaid Michelangelo, on the other hand, that the Most Reverend Cardinal will observe the conditions of payment as herein set forth in writing. And in token of good faith, I Iacopo Gallo have drawn up the present agreement with my own hand the year month and day aforesaid. Furthermore be it understood that all previous agreements between the parties drawn up by my hand or rather by the hand of the aforesaid Michelangelo are by the present declared null and void and only this present agreement shall have effect.

The Most Reverend Cardinal gave to me Iacopo Gallo one hundred gold ducats of the chamber some time ago, and on the aforesaid day as above set forth I received from him a further sum of fifty gold ducats in papal gold.[77]

. . .

THE AFTERMATH OF PIERO'S ATTEMPT ON FLORENCE WAS THE beginning of the end for Savonarola. The government launched a manhunt to root out Piero's co-conspirators. In August 1497 Lamberto dell'Antelli, a disappointed Medicean, was arrested and flogged. Under duress Lamberto implicated others, including Bernardo del Nero, Lorenzo Tornabuoni, and Niccolò Ridolfi. These noblemen were imprisoned in the Bargello and put to torture until they confessed. There was a heated debate in the city over the harshness of sentencing these scions of leading families to death instead of exile. But the fatal error was the Signoria's insistence on immediate executions without allowing a final appeal, as provided by the new constitution. Landucci wrote in his diary on August 17:

> . . . all Florence was sorry. Everyone marveled that such a thing could be done; it was difficult to comprehend it I could not refrain from weeping when I saw that young Lorenzo Tornabuoni carried past the Canto d' Tornaquinci on a bier, shortly before dawn.[78]

Savonarola was under excommunication and not preaching at this time, but he erred in thinking that he could distance himself from a government formed of his staunch supporters. Inevitably, he bore the brunt of the public's revulsion.

On Christmas day 1497, Savonarola celebrated mass at San Marco and led a solemn procession around the piazza: it was an act of open disobedience against the papal interdict and scandalized many, though no response was heard from Rome. Pope Alexander was locked in conference with his closest confidant, Ascanio Sforza, over the problems arising from his son Cesare's desire to leave the cardinalate and assume a secular crown. A suitable arrangement would have to be found to reduce the affront to the Curia and recoup the loss of 35,000 ducats of yearly revenue.[79] Lucrezia Borgia, pretty, blonde, and pliable, would be a valuable pawn in Alexander's politics as soon as her marriage to Giovanni Sforza could be annulled on the improbable grounds of nonconsummation. Over her husband's protests, Lucrezia was declared to be in a state of virginity, "a conclusion," it was chronicled, "that set all Italy laughing it was common knowledge that she had been and was the greatest whore there ever was in Rome."[80] Or so it was said.

Lucrezia's good name was officially upheld on December 20 by the annulment of her marriage. By then, however, she was implicated in an affair with her father's Spanish chamberlain, Pedro Calderon, known as Perotto. Indeed, by many accounts she had recently given birth to his bastard. With so much at stake for Borgia aspirations, the outcome of this liaison was foreseeable. To make a long story short, on February 14, 1498, the papal master of ceremonies noted dryly in his diary, "Perotto, who last Thursday, the 8th of this month, fell not of his own will into the Tiber, was fished up today in that river, concerning which there are many rumors running through Rome."[81]

Early in the new year, while Michelangelo was in Florence, Savonarola was gripped by his dilemma. On the one hand, if the friar refrained from preaching, he would probably be pardoned, for Alexander VI had acted mainly in response to the suggestions of the monk's enemies and had many greater concerns on his mind.[82] On the other hand, it already seemed to Fra Girolamo that his influence was declining as a result of his silence. Amid vociferous dissension, he broke his silence on February 11, 1498, preaching in San Marco of the Borgia pope's unworthiness for his office. Many Florentines stayed away out of fear of their own excommunication. The bonfire of the vanities organized on the last day of Carnival, February 27, did not pass without incident. As before, the friar's boys enthusiastically piled up every sort of

vanity, including, Landucci says, "nude statues and playing-boards, heretical books, *Morganti* [a satirical poem by Luigi Pulci], mirrors and many other vain things of great value, estimated at thousands of florins."[83] But the thrill was spoiled by the impious protesters, who threw quantities of dead cats and other rubbish on the fire.

The political fortunes of brothers Lorenzo and Giovanni di Pierfrancesco de' Medici were notably in ascendance. Giovanni had secretly married Caterina Sforza, Lady of Forlì and Imola, and had been living in Forlì for more than a year. Thirty-six years old and still beautiful, Caterina bore his son, Lodovico de' Medici, in April 1498. The boy was named in honor of his mother's uncle and best ally, Ludovico Sforza, the duke of Milan. The marriage between Giovanni de' Medici, il Popolano, and Caterina Sforza was strategic from many points of view, including the importance of the fertile Romagna as a breadbasket for starving Florence. More and more it appeared that Lorenzo and Giovanni would emerge as the heads of an aristocratic oligarchy that would resume control of the city without their Medici cousins.

The council elections on February 18 were bitterly contested. One of the several candidates for the post of deputy chancellor was a previously untried twenty-eight-year-old, Niccolò Machiavelli, who was ultimately excluded because of his anti-Savonarola sympathies.[84] Machiavelli sent secret reports on the political situation to a Florentine secretary at the Vatican. On March 9, 1498, he passed along the cynical opinion that Savonarola "acts in accordance with the times and colors his lies accordingly."[85]

On March 17 the Signoria acceded to the pope's wishes and decreed that Savonarola must henceforth refrain from preaching. The next day he gave his last sermon. He quoted Scripture to defend himself against those who had ruined the Church, "I say to you that those who persecute me will fall, some by the sword, some by pestilence; they will all be thrown down, and their forces will be weak and invalid, like ants, and they will be vehemently confused and their confusion will be great."[86]

His place in the pulpit at San Marco was filled by his closest companion, Fra Domenico da Pescia. Emboldened by Savonarola's proscription from preaching, his Franciscan enemies chose this moment to strike. On Sunday, March 25, Francesco da Puglia, preaching in Santa Croce, challenged Savonarola to prove by a miracle the veracity of his declarations. Fra Domenico at once replied that he was willing to pass through fire for Savonarola. Thus the trap was set and sprung. That same day the Franciscan accepted the invitation to the deadly trial by fire, saying, "I believe that I shall burn, but I am

content to do so for the sake of liberating this people; if *he* does not burn, then you may believe that he is a true prophet."[87] The Signoria was obliged to organize the event, constructing in the central piazza a great long corridor of wooden beams soaked with oil and enclosed by a wall of bricks. The date was fixed for April 7; it was settled that at the first hour of the afternoon Fra Domenico of Pescia should enter the fire for those of San Marco and Fra Giuliano of the Osservanza for the Franciscans. As Fra Girolamo entered the piazza that day following two hundred fifty friars, walking two by two, he did not know that his sole political ally, Charles, was dying in France, felled by a sudden stroke.

The trial by fire did not take place. Landucci was there: "The people awaited the great spectacle. After a wait of several hours, everybody began to wonder. The reason for the delay was an argument between the friars. The Franciscans would not allow Fra Domenico to carry the host through the fire with him. . . . The dispute ended in all the Franciscans leaving, the Dominicans soon followed them, causing great perturbance amongst the people, who almost lost faith in the prophet."[88]

The next day, April 8, was Palm Sunday. The mood in the city was despondent. The Signoria was determined now to banish Fra Girolamo, but his enemies would not wait. In the evening all hell broke loose. The church and convent of San Marco were assaulted by an infuriated mob. Francesco Valori, head of the Piagnoni party, sought reinforcements but was murdered before his own door. Finally, the Signoria intervened and brought Savonarola and Fra Domenico—under arrest and amid the terrifying uproar—to the Palazzo Vecchio. On April 19 the confession given by Fra Girolamo from the torture rack was read in the great hall. The faithful Landucci wrote:

> We had all believed him to be a prophet, and he confessed that he
> was not a prophet and that he had not received from God the things
> that he preached; and he confessed that many things in his sermons
> were the contrary to what he had given us to understand. I was
> present when this protocol was read, and I marvelled, feeling utterly
> dumbfounded with surprise. My heart was grieved to see so great
> an edifice fall to the ground on account of having been founded on
> a lie. Florence had been expecting a New Jerusalem, from which
> would issue just laws and splendour and righteous living, and to see
> the renovation of the Church, the conversion of unbelievers, and
> the consolation of the righteous. And I heard the very contrary and

I had to resign myself with the thought: *In voluntate tua, Domine, omnia sunt posita.*[89]

The pope's commissioners arrived in Florence on May 19. "It was said that they meant to put Savonarola to death, even if he were a second Saint John the Baptist."[90] Once again a scaffold was constructed before the palace of the Signoria. The people seeing this said among themselves, "They are going to crucify him."[91] Fra Girolamo and two brother friars, Silvestro and Domenico, were hanged on May 23, Ascension Day. The scaffold was set afire and kept burning with brushwood for several hours until every last piece of their bodies was consumed. The executioners carried the last bit of dust to the Ponte Vecchio and threw the ashes into the Arno so that no remains should be found. A few faithful people gathered some of the floating ashes at their own peril, for the authorities were anxious to destroy every relic.

. . .

ON THE MORNING OF MAY 21, 1972, A THIRTY-THREE-YEAR-OLD geologist named Lazlo Toth quietly slipped into the crowd entering St. Peter's Basilica. A Hungarian-born émigré to Australia, Toth had spent a long time studying the rock formations of the Outback. Since coming to Rome in the fall of 1971, he had spent his time relaxing in a youth hostel and sitting in cafés. On this Pentecost Sunday, however, Toth sheared off from the people arriving for mass and went directly to the first chapel on the right-hand side of the nave, where Michelangelo's *Pietà* was spotlighted. Vaulting the marble balustrade, Toth assaulted the statue, shouting over and over, "I am Jesus Christ, risen from the dead!" The crazed geologist was apprehended but not before he had severely damaged the figure of Mary. Fifteen blows with a nine-pound iron hammer broke off the nose and left arm, and shattered one of the eyelids.

The criminal charges against Lazlo Toth carried penalties of up to nine years in prison, but he never stood trial. Examined and found insane, he was committed to confinement in an Italian psychiatric hospital. He was released on February 9, 1975, and immediately deported to Australia as an undesirable alien. He has not been heard from since. According to an American who had befriended him a few months before the attack, Toth had appeared intelligent

and articulate, never hinting in any way that he might do such a thing. The one peculiarity was that he always carried a Bible.[92]

The director of the Vatican Museum, Professor Redig de Campos, at once announced that he would personally oversee the restoration of the *Pietà*. On the very day of the attack, Vatican conservators were on the scene, recovering every glistening splinter of the Carrara marble. The arduous task of identifying the fragments was facilitated by comparison with a life-size plaster cast that had been made in the 1940s. Within a few months the cataloguing was concluded, and the restorers had begun to reattach the broken pieces and, as Redig de Campos told a reporter, "substitute the missing parts with a prosthesis, just as dentists do."[93] The marble bits were put in place with a putty of marble dust and resin. During their intense engagement with the *Pietà*, the Vatican team discovered the traces of an "M"—perhaps a secret signature— in the junction of the lines on the palm of the Madonna's left hand. This hand attracted particular attention because its fingers had been restored in 1736 by sculptor Giuseppe Lirioni, how accurately is still in dispute today.[94] On October 25 Walter Cronkite announced on the *CBS Evening News* that the restoration would be completed before the end of the year, "as a Christmas present to the world." And so it was. The official unveiling took place after New Year's. Behind a wall of bulletproof glass, the *Pietà* appears as beautiful as ever, showing absolutely no signs of its injuries.

The vandalism suffered by the world's most beloved work of art inspired countless commentaries on the ramifications of this deplorable event. Philosopher Mark Sagoff wrote that the *Pietà* had lost its integrity as a creation by Michelangelo, but its Idea was intact. What we love in persons or things, he argued, following Plato, is the "image of the Idea in them," observing that people will cross continents to stand in the presence of the original even if they cannot see the difference between Carrara and Union Carbide.[95] Plato was the first Westerner to realize "how intense and passionate may be our attachments to objects as abstract as social reform, poetry, art—an attachment that has more in common with erotic fixation than one would have expected."[96]

Art historian David Freedberg arrived at an analogous reading while attempting to make sense of Toth's delusions: "The Virgin of Michelangelo's *Pietà* looks too beautiful, so the man, for all his messianic impulses, breaks those parts which make her beautiful and therefore make her seem desirable. . . . Not only does she threaten the senses, she is also the Mother of God. She should not rouse carnality in the ways ordinary women do, the women of this earth."[97]

Mary's surprising youthfulness and beauty, which is the pivotal Idea of Michelangelo's sculpture, was always controversial. In March 1549 a full-size copy of the *Pietà*, sculpted by Nanni di Bigio, was installed in a chapel in Santo Spirito, Florence, where it immediately attracted attention.

> In this month a Pietà was unveiled in Santo Spirito, sent to this church by a Florentine, and they said that the original came from Michelangelo Buonarroti, that inventor of filth who puts his faith in art rather than devotion. All the modern painters and sculptors imitate similar Lutheran caprices so that now throughout the holy churches are painted and carved nothing but figures to put faith and devotion in the grave. But one day God I hope will send his saints to throw idolatries like these to the ground. The patron of the chapel was [blank], who anxiously waited from day to day to send this figure, but he had considerable difficulties with Pope Paul III, who was quite indignant that a statue of this kind should come from Rome, so that for the moment it stands deprived of adornment; if it comes I shall note it.[98]

Evidently the *Pietà* was infuriating to zealots like the author of this diatribe. By 1549 even the pope was said to be opposed: no lover of art, Paul III Farnese presided over the definitive break with the Protestants and launched the Holy Office of the Inquisition to underscore his intentions. The diarist's slur against "Lutheran caprices" was both inflammatory and a direct attack on the fathers of Santo Spirito, who, like Luther, were Augustinians. That modern artists felt free to read the Scriptures in personal and untraditional ways was the controversial legacy of St. Augustine's Platonic viewpoint that every visible thing contains a transcendent meaning.

By the time the copy of the *Pietà* was installed in Santo Spirito, Michelangelo was in his seventy-fifth year and an institution in his own right. Nevertheless, he hastened to defend himself from criticisms against the Virgin's youthful form. The danger of the moment induced the old man into one of his most revealing statements about his art and himself, which his obliging scribe Condivi, then in his twenties, records as a dialogue with the great master.

> The Madonna seated on the rock in which the cross was fixed,
> with her dead son across her lap, is of such great and rare beauty

that no one sees it who is not moved to pity. It is an image truly worthy of that humanity with which the Son of God and so great a mother were endowed, even though there are some who object to the mother as being too young in relation to the son. When I was discussing this one day with Michelangelo, he answered: "Don't you know that women who are chaste remain much fresher than those who are not? How much more so a virgin who was never touched by even the slightest lascivious desire which might alter her body? Indeed I will go further to say that this freshness and flowering of youth, apart from being preserved in her in this natural way, may also conceivably have been given divine assistance in order to prove to the world the virginity and perpetual purity of the mother. This was not necessary with the Son, in fact rather the contrary, because in order to show that the Son of God truly assumed human form, as He did, and submitted to all that an ordinary man undergoes, except sin, there was no need for the divine to hold back the human but it was necessary to let it follow its own course and order so that He would show exactly the age He was. Therefore you should not be surprised if, with this in mind, I made the Holy Virgin, mother of God, considerably younger in comparison with her Son than her age would ordinarily require, though I left the Son at His own age." This consideration would be most worthy of any theologian and perhaps extraordinary coming from others, but not from him whom God and nature formed not only to do unique work with his hands but also to be a worthy recipient of the most sublime concepts, as can be recognized not only from this, but from very many of his thoughts and writings. Michelangelo could have been twenty-four or twenty-five years old when he did this work. Through it he acquired great fame and reputation, so much that, already in the opinion of the world, he not only far surpassed any other man of his time, and of the time before him, but he even rivaled the ancients.[99]

The thoughts are worthy of any theologian, as Condivi says, and the portrayal of the Son as older in years than His Mother is more powerful still. Michelangelo offers Mary's freshness and Christ's serenity even in death as the proof of their spiritual perfection.[100] The Idea descends by inheritance from Plato's *Symposium* to Augustine's *City of God* and Ficino's *De Amore*. "His

Pietà is one of those sublime conjunctions of classic and Christian philosophy to which, for a few years either side of 1500, Italian art could give visible expression."[101]How much of these greats Michelangelo knew in the originals is anybody's guess. Galli and Riario owned the texts as well as the copious commentaries and glosses. We know from later evidence that Michelangelo used this time to take himself to school with his private reading. Caring to convey his thoughts in poetry was still several years away. Meanwhile, the *Pietà* was Michelangelo's contribution to mystical Christianity.

The Italian word *pietà* means "pity." Its use in art derives from the Latin *imago pietatis*, an image made to provoke an emotional response.[102] The scene of the Pietà, in which Christ's body is placed across his mourning mother's knees, is not mentioned in the Bible, but first appears during the Middle Ages as one of the Seven Sorrows of the Virgin. The subject became widely known in northern European wooden sculpture, which explored its depths of pain and sorrow. In fifteenth-century Florence, Botticelli and others had painted it, and Bertoldo had cast a small bronze relief, but Michelangelo was the first to attempt to resolve in life-size marble statuary the "exceedingly difficult task," as Heinrich Wölfflin puts it, of placing "the body of a full grown man on the lap of seated woman."[103]

Jacopo Galli promised the cardinal that Michelangelo would complete the work within one year and that it would be the most beautiful sculpture in Rome that any living master could possibly make. These remarkable conditions were fulfilled in all respects except one: the remarkable young man under Galli's protection took two years, not one. The delay was not the result of any uncertainty in shaping the marble, but rather in the extraordinary care he devoted to polishing it. The qualities of this Polvaccio marble are its "tight, closed grain, *finissima* crystallization, lively brightness, airy semi-transparency, marvelous pliability in every sense under the chisel, and yet a hardness and specific gravity that surpasses every other marble save one, the *bardiglio*."[104] He devoted months, if not a year, to polishing the surface with any number of materials, including pumice, Tripoli chalk, leather, and straw, in order to coax the stone to its maximal liquid splendor.[105]

All observers agree on the harmony of Michelangelo's group, which combines the two figures within the outline of a pyramid. "Christ's head is turned back in such a way as not to break the bounding line, and beneath his body the folds of the Virgin's cloak flood down like a waterfall"—Pope-Hennessy.[106] "Instead of rising in a series of angular gables, it sags like a garland; and, in fact, it is inspired by an antique relief, the death of a hero or *pietà militare*, in

which the figure is being carried"—Clark.[107] The Savior's torso and limbs are smooth and hardly show the marks of his sufferings. His figure touches our deepest feelings, as if in death he has again become a child gathered up in his mother's arms. Her expression is mild and contemplative. "Just how the *Pietà*, Michelangelo's most sacred work, arose out of *Bacchus*, his most profane, is a mystery"—Irving Stone.[108] But there is an answer: Michelangelo had abandoned the idea of making his work interchangeable with the antique. The *Bacchus* had required a total immersion in the classical resources of Rome; afterward he no longer harbored any doubts of his superiority. Compared to the fire that burned inside him, the pagan stones were cold and dead.

Cardinal Bilhères never saw the completed sculpture installed over his tomb in a chapel inside St. Petronilla, a circular Roman mausoleum adjacent to the south transept of St. Peter's. According to the research of Redig de Campos, the *Pietà* was intended for installation at a height of 120 centimeters (4 feet) above the ground. By 1517 the reconstruction of St. Peter's had engulfed the ancient church and the cardinal's *Pietà* was brought into the interior of the new basilica. It was first placed in the chapel of Santa Maria della Febbre, where it was seen by Vasari and Condivi. After a series of moves, in 1749 the *Pietà* finally found its permanent home in the first chapel to the right of the entrance.

· · ·

IN AUGUST 1498, BEFORE A SECRET CONSISTORY OF HIS FELLOW cardinals, twenty-three-year-old Cesare Borgia solemnly swore that he had always been averse to the priestly calling and had only taken orders in obedience to his father's wishes. Gregorovius said that these were the only true words the prince ever spoke.[109] Something large was afoot, for no one lightly renounces revenues of 35,000 ducats. The end result of extremely intricate dealings, which involved granting permission to Louis XII, the new French king, to divorce his wife and marry Charles VIII's widow (for her hereditary claims on the thrones of Milan and Naples), and a host of secret negotiations soon to be revealed, was the arrival on August 17 of a royal envoy carrying the letters patent granting Cesare Borgia a duchy in France. Thus the former cardinal of Valencia overnight became the duke of Valentinois. In Italy he was known as the duke of Valentino or, for brevity, Il Valentino.[110]

In October Cesare departed for Paris and the court of Louis XII. The king would assist him in finding a bride among his nobility. To provide for

his son, Pope Alexander had engineered a massive shift in foreign policy that left even his closest advisors gasping. The Holy See now favored France at the expense of its former allies—Milan, Naples, and Spain. Cardinal Vice-Chancellor Ascanio Sforza spoke out sharply in consistory, declaring that sending Cesare to France would bring only ruin. "Are you aware," the Pope replied, "that it was your brother who invited the French into Italy?"[111] The price of Cesare's duchy, everyone knew, would be papal complicity in the annexation of Naples and Milan to the crown of France. A clause to this effect was inserted in Il Valentino's remarkable marriage contract, signed in Paris on May 10, 1499.

Louis XII intended to cross the Alps in early summer to press the same hereditary claims as Charles VIII, but this time seeking a lasting result. By the middle of August his army was marching toward Milan across the Lombard plain, capturing the outlying towns one by one with little or no resistance. All those who could, fled, including Duke Ludovico Sforza, who went north to Innsbruck. His brother Cardinal Ascanio had slipped out of Rome and raced to Milan in July, passing incognito through Florence on July 13.[112] Milan fell to the French without the firing of a single cannon on September 6. A month later Louis XII made a triumphant entrance into the city. At the king's side rode three unlikely comrades in arms, Cardinal Giuliano della Rovere and the pope's sons Cesare Borgia and Cardinal Giovanni Borgia.[113]

The most notable member of the Sforza court to remain in Milan was the duke's artist, Leonardo da Vinci. Some manuscript notes in his hand—written in reverse with the names scrambled—reveal that Leonardo was in contact with the comte de Ligny, the French army commander, about employment of some kind (perhaps on fortifications, or as a spy?).[114] The deal came to naught, even though Louis XII was entranced by the *Last Supper*, wondering out loud if it could be detached from the refectory of Santa Maria della Grazie and transported to France.[115] After only six weeks' occupation, the French unceremoniously decamped and hastened home before the snows blocked the mountain passes.[116] December came, bringing rumors that the irrepressible Moro might return. Perhaps suspecting that by overstaying he would no longer be welcome, Leonardo also chose this time to say farewell.[117] On December 14 he transferred six hundred florins—all he had—to his account in Florence. Departing Milan after seventeen years' service, his first destination was Mantua, where the young marchesa Isabella d'Este was a possible patron.

Cesare Borgia thus returned to Italy as a captain of invading troops. In October 1499 the time had come, his father knew, to realize his most cherished

ambition: the creation of a state for his son. The papal domains of Imola and Forlì, which the Riarios governed as apostolic vicariates, were two plums ripe for picking.[118] Herein lay another motive for the pontiff's betrayal of Cardinal Ascanio: it would be necessary to depose his niece Caterina Sforza Riario. Indeed, the timing was extraordinarily favorable, for Caterina's third husband, Giovanni di Pierfrancesco il Popolano, had suddenly taken ill and died the preceding year. If Alexander could drive out all the lords of the Papal States in the Romagna and the Marches, he would assert the power of the Church and gain a rich domain for his son. He took the first step by revoking the vicariates of Imola, Forlì, Rimini, Pesaro, and Faenza on the grounds of unpaid taxes.[119]

Caterina Sforza, although besieged and urged on all sides to yield, had no intention of capitulating. In July she had discussed matters of mutual concern with a young man sent by the young post-Savonarola government of Florence. The emissary was Niccolò Machiavelli, whose report of their meeting is preserved. The conference ended badly. At first the marchesa appeared agreeable to the Florentine terms regarding a renewal of her son Ottaviano Riario's contract to fight against Pisa. And the young emissary wrote as much in a letter to the Signoria, adding complimentary words about her beauty and intelligence. A few days later she summoned him again, having changed her mind. Nothing less would do than a written commitment from Florence to defend her state. Machiavelli, embarrassed, could not respond.

The Borgia papacy never discovered Michelangelo. The last year of the century wound down as he continued to polish the Pietà. The sculpture should have astonished the clients and patrons brought by Galli to admire it, yet, incredibly, no one was inspired to tender another commission. Bent on war, and carving out a Borgia duchy in central Italy, Alexander VI paid scant attention to the approaching Jubilee of 1500. Despite the importance of the anniversary, marking a half-millennium, no chapels or statuary were under way in which a sculptor could showcase his genius. Michelangelo profited from his unemployment by deepening his reading in Galli's library, concentrating, it appears, on the collected works of Petrarch. He began to write his own poetry in emulation of that master. One of his earliest surviving poems is an explicit attack on the Borgias' Rome.

> Here they make helms and swords from chalices
> And sell the blood of Christ in cupped hands;
> his cross and thorns are made into lances and shields;
> yet Christ's patience still rains down.

But let him come no more into these streets:
his blood would rise as far as the stars,
since now in Rome they are selling his skin,
and here the roads are closed to every virtue.

If ever I wished to lose my worldly treasures,
since no work is left me here,
the man in the cope can do as Medusa did in Mauretania.
But if to heaven above poverty is welcome,
what will be the great refreshment of our state
if another purpose diminishes the other life?

Finis

Your Michelangelo in Turkey [120]

The poem is signed as if it were a letter, which suggests that it was sent as such to his family in Florence. Replacing Rome with "Turkey" *(Turchia),* which was synonymous with a place inimical to Christians, underscored his disgust with Rome. The "man in the cope" was the pope himself, here compared to Medusa, who transformed mighty Atlas, resident in Mauretania, into immobile stone. Rather like Michelangelo's situation, he thought.

On August 6, 1499, Cardinal Bilhères died. In the year since the signing of the contract for the *Pietà,* Michelangelo had received interim payments, which now ceased. It is not precisely clear when the work was finished. Reading the deposits and withdrawals like tea leaves, with approximately the same certainty of results, two possibilities arise. One theory is that three ducats and change paid to a mason on the very day of the cardinal's death may relate to its installation in his chapel. Another possibility is that a substantial cash deposit of 232 florins on July 3, 1500, represents the final payment for the finished statue.[121] Though unspecified, the money came from the same Sienese bankers who were used by Cardinal Bilhère's estate. The later date and longer duration—almost two years instead of one— are supported by a significant gap in the evidence. From summer 1498 to summer 1499, Michelangelo's accounts fairly hum with small transactions, sometimes done in person, but increasingly effectuated by his assistant, Piero d'Argenta. Rent is paid, wine purchased, cloth purchased, trivial debts paid off, and so on.[122] These glimpses into daily life effectively cease in the

second year of the contract, as if Michelangelo had closed himself in his studio and locked the door.

He shut out the real world, in which the Borgia war against Romagna was coming to a head and would penalize Michelangelo's closest friends and protectors. As a parting gift to his newest duke, Louis had placed three hundred French lancers and four thousand Swiss and Gascon infantry at the disposal of Cesare Borgia, who immediately marched toward Imola. Abandoned by the Florentines, who had declared themselves neutral, and not beloved of her subjects, Caterina Sforza resorted to her own devices. Two Forlivese citizens were dispatched to Rome in early November with the aim of infecting the pope with a cloth removed from a pestilent corpse. This ingenious attempt was thwarted by the assassins' capture and full confession. Now Caterina could not expect mercy. Nor could her brother-in-law. On November 21 Cardinal Raffaele Riario slipped out of Rome dressed in plain clothes and did not pause until he had reached the safety of his family estates in Savona, where his cousin Cardinal Giuliano della Rovere was constructing a magnificent palace. They would stay away from Rome as long as Borgia lived. Il Valentino laid siege first to Imola, taking it after a cruel bombardment, and then Forlì, in whose fortress of Ravaldino the marchesa would make her last stand. Cesare entered the city center on December 17 under torrential rain and after a continuous bombardment described by Bernardi, the contemporary chronicler of Forlì, as "similar to the pains of hell."[123] There remained the problem of the defiant "Madonna Caterina" inside the citadel. The young duke, who was classically handsome—taller by a head than most men, athletic, and agile—promised the beleaguered citizens that "if he lived to be their lord, he would make it up to them." The ability to command loyalty from the towns he suppressed was but one of the qualities that inspired Machiavelli to make him the paragon and protagonist of *The Prince.*

CHAPTER FIVE
DAVID
FLORENCE
JULY 1500–JUNE 1504

"YOUR MICHELANGELO IN TURCHIA," HE SIGNED HIS POEM, AS IF
writing from some foreign prison instead of Rome.[1] His misery was noth-
ing compared to his family's—in their opinion. His father and his brothers
had watched helplessly as the family's most gifted son left home in search of
fortune. Without Michelangelo, the Buonarroti household was as bereft as
Jacob's after Joseph went down to Egypt.

The Holy Year 1500 dawned. Holding open the remote possibility of
coming to Rome for the Jubilee was Lodovico Buonarroti's excuse for keep-
ing close watch over Michelangelo. "I hope, if I have the money, to come to
Rome for the Jubilee. . . . And don't think that I would come in order to annoy
you, or to come to your house."[2] Alternating between laments and rebukes,
Lodovico's letter of February 14 makes it plain that Michelangelo's return was
of far greater concern than a pilgrimage that would not take place. "I heard that
you are thinking of returning here after Easter. I think it would be for good for
you if you did, but I don't think you will. Anyway, do as you think is best. I take
great pleasure that you have honors, but also, to me, it would be better if you
had money, even if I hold honor in higher esteem. But when one and the other
are together, as by rights they should be, there is even greater happiness."[3]

The letter is a vivid portrait of a relationship based on interwoven obliga-
tions rather than trust. Lodovico pleads with Michelangelo to come home
without directly saying so, as he tries to find out how much money his son
has without daring to ask the question. "I don't want anything from you but

I feel passion because you have been there so long and, according to what you write me, you don't have bread for your table. If you were home, perhaps you'd have something and you wouldn't have had so many difficulties nor been exposed to so many risks. . . . Do as you think best in your affairs which you know more than me."[4]

It is hard to decide who was being more manipulative: Michelangelo, who was pleading poverty, although his accounts at the Balducci bank already contained more money than his father earned in ten years, or Lodovico, who pretended to believe him. Evidently the discussion went on uninterruptedly over the next eleven months, for Lodovico's next extant letter (Michelangelo's letters from 1497 to 1506 are lost) resumes where this one leaves off. In the interim, Michelangelo had briefly visited home in late September to look after some banking,[5] and Buonarroto had been to see him in Rome. To his horror, Buonarroto had found his brother lodged in a miserable house for which he paid a rent of a ducat and a half a month. The money that had begun to stream into his hands had not improved his standard of living in the slightest. On the contrary, he lived like a pauper with just a blanket to cover himself, rarely sleeping and barely eating. Buonarroto brought this news to their father in Florence on December 14. Lodovico knew his son too well not to understand that Michelangelo, alone, away from home, had succumbed to a morbid obsession with money. He approached the matter delicately in a letter sent on December 19.

> Dearest son, etc.
> Buonarroto tells me that you live in Rome with great frugality, or
> rather penury. Now frugality is good, but penury is evil, for it is
> a vice displeasing to God and men, and, moreover, harmful both
> to soul and body. So long as you are young, you will be able for a
> time to endure these hardships; but when the vigour of youth fails,
> then disease and infirmities make their appearance, for these are
> caused by such discomforts, poor living and penurious habits. As I
> said, economy is good, but above all things, do not deprive yourself
> of basic necessities. Live reasonably well and take care to avoid
> hardships, since in your kind of work if you became infirm—God
> forbid—you would be lost. And above all take care of your head:
> keep it moderately warm and never bathe yourself. Keep yourself
> clean but don't wash yourself.

Furthermore Buonarroto tells me that you have one side that is swollen, which comes through hardship or fatigue or for having eaten bad, windy food or to have taken a chill on your feet or from the damp. I have had the same thing and it still often troubles me when I eat windy food or when I take a chill. Our Francesco had it and so did Gismondo. You must guard against such things because they are dangerous for the eardrum which might burst. Take care of yourself. I will tell you the medicine that I made [describes various herbal remedies . . .]

Lodovicho Bonarroti in Firenze[6]

He adds a postscript:

Once again I remind you to devise a way to return as soon as you can: and believe me that when you are here you will have much to do. Figure out a good way to get away from there. If you cannot finish those marbles arrange to take them to one of your friends. And when the time comes it would not take much for you to return there one day.[7]

Lodovico never organized himself in time to go to the Jubilee now ending. Buonarroto, the only one in the family whose company Michelangelo enjoyed, was sent instead. He came home with Michelangelo's promise to underwrite him and their brother Giansimone in the wool business. Their choice was analogous to their father's government service: an honorable, old-fashioned career in irreversible decline. Lodovico wrote, "You have also advanced some things," referring, no doubt, to income.[8] If Buonarroto's comments on the *Pietà*, which he would have seen in the French Royal Chapel attached to St. Peter's, impressed him, Lodovico did not show it. The truth is, neither his father and nor any of his brothers is ever recorded as taking an interest in his art. By 1500, his twenty-fifth year, and for the rest of his life, Michelangelo would be viewed exclusively as the family's sole provider. Keeping his cards close to his chest was only prudent. Lodovico, meanwhile, shows no inkling of the kind of money at his son's disposal.

• • •

THE PREPARATIONS FOR THE HOLY YEAR 1500 WERE ASTONISHINGLY modest. Neither the Loggia of Benediction nor the Via Alessandrina, one of two new straight streets, was completed. The ceiling of Santa Maria Maggiore, where Rodrigo Borgia had served as archpriest, was restored to its ancient glory, but that was the extent of the papal largesse. As an unpopular pope, Alexander VI put security first—his own and his family's. The Via Alessandrina, appropriately named in his own honor, would connect St. Peter's Square with the papal stronghold of Castel Sant'Angelo, whose defenses were strengthened. Instead of building accessible palaces or villas, he added a fortified tower, the Torre Borgia, to the Vatican apartments. The forbidding exteriors of these buildings concealed gilt interiors of almost oriental splendor.[9]

The celebrations in the opening year of the new century brought hundreds of thousands of pilgrims to the holy city. The papal bull announcing the Jubilee offered pilgrims free indulgences for the most grievous sins.[10] The great sums they would bring to Rome were to be set aside for a crusade against the Ottoman Turks (now advanced past Athens) or otherwise spent to advance the Borgia family. In glaring contrast to these pious undertakings was the forced exile, or worse, meted out to those who might impede the pope's consolidation of power. The Venetian ambassador wrote in his dispatch, "Every night four or five murdered men are discovered—Bishops, prelates, and others so that all of Rome is trembling with fear of being destroyed by the Duke Cesare."[11]

One by one the wealthiest and most powerful cardinals fled the city to remove themselves from the pontiff's avaricious gaze. There would be no further statues, antique or modern, for the cardinal of San Giorgio, now a fugitive for his life. Cardinal Ascanio Sforza, the ally who had secured the pope's election, had hastened to Milan in a vain attempt to assist his brother Ludovico il Moro against the French invaders. He was taken prisoner in April 1500, and languished in a prison in Bourges until Alexander's death in 1503.

Michelangelo's circle of contacts was shrinking, not expanding. The Florentine friends who had gathered frequently at the house of Cardinal Giovanni de' Medici had broken up during the cardinal's travels north of the Alps through the whole of 1499. Unsure of his safety in Italy, as the French invasion loomed, Cardinal Giovanni and his cousin Giulio de' Medici went abroad, accompanied by twelve friends. Traveling incognito, their party was arrested in Rouen and detained until letters were obtained from Giovanni's brother Piero de' Medici, then in the French camp at Milan.[12] Returning into

Italy, the Medici cousins encountered Giuliano della Rovere, the cardinal of San Pietro in Vincoli, in his family's ancestral seat in Savona, near Genoa. United in their enmity toward the reigning pope, their exchange of views made this meeting portentous. Afterward Cardinal Giovanni went to Genoa for a lengthy stay with his sister Maddalena, the wife of Francesco Cibò. Having failed to re-enter Florence in each of the three years previous, Piero was attempting to forge an alliance with the newest power in Italian politics, Cesare Borgia, the duke of Valentino. Everyone in Florence felt the ominous pressure of circling soldiers.

On December 28, 1499, Cesare Borgia deployed his French and Italian artillery outside Ravaldino, the fortress of Forlì, and opened fire on Caterina Sforza's last refuge. Her guns replied, striking and killing Cesare's most expert bombardier.[13] This stroke of fortune was not enough, however, to diminish the besieger's advantage or the devastation of his seven heavy guns and ten lighter falconets. As the jubilee year dawned, Caterina's stout defense became a nuisance. The battleground at Forlì lay close to the Muraglione pass through the Apennine Mountains. Soon thousands and thousands of pilgrims would come streaming south on the way to Rome. It would be profoundly embarrassing for Alexander VI if it happened, as was inevitable, that they were harassed by the pope's son's soldiers.[14]

At noon on Sunday, January 12, 1500, Cesare bet his officers three hundred ducats that by Tuesday Caterina would be at his mercy. Caterina's beleaguered forces resisted valiantly, but the walls were broken and Swiss and German mercenaries came flooding through the breach. Though her men surrendered to save their lives, Caterina did not. Wearing a cuirass and fighting like an Amazon, she and a few trusted captains backed their way into the strong main tower and prepared for another siege, this time protected only by the tower.[15] Cesare called upon her to surrender; she appealed for his mercy for her soldiers and subjects. At that moment she felt a hand descend upon her shoulders and heard a chivalrous voice: "Madam, you are the prisoner of my Lord, the *bailli* of Dijon." One of Cesare's commanders had somehow entered the tower. As fate would have it, Caterina was protected at this crucial moment of high emotions by the intervention of the French, whose prisoner she officially was, at least until Cesare paid a ransom.

Leaving nearly seven hundred dead in the battle, the army disencamped. Cesare led his army, Caterina under guard, eastward against the port city of Pesaro. At this very moment, late in January, came word that Ludovico il Moro was marching against Milan; indeed, within a few days the hated

French protégé Trivulzio had been overthrown by Ludovico's fickle subjects. The French general Yves d'Alègre hurriedly marched northwest, depriving Cesare of the backbone of his army.[16] His one realistic option was to suspend his Romagna campaign and return to Rome.

On February 26, 1500, the Porta del Popolo was lined with crowds eager to watch the handsome, powerful duke of Valentino enter the city in the style of a Roman emperor. The Vatican master of ceremonies had never seen such extravagance, not to mention the disorder that the event introduced into an already wild carnival season.[17] Dressed simply in a knee-length black velvet robe and the gold color of the Order of St. Michael, the pope's son was preceded by ambassadors, *conservatori* of the city, cardinals in purple and ermine, heralds in the colors of France and the Borgia arms, his personal guard with CESAR emblazoned in letters of silver on their chests, fifty officers of his command, and a train of wagons laden with captured booty.[18] The procession passed Castel Sant'Angelo, saluted by thunderous salvos of artillery, and marched up to the Vatican, where Alexander was waiting. Overcome by paternal pride, the pope interrupted the reception, alternating between laughter and weeping. The next day's events were headlined by a procession of great chariots in the Piazza Navona, eleven of them, each decorated with allegories of the victories of Julius Caesar, to whose triumphs young Borgia's conquest of Imola and Forlì could not accurately be compared.

Cardinal della Rovere rode in the parade, pretending to be reconciled with the Borgia. His cousin, Caterina Sforza, Cesare's prisoner, was spared the embarrassment. She was taken without fanfare to the Vatican and locked in a room in the Palazzo Belvedere. The public admired Caterina's courage, the Curia and nobility regarded her cause as lost. Her refusal to cede her territories was superseded by the willingness of her cities to be governed by their new Count Cesare. For Florentines, she was the mistreated widow of one of the city's scions, Giovanni di Pierfrancesco il Popolano. His brother Lorenzo, the man responsible for bringing Michelangelo to Rome, was at the height of his influence in the government of the young and struggling Florentine Republic. It was a long time, though, since he had shown any interest in marble statues.

• • •

VASARI TELLS A TOUCHING ANECDOTE ABOUT THE DISCONSOLATE young sculptor going to eavesdrop in the Pietà chapel: "One day when Michelangelo found a large number of foreigners praising the statue very highly, one of them asked another who had sculpted it and he replied, "Our Gobbo from Milan" (Cristoforo Solari).[19] According to Vasari, Michelangelo said nothing and then took action. Disdaining to make the incident public by applying for permission, "one night he locked himself inside the church with a little light, and having brought his chisels, he carved his name upon the statue." Vasari forgets to tell us how Michelangelo found the time to polish his handiwork: his concern is to explain somehow why the Pietà is Michelangelo's only sculpture with an autograph signature. The premise of this harmless story is that the Pietà attracted surprisingly little notice.[20]

Michelangelo was underemployed but he was not hard up for cash. His bank accounts show a flurry of prosperous transactions. At the end of February he had no intentions of leaving the city, paying six months' rent in advance to a new landlord, Fabrizio Pugligate Vanoso, for his lodgings.[21] During March he recorded deposits of sixty-one and ten ducats, respectively, from unspecified sources. These respectable sums were dwarfed by his receipt, on July 3, from the executors of Cardinal Bilhères, of the final payment for the Pietà. Tendered by the Sienese banking house of Donato Ghinucci, 232 papal ducats represented a small fortune.[22] He celebrated the next day by sending his assistant, Piero d'Argenta,[23] to withdraw fifteen ducats, and another four before the end of the month. Now that he had money, he liked to keep substantial sums at home safely out of sight. Although still a young man, he denied himself the pleasures of youth. His purchases, duly noted down, were strictly practical; only occasionally would he permit himself a new shirt. At age twenty-five Michelangelo had already adopted an old man's habit of keeping his wealth invisible—to the extent possible.

He was staying on in Rome because, circumstances tell us, a major commission was about to come through. Four years earlier, at the time of Michelangelo's arrival in Rome, a rich bishop of Cortona named Giovanni Ebu had died, naming Cardinal Riario as his executor. Ebu's will was contested by his heirs and settled only in 1499; on July 30, 1500, Cardinal Riario, through his agent Jacopo Galli, sold some property to raise funds for the decoration of a chapel in the bishop's honor in the church of Sant'Agostino in Rome.[24] Riario had been protector general of the Augustinian order since 1483. As soon as the summer doldrums were past, on September 2, "Michelangelo the sculptor" received sixty ducats from Riario's auditor on account for a "panel

painting to be made for Sant'Agostino."[25] Another note in the prior's books adds the precious detail that the moneys were paid "for the painting of the *ancona* [altarpiece] to Michelangelo of Florence."[26]

The untitled altarpiece was never delivered. Five months later Michelangelo was in Florence, where, without delay or complaint, he refunded the friars the full sixty ducats.[27] Most students of Michelangelo conclude that the commission was never begun, but recently two British authorities, Michael Hirst and Jill Dunkerton, have argued that the *Entombment of Christ* in London should be identified with this work, pointing out the chapel's dedication to the *Pietà*.[28] The unfinished *Entombment* is the most controversial attribution among Michelangelo's paintings. Prior to this association with the Sant'Agostino chapel, none of its defenders had advanced a date as early as 1500. Yet, if the picture is indeed his, it is only in these last moments of immaturity that the disjointed groupings and flat perspective—as if the artist were torn between sculpture and painting—are imaginable. Two years hence, in the *Doni Tondo*, all such awkwardness will be banished.

Once again the Augustinian context is decisive. Christ's delicate body in the *Entombment* is as graceful as in the Santo Spirito crucifix, and the absence of his wounds has perplexed just as many observers. True to the tradition of Florentine humanism, the sacred subject of the painting is presented as a meditation on the mystery, as opposed to a narration of the biblical event. Precedents in the religious paintings of Fra Angelico have been noted.[29] The poses of the bearers are adapted from classical sculptures of fallen heroes.[30] These borrowings are intensified by the languorous tresses of Christ's favorite apostle, John, who resembles a Dionysius with broad shoulders. At lower left a youthful Mary kneels, her gaze directed at the unpainted place where her arm would have held the crown of thorns for her contemplation. Michelangelo's remarkable drawing of this girl has come down to us. Prepared on pink-toned paper in the Florentine way, the drawing is a study, evidently drawn from life, of a young and nubile woman completely nude.

The *Entombment* is the first major abandonment of Michelangelo's career. For inexplicable reasons he did not insist on compensation for his time and effort. The painting disappears in the documents until 1644, when it is cited as a valuable part of the Farnese collection in Rome.[31] On the other hand, its extraordinary composition must have been accessible to a fortunate few, like Jacopo Carrucci, called Pontormo, whose great *Deposition* in the Capponi Chapel, Florence, of 1528, emulates its eerie silence and floating figures.

By February 27, 1501, Michelangelo's mind was made up. He had transferred the marbles in his possession to Jacopo Galli in exchange for a personal loan of eighty ducats.[32] His father had written of these valuable stones as an obstacle to Michelangelo's departure. The ingenious solution was a precocious example of the artist's skill at turning marble blocks into gold without even bothering to carve them, for these can only be the extra Carrara marble he had acquired with the cardinal's money for the *Pietà*. Perhaps Galli taught his protégé this trick, as the banker was obviously complicit.[33] On March 18 Michelangelo arranged with his banker to transfer 266 ducats to be collected in Florence.[34]

Vasari, who was not in Michelangelo's confidence, connected the youth's return to Florence with the impending commission for the *David*. He claimed that "Piero Soderini the Gonfaloniere had talked of giving it to Leonardo da Vinci, and now was preparing to give it to Andrea Contucci."[35] Condivi simply connects his return to "family affairs." Both accounts, or neither, may be true.

His willingness to abandon the *Entombment* was encouraged, if not occasioned, by the opportunity to carve marble sculptures for the Piccolomini altar in the cathedral of Siena. The patron was Cardinal Francesco Todeschini Piccolomini, who was one of Jacopo Galli's most important contacts in the Curia. The cardinal had been an executor of Cardinal de Bilhères's will and also the agent for the heirs of Bishop Giovanni Ebu. He had both the means and the motivation to forgive the artist for not fulfilling the commission; he could also make it up to him. The painting's esoteric style may have presented problems, or perhaps the heirs lost interest in endowing the chapel. However it was, Michelangelo returned the Augustinians' money on May 19. Three days later he promised in writing that he would carve fifteen statues for the cardinal's altar.[36]

The contract was drawn up and signed in June by the cardinal, the sculptor, and Jacopo Galli.[37] This is the last transaction for which the elderly Galli would act as guarantor for the young genius. The fifteen sculptures were to be made of Carrara marble that was "new, pure, white and not veined," in a word, "perfect."[38] Michelangelo agreed to go in person to Siena and measure the semicircular niches and bases for his creations. Cardinal Piccolomini's agreement was more punctilious than Galli's usual style; Michelangelo was to be paid as each figure, about 114 cm (3¾ feet) high, was completed and approved by an independent expert. The sum payment was to be five hundred gold ducats.

For more than a decade Cardinal Piccolomini had been constructing a memorial to his uncle Pope Pius II in the Duomo of their native city. Andrea Bregno, the leading Roman architect, was engaged to erect an altar in his most classical style. Its basic form is that of a triumphal arch covered with finely chiseled ornaments. This elegant reredos frames the altar niche and stands next to the Piccolomini library, which was not yet finished. As one of the great humanist popes, Pius II had amassed an important library that his nephew wished to make the foundation of a center of learning. Bregno's altar in white marble is a masterpiece of early Renaissance architecture. For some years it had stood with its niches empty like a crown without its jewels. The June contract contains the curious fact that Michelangelo was not the first sculptor contemplated. Rather, the young man was obliged to complete the head and robe of a statue of St. Francis begun and left imperfect by Pietro Torrigiani.[39] Either he was replaced or he resented the proposal to collaborate with Michelangelo. Whatever the reason, Torrigiani resumed his many duties for the Spanish cardinals in Rome.[40] The assignment was thus analogous to the Arc of St. Dominic in Bologna, requiring Michelangelo to integrate his sculptures into a pre-existing framework.

Later that summer, the Opera del Duomo, or cathedral works commission, in Florence met on July 2 to consider what to do with a "marble male figure known as 'David'" that was lying in a piteous state, "roughly blocked out," in the yard of the Opera adjacent to the church. "Desiring said *gigante* [giant] to be erected and raised up high by the masters of the Opera—it should be stood upright, so that masters expert in such things can consider if it can be fulfilled and finished."[41] It is not known, but it is probable that Michelangelo was among the masters convoked; he was, after all, the sculptor of the large marble Hercules in the Palazzo Strozzi. A month later the assignment was his, more or less by default. "Perceiving his confidence that he could carve something good from it," Condivi says, "in the end they offered it to him."[42]

By August it was official, and Michelangelo found himself in a delicate situation. Within six weeks of promising fifteen sculptures to one of the most influential cardinals, he was the object of a momentously exciting announcement. On August 16 the consul of the Wool Guild chose "the worthy master Michelangelo, the son of Lodovico Buonarroti, a citizen of Florence, to the end that he may make, finish and bring to perfection the male figure known as the Giant, nine braccia in height, already blocked out in marble by Maestro Agostino the Great of Florence and badly blocked and currently stored in the workshops of the Cathedral."[43] This enormous

undertaking, which many doubted possible because of the previous cutting into the stone by Agostino di Duccio, was to be completed within the improbably brief span of two years. The artist would be provided a salary, workplace, assistants, and anything else he might need. This would have to be balanced somehow with the Piccolomini contract, which prohibited him from taking on conflicting jobs.

. . .

MICHELANGELO WENT TO SEE LORENZO DI PIERFRANCESCO, who was immersed in politics and voyages of discovery—these were over-lapping considerations in 1501. Lorenzo was the chief promoter and cor-respondent of Amerigo Vespucci, the Florentine explorer who would lend his name to the newly discovered continent of America. Vespucci had been employed by Lorenzo and Giovanni di Pierfrancesco since 1492, when they sent him to their office in Seville, Spain. Their support was about to pay off, at least in terms of prestige, as Vespucci's discovery voyages were finally under way. *Mundus Novus* ("New World"), the famous letter in which Vespucci describes the inhabitants of South America in 1501, is addressed to Lorenzo. On the French front, the second invasion, this time led by Louis XII, meant that Florence had greater need than ever of Lorenzo's longstanding rela-tionships at the court of France. Since Piero de' Medici's expulsion in 1494, Lorenzo's name had been repeatedly mentioned as a leading candidate to assume, under a reorganized constitution, a chief executive role in the gov-ernment. In 1498 he traveled to France, together with Cosimo de' Pazzi, who was the bishop of Arezzo, and Piero Soderini, one of the city's most respected leaders, to represent their city at the coronation of their most important ally, Louis XII.[44] After Pope Alexander unexpectedly reached an agreement with the French, trading favors with the king, who in turn named Cesare Borgia duke of Valentino, arming him with career officers and experienced soldiers, Lorenzo's involvement was essential. Michelangelo found Lorenzo on the verge of departure on yet another mission. Luca Landucci noted in his diary on May 3, 1501, "We sent 20,000 florins to the King of France, and Lorenzo, son of Pierfrancesco, went to France with the money."[45]

Three days later, a messenger arrived from the pope bearing an ominous request for a safe passage across Tuscany for his son the duke of Valentino and his army. Permission was duly granted. Unfortunately, Il Valentino's

intentions were mischievous rather than peaceful. Through May and into the next month, his troops marched menacingly through the countryside, "doing all sorts of damage, burning and robbing, and cutting the corn."[46] A nervous watch was kept in Florence all of those nights. By a proclamation of the Signoria, every house was ordered to keep a light burning in the window all night.[47] Piero Soderini was sent out several times to the duke to find out what he wanted. The Florentines marveled, "What have we to do with Valentino, we are not at war with him."[48] Finally, Borgia revealed his intentions: the Florentines should purchase his benevolence by paying him 36,000 florins a year for three years to be their *condottiere*, or mercenary captain.[49]

During these negotiations, to which the city acceded, Cesare requested a kind of vaguely worded pardon for anything, in Landucci's words, "that had been done against our state from the day when he left Imola [that is, in January 1501] until now; and this was on account of its being said by many that some citizens had sought his coming on their behalf."[50] Rumors ran rampant among the populace that their government's meek response to these provocations stemmed from a conspiracy by "certain leading citizens who aimed in this way to overturn the government."[51] The streets were filled with poisonous feelings against the suspected traitors, especially Bernardo Rucellai, the Nerli, Alfonso Strozzi, and Lorenzo di Pierfrancesco. Their houses were in danger of being burned down. Guicciardini, who provides these details, did not believe these rumors were true, but the damage was done. Lorenzo, who yearned to lead the young Republic, regarding it as his birthright, saw his hopes reduced to ashes.

Michelangelo also noticed the return of Leonardo da Vinci. Since the French conquest of Milan, Leonardo had fruitlessly been seeking a new patron on the order of Duke Ludovico Sforza. He sent his money to Florence for safekeeping in the bank of Santa Maria Nuova, and went to Mantua at the invitation of the Marchesa Isabella d'Este, Sforza's sister-in-law. He stayed long enough to make a marvelous portrait drawing of Isabella in half-length profile, leaving her with a promise to deliver a painted version. Venice was the next 'stop on his tour; he arrived in February 1500, taking the drawing with him to complete. The position of the marchesa's hands in the portrait drawing, today in the Louvre, anticipates the *Mona Lisa*. In April, while he was still lodged in Venice, Leonardo received the news of Ludovico Sforza's capture by the French.[52] There was no chance now that his principal project for the Milanese duke, a huge clay model of a horse, would ever be realized in bronze. Ludovico il Moro, whose reckless

gambles had caused war and devastation up and down the Italian penin-
sula, was taken to France and imprisoned until, driven mad by the confine-
ment, he died eight years later.

Failing to find either a suitable patron or a commission to prolong his stay
in Venice, Leonardo da Vinci returned to Florence for good by April 24. He
found that the most active workshops belonged to Lorenzo di Credi, his for-
mer colleague in the workshop of Andrea Verrocchio, and to Filippino Lippi,
Botticelli's pupil. As for Botticelli himself, his spirit seemed broken after the
auto-da-fé of Savonarola. For some years, only Lorenzo di Pierfrancesco had
continued to employ him, even though he had renounced the pagan aestheti-
cism of the Birth of Venus and other masterpieces of his youth still in Lorenzo's
collection. The most interesting new painting in Florence was Baccio della
Porta's unfinished Last Judgment in Santa Maria Nuova, the convent where
Leonardo kept his money. Born in 1472, Baccio's artistic training was similar
to Michelangelo's, except that he was more deeply influenced by the work
that Leonardo had left in Florence almost twenty years before. Baccio's Last
Judgment infuses Florentine realism with a spiritual sensibility.

Leonardo's fame as the artist of the Last Supper preceded him, and he
received many offers of work—more even than he cared to execute. The
Servite brothers of Santissima Annunziata commissioned a large painting
of the Annunciation to place above the high altar of their church. Although
Filippino Lippi was originally chosen, he graciously stepped aside as a
courtesy to the returning master, who was given lodging and board in the
monastery.[53] Instead of painting the altarpiece, Leonardo preferred to
pass his days studying geometry and other intellectual pursuits. "In short,
his mathematical experiments have distracted him so much from painting
that he cannot abide the paintbrush," reported an eyewitness to Isabella
d'Este, who remained under the impression that Leonardo was still serv-
ing her.[54] He was taking his time finishing a small painting, The Madonna
of the Yardwinder.[55] He kept the Servites waiting without even starting,
then he executed a cartoon (large drawing) of an entirely different com-
position, Our Lady with St. Anne and the Infant Christ. "This work not only
won the astonished admiration of all the artists, but when it was finished
it attracted to the room where it was exhibited for two days a crowd of the
curious, who flocked there as if they were attending a great festival, to gaze
in amazement at the marvels he had created."[56] This took place in April
1501, in time for Michelangelo to be among the stupefied onlookers. The
cartoon, which is lost, was precisely described by Isabella's agent, Fra Pietro

da Novellara, the head of the Florentine Carmelites. Unable to goad the uncooperative genius into completing his work for Mantua, the good monk compensated with other details about his activity.

> The Mother, half rising from Saint Anne's lap, is taking the child to draw it from the lamb, that sacrificial animal, which signifies the passion. While Saint Anne, rising slightly from her seat, seems as if she would hold back her daughter so that she would not separate the child from the lamb, which perhaps signifies that the church did not wish to prevent the passion of Christ. These figures are life-sized but can fit into a small cartoon because all are either seated or bending over and each one is positioned a little in front of each other and towards the left-hand side. This drawing is as yet unfinished.[57]

That St. Anne should attempt to hold back her daughter was a novel invention. Michelangelo, no less than the others, was deeply impressed by Leonardo's new direction, which delved into the interior lives of the sacred personages.

At the end of June 1501, Lorenzo di Pierfrancesco and Piero Tosinghi, the Florentine envoys to France, wrote from Lyons to the Signoria on behalf of Pierre de Rohan, the maréchal de Gié, who asked their assistance in obtaining from Florence a bronze statue of a David. "The Maréchal de Gié has shown his favor towards the city and has urged us to write to you, the Signoria, his desire to cast for him a life-sized bronze figure like that standing in the cortile of the Palazzo della Signoria. He would pay the expense, but we suspect he would welcome it as a gift."[58] In 1498 the maréchal de Gié had asked the Signoria for seven Roman busts that had belonged to Lorenzo de' Medici. Rohan had served in Italy under Charles VIII and the statue that had caught his eye was none other than Donatello's *David*. The Signoria lost no time in replying, "We have sought who could cast a figure of David like the one you requested for the Maréchal de Gié, but there is a lack here of master sculptors; however we shall continue to inquire diligently."[59] Michelangelo's reputation, evidently, was exclusively as a stone carver. Through the autumn the maréchal persisted in his request.

• • •

Florence had bought a respite from the unwanted attentions of Cesare Borgia, duke of Valentino. Pressing political affairs kept him in Rome for much longer than expected. One of his persistent problems was Caterina Sforza, who, by June 1501, had been his prisoner for more than a year. Despite his new title—duke of Romagna—and possession of her cities, Cesare Borgia desperately needed her abdication so as not to seem ridiculous. Caterina passed her days weeping, refusing to eat, and rejecting her sons' craven appeals to sign away her territories. The pope was showering promises of pensions and even an archbishopric for her sons fathered by Riario—Cesare and Ottaviano—neither of whom had their parents' pluck. She was transferred from the Belvedere to the dungeon of Castel Sant'Angelo, but she did not concede.

Sforza might very well have died there were it not for Yves d'Alègre, the French commander whose troops had captured her at Forlì. As the king of France passed through Rome en route to conquer Naples, d'Alègre went straightaway to the pope to demand her release. With assurance of French protection, Caterina relented, relinquishing her own and her children's claims in the region of Romagna. After sixteen months' imprisonment she was freed on June 30. A few weeks later she was sufficiently recovered from her ordeal to travel. She chose passage by sea, fearing that enemies might lie in wait on the road. Having no dominions in her own name, she decided on Florence as the most suitable place to raise her son fathered by Giovanni di Pierfrancesco, whose body had been brought back for burial in San Lorenzo, the Medici family church. A year later, Cesare Borgia fiercely told Piero Soderini, "The fact that she was a woman made no difference to him, and if it had been up to him he would have never let her out of Sant'Angelo."[60] But he could not refuse a demand made in the name of France when Rome was full of the king's troops. Caterina Sforza darkly hinted at the abuse inflicted on her person by the Borgias, "If I could write of it, I would shock the world."[61]

Scandalous rumors did not deter the Borgias from the enjoyment of their appointed rounds. In July of that year, Agostino Vespucci, the Florentine envoy in Rome, wrote to Niccolò Machiavelli, by now secretary of the Signoria: "It is known by everyone that the Pope, surrounded by his illicit flock, brings twenty-five women or more to his palace every evening, from the Ave Maria to one o'clock, so that his house becomes an open brothel."[62] On All Saints Eve, a special sort of Roman orgy was organized by Burchard, the papal master of ceremonies, and duly recorded.

On Sunday evening, the last day of October 1501, there took place
in the apartments of Duke Valentino in the Apostolic Palace, a
supper, participated in by fifty honest prostitutes, those who are
called courtesans. After supper they danced with the servants and
others who were there, first clothed then naked. After supper the
lighted candelabra on the table were placed on the floor. Chestnuts
were thrown among them for the prostitutes to pick up as they
crawled between the candles. The Pope, the Duke, and Lucrezia,
his sister, were present looking on. At the end they displayed prizes,
silk mantles, boots, caps, and other objects, which were promised
to whoever was able to make love to these prostitutes the greatest
number of times. The prizes were distributed to the winners
according to the arbitration of those present.[63]

The festive mood was carried through the end of the year, which was domi-
nated by the extraordinarily extravagant celebrations of Lucrezia Borgia's
wedding—her fourth—this time to Alfonso d'Este, the duke of Ferrara. Her
brother Cesare did not organize himself sufficiently to march again until June
1502, when his military staff was enhanced by the renowned engineer and
scientist Leonardo da Vinci.

The two men were probably introduced in 1499, when Cesare partici-
pated in the French invasion of Milan and Leonardo did not flee with the rest
of the Sforza court. It was in the service of Ludovico Sforza that Leonardo
had first demonstrated a passion for designing fortifications and other tacti-
cal engineering. Now Valentino gave him his chance to put his theories into
practice. Famed for his evasive movements, Cesare's travels back and forth
across Romagna and the Marches can be tracked in the pages of a notebook the
artist kept.[64] It was no secret that the Borgias desired to carve a family duchy
out of papal possessions in north-central Italy, an ambition that was only
possible while the elderly pope was still alive. Leonardo's duties included
surveying the terrain ahead, examining fortresses, and planning bridges
for troops to cross in the mountainous landscape of the Marches, where
Valentino was now headed. With the towns of Camerino and Senigallia
dead ahead in his sights, the duke sprang a surprise, a stroke of strategic
genius, by unexpectedly attacking the capital city of Urbino from three
directions at once—from the north, east, and south. Guidobaldo da
Montefeltro, duke of Urbino, barely escaped with his life during the night
of June 20.

Cesare's taking of Urbino sent shockwaves through the courts of Italy.[65] Florence was already in a state of alarm over the uprisings fomented in several nearby towns by Vitellozzo Vitelli, one of Borgia's most fearsome *condottieri*. Piero and Giovanni de' Medici, still banned from Florence, had been welcomed in Arezzo, now briefly freed from Florentine control. The Signoria immediately dispatched Machiavelli and Francesco Soderini, bishop of Volterra, on June 24 to meet with Borgia and implore him to cease his threats. The Florentines went away perplexed as to Cesare's true intentions, but deeply impressed by his person:

Urbino, 26 June 1502

This Lord is truly splendid and magnificent, and in war there is
no enterprise so great that it does not appear small to him; in the
pursuit of glory and lands he never rests nor recognizes fatigue or
danger. He arrives in one place before it is known that he has left
another; he is popular with his soldiers and he has collected the
best men in Italy; these things make him victorious and formidable,
particularly when added to perpetual good fortune.[66]

These praises came even after he had upbraided them for their city's failure to maintain the promises of the year before. Brushing aside the envoys' protestations, Borgia delivered a menacing ultimatum:

I know well that you are prudent men and understand me;
however I will repeat what I said in a few words. I do not like your
government and I cannot trust it. You must change it and give
me guarantees of the observance of the promises you made me;
otherwise you will soon realize that I do not intend to live in this
way, and if you will not have me as a friend, you shall have me as
an enemy.[67]

Machiavelli's letters were conveyed to Florence and kept under lock and key, with severe penalties announced against any citizen who revealed their content. Even so the populace knew at once that Valentino, as they called him, wished to "make an alliance with us, or else he would come and attack us; and he gave us four days in which to decide."[68] Exactly two months later, the motion was introduced into the Great Council of the Signoria that the city

should elect and be governed by a doge in the Venetian manner, as Landucci put it.[69] Piero Soderini was elected gonfaloniere for life on September 22. There were 150 candidates, but only three were voted for, not including Lorenzo di Pierfrancesco, much to his disappointment. This action was regarded by Guicciardini and later historians as the final tolling of the bell for Piero de' Medici's chances to return to the throne of the city where he was born.[70]

The castle and fabled art collections of the duke of Urbino were now the possession of Cesare Borgia: the first object sought from him was Michelangelo's *Sleeping Cupid*. Within hours, it seems, of the fleeing duke's arrival to the safety of Mantua, his sister-in-law Isabella d'Este was writing to her brother Cardinal Ippolito in Rome. After a reverent greeting, the letter of June 30 goes straight to the point:

> The Duke of Urbino, my brother-in-law, had in his house a small
> marble antique Venus and similarly a Cupid that was once given
> to him by the Duke of Romagna. I am certain that these and other
> items have come in the hands of the Duke of Romagna [Cesare
> Borgia] in the transfer of the state of Urbino. I, having devoted great
> care to collecting antique works to honor my private studio, desire
> them greatly. Nor does it seem to me inappropriate to think [this],
> knowing that his Excellency does not delight much in antiquities
> and that he would easily accommodate this request.[71]

Isabella's instincts were correct; Valentino was pleased to assuage her disappointment over her family's loss for the price of two works of art. The *Cupid* was in her possession within a month, as we learn from her letter of July 22 to her husband, Marchese Francesco II Gonzaga, "I won't write about the beauty of the *Venus* because I believe you have already seen it, but the *Cupid* for a modern work has no peers."[72] The *Cupid* remained in Mantua until 1632, when it was sent to England with the sculpture from the Gonzaga collection bought for Charles I, and was presumably lost in the Whitehall fire of 1698.[73]

· · ·

A NOTE IN THE MARGIN OF HIS CONTRACT WITH THE OPERA DEL Duomo states, "the said Michelangelo began to work and carve the said giant on 13 September 1501, a Monday. Previously on the 9th, he had given it one or

two blows with his hammer to strike off a certain knot that it had on its chest. But on the said day, that is the 13th, he began to work with determination and strength."[74] The knot (*nodum*) must have been a remnant of the earlier sculptor's attempt. By knocking it off, Michelangelo declared his independence from the block's past.

In describing the *David* to Condivi, Michelangelo was not forthcoming about his working methods. Later in life he habitually encouraged the impression that his works came into being fully conceived, requiring no modifications along the way. Vasari provides the most extensive account of the task facing Michelangelo and how the twenty-six-year-old set about resolving it. This description is a valuable record of what was remembered of this event half a century later. "Although it seems impossible to carve a complete figure from the block (and only Michelangelo was bold enough to try without adding fresh pieces), he had felt the desire to work on it many years before, and he tried to obtain it when he came back to Florence. The marble was 18 feet high, but unfortunately an artist called Simone da Fiesole had started to carve a giant figure and had bungled the work so badly, hacking a hole between the legs, that he left the block completely botched and misshapen. . . ."[75]

Vasari glossed over the original destination of the block. For almost a century the *operai* of the Duomo had been engaged in an effort to place a series of twelve monumental statues of prophets high atop the buttresses around the east end of the cathedral. One of the twelve was to represent David—not as a king but, in accordance with the Florentine tradition, as a handsome shepherd boy, armed with a sling and the grace of God, who would become the defender of his people.[76] In 1464 Agostino di Duccio was sent to Carrara to select the marble for the figure, which was expected to be carved in four separate pieces. The decision was made, however, to employ a single block. Then, two years later, the *operai* terminated Agostino's contract for unknown reasons, and the project was shelved, seemingly forgotten, until July 1501.[77]

Separate pieces of marble, sculpted and then joined, would allow the statue to extend its arms in gesture. The block now taken in hand by Michelangelo was three times life size in height and extremely shallow. The ratio of its width to its depth was about 7:4, which meant that he was committed to a pose that was both open and flat.[78] "The side views could never rival that from the front, and it was through contour that the figure must make its effect."[79] Michelangelo envisioned his figure inside the block and used the dimensions to the utmost. Condivi writes, "Without adding any

pieces, he extracted this statue so precisely that the old rough surface of the marble still appears on the top of the head and on the base."[80] Viewing the statue from above, it is evident that the head was originally blocked out as a square facing directly forward and constrained by the marble's shallow depth. Michelangelo's options were to carve a flat, frontal face or turn the head on a diagonal and position the nose, chin, and forelock tightly in one corner.

"So Michelangelo made a model of the young David with a sling in his hand. . . . He began work on the statue in the opera of Santa Maria del Fiore [the cathedral's office of works], erecting a partition of planks and trestles around the marble; and working on it continuously . . . without letting anyone see it."[81] He worked at an incredible pace. His contract stipulated that the sculpture was to be completed in two years' time—before September 1, 1503. By the end of February 1502, the consuls of the Wool Guild declared that since the work was "already half-done [iam semifactum]," they were disposed to increase his pay to a total of four hundred gold florins. The initial agreement with Michelangelo had treated him as a salaried employee who would receive six florins a month for two years, or 144 florins in total. But, the consuls' excitement at what he had accomplished in a mere five months led them to treble his compensation and to extend the deadline to February 25, 1504.

Michelangelo's considerable workload did not deter him from accepting a commission for yet another David. The maréchal de Gié's desire to have a bronze figure, slightly less than life size (2¼ braccia), was finally to be satisfied. Michelangelo promised the Signoria of Florence on August 12, 1502, that he would deliver the statue within the next six months for a fee of fifty large florins and the cost of his materials.[82] His lack of experience at casting bronzes seems not to have preoccupied him unduly.

The bronze David is known from an ink drawing that Michelangelo made on a folio containing a study for the marble David's pendant right arm. Rohan's immediate request had been for a David on the model of Donatello's sultry ephebe, which belonged to the Medici until their expulsion. Michelangelo's response incorporated elements of Verrocchio's famous bronze David as well, especially the youth's jauntiness. He indulged himself in contrasting the boy's bent knee with his left arm akimbo. He drew his idea with the head in profile turned toward one shoulder. Evidently the solution he was working on for the giant intrigued him. This same sheet in the Louvre contains handwritten notes that are like fragments of his thoughts. They offer a revealing glimpse of a cerebral and poetic cast of mind.

Davicte cholla fromba / e io chollarchio

David with his sling, I with my bow.

Not surprisingly, and perhaps deliberately, Michelangelo's meaning is ambiguous. The word *archio* could mean "harp" or anything else shaped like a bow. It is the instrument of his power, like David's sling. From Greek antiquity the bowlike running drill was a major tool for European marble and stone sculptors.[83] Michelangelo was comparing the tool that he used to remove the unwanted encasement of his conception to David's simple sling, with which he killed the sinful Goliath.

Lower on the same sheet he inscribed: *Rotta l'alta cholonna,* "broken [is] the tall column," the opening words of a famous poem by Petrarch (1304–74). Michelangelo, like most literate men of his age, knew Petrarch by heart. The original line continues:

Rotta è l'alta Colonna e 'l verde Lauro,
Che facean ombra al mio stanco penserò

Broken is the tall column and the laurel tree
That lent their cooling shade to my tired mind[84]

Petrarch composed this poem in 1348 while mourning the death within months of his patron, Cardinal Giovanni Colonna, and his feminine ideal, Laura.[85] Sitting wearily at the foot of his tall, chiseled column, Michelangelo's thoughts flitted to this verse.

He was consumed by this task, yet incredibly in November 1502 his name crops up in an entirely different context. A massive order for Carrara marble was registered that month by the *operai* of the Duomo with a broker named Matteo Cucarello.[86] The material was needed for the altars and pavement in the chapels of the apse and tribune of Santa Maria del Fiore. The contract instructs Cucarello, moreover, to provide Michelangelo, "freely and on his own account," with the stones he might require. The most likely purpose for fine Carrara blocks was the Piccolomini altar in Siena. Fifteen statues was a serious task, and he is suspected as well to have redesigned the two lowest niches.[87] Cardinal Piccolomini was too important a prelate to ignore.

The following spring, on April 24, 1503, the consuls of the Wool Guild offered him a contract that would bind his services to them, at least part-

time, for the next twelve years. They desired marble statues of the apostles for placement inside the cathedral. Michelangelo agreed to execute one a year, each approximately 270 centimeters (8¾ feet) in height. Evidently unconcerned about distracting him from the *David*, the consuls stipulated that Michelangelo leave at once for Carrara to acquire the necessary stones. As for compensation, Michelangelo would receive two florins a month during his twelve years of work, beginning the moment he arrived in Carrara or started to work on a block. The Opera of the Duomo also committed itself to constructing a house for Michelangelo, to be designed by the architect Simone del Pollaiolo with a budget of six hundred florins. It is doubtful that he left posthaste for the quarries.

He was pressured for work by both church and state. Within a few days, on April 29, the Signoria paid him an additional twenty florins toward the bronze *David* so eagerly awaited by the maréchal de Gié. The Florentine ambassadors in France were told to reassure Rohan that "the statue would be delivered within 2 months, by the holiday of Saint John the Baptist [June 24], if Michelangelo maintains his promise, which is not very certain given the brains of such people, and because he had occasion to request it, yesterday he was given more money."[88] Lorenzo di Pierfrancesco, who had staked his good name on it, was bitterly disappointed when the promise proved hollow. He died "languishing," the document says, even before the two months' deadline.[89] The bronze would be cast and shipped only in 1508. It would be too late for Pierre de Rohan, who had fallen out of favor at court by then. The Signoria sent the statue to his successor, Florimond Robertet, builder of the château of Bury, where the statue stood for many years. According to some sources it was eventually transferred to Villeroy and melted down to make a cannon sometime after 1650.[90]

Despite Michelangelo's assurances to patrons, his time was wholly committed to the giant, which by mid-June had reached such an advanced state that the *operai* of the cathedral spontaneously decided to organize a special viewing. The fence around it would be removed and the public would be allowed to view it on June 23, the eve of the annual feast in honor of the city's patron saint, John the Baptist.

• • •

LEONARDO DA VINCI MISSED THE EXCITING PREVIEW OF Michelangelo's nearly completed *David,* having been called away on urgent business by Niccolò Machiavelli. The two had formed a bond of trust the previous winter, when Machiavelli spent three uncomfortable months, from November to January, as emissary to Cesare Borgia in Imola. Machiavelli's highly praised reports to the Signoria never mention Leonardo by name; rather, it is suspected that his fellow Florentine, the duke's military engineer, was his inside source, enabling him to anticipate Borgia's tactics.[91] Now reunited in Florence, Machiavelli was determined to employ Leonardo's genius to find a resolution for the interminable war with Pisa.

La Verruca, an enemy stronghold on a rock to the east of Pisa, was a strategic target in Machiavelli's sights. In June he ordered the Florentine forces on the front line to seize the fort. Within days, on June 19, the news arrived that La Verruca had fallen the previous day. Two days later, Leonardo was already inspecting the site, remaining there through the feast day of the Baptist. A Florentine field commander wrote, "Leonardo da Vinci came here and we showed him everything, we think he likes La Verruca very much . . . afterwards, he said he was thinking of having it made inexpugnable."[92] Leonardo's notebooks contain sketches of the fort covered with calculations, proving how carefully he had examined it.[93]

A month later Leonardo was sent to the front again, this time to assess the practicality of a far greater scheme than the conquest of a fortress. During their winter together, apparently, the two Florentines had hatched a plan to change the course of the Arno River. Leonardo made copious notes, charts, and maps about the Arno plan, all of which underscore two primary objectives: bringing Pisa to its knees by cutting off its water and building canals that would open landlocked Florence to maritime trade. The grandiosity of the idea was as quintessentially Leonardesque as was its absurd impracticality. Nevertheless, Machiavelli was willing to risk his position as second chancellor on its success, and, before July was past, Soderini had already put his whole weight behind it, despite the misgivings of the many Florentines who remembered that an earlier genius, Brunelleschi, had failed miserably to do this very thing, that is, divert a river to cut off Lucca's water.

• • •

MICHELANGELO'S CREATION OF A MARBLE PERSONIFICATION OF liberty coincided with the utter and irrevocable collapse of the Borgia reign. The sources do not agree on the causes of the illnesses that struck Alexander VI and Cesare Borgia in the summer of 1503. Tradition, and contemporary rumor, hold that they plotted to poison their enemy the cardinal of Cornetto, and the lethal glasses were unaccountably served to themselves. It was the evening of August 15, a feast day, and both father and son liberally slaked their thirst with the poisoned wine. The pope collapsed at once and was carried, dying, back to the Vatican. Three days later his horribly bloated corpse lay on view in St. Peter's. Old and infirm, he could not withstand the affliction, which some believe was a case of malaria. Valentino lingered on the point of death for several days. On August 21 the rumors reached Florence:

> We heard that Valentino was dead and also four Cardinals.
> This was not true; only one Cardinal was dead. It was said that
> Valentino had poisoned a flask of wine and that this Cardinal
> died in consequence; and it was said besides that the Pope had
> also drunk of it by mistake. If so, for the sake of poisoning the
> Cardinals, he had poisoned his father.[94]

Cesare Borgia awoke from his fever and found a world altered beyond recognition.

Pope Alexander died on August 18. The conclave to elect his successor was convened on September 16. The chief concern of the gathered Curia was to elect a pontiff capable of balancing the competing interests of Spain and France while resisting the interference of Cesare Borgia.[95] Cardinal Piccolomini of Siena was elected on September 22, taking the name of Pius III in honor of his uncle Pius II. Piccolomini's health was so weak at the time of his coronation on October 8 that the customary ceremonies were abbreviated or omitted. The cardinals had wanted a brief pontificate as a breathing spell; the plan worked all too well when their new pope died just ten days later. Rumors of poisoning were inevitable in a city now famous for the Borgias' refinements of the lethal art. During the pope's ten-day reign, Cesare felt safe enough to enter the city and renew his violent conflicts with the Roman barons. Many of the duke's soldiers were killed, and finding himself in imminent danger, he retreated, with the pope's consent, to Castel Sant'Angelo. The process of restoring lands confiscated by Alexander VI began at once. Duke Guidobaldo resumed his control of Urbino, leaving the *Cupid* in Mantua as a thank-you gesture to Isabella.

The Signoria sent Niccolò Machiavelli to Rome to keep them informed on the next papal conclave. He left his assistant, Agostino Vespucci, to attend to the office. Reading a new edition of Cicero's letters, Vespucci made a careful annotation in the margin. "Leonardus Vincius," who is currently painting Mona Lisa, "is our Apelles," referring to the mythological painter cited by Cicero. The notation, discovered in the library of Heidelberg University in December 2007, is dated October 1503.[96] On the day of Machiavelli's departure, October 24, Leonardo was given keys to the space in Santa Maria Novella where he could live and work on his cartoon for the largest fresco he would ever attempt.[97] Through Machiavelli's intervention, Leonardo, now fifty years old, had been commissioned to paint a mural representing the Battle of Anghiari on one of the long walls in the Sala del Gran Consiglio in the Palazzo della Signoria.

The death of Pius III added to Cesare's misfortunes as it opened the way for the elevation to the pontificate of Giuliano della Rovere, cardinal of San Pietro in Vincoli, the ancient and most determined enemy of his family. With the help of lavish promises and bribes, and a feigned indulgence towards the Borgias, Giuliano secured his election in a single day. The new pontiff adopted the name Julius II on November 1. Julius II's pontificate would be dedicated to the preservation and extension of the same territories that Alexander VI had sought for himself, with the difference that the new pope wanted them for Rome. The scattered cities of Romagna were standing by Cesare Borgia, finding his absentee administration more congenial than the stressful epoch of the Sforzas. That fall, when Cesare was in Ostia about to set sail for his properties in France, Pope Julius suddenly arrested him. The price of his freedom was precisely the same as Cesare had demanded of Caterina: his claims to the district of Romagna. Valentino reluctantly yielded and was released. News soon reached Rome, however, that Cesena and other towns were resisting the transfer. The pope had Cesare imprisoned in the Torre Borgia, built by his father. His dreams of dominion were at an end.

The end was also at hand for another young captain, whose sins by contrast were largely venial. Piero de' Medici's unfortunate life was terminated on December 29, 1503. Thwarted in his attempts to regain Florence, Piero had joined the French army, whose conquest of Naples had collapsed. At Gaeta, north of Naples, the French were routed in a battle over the crucial ford of the Garignano River. Escaping with the others, Piero attempted valiantly to prevent four heavy guns from falling into enemy hands. The barge on which he loaded them foundered under the weight, drowning everyone on board. Piero's body was recovered several days later downstream. Ten

years of exile and disappointment had rendered futile a life begun with the most favorable prospects.

• • •

LESS THAN A MONTH LATER, LEONARDO DA VINCI WAS INVITED to take part in a blue-ribbon committee convened by the consuls of the Wool Guild on behalf of the cathedral. Called away from planning his battle mural, which to maintain his reputation would have to be a tour de force, and from plotting to divert the course of rivers, Leonardo attended the meeting unenthusiastically and spoke briefly, seeing nothing in it to benefit his own interests. But he could not decline the honor of joining the most distinguished artists and architects in the city as they considered, in a public meeting on January 25, 1504, where to place the *David*, which was now almost finished.[98]

There was a curious lack of passion in the deliberations of this gathering of illustrious minds, at which Michelangelo was not present. His sentiments were presumably shared by Francesco Granacci—his boyhood friend was now a painter of established standing—but Granacci did not speak. The other participants were the painters Piero di Cosimo, Filippino Lippi, Cosimo Rosselli, Sandro Botticelli, Pietro Perugino, Lorenzo di Credi, and Davide Ghirlandaio, the brother of Michelangelo's master, Domenico; the sculptors and architects included Antonio da Sangallo, Giuliano da Sangallo, Simone del Pollaiuolo, and Andrea della Robbia. Also present were two men known in history as the fathers of the best Florentine sculptors of the next generation—Michelangelo Bandinelli, father of the sixteen-year-old Baccio, and Giovanni Cellini, a musician to the Signoria and father to Benvenuto, born in 1500. Leonardo, of course, was in a class by himself.

The committee considered four different sites: the raised platform, called the *ringhiera,* near the entrance to the Palazzo della Signoria, where Donatello's *Judith* was currently positioned; the palace's courtyard, where Donatello's *David* had been transferred from the cortile of the Palazzo Medici; the Loggia on the Piazza della Signoria, which was used for public ceremonies; and finally, as two or three of the twenty authorities suggested, a position in front of the Duomo. There was no talk now of the buttresses behind the Duomo. Leonardo thought it should be placed inside the Loggia, toward the back, so that it wouldn't interfere with the official ceremonies.[99]

None of these positions was stated with vehemence. Most of the authorities expressed their contentment with their peers' remarks and openness to consider alternatives. Some said they had not really thought about it. The statue itself was never discussed. The meeting ended without a decision having been reached. A visiting artist, Andrea Riccio, made the only unguarded remark: "It would be better to have it in the Loggia, under cover, because travelers would go in to see it rather than being confronted by such a thing [*tal cosa*], that is, we and others would go to see the statue rather than have it come to see us."[100] The committee members appear to have been in a state of shock.

Instead of defying expectations, Michelangelo had confounded them. As the problem was the block—for forty years, everyone had said it was hacked, abandoned, it could not be saved—he would annihilate it once and for all. From the first blow he was determined—the outcome makes this obvious—that no one looking at the *David* would ever again ask about the block. Marble statues require bases, and the four edges of a rectangular base are like the footprint of the original mass. Michelangelo manipulates this truth by placing *David* off-center. His powerful right arm hangs in space, completely outside the box defined by the base. What about the other side? *David*'s left side is where everything takes place. Energy pours in through his extended leg and folded arm and is shot out through his fierce gaze. *David* doesn't stand still, he recoils. He smiles confidently, menacingly, through pressed lips.

Violence in Christian art was nothing new. The experts were shocked because Michelangelo's sculpture did not fit into any tradition they knew. It remains the least imitated masterpiece in the history of art. The only sculptor directly influenced by the *David* was Gian Lorenzo Bernini, a century later. Bernini's *David*, today in the Borghese Gallery, is completely involved in the winding up and unleashing of a sling—he hasn't another thought to speak of. The tension of incipient force is Michelangelo's invention, but he uses it only as an attribute, like the furrowed brows, to let us know his subject is David.

Michelangelo's *David* is the embodiment of an idea. One never imagines anyone posing for the *David*—or resembling him. Disagreement over the nature of this idea is recorded as early as Vasari. "A young David with a sling in hand, as the symbol of the palace, for just as David had defended his people and governed them with justice, so, too, those who govern this city should courageously defend it and govern it with justice."[101] Vasari wrote for a master, Cosimo I, who had officially put an end to the Republic. When Piero Soderini, exercising his influence over the Wool Guild, commissioned Michelangelo, the Florentines had just liberated themselves from

the dictatorship of Savonarola and now were threatened by Cesare Borgia on the one hand and Piero de' Medici on the other. It stands to reason, given his republican sympathies, that Michelangelo conceived his *David* as a monument to past valor and as a call to vigilance.

Michelangelo also had to please himself. He conceived of art as an unending succession of contests. His *David* meant measuring himself against Donatello and Verrocchio. It was not a logical comparison because his *David* was originally intended to be one of a series of colossal statues viewed at a steep angle from a great distance. From the beginning, therefore, he was resolved to make the *David* in such a way that no one in his right mind would consider placing it on a buttress, and in fact nobody did. Apart from its expressive qualities, having David glare sideways at his enemy makes the work inconceivable in a row of other prophets.

The figure was meant to be heroic; it was meant to express the full vigor of the youth's faith in his God. In contrast, Donatello's and Verrocchio's *David*s were private commissions for sophisticated art collectors, the Medici. They describe different aspects of adolescence: freshness and sensuality. Michelangelo's hero is an athletic young man, which explains his luxuriant pubic hair. In stature, mass, and virility, *David* is comparable to the *Dioscuri* horsemen on the Capitoline Hill in Rome, the classical statues most frequently cited as his models. Vasari said with grudging admiration that he disguised his sources until they were unrecognizable. According to an old story, Michelangelo took measurements of the *Dioscuri* and found that their faces were much larger than normal so as to appear in proportion when viewed from below.[102] He concluded, "Painters and sculptors need to have proportions and measures in their eyes in order to use them rightly."[103] It was a retort to artists (like Leonardo) who drew figures with compasses. *David* flaunts the disproportions between the parts of his body: the hands and feet are too large; the thighs are too smooth compared to the tightly muscled chest; the head is overwhelming. Michelangelo makes the incongruities integral to the profile of an indomitable spirit.

Between January and April Michelangelo put the final touches on the *David*. The public debate over positioning the statue had ended inconclusively, but by April 1 it had been decided to transport it from the Piazza del Duomo to the front of the Palazzo della Signoria.[104] Piero Soderini is presumed to have guided the decision. Had Savonarola lived, this giant emblem of a Christian soldier would have certainly remained on guard by the cathedral. Since the friar's death, the government had been taken out of the hands of the clergy.

Michelangelo's *David* was a secular hero, more like a Florentine than a Hebrew, down to the detail of his uncircumcised genitalia. He would symbolize the authority of the government, the resilience of the common people.

On May 14 toward sunset, the arch over the gate to the Opera workshop was broken to allow *David* to pass through. Landucci describes the sight: "It went very slowly, being bound in an upright position and suspended so that it did not touch the ground with its feet. There were immensely strong beams constructed with great skill."[105] Transporting a six-ton monolith a distance of five hundred meters was no mean feat in an age of wooden axles. The equipment employed—levers, scaffolding, rollers, and ramps—was essentially unchanged since the pyramids, although Florentines had the benefit of the improved methods of lifting weights that Brunelleschi had invented to build the Duomo's dome. Antonio da Sangallo, representing the city, and Simone del Pollaiuolo, architect of the Opera, were the engineers in charge of the operation. "It was moved along by more than forty men. Beneath it were fourteen greased rollers which were changed from hand to hand."[106] The procession moved at a snail's pace as the populace watched in awe. In the darkness of the first night, unknown troublemakers threw stones at the statue. No damage was done. It was rumored that they were frustrated supporters of the Medici.[107] A watch was posted the next night and there were no further incidents.

Every step was painstakingly programmed in sequence. On June 8 Donatello's bronze *Judith* was carried from the *ringhiera* to the Loggia. The space by the door of the Palazzo della Signoria was now free. A Renaissance sculpture was not considered complete until it was definitively sited on its own pedestal. On June 11, "They decided that they should make as quickly as possible a marble base under and around the feet of the giant, at present in front of the door of the palace, the base to be in the style and shape designed by Simone del Pollaiuolo and Antonio da Sangallo architects of Florence."[108] The decision to gild the tree trunk and the sling, worn like a sash across the giant's back,[109] and, finally, crown the figure with a golden wreath, must have been Sangallo's. Luxurious contrasts of gold and polished stones were in the antique taste of the Borgia papacy, which Sangallo had served in Rome.

The successful transport of Michelangelo's colossus was another plume in the cap of Florentine engineering. The word was passed to Rome, whence an invitation to serve the papacy soon reached Giuliano da Sangallo, Antonio's older brother and colleague. The new pope was a visionary of boundless ambition. Impressed by Giuliano's recent experience, Julius II

instructed the architect to devise a way to move an Egyptian obelisk weighing 330 tons from its original Roman site to the piazza in front of St. Peter's, a distance of 251 meters (275 yards). Giuliano took accurate measurements of its 29-meter (95-foot) height but proceeded no further. In later years, when other popes asked Michelangelo to attempt it, he phrased his reply as a question, "And what if it were broken?"

CHAPTER SIX
THE VIZIER

FLORENCE · ROME · CARRARA · BOLOGNA · ROME
JUNE 1504–MARCH 1508

RETURNING TO FLORENCE HAD BEEN A DELIVERANCE, EXACTLY AS his father had promised. After the *David*, "the sculptor Michelangelo" was recognized everywhere. Public success vaulted him into the front rank of Florentine artists, pushing aside the generation of Botticelli, now on its last legs. The *David* had poured four hundred florins into his hands, making him a rich young man. Not quite thirty, Michelangelo had more cash in the bank than Leonardo would accumulate in his lifetime.[1] Suddenly he found himself, if not the czar of Florentine art, then very nearly the vizier.

The summer of 1504 was spent working on minor things—in his estimation—and not on those awaiting his attention. He would remember these years as the interval between *David* and the Sistine Ceiling, during which, Condivi says, he took pleasure in reading the great poets and authors, and composing sonnets.[2] Buonarroto and Giovansimone, with their father's blessing and brother's backing, had gainful employment in the Strozzi trading office in Via Porta Rossa, behind the Palazzo Strozzi. It was a rare moment of family harmony.

As soon as the *David* was set up in the city square, the heirs of Cardinal Piccolomini—the short-lived Pius III—came up from Siena to see about the sculpture for their altar. Michelangelo had missed the preset deadlines, so a new contract was drawn up and duly signed on October 11, 1504. If the Piccolomini were expecting resistance, he surprised them, suddenly producing four of the fifteen statues. These diminutive figures of St. Peter, St. Paul,

and Popes Gregory and Pius I are so shallowly cut—and inanimate—that they hardly seem to be his work. They melt unnoticed into the shadows just outside the Piccolomini Library in the left nave of the Siena cathedral. Fitting statues into narrow niches designed by someone else did not excite him. A hundred ducats from the original advance were still outstanding. Rather than refund this money, he promised rather hollowly to deliver eleven more statues within the next two years. If he fell ill, he could have the deadline extended accordingly.

The clause reflects a lack of confidence in his health, a topic on which his father continually brooded, being directly linked to his chief obsession, the fragile family finances. As a child Michelangelo looked undernourished, and he probably was. He was born short, and did not grow tall, but working with marble made him exceptionally strong. A heavy brow made his head appear larger than it was, but what seriously disfigured him was his misshapen nose. A cutting wisecrack to another youth, Torrigiani, had earned him that punch in the face; now the scar seemed the outward sign of his disdainfulness. The mocking satyrs he idly sketched around the margins of his drawings perhaps reminded him of himself. Convinced of his own ugliness, Michelangelo paid little attention to his person—clothing, feeding, or resting it. His body was a plaintiff whose appeals had to be denied. He sustained himself on willpower.

Even in this season of triumph, Michelangelo's fatalism was untouched, intact, instinctive.

> After being happy many years
> One short hour may make a man lament and mourn;
> Another, through famous or ancient lineage
> Shines brightly, and in a moment grows dark.
>
> There isn't a moving thing under the sun
> That death does not defeat and fortune change.[3]

Nothing he had witnessed in life gave him confidence in his own permanence. Cities and castles had fallen before his eyes; the Medici expelled; Savonarola burned at the stake; his noble protectors had either fled for their lives or died in disappointment like Lorenzo di Pierfrancesco. Even as he enjoyed his own favorable turns of Fortune's wheel, Michelangelo was unable to breathe easily.

These lines of poetry are neatly penned in the corner of a sheet filled with hasty, vibrant ideas for works in progress or coming soon. The same page, now in the British Museum, contains: the rapid outline of an apostle, presumably for the Duomo series (the first block of marble was delivered in December, but he barely took a look at it), a cavalry skirmish, and some ornamental sketches of unknown purpose.[4] Remarkably, not a single word of the poem is crossed out or gone over. We see the same thing on other sheets. He polished the verses over and over in his mind while working, and then wrote them down on the first available piece of paper.

Another poetic fragment from this time is more personal. Between a tremulous sketch of the Madonna and Child and various poses of the infant John the Baptist,[5] he inserted these chiseled lines:

> I alone keep burning in the shadows
> When the sun strips the earth of its rays;
> Everyone else from pleasure, and I from pain,
> [From] prostrate on the ground, [I can] lament and weep.[6]

The words have sexual overtones: "burning" is the translation of *ardente*, which is mainly applied to passion, while "strips" in Italian is *spoglia*, a form of the verb "to undress." The fragment as given describes anguished sexual yearnings—and then it stops.

• • •

THE SALA DEL GRAN CONSIGLIO IN THE PALAZZO DELLA SIGNORIA was the visible symbol of Florentine independence. The immense council chamber was specially constructed by the provisional government that took power following the expulsion of Piero de' Medici. On December 2, 1494, a few days after the French invaders had left the city, twenty men were chosen to lead the town during the transition period before the drafting of a new constitution.[7] The creation of a Consiglio Maggiore (Great Council) that would involve all responsible citizens, as many as 1,500 or more per session, was first proposed by the jurist Paolantonio Soderini, although firmly opposed by many *ottimati*, or aristocrats.[8] Ten days later Savonarola broke the deadlock by throwing his authority behind the reform. The people responded at once, marching through the streets in processions, loudly

demanding the formation of a council, which took place before the end of that year.

There was no space large enough to contain the new assembly, so a structure would have to be built. In the spring, ground was broken behind the palace to lay the foundations for a major addition that would be connected to the old council chamber, today called the Sala del Duecento. Although Vasari names Leonardo, Michelangelo, and Giuliano da Sangallo as contributors to its design, none of them was in Florence at the time. In 1497 the *operai* of the palace confirmed that for two years Antonio da Sangallo, Giuliano's nephew, had been working as the architect to their great satisfaction, and that the exterior construction was almost completed.[9] The second working phase, during which the Great Council Hall was furnished, lasted from 1497 to the summer of 1502. Luca Landucci praises the quality of the woodwork used for the galleries, benches, and platforms of the magistrates and council members. The hall extended the entire width of the Palazzo della Signoria. An irregular rectangle, oriented north to south, its end walls were not precisely parallel, owing to the irregularities of the streets below. One entered the hall from the level of the council chamber in the palace through a door at the north end of the long west wall. The visitor's attention was immediately drawn to the great east wall, opposite, which was dominated in the center by a raised dais, crowned by a loggia. Here the gonfaloniere sat in the midst of the eight *signori*, or priors.

Under the new constitution, the Republic's highest offices were assigned by lottery, and the selected citizens served very short terms. The gonfaloniere of justice, literally the city's standard-bearer, held the position for only two months and was required to sleep in his office—to symbolize that he served the people, not himself. These and other safeguards against the concentration of power in too few hands worked only too well. Inexperienced men were often obliged to face critical problems at home and grave dangers from beyond their borders. To remedy this problem, and others, including the paralyzing conflicts between the social classes represented in the Great Council, the Florentines suddenly went to the opposite extreme. In the autumn of 1502 Piero Soderini was elected *gonfaloniere a vita*—for life. In such precarious times, the bestowal of any office for so long a term seemed almost ominous.

Soderini inherited the oversight of two religious commissions that were legacies of Savonarola. One of the friar's last acts had been to lay the plans for a chapel on the west wall of the Great Council Hall. A contract in May 1498 assigned the altarpiece to Filippino Lippi. The painting was to represent, on a canvas more than four meters (thirteen feet) high, the Madonna and Child

attended by the patron saints of Florence and "all the saints on whose days the city was victorious."[10] An ornate gilt wood frame, designed by Lippi, was completed by Baccio d'Agnolo in June 1502.

That same month, the Signoria engaged the services of Andrea Sansovino for a life-size marble statue of the Savior. The sculpture was intended to stand on the loggia above the seat of the gonfaloniere. Sansovino had been passed over for the marble statue of David, but not many months afterward the *operai* of the Duomo approved his design for a sculptural group of the Baptism over the south door of the Baptistery. The *Savior* was desired, Sansovino's contract explained, because Florence was freed on St. Savior's day, November 9, 1494. Savonarola had ratified the connection in a rousing sermon in which he announced, "Our new leader is Jesus Christ. He wants to be your king."[11] The new Republic proclaimed the day a perpetual holiday. Sansovino received a small down payment, but the block of marble didn't arrive in Florence until the last day of 1503.[12]

Soderini was vexed by delays. At the turn of the new year, the war to recover Pisa was going badly. He wanted these decorations as embellishments to the government's public face—which, ideally, would boost the general morale. The preview of Michelangelo's *David* had raised his hopes immensely, but the brilliant young man seemed to be the only artist capable of keeping to a schedule. Leonardo da Vinci was closeted at the city's expense in the papal apartment of Santa Maria Novella and so far had nothing to show for it. His subject, the Battle of Anghiari, was chosen to commemorate an embarrassingly distant memory—the last major Florentine victory in 1440. No one doubted Leonardo's genius—indeed, Machiavelli, now Soderini's chancellor and protégé, was constantly pointing it out—but he had a bad reputation for dragging things out. Soderini's ears would have pricked up upon hearing that one of the proposals aired for the location of the *David* was in fact "in the middle of the council hall."[13] Ultimately, though, the marble colossus better served the government's purpose standing in front of the palace. Matters were not improved when Filippino Lippi died in April without ever touching his brush to the altarpiece.

By May 1504, having seen no progress in six months, Soderini and his priors moved to pressure Leonardo by binding him to a contract. "Considering that . . . these Lords desire the work completed as soon as possible," the contract began, "Leonardo will have to finish the entire cartoon completely by next February 1504 [1505], no exception or excuse accepted. . . ."[14] The contract was signed in the presence of Machiavelli, who had drafted it

after delicate negotiations with the two parties. On the one hand, the art-
ist's compensation schedule was carefully worked out—a monthly stipend
of fifteen large gold florins. On the other hand, the full-scale cartoon for the
fresco, whose precise dimensions and location in the hall unfortunately are
not specified, absolutely had to be finished within eight months. All sorts of
subtle tweaking to accommodate Leonardo's unprogrammable lifestyle were
admitted. For example, "It could be the case that Leonardo would consider
it proper to begin painting on the wall of the hall the part he had drawn on
the cartoon,"[15] in which event, since he would be engaged (at long last!) in
painting the wall, Soderini agreed to extend the cartoon's deadline. No one
else was to be permitted to paint the wall from Leonardo's drawing.

Almost as soon as this agreement was reached, another postponement
intervened. This time it was Soderini who had other purposes for Leonardo.
A year had passed since Machiavelli had broached da Vinci's plan to divert the
Arno and bring to an end the miserable war with Pisa. Soderini had tirelessly
lobbied the skeptical Signoria to authorize the expense of men and money.
The linchpin of his argument was that besides depriving the Pisans of water
and thereby compelling their surrender, the diversion would give Florence
a direct link to the sea. Leonardo estimated the trading income to be gained
would amount to 200,000 florins a year.[16] He filled pages of his notebooks
with charts and maps of the terrain. He figured the diversion channel to be 9.1
meters (30 feet) deep, 1.6 kilometers (1 mile) long, 24.4 meters (80 feet) wide
at its mouth, and 19.5 meters (64 feet) wide where it entered the sea near a
marshy saltwater pond called Stagno. It is a proof of Soderini's power of per-
suasion—and of his faith in Leonardo—that the parsimonious Florentines
were talked into a scheme that would give pause to modern engineers, let
alone two thousand men equipped with shovels.

That the hardheaded Florentines overlooked the impracticality of this
scheme underscores their desperation to end the war. Soderini staked his
career on it. The loss of Pisa through Piero de' Medici's blundering had hurt
more than civic feelings. Florence owed its position as one of Italy's five
great powers to its conquest of Pisa in the previous century, as a result of
which it had acquired a seaport. While the Pisan rebellion persisted, Florence
was losing revenues and other cities under Florentine rule might seek to
follow suit. A significant factor contributing to the political machinations
was the number of *ottimati* who owned property in or near Pisa. Among
these families were the Ridolfi and Capponi, the Rucellai and Nerli, the
Salviati, and the Soderini as well.

In the euphoria of late August 1504, as the Signoria gave the orders to move a million tons of earth, it suddenly occurred to Soderini and Machiavelli that Michelangelo was a talent to keep employed in the civic service. With Leonardo called away indefinitely, and still no signs of progress on his painting, it was only prudent to demonstrate the government's ongoing commitment to the Great Council Hall—and better yet with a masterstroke of public relations. The Gonfaloniere for Life approached the sculptor of the *David* with the commission to paint a war mural to stand beside Leonardo's. Only Florence could command such a concentration of genius. Five centuries later, their civic-minded head-to-head competition is considered a turning point of the Renaissance.

The subject chosen, unsurprisingly, was a historic Florentine victory over Pisa centered on the Arno River. The Battle of Cascina, which took place on July 29, 1364, began unheroically, and was very much a case of victory snatched from the jaws of catastrophe through the gallantry of one man, the Florentine captain Manno Donati. Observing his troops seeking a break from the summer heat by bathing in the river, Donati sounded a false alarm that brought his solders running from the water. The earliest accounts differ as to whether Donati's test took place on the eve of the battle or was a real call to arms in the face of a surprise attack. In either event, the outcome was the same; the enemy attempt to catch the Florentines off their guard resulted in a Pisan rout.

Michelangelo had done nothing whatsoever as a painter. The two unfinished altarpieces in Rome were a deep, dark secret. He had not touched the fresco medium since Ghirlandaio's workshop, where, as a tender apprentice, he probably was only allowed to carry buckets. Accepting the commission shows more plainly than anything else what an exalted idea he had of his own capabilities. Nor could he resist the opportunity to compete with the greatest living painter. Leonardo's *Last Supper* was the *David* of Milan. If Leonardo was painting one wall of the Great Council Hall, he wanted to paint the other. We can only imagine how this news was received by the procrastinating master from Vinci.

The contestants in this artistic battle could not have been more dissimilar. Leonardo still turned heads for his fiery eyes and magnificent beard. Now fifty-two, Leonardo's beautiful, silvery hair gave him a regal, almost leonine bearing. Personal beauty and social genius had fed his addiction to luxury. He traveled with a retinue, which included Salai, a seductive young man whom he had raised as his ward. Nature repaid Leonardo, Vasari felt, by showering him with favors. Vasari was told by those who saw him that "Leonardo was

so pleasing in his conversation that he won everyone's heart and although he owned nothing and worked very little, he always kept servants and horses; he took special pleasure in horses as he did in all other animals, which he treated with the greatest love and patience. And passing by places where birds were sold, he would often take them out of their cages, and after paying the price that was asked of him, he would set them free in the air, restoring to them the liberty they had lost."[17]

Their workplaces were emblematic of their differences. Leonardo requested and was granted the Sala del Papa (Hall of the Pope) in the monastery of Santa Maria Novella, where in former times popes and kings were entertained.[18] Michelangelo chose to underscore his lineage by locating his studio behind his family's parish church of Santa Croce. In this unstylish neighborhood, near the Porta della Giustizia, the city gate through which criminals were led out to be executed, the wool dyers, or *tintori,* had built a hospital for its infirm members and orphans of the guild.

On September 22 the Sala dei Tintori (Hall of the Dyers) in the hospital of Sant'Onofrio was given to Michelangelo as a studio.[19] A room large enough to unwind bolts of cloth in was easily adapted to accommodate the full-scale drawings for the fresco. He requested, and was granted, the barest of furnishings: tables, chairs, some trestles on which he could stand to paint the upper reaches of the cartoon once it was mounted on the wall. The furniture was installed and paid for by November. Michelangelo was given the ancient key to the building, which no one entered without his permission. No one was invited to see him working.[20]

At summer's end, the reports filtering back about the dig at Pisa were initially perplexing and then decidedly discouraging. On September 21 Machiavelli expressed his concern to the site engineer about his departures from Leonardo's original plan. Specifically, the engineer was digging two canals instead of one. The chancellor's letter reflected his consultation with the master himself, who was greatly concerned that the canals would not be deep enough to divert the waters in a new direction.[21] A flood in the Arno had filled the newly dug ditches. Then, ominously, the water had flowed backward. The barricade constructed to narrow the river was irreversibly deepening the channel faster than the Florentines could dig. The river waters would not divert into a canal with a shallower bed. Meanwhile, Pisan efforts to harass and obstruct the project obliged the Signoria to dispatch a thousand soldiers to guard the canals. Early in October, the site was struck by a violent storm. Several Florentine ships guarding the mouth of the Arno were wrecked and eighty lives were lost. The

walls of the ditches collapsed. The Arno diversion was abandoned. A report on the failure prepared by Machiavelli's assistant Biagio Buonaccorsi noted that the preliminary estimates of the time and labor required had been too low by half. More than seven thousand ducats of public funds had been wasted.[22]

The cost in political capital was also extreme. Many of Soderini's supporters, especially those *ottimati* who had arranged his election, lost faith in his direction. Machiavelli was even more vulnerable, as his term as chancellor would soon expire and his renomination was far from certain. Immediately after the collapse of the Arno diversion, Machiavelli suddenly received several weeks of unscheduled leave from his post.[23] He used this time to write his poem "First Decennale," which paints a rosy picture of the history of Florence since 1494.[24] The important contributions of Alamanno Salviati, the powerbroker who had made Soderini and now held Machiavelli's future in his hands, are highlighted throughout. Leonardo was sent on a diplomatic mission to Piombino on the southern Tuscan coast. Perhaps Machiavelli thought a cooling-off period for the unsuccessful inventor was in order. Sending Leonardo away until well into December was unfortunate in its timing so close to the February deadline for the *Anghiari* cartoon.[25]

· · ·

BEFORE HE PAINTED, BEFORE HE SCULPTED, MICHELANGELO COULD draw. At fourteen he drew better than Ghirlandaio—not, perhaps, the sheen on satin folds in which his master specialized, but his copies of Giotto's and Masaccio's human figures were altogether more compelling, and weightier, than anything drawn by the brothers Domenico and Davide Ghirlandaio. Michelangelo wasn't interested in the surface appearance of things anyway. After entering the Palazzo Medici, he had sat at table with the philosophers at the court of the Magnifico —Ficino, Poliziano, Pico della Mirandola, and Lorenzo himself—who believed, on Plato's authority, that pictorial illusion was a form of falseness (albeit a most seductive one). Plato would have banished painters from his republic. Michelangelo's mentors were not opposed to art, however, as long as it was beautiful. Ficino taught a Platonic Christianity in which the contemplation of human beauty incited love, and only through love could the soul aspire to know the divine.

The ancients held the perfectly proportioned and posed male nude to be the highest subject of art, although Greek and Roman sculpture was

obviously not averse to representing Venus and other beautiful women. Since the classical age, no one had felt as certain as Michelangelo of "the godlike character of the male body"—"and held it for something divine."[26] With his Platonic cast of mind, Michelangelo transforms the human body into ideal forms that retain hardly any trace of the studio model. His fascination with the male nude was born perhaps of sensual love, but the naked body, as he drew it, is an idea not found on this mortal coil.

Not by coincidence, Michelangelo opted for a mural that gave him a pretext to paint the male nude. When Soderini proposed, or agreed to, the Battle of Cascina, a fourteenth-century victory over the hated Pisans, it is doubtful that he envisioned that the central scene would feature the episode of Florentine soldiers stripping off their armor on a hot summer day and going for a swim in the Arno. It was at that moment that the Pisans attacked, but the Florentines rallied in time to rout their enemies. As with the *David*, Michelangelo was left free to interpret the story on his own terms. It seemed to everyone watching that the emphasis on the soldiers' muscularity was meant to display the knowledge gained from the dissection of human cadavers, especially because he was competing against Leonardo, who specialized in such research. Within a few years, a popular anecdote claimed that Michelangelo had accidentally cut up the corpse of a deceased Corsini. The outraged family had raced to Piero Soderini in protest, but the gonfaloniere, or so the story goes, was amused by the incident and defended the artist's right to improve his skill.[27] Rather than deny such rumors, Michelangelo did all he could to make them part of his myth. He approved, for example, when Condivi wrote that he did so many human dissections that it made him ill and he often thought of writing a treatise as a service to artists.[28] (Thirty years after Leonardo's death, he was still competing with him.)

Strictly anatomical drawings by Michelangelo of the kind that show the skin peeled away to expose the underlying bone and tissue are rare, however. His concern, after all, was to delineate the contours of active muscles, not lifeless flesh. The soldiers' physiques, although ultradeveloped, did not require knowledge gained from subcutaneous explorations. Instead, the evidence shows that he drew upon his profound observation of both living people and classical sculpture. One of the best-known drawings for his *Cascina* fresco is preserved at the Albertina Museum in Vienna.[29] It is a study for a soldier in the last row of the bathers on the riverbank. Viewed from the back, he is lifting a lance. But the main purpose of this figure is to display a cascade of rippling muscles that, if encountered on the street, would attract the stares of passers-by.

The least of Michelangelo's concerns was to paint a chronicle of the battle that took place in 1364. The scene of the bathers would presumably be one of several sections of the mural, perhaps the middle of three, which by some estimates was expected to be 45 meters (148 feet) long. Michelangelo drew some sketches of fighting horsemen that some believe were connected with the Cascina project, but no studies for a panoramic battlefield are known. From the beginning he concentrated his effort on the bathers, which he related to the Florentine theme of battles between nude men. His huge mural in the Great Council Hall would be the definitive culmination of the tradition previously dominated by Antonio del Pollaiuolo.

Another contemporary point of reference was Signorelli's recently completed fresco of nude men and women on the walls of the Brizio Chapel in the cathedral of Orvieto. Michelangelo knew Signorelli as a master whose realistic paintings of the nude were highly prized at the court of Lorenzo il Magnifico. His subject at Orvieto, which Michelangelo would have seen on his journeys between Florence and Rome, was the resurrection of the flesh, a metaphysical event occurring outside of time and place. If Signorelli could paint naked people in a chapel, Michelangelo could do the same in a hall of the Soderini government. It would not have happened under Savonarola. The importance of Signorelli's precedent has always been noted. Michelangelo surpassed his colleague, however, by indicating to the spectator that the massive figures are arrayed in a kind of screen that blocks our vision of the fighting breaking out some thousand feet away. The effect would have been cinematic, like panning across a crowded foreground in a movie.[30]

The *Battle of Cascina* is the first work of Michelangelo's career for which a number of preparatory studies have come down to us, perhaps ten in all. These represent but a small fraction of the hundreds he must have made for the composition as he conceived it in the autumn of 1504: nineteen male figures, all nude, and a pair of hands emerging from the river. He would have needed many studies to perfect each figure before transferring them to the final cartoon. This handful of original drawings is all we have to confirm the breathtaking quality of the cartoon, which was never used and later cut into fragments, all of which are now lost. Michelangelo was ruthless or, perhaps more accurately, deliberate about discarding his preliminary drawings. He never affords us a glimpse of the evolution of his ideas. To judge from his surviving sheets, the forms sprang from his mind complete and whole. He does not typically experiment with three positions of an arm or leg; he prefers to draw the figure again. Michelangelo never seems hasty in his thinking.

Like the sonnets fitted into empty corners, his sketches rarely show canceled parts. He was as economical with ideas as he was with paper.

The earliest studies for the soldiers contain an interesting example of an idea that he examined intensely but ultimately rejected. The nucleus of a trio of soldiers was a noble youth with outstretched arm that he adapted from the *Apollo Belvedere*. Michelangelo transformed the pose of this famous antiquity, which was in the collection of Pope Julius II in Rome. Standing on a piece of cloth gripped by two nude companions, Apollo became a kind of sentry alerting his comrades to the Pisans' surprise attack. Michelangelo worked this out in various drawings now in the British Museum and in the Uffizi, Florence.[31] The pose of the supporter to the right of the Apollonian figure was derived from one of the two famous Horse Tamers, the *Dioscuri*, on the Quirinal in Rome. This fascinating group was perhaps intended as an homage to the new pope, but he was ultimately unable to work it into the composition.

A drawing in the Uffizi shows a middle stage in his thinking about the bathers. Although many of the figures he would use in the full-scale cartoon are discernible amid the teeming profusion of male torsos, heads, and limbs, the action is different. In this sketch the soldiers surge away from the riverbank, desperately pointing at the enemy's arrival in the rear. Michelangelo subsequently settled on an arrangement in which the soldiers mill about, dressing themselves and looking in different directions. Several lean over to pull their comrades out of the water. Perhaps this new emphasis on the river ditch was an irreverent dig at Leonardo over the Arno debacle.

One has the impression that Michelangelo worked in inverse order from the norm, concentrating on single motifs that he later assembled. At least four drawings, including the Albertina sheet just mentioned, are so highly finished that they must represent the final consideration of the figure before its enlargement in the cartoon.[32] In each case, remarkably, Michelangelo leaves unfinished any part of the figure that would be covered in some way and not seen in the painting. His drawings often show his unusual capacity to isolate and elaborate details as if the rest of the body were visible to him on the blank page. Although the body may twist and turn in space, even exaggeratedly, Michelangelo maintained its separate integrity by enclosing the figure in a single continuous outline. The British Museum drawing for the man seated in the center foreground who rotates 180 degrees to look back over his shoulder is an extraordinary example of this technique. On the last day of October 1504, Michelangelo's studies were complete.

• • •

> The bearer of this letter will be Raphael painter from Urbino, who having good skill of his profession, has decided to stay for some time in Florence to learn. And because his father was very virtuous and dear to me, so therefore his son is a well-mannered and charming youth; for these qualities I love him completely, and I desire that he should attain a good education; I highly recommend him to the Signoria, as much as I can, asking you out of your love for me that in any of his needs it would please you to lend him every assistance and favor.[33]

Thus Raphael was introduced to Piero Soderini in October 1504.[34] His patron, Giovanna Feltria della Rovere, was the mother of Francesco Maria della Rovere, the designated heir to Guidobaldo Montefeltro, duke of Urbino.[35] She was also the sister-in-law of Pope Julius II, who had wrested Urbino away from Cesare Borgia and restored the hereditary duchy. Raphael Santi, or Sanzio, was a favorite son of Urbino. His father, Giovanni Santi (ca. 1440–94), had been the principal painter at the Montefeltro humanist court established at Urbino by Federigo da Montefeltro. Giovanni Santi moved easily in the highest social circles and possessed the culture to compose "La Cronaca," a poem about Italian arts and letters. In his estimation, the two greatest masters of "the new generation" were Piero Perugino and Leonardo da Vinci. Only eleven at his father's death, Raphael stayed on in the workshop until he was old enough to be sent to study with Perugino. By 1500 he had already obtained the status of *magister*, enjoying a solid client base in Urbino and nearby towns in Umbria. He signed his works "Raphael Urbinas" as a way of vaunting his attachment to a glorious court.

Michelangelo knew of him without being impressed. Raphael came to Florence that autumn by way of Siena, where he had assisted Pinturicchio in the lavish decorations of the Piccolomini Library. Michelangelo's sculptures were being installed just outside the entrance. Pinturicchio, the favorite painter of the Borgias, was at the height of his fame in June 1502 when Cardinal Francesco Todeschini Piccolomini engaged him to paint ten episodes of the life of Enea Silvio Piccolomini, Pius II (1405–64). His contract stipulated that he would personally execute the frescoes, but it was an open secret that Pinturicchio had immediately availed himself of a nineteen-year-old prodigy, Raphael. Several of Raphael's original drawings are preserved,

and they are superior in quality to Pinturicchio's execution of them. The older master could not resist prettifying Raphael's solid forms. Their collaboration resulted in a glittering ornamentation with an emphasis on pageantry that looked back to the previous century. The prestigious venue was a professional step in the right direction for the young genius, who, however, knew that the future lay in Florence.

Raphael had learned Perugino's style to perfection. Indeed, even Vasari, an expert at attributions, thought that no one would believe his *Crucifixion*, executed in 1503 for the church of San Domenico in the Umbrian town of Città di Castello, was by Raphael and not Perugino, "if his name were not written on it."[36] Every detail, from the sweet expressions of the heart-shaped faces to the gentle Umbrian hills in the distance, is modeled on the master. Though Raphael's time with Perugino is not confirmed by documents, the apprentice's hand has been detected in predellas and other secondary parts of the master's paintings between 1497 and 1500. And though Perugino would live and work prolifically until 1520, these years marked the pinnacle of his fame. In 1500, no less a collector of the first order than the banker Agostino Chigi described him as the most eminent Italian painter. Perugino had maintained a house and studio on Borgo Pinti in Florence since 1493. As a sign of his standing among the Florentines, he had been included in the deliberations over the installation of the *David*.

Like his master, Raphael opted for an itinerant career, accepting commissions wherever offered. This strategy was facilitated by his genius in personal relations. He was *gentilezza stessa*—amiability itself—says Vasari.[37] The next year, when required to note on a contract the venues where he could be called to judgment in case of a legal dispute, the twenty-two-year-old painter listed the following cities: Perugia, Assisi, Gubbio, Rome, Siena, Florence, Urbino, and Venice.[38] Despite his youth, he was already friends with Baldassare Castiglione, the courtier par excellence and future author of the *Cortegiano*. In July 1504, while Raphael was in Urbino, Castiglione remarked to his mother that he had lent his best lance to *maestro Raphaello depintore*, presumably so he could copy it in his painting *St. George and the Dragon*.[39]

"He was as delighted by the city of Florence as by the works of Leonardo and Michelangelo, which he considered divine, and he decided to live there for a while, having become friends with some of the young painters, Ridolfo Ghirlandaio, Aristotele San Gallo, etc."[40] The workshop of Baccio della Porta, soon to be known as Fra Bartolomeo after taking Dominican orders, was a popular meeting place for artists and their patrons. Raphael

expanded his acquaintances there, making friends very quickly, even to a certain extent with the intractable Michelangelo, who sometimes stopped by. The warmth of his personality was unusually complemented by his serious aspirations to improve his art. Almost at once, it seems, Raphael understood that he would have to come to grips with the situation unfolding in Florence and liberate himself from his provincial style. True to his habitual method of learning, he first immersed himself in the thought of his friend Fra Bartolomeo. Vasari says he took from him perspective and a greater harmony of color, but only the latter observation is true. Raphael's formation under the lingering influence of Piero della Francesca in Urbino gave him a sense of spatial clarity second to none. A small fresco representing the Trinity and Benedictine saints (San Severo, Perugia) is the first evidence of his exposure to Florentine painting. He took as his model Fra Bartolomeo's *Last Judgment,* painted in 1501 with Mariotto Albertinelli for the Hospital of Santa Maria Nuova, specifically copying the saints and patriarchs throned in Heaven and emulating their massive volumes, while awkwardly retaining the disproportionately small heads typical of Perugino.

Raphael drew assiduously to improve his draftsmanship. His study sheets include motifs from the paintings and sculptures of such Florentines as Donatello, Masaccio, Signorelli, Ghirlandaio, Botticelli, and Filippino Lippi. Among his first tasks was to come to terms with Michelangelo's *David,* transforming it according to his own vision, as great artists will. Raphael's training in anatomy was woefully deficient compared to Michelangelo's or Leonardo's. Neither his father nor Perugino had any interest in the subject, leaving him ill equipped to render the tense muscles from which Michelangelo extracted his forcefulness. When Leonardo drew the *David* he instinctively corrected the expressive liberties, making the body more natural.[41] Raphael's best drawing of the statue shows it from the back, the contours softened to emphasize its gracefulness.[42]

Leonardo was an acquaintance who probably became a friend, as he gave the young artist access to his drawings and paintings, including the unfinished *Mona Lisa.* The older master's influence was already visible in the works of Fra Bartolomeo, and now the youth was able to absorb it directly. He proceeded quickly to supplant his simple forms with the more sensuous and classically conceived models of Leonardo. Raphael was deeply impressed, moreover, by Leonardo's variations on the theme of the Madonna and Child with St. Anne. "The Madonna and Child became the vessel into which most of Raphael's creative thought was poured."[43] In picture after picture Raphael developed what

in Leonardo was an innate instinct, the desire to pose his figures with an abso-
lute geometrical clarity, usually based on a triangle.

For his part, Michelangelo despised Perugino's repetitiveness and
assumed that if he simply ignored Raphael, he would go away. If he gave the
young man any thought at all, he considered him an annoying and exces-
sively ingratiating painter of Madonnas. No doubt because he was already
fully formed when he was Raphael's age, Michelangelo did not foresee his
evolution or remotely imagine him as a rival. This misapprehension would
soon prove irksome.

• • •

EARLY IN SEPTEMBER 1944 TWO GERMAN OFFICERS VISITED THE
church of Notre Dame in the occupied city of Bruges, Belgium. Since the
beginning of the war, the church's greatest treasure had been placed in a spe-
cially constructed shelter in the north aisle. Michelangelo's marble sculpture
of the Madonna and Child was accessible upon request, and a number of
Nazi authorities had at various times received permission to see it.[44] Seeking
out the sacristan, the officers warned him that the statue should be better
protected, but they knew more than they said.

A few days later the bishop of Bruges appeared at Notre Dame and
instructed the sacristan to have the shelter sealed at once. It was too late in
the day to begin the work, however, and that night the sacristan was abruptly
wakened by two uniformed Germans accompanied by a squad of armed
sailors. They demanded entrance to the cathedral; he took them instead to
the dean. The officers produced their orders to remove the *Bruges Madonna*
without delay. The somber party proceeded to the nave. The windows were
covered, armed men were placed on guard outside, and the statue was
removed by the light of hand torches. Instead of crating their precious cargo,
they wrapped several mattresses around it and loaded it onto a Red Cross
truck. Several valuable paintings, including a *Crucifixion* by van Dyck, were
also carted away. After a safe interval, a distorted account of this clandes-
tine operation was leaked to the London press. The *Daily Express* carried the
story on October 17, 1944. Here it is in its entirety:

> The Germans sent 45 crack troops and an art expert to get
> pictures by Michael Angelo and Van Dyke just before the Allies

entered Bruges, German radio said yesterday. It added two points: "The German Army has decided to safeguard these treasures for Europe."[45]

The looting of the *Bruges Madonna* was a war crime.

It was the second time the sculpture had been removed from Notre Dame since its arrival in 1506. During the Napoleonic invasions, the French included the *Bruges Madonna* in its wagon trains of war booty destined for Paris. The piece was restored to its home in 1815. The work had been commissioned directly from Michelangelo by a noble family of Flemish cloth merchants named Mosaren (Mouscron in French) for their family chapel in the cathedral.

Carved from a single block of Carrara marble, the life size figures of the Virgin and her Child are thematically and formally united in a compact composition. Mary sits impassively on a roughly hewn plinth with her right hand on a closed book. Her left foot is slightly raised on a rock, while her knees compose a kind of throne for her son, who somberly steps down from her lap. The Madonna enthroned, holding a book, with her Child next to her womb, represents the *Sedes Sapientiae,* the Seat of Wisdom. Michelangelo knew an important precedent in Florentine sculpture, the *Madonna Sedes Sapientiae* by Tino di Camiano, a contemporary of Giotto. Carved about 1320 for a tomb in the cathedral, the Gothic group inspired the downward gazes and the Child's animation in the *Bruges Madonna.* Michelangelo invented a new iconography, however. The Christ Child leans for reassurance on his Mother's thigh as he begins to take a first step. Their hands join in a clasp that will soon be released. In human terms he is about to walk on his own; theologically he is the *Logos,* the Word (also translated as the Wisdom) descending from heaven.[46]

The Madonna and Child are entwined together in a way that Leonardo da Vinci first explored in his large drawing of 1501, which Michelangelo evokes in order to reject. In both works the Child leaves the sanctuary of his mother's lap. But in Michelangelo's version Mary makes no attempt to restrain him from the mission foretold in her prayer book. Her eyes are heavy and almost closed. Heinrich Wölfflin, the nineteenth-century *Kunsthistoriker,* said, astonished, "This is a Mary that one can hardly speak to."[47] Perhaps the explanation for her emotional reserve lies in a reference to Dante's *Rime petrose,* four long poems addressed to a woman of quasi-divine beauty. It is her indifference to the poet that makes her a *donna petrosa* (woman of stone).[48]

The Virgin's love for her child is not in question; her self-restraint makes her exemplary of virtuous stoicism in the face of pain.

The Mouscrons paid Michelangelo an initial fifty ducats on account of a total of one hundred on December 2, 1503. His work on the piece thus overlapped with the final stages of the *David* and his initial planning for the *Cascina* mural. Despite his pending commitments and travel to Rome in early 1505, the sculpture was ready for transport in August of that year, with the Mouscrons agreeing to the construction of a wooden case. A few artists, most notably Raphael, saw the work before it was shipped away in 1506. The *Bruges Madonna* is not mentioned in the 1550 edition of Vasari, and it is wrongly described by Condivi as in bronze—an error that Michelangelo did not correct. But Albrecht Dürer made a point of admiring it during his visit to Bruges on April 7, 1521.[49]

Most of the important art looted by the Nazis was sent to Schloss Neuschwanstein, Adolf Hitler's favorite castle in southern Germany, to be inventoried and photographed. If restoration was necessary, the art was sent to the monastery at Buxheim, but if it was ready for storage, it was taken to the salt mine above the small town of Altaussee, about 121 kilometers (75 miles) southeast of Salzburg, Austria. The Altaussee storage rooms were located more than a mile inside the mountain, inaccessible except by a tunnel through which an engine drew eight small flatcars. There were seven sections called *Werke*, each consisting of several vaulted chambers filled with racks to accommodate thousands of paintings. Hitler's plan was to construct a new Führer-Museum at Linz.

On or around April 10, 1945, only a month before the final German surrender, the service train carried eight cases marked "marble, don't drop" into the heart of the mountain. As the porters withdrew, they unwound fuses from the boxes through the tunnel. A few days later, a professor from the Vienna Art Museum who was employed as a specialist in the Altaussee and Laufen mines, received a piece of disconcerting intelligence. Unknown to his employers, he worked with the resistance movement, which had learned from reliable miners that the boxes marked "marble" contained explosives. Rather than surrender the treasures to the Allies, the Nazis had resolved to blow up the mine.

From September to November 1944 Belgium was the scene of major fighting by the First Canadian Army, the largest fighting force that had ever been under the command of a Canadian general. Two Canadian divisions landed on the beaches of Normandy, France, on D-Day, June 6. After the victory at

Normandy was sealed in August, the Canadians were given the crucial tasks of pushing eastward through France, clearing the coastal areas, capturing the launching sites of German rockets targeting England, and opening the Scheldt River, gateway to the Belgian port of Antwerp. More than 7,600 Canadian soldiers died during the ensuing liberation of France and the Netherlands. On September 6 an armored division crossed the Franco-Belgian border and overcame the German defenders at Ypres. The next day the Canadian tanks reached Roulers, 24 kilometers (15 miles) north of the town of Mouscron. Turning north toward Bruges, the Canadians arrived at the Ghent canal. The Germans had destroyed all bridges in an attempt to slow the Allied advance toward Antwerp and the Scheldt. Under heavy fire and enemy mortars a narrow bridgehead was established and the canal was crossed. Outflanked, the Germans were forced to withdraw from Bruges. On September 12 the 4th Canadian Armored Division, assisted by the 2nd Canadian Infantry Division's 4th Brigade, entered the city amid cheering crowds.[50]

For more than a year, the Allies had been preparing for the liberation of Europe. As early as 1941, President Roosevelt had recognized that lives would be put at risk during the rescue and preservation of artistic and historical monuments. At the dedication ceremony of the National Gallery of Art in Washington on March 17, 1941, he spoke of "the world's great art and all of science" as "symbols of the human spirit, and of the world the freedom of the human spirit made—a world against which armies now are raised and countries overrun and men imprisoned and their work destroyed."[51]

In August 1943 Roosevelt established a commission to oversee teams of experts in Monuments, Fine Arts and Archives to accompany the Allied advance across Europe. One of the MFAA officers attached to the Canadian First Army was killed by enemy artillery fire on March 10, 1945, while engaged in art salvage work at Cleves, Germany. Two MFAA officers, Lt. Cdrs. George Stout and Thomas Howe, entered the Alt Aussee mines on Victory in Europe Day, May 8, 1945. Hitler's plan to blow up the repository had been thwarted. The miners had cut the long fuses and used some of the explosives to seal the entrance to the shafts. Stout and Howe were immediately led to the treasure trove containing the *Ghent Altarpiece*, Vermeer's *Astronomer*, the bust of Nefertiti, and Michelangelo's *Bruges Madonna*.

• • •

LEONARDO CAME BACK TO FLORENCE WITH HIS CONFIDENCE INTACT despite the incredible pressures now facing him. The Arno debacle would never be forgotten, he knew that, but the *Anghiari* fresco would save his reputation. The mission to Piombino had cost two months he could hardly afford; on the other hand, it refreshed him for the work ahead. Despite his youth, Michelangelo could not be taken lightly—the *David*'s creator was Sculpture personified. But by any standard, Leonardo da Vinci was Painting.

Resuming work in the Sala del Papa at Santa Maria Novella, he realized it would take all his energy to compete with Michelangelo. Proceeding at his normal rate, that is, as if pursued by demons, Michelangelo had somehow pulled abreast of the older man despite his late start. The Signoria had purchased and delivered to each artist hundreds of sheets of sturdy paper suitable for painting, and hundreds of pounds of flour for making glue.[52] The city sent papermakers to glue the sheets together into a single immense cartoon, perhaps 11 meters (36 feet) long. The height of the mural must have been about a third of its length, since Michelangelo's trestles stood four braccia, or 2.4 meters (8 feet), above the floor.[53] From December 1504 until February 1505, Florence was witness to the most intense artistic competition in history. Leonardo could not allow himself to be overtaken. Michelangelo could not bear to lose.

In Machiavelli's original suggestion, the victory frescoes of these great artists would be a boost to the young Republic's morale—and that was before the canal disaster. Soderini's beleaguered government was glad for the distraction. But for the artists, the tension was unbearable. Supremely confident in his own genius, Leonardo handled it well, turning his age to his advantage by assuming the role of mentor and dean of Florentine artists. Fra Bartolomeo and Raphael were only the most gifted of those who sought his advice at dinner or in the piazza. That these same artists would someday comprise a commission of peers to judge the frescoes was not lost on this strategic thinker. Vasari gives a long list of the artists close to Leonardo, while Michelangelo had only Granacci. Instead of inspiring confidants, Michelangelo struggled to contain his temper. Once, Leonardo was enjoying an amiable discussion concerning some lines from Dante when he noticed his rival walking nearby. "Let's ask Michelangelo," he said. "We all know his devotion to the Poet." Not appreciating his tone—or perhaps misreading it—Michelangelo rudely told him to mind his own business.[54]

Poor Perugino, prolifically working in his old-fashioned style, came in for the brunt of Michelangelo's hostility.[55] Michelangelo's mockery reached the point—calling him a "clumsy fool" in front of witnesses, Vasari says—that

Perugino sued in court to make him stop.[56] Although Leonardo was more prac-
ticed at maintaining his composure, he also felt the stress. Passing by to col-
lect his monthly stipend, he was given his pay in copper coins, but Leonardo
pushed them back, asking the cashier, "Do you take me for a penny-painter?"[57]

By February 1505 the *Anghiari* cartoon was complete enough to satisfy his
contract. None of his studies for the whole composition, destined to cover
three times the length of the *Last Supper*, has survived, so posterity has had to
rely on guesswork ever since. From what is known, Leonardo seems to have
distilled the sprawling panorama of the battle that took place on June 29, 1440,
into a single dominant centerpiece representing the Florentine captains fight-
ing for a standard.

A long stretch of the east wall of the council chamber was prepared for
painting that spring.[58] "On 6 June 1505, a Friday, at the thirteenth hour [since
the last sunset, that is, 9:30 A.M.], I began to paint in the palace." And that was
as far as he got before Nature intervened. Leonardo recorded what followed
with his usual detachment. "I was just picking up my brush when the weather
took a turn for the worse and the church bells rang the alarm. . . . The cartoon
began to come apart. The container of water suddenly broke, spilling water
everywhere. Suddenly the weather grew worse still, and it poured with rain
until evening; the day had been transformed into night."[59] Someone supersti-
tious would have been struck by this succession of ill omens, but Leonardo
proceeded notwithstanding.

The events of the Florentine triumph over the Milanese troops led by
the fearsome *condottieri* Francesco and Niccolò Piccinini are recorded in dis-
patches sent back from the battlefield and in chronicles, including one later
written by Machiavelli, who had chosen the subject for Leonardo in the first
place. The battle spilled back and forth on the plain of Anghiari between
Arezzo and Borgo San Sepolcro at the foot of the Apennine Mountains.
The point of contention was a bridge across a stream flowing into the head-
waters of the Tiber River. Three years earlier Leonardo had drawn a map
of this same strategic area for Cesare Borgia. But none of the topographical
details made it into the final conception.

Instead, he proposed to immortalize a colossal apparition of men and
horses, locked together in murderous rage. The observation that the *Battle
for the Standard* resembles an inextricable knot—one of Leonardo's obses-
sions—goes as far back as Vasari, who used Leonardo's own word for knot,
that is, *gruppo*.[60] No one knows what Leonardo saw in knots: according
to Vasari, he used to "waste his time" filling pages with them.[61] Six knots

resembling labyrinths were engraved after his death and inscribed ACADEMIA LEONARDO VINCI. Centuries before topology, Leonardo compared the swirling flow of water to the braiding of hair, evidence that the principle of the knot was embedded in his scientific as well as his artistic thinking.[62] Leonardo's knots have also been read as encrypted signatures of his own name, as a *vincolo* is a chain or knot.[63]

Unlike his knots, however, Leonardo's *Standard* is composed of men and beasts, not geometry, and his subject is grounded in history. Yet most observers of his composition find its combatants indistinguishable—none of its motifs point specifically to Anghiari. "It would be impossible to express the inventiveness of Leonardo's design for the soldiers' uniforms," praised Vasari, making a virtue out of something almost inexplicable in a commemorative. The action swirls in a furious vortex of tangled swords, biting horses, anguished faces, and thrusting spears. Rather than chronicle a past event, Leonardo appears to have dedicated his painting to the most serious subject deliberated in the Great Council Hall—war—and regrettably often at that. The *Standard* cannot have been intended as a criticism of war, which was, after all, a bulwark of Florentine foreign policy. For some centuries the city had both defended itself through arms and retained its possessions, like Pisa, by superior military means. For his part, Leonardo was an avid engineer of fortifications and high-tech weaponry. The *insania belli* (madness of war) discussed by Virgil in the *Aeneid* is a vice attributable to the irrational aggression of one's enemies. But to resist attacks, to come to the rescue of city and populace, is a virtue praised in the highest terms by both Aristotle and Virgil. Indeed, in several instances the *Aeneid* commends the strength that heroes derive from their sense of anger. In a Christian context, Paul, a Roman soldier before he was an apostle, declared, "Be angry but do not sin; do not let the sun go down on your anger."[64] The fifth circle of Dante's inferno was reserved for those who could not control their anger.

• • •

HAVING SPRINTED TO CATCH UP TO LEONARDO, MICHELANGELO'S progress inexplicably slowed after December 1504. For the author of the *David,* the opportunity to project his beautiful bodies into dimensions larger than life should have been pure pleasure. Yet by the end of February it was Leonardo who had completed his cartoon and was overseeing preparations

Old St. Peter's Basilica, ca. 1450, according to a reconstruction by H. W. Brewer, 1891, engraving.

Anonymous 19th-century artist, after a late-15th-century painting,
The Execution of Savonarola. Galleria Corsini, Florence.

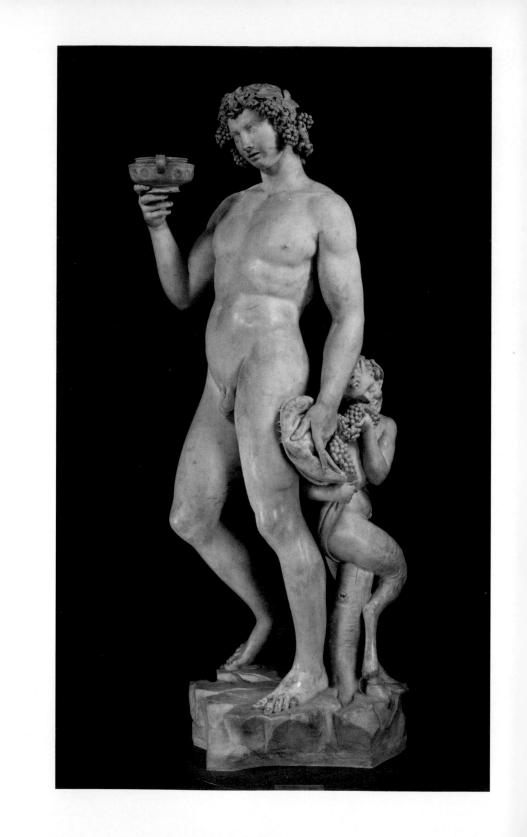

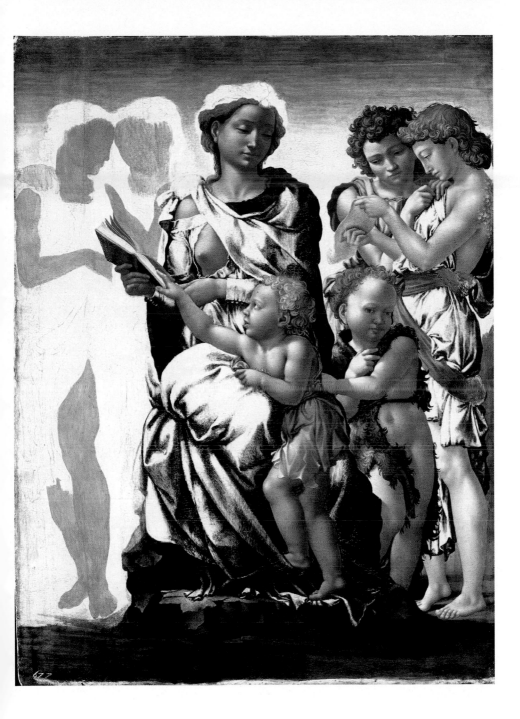

OPPOSITE: Michelangelo Buonarroti, *Bacchus*, 1496–97,
marble. Museo Nazionale del Bargello, Florence.
ABOVE: Michelangelo Buonarroti, *Manchester Madonna*, 1497,
tempera on panel. National Gallery, London.

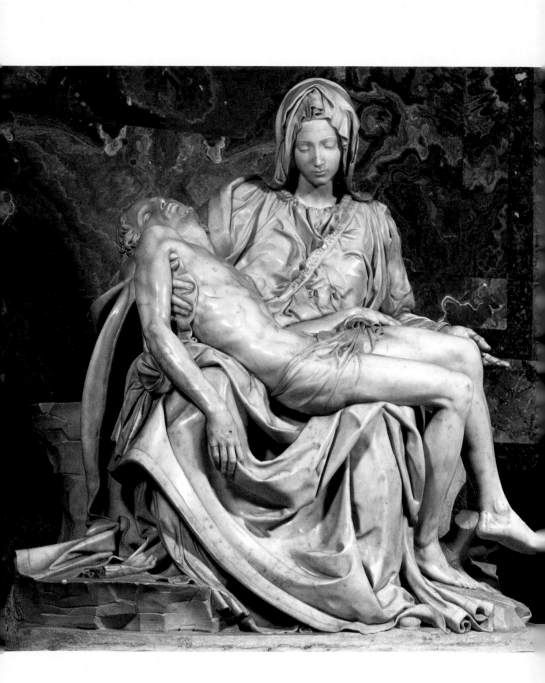

Michelangelo Buonarroti, *Pietà*, 1498–99, marble. St. Peter's Basilica, Vatican.

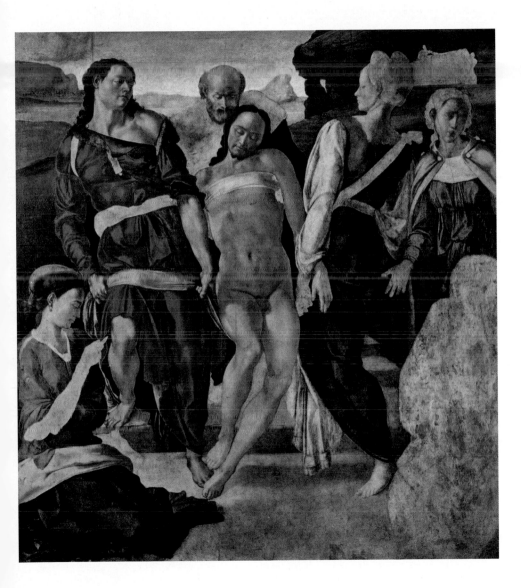

Michelangelo Buonarroti, *Entombment of Christ*, 1500, tempera on panel.
National Gallery, London.

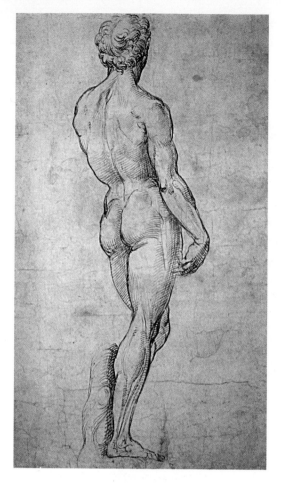

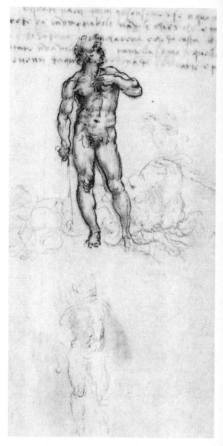

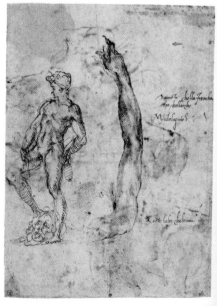

ABOVE LEFT: Raphael, *Study of Michelangelo's David*, 1505, drawing. British Museum, London.
ABOVE RIGHT: Leonardo da Vinci, *The David of Michelangelo, with Variations*, 1504–5, drawing. Royal Library, Windsor Castle, U.K.
RIGHT: Michelangelo Buonarroti, *Sketch for the Bronze David and Other Studies*, 1502. Louvre, Paris.
OPPOSITE: Michelangelo Buonarroti, *David*, 1501–4, marble. Galleria dell'Accademia, Florence.

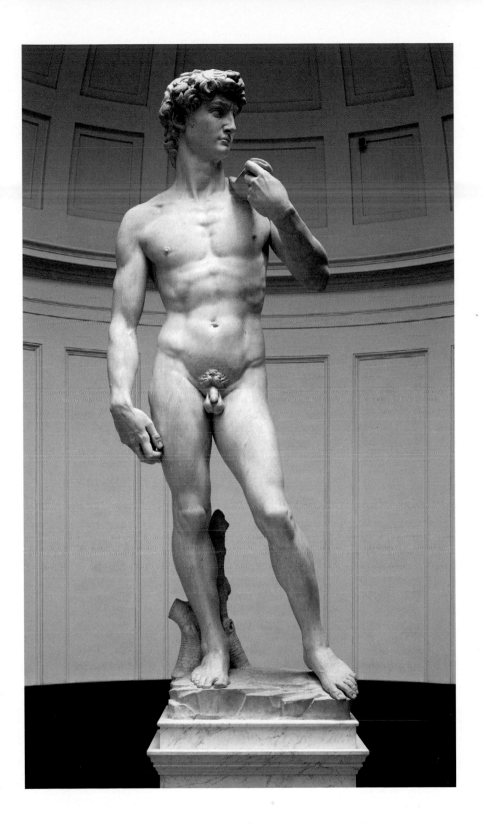

FRAN·PICCOLOM·CAR·SENEN· PII·II·PONT·MAX·NEPOS·

OPPOSITE: Piccolomini altar. Cathedral of Siena.
RIGHT: Melozzo da Forlì, *Pope Sixtus IV Appoints Bartolomeo Platina Prefect of the Vatican Library,* ca. 1477, fresco. Pinacoteca, Vatican. Platina kneels before Pope Sixtus IV; Raffaele Riario is to the pope's right; Giuliano della Rovere stands before the pope; Girolamo Riario and Giovanni della Rovere are behind Platina.
BELOW: Michelangelo Buonarroti, *Study for Battle of Cascina,* ca. 1504. Albertina, Vienna.

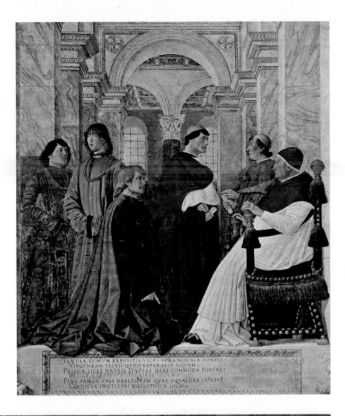

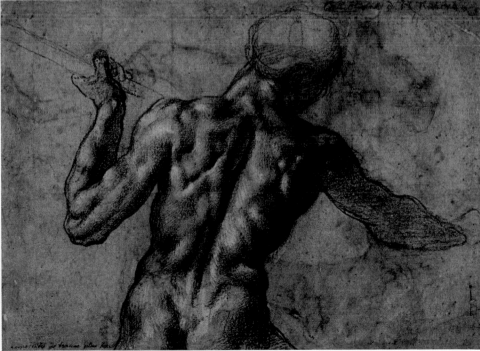

ABOVE: Luca Signorelli, *Resurrection of the Dead,* 1499–1502, fresco. Duomo, Orvieto.
BELOW LEFT: Santi di Tito, *Portrait of Niccolò Machiavelli,* 16th century,
oil on canvas. Palazzo Vecchio, Florence.
BELOW RIGHT: Altobello Melone, *Portrait Allegedly of Cesare Borgia,* n.d.,
oil on canvas. Accademia Carrara, Bergamo.
OPPOSITE: Michelangelo Buonarroti, *Bruges Madonna,* 1504–5,
marble. Church of Our Lady, Bruges, Belgium.

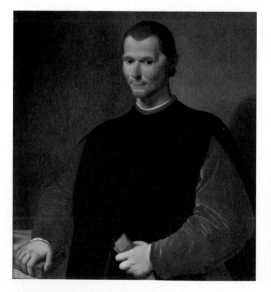

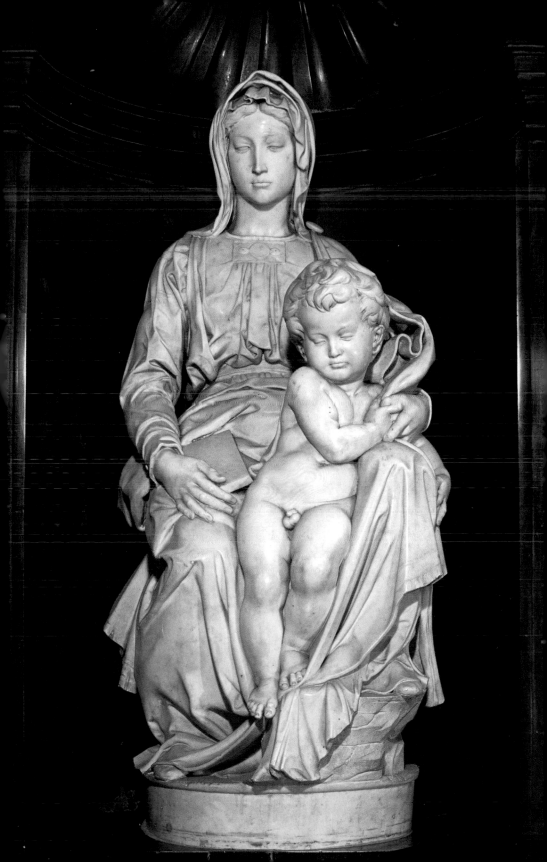

Peter Paul Rubens, *Battle of Anghiari,* after Leonardo da Vinci, 1603, drawing. Louvre, Paris.

Aristotele da Sangallo, *Battle of Cascina*, after Michelangelo's cartoon, ca. 1542.
Holkham Hall, Norfolk, U.K.

RIGHT: *Laocoön*, 1st century B.C., marble. Museo Pio Clementino, Vatican.
BELOW: Michelangelo Buonarroti, *Taddei Tondo,* ca. 1504, marble. Royal Academy of Arts, London.

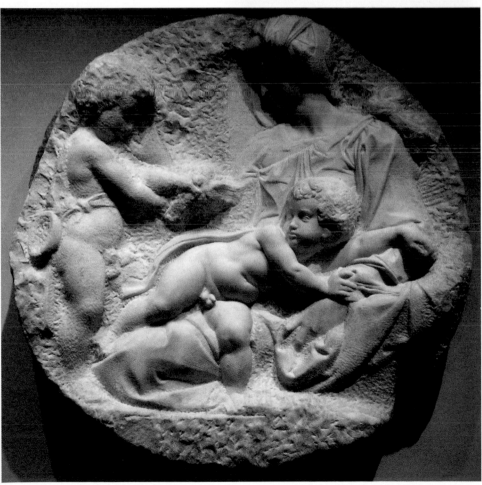

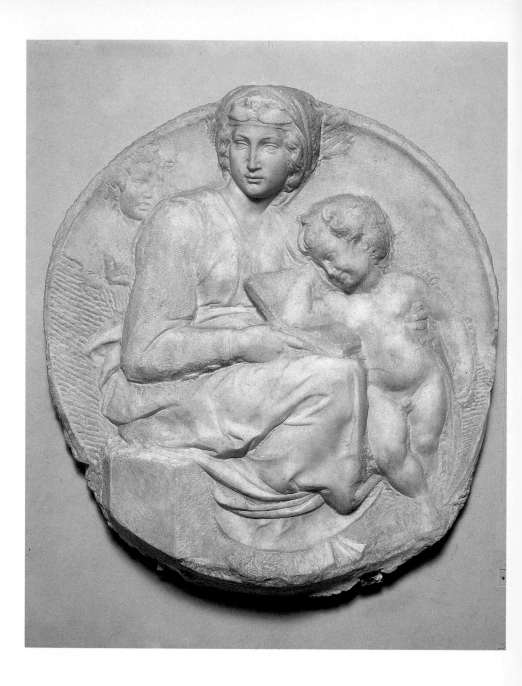

ABOVE: Michelangelo Buonarroti, *Pitti Tondo,* ca. 1505,
marble. Museo Nazionale del Bargello, Florence.
OPPOSITE: Michelangelo Buonarroti, *St. Matthew,* 1506,
marble. Galleria dell'Accademia, Florence.

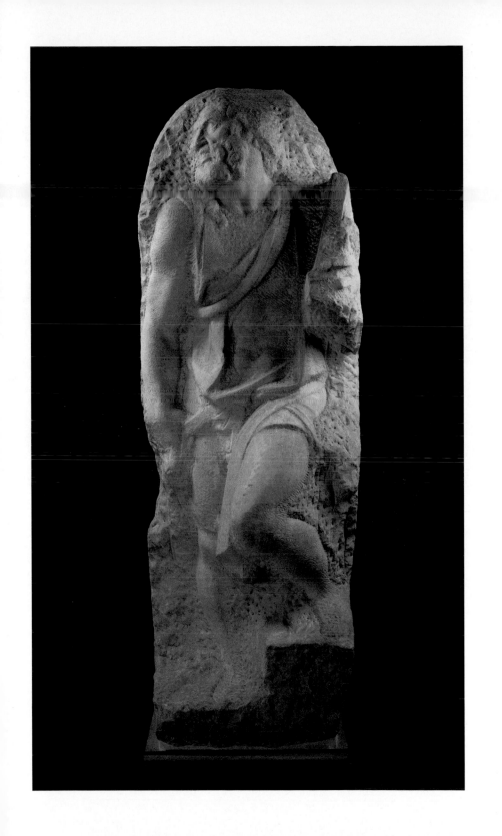

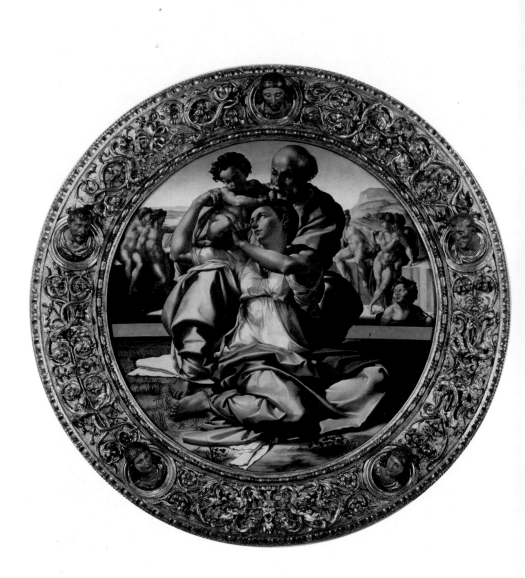

Michelangelo Buonarroti, *Doni Tondo,* ca. 1506, oil and tempera on panel. Uffizi, Florence.

of the wall inside the Sala del Gran Consiglio. The outlines of his *Battle* would be transferred by pinpricks to an intermediary cartoon in order to preserve his breathtaking original. Michelangelo, ever secretive, kept his *Cascina* out of sight. On February 28 the Signoria paid him forty florins "to paint the cartoon," which, however, he now had no intention of doing.[65]

Gonfaloniere Piero Soderini might well have asked about Michelangelo's plans. His intense young friend had accumulated commitments that would occupy years, accepting interim payments and then showing little interest in carrying through. The Piccolomini tomb was a case in point: Michelangelo had done nothing since signing a new contract. Nor did Michelangelo seem to care if Soderini was embarrassed by his delays. His commission for apostle statues for the cathedral of Florence—one a year for twelve years—was barely moving forward. Twenty months after he and the Signoria reached agreement, the first block was finally delivered to the house the Signoria was building for him in the street called Borgo Pinti. The original intention was for Michelangelo to go to Carrara to select the marble, but he had not. When the block arrived in January 1505, he ignored it.[66] Yet still more pressing was the constant irritant of the bronze *David* promised to Pierre de Rohan, the maréchal de Gié. The Signoria had been under pressure for almost four years to deliver this gift to one of Florence's best friends at the court of France.

Unbeknownst to Soderini, Michelangelo had already turned his back on the *Cascina* fresco.

On the day before the granting of another forty florins, Michelangelo had carried nine hundred large gold florins to Santa Maria Nuova and opened an account. The largest hospital in Florence was also the city's largest bank. Nine hundred florins represented his earned savings to date—a small fortune for a thirty-year-old, an unimaginable sum for an artist.[67] He left instructions that in the event of his death, the money was to be paid to his father, or, if his father was deceased, to his surviving brothers. In the meantime, putting it in the bank would keep it away from their inquiring eyes.[68]

This transaction was an unmistakable preparation for a departure, which in hindsight we know was imminent and would be to Rome. The events leading up to this precipitous change in plans are completely unknown, no doubt because they transpired in secret. In 1550, lacking firsthand information, Vasari assigned the responsibility to Pope Julius II. It was safe for Michelangelo's biographer to assume that Julius, contemplating his tomb, was suddenly inspired to summon him. Vasari's version became the tradition after it was confirmed and embellished by Condivi, who wrote, with Michelangelo's

approval, "After the death of Pope Alexander VI, he was called to Rome by Pope Julius II, and he received a hundred ducats in Florence for his travelling expenses."[69] The statement is indisputably true, down to the last ducat, which Michelangelo was paid in Florence on February 25, 1505.[70] He went to the bank every day that week. But it was not true, as Condivi goes on to state, that the pope extended the invitation in 1503, a curious error that Vasari respectfully inserted in his second edition.[71]

Francesco da Sangallo, the son of Giuliano da Sangallo, wrote later that it was his father who first recommended Michelangelo to Pope Julius.[72] In his long and distinguished career in architecture Giuliano had served both Lorenzo de' Medici and Cardinal Giuliano della Rovere. Soon after della Rovere's election as pope, Sangallo had raced to Rome to reenter his service. The friendship between Michelangelo and Sangallo, who was his senior by thirty years, must have dated back many years, although the earliest record is Sangallo's witness to the 1503 contract for the twelve apostles for the cathedral.

Certainly Sangallo recommended him. And others were involved as well, most notably Alamanno Salviati, a wealthy banker in Rome, Pisa, and Florence, the powerbroker who had helped make Soderini's career and now hated him. It was Salviati who informed Michelangelo on February 21 of the pope's agreement to pay a hundred Cameral ducats towards his travel expenses,[73] and it is Salviati who is revealed in a later letter as Michelangelo's conduit to the pope's treasurer and confidant, Bishop Francesco Alidosi.[74] A hundred florins was remarkably generous, considering the pope had yet to meet him. It was roughly equivalent to his fee for the *Bruges Madonna*, and about half his profit on the *Pietà*.

The facts are by no means contradictory; they only lack a connective thread, which would be, of course, Michelangelo himself. No one would urge an imperious pope like Julius to extend his favor to a headstrong artist like Michelangelo unless the artist had already consented. Indeed, given the extraordinary circumstances of this moment, we may well assume that it was his own idea. If the call to Rome was not a bolt from the blue but something he had orchestrated, we then must ponder the motivation for such a drastic step. This particular point has been glossed over, beginning with Vasari, as it is hardly comforting to think that it might have been a craven desire for richer patronage that induced him to flee the contest with Leonardo and betray Soderini.

One event looms large in early 1505: Leonardo's completion of his design for the *Battle for the Standard*. Michelangelo's reaction to his rival's

painting is not recorded, but his own *Cascina* is an excellent window into his thinking at the time. He had assumed that Leonardo would dazzle the world with his celebrated knowledge of anatomy, human as well as equine. Completely confident in his own ability to draw the human form, the *Cascina* was Michelangelo's calculated response to that challenge. As many muscular men as Leonardo might draw, Michelangelo had pushed to give us twenty, each individually studied.

What Michelangelo had not anticipated was the possibility that Leonardo's mastery of painting would make a difference. He had not viewed the competition as confined to *painting,* a medium in which his accomplishment amounted to two abandoned attempts. He approached the contest thinking like a sculptor, even though competing with the most celebrated painter in Italy. He envisioned the *Cascina* composition like a marble relief, leaving no space between the soldiers or distance behind them. The perplexing croppings in his figure studies, the arms and legs that simply go flat, were mostly places that would be overlapped. The nude bodies were modeled from their outlines toward the viewer. He ignored the painter's tricks for drawing illusionary figures in the round.

Leonardo paid him no attention. Nothing the younger man had ever done came close to his own ambitions of pushing the art of painting to a dynamism never seen before. The *Battle for the Standard* turned in space, it moved the air. Is it a coincidence that this was the period of Leonardo's fascination with flying machines? The *Cascina,* by comparison, looked like a petrified forest of statues. Leonardo transformed a battle piece into a gripping statement on the power of anger. Michelangelo's design was not nearly as innovative, albeit a tour de force. The *Cascina* was stuck in the old debate on drawing nudes, obviously influenced by Signorelli's new frescoes in Orvieto, and ultimately nothing more than a new edition of Pollaiuolo's *Battle of the Nude Men.*

Although it has never been connected with Michelangelo's departure, there is every reason to suspect that the *Battle for the Standard* discouraged him to the extent that his only thought was to flee the city as soon as he could find an excuse. He would never come close to touching a brush to a wall in the Great Council Hall. Years later, he allowed Condivi to shift the date of his journey to Rome to 1503—a year earlier than the *David*—thus wiping the calendar clean of this episode. Condivi sings the *David*'s praises, and the *Cascina*'s, in isolation: he never mentions a competition with Leonardo. Vasari refers to it in both editions, but never ventures to say who won. One fact is certain. By March, Michelangelo was in Rome.[75]

. . .

A MEETING WAS ARRANGED WITH THE POPE, PRESUMABLY IN PRIVATE audience, as no particulars of it were recorded by witnesses, nor was it noted in the diary kept by Paride de' Grassi, the Vatican's gossipy master of ceremonies.[76] Although Condivi writes of tiresome weeks waiting for this appointment, the calendar tells us differently. Michelangelo must have been ushered in straightaway, because between March and April he had time enough to meet the pontiff, gain his confidence, learn his plan, submit a project, and have it approved. His way was paved by excellent recommendations, but the only person whose presence was indispensible at each of his meetings was Giuliano da Sangallo.

Sangallo occupied a unique position as the one person in the world who was friend to both Michelangelo and the pope. Sangallo had worked for Julius II when he was cardinal of San Pietro in Vincoli, but his relationship went deeper than being his favorite architect. After Piero de' Medici's expulsion, Sangallo left Florence and entered the cardinal's service, first fortifying his palace in Ostia, then accompanying him to France when he took refuge from the Borgias in 1495. They shared the bond of exiles in a foreign land. While traveling to and from France in 1496, he supervised the addition of a grandiose façade and vestibule for the Palazzo della Rovere in Savona, the small town near Genoa where his patron was born of poor and obscure parentage.[77]

Sangallo was a self-taught antiquarian, and this passion was one of the pillars of their friendship. During his uncle's long pontificate, Cardinal della Rovere indulged his taste for Greco-Roman antiquities and restored the churches and religious buildings under his jurisdiction. The *Apollo Belvedere* was discovered on one of his estates and thereafter displayed in the garden of the palace he constructed around the church of SS. Apostoli. Sangallo was a diligent notetaker, filling notebooks with sketches of every Roman monument that crossed his path. While in Provence he found many antiquities to draw.

By 1497 Sangallo was back in Florence, resuming his status as the leading architect in the region, if not all of Italy. Despite having twice as many years as Michelangelo's thirty, he and the sculptor shared a bond as Florentines formed in the house of Lorenzo de' Medici. There were ample opportunities for Sangallo to be helpful after Michelangelo's return from Rome—witnessing his lucrative contract for the cathedral apostles, for one. Sangallo raised his voice in favor of changing the *David*'s destination from the Duomo to the

central square, declaring it "a public monument." According to Vasari, it was Sangallo who helped engineer the harness that safely cradled Michelangelo's *David* across the city to its final position in front of the Palazzo della Signoria in 1504. That operation had cemented their trust.

The election of Giuliano della Rovere as Pope Julius II in 1503 brought with it the promise of major commissions. Sangallo hastened to Rome; within a year he had completed an elegant loggia in the Doric style in the Castel Sant'Angelo and was working on two projects, including a villa, for Francesco Alidosi, whom he had met during his exile in France.[78] Alidosi was Julius's most intimate advisor, a fact underscored by Machiavelli in his reports during his mission to the papal conclave.[79] In 1505 Sangallo transferred his residence, and family, to the papal city, which in itself would have encouraged Michelangelo's desire to follow. Sangallo's friendship was extremely important to Michelangelo, who was accustomed to the assistance and recommendations of influential men. It is not clear that he placed any more credit in their advice than he did in his own father's. But the recent death of his guardian angel, Jacopo Galli, left him disturbingly on his own. The circumstances were utterly different from nine years earlier, when his first negotiation with a churchly prince, Cardinal Riario, had been to make a plea for his *Cupid.* This time he was summoned by Riario's cousin, the pope.

It is fair to say that Julius II's entire life had been devoted to the single objective of filling Sixtus IV's chair, as though the throne of St. Peter were a birthright. Giuliano della Rovere had professed as a Franciscan friar, like his uncle before him. Soon after his election in 1471, Sixtus brought his nephews to Rome and bestowed cardinal's hats on three of them: Giuliano della Rovere, Pietro Riario, and Raffaele Riario, the cardinal of San Giorgio.[80] These hot-blooded kinsmen were the war council Sixtus consulted before consenting to the Pazzi plot to assassinate the Medici.

Of all the passions of Julius II, the strongest was that for building. This, too, was an inheritance from Sixtus IV, who became known as the *gran Fabbricatore,* the "Great Builder," so vigorous were his efforts to transform medieval, dilapidated Rome into a capital city. As Cardinal Giuliano, he assisted his uncle's feverish preparations for the Jubilee celebrations of 1475, which included the construction of new churches. When Sixtus IV proceeded to build the chapel that bears his name, he entrusted its walls to Florentine painters, notwithstanding his antipathy toward their city. They were the best he could find in Italy. The frescoes of the Sistine Chapel were all completed within a few years; the parallels between Moses and Christ were its predominant theme.

On August 15, 1483, his cardinal-nephew Giuliano presided over mass in the chapel. Among his other reasons for hating the Borgias was their wasting of the Jubilee year of 1500—and depriving him of the opportunity.

Within months of his election, Julius II revealed the scale of his architectural aspirations. He desired to unify, if possible, the scattered papal residences on the north side of St. Peter's, and he entrusted this huge task not to Sangallo but to Bramante, an architect who had shown signs of a gift for thinking monumentally. Originally trained as a painter and architect at the court of Urbino, Bramante, whose Christian name was Donato d'Angelo, was nearly sixty years of age, having already made a career at the court of Ludovico Sforza before being driven away from Milan, like Leonardo da Vinci, by the French invasion. During the winter of 1499 Bramante came to Rome in search of patronage. He at once took advantage of his unemployment to immerse himself in the monuments, even dashing off a four-page pamphlet for classically minded tourists. "Le Antiquarie prospettiche romane" (Roman Antiquities in Perspective) appeared in time to profit from the Jubilee, signed with a pseudonym that left no doubt as to the author: the so-called "Prospettico melanese depictore" (Mr. Perspective, a painter from Milan).[81] Inside were still more hints of this kind, most notably a dedication to his friend Leonardo, whom he "yearns" to see, using the verb *bramare*, recalling his nickname, which means "ravenous." Bramante was indeed ambitious, and his service to Il Moro had honed his diplomatic skills. His major design to date was the Tempietto, a small, circular temple inside the cloister of San Pietro in Montorio, on the site of the apostle Peter's crucifixion. Ringed by heavy columns, the exquisitely proportioned Tempietto is not a literal copy of antiquity and yet is unsurpassed for Roman gravitas. Now Bramante's assignment from Julius II was to connect the old Vatican palace with the Villa Belvedere to the north, a distance of a thousand feet on a rising slope.[82] By the time Michelangelo arrived in Rome, the Belvedere hill was enclosed in a massive building site that would eventually yield gardens, courtyards, porticos, and an open-air sculpture loggia fit for a Christian emperor.[83]

A passionate desire for posthumous glory was a leading motive for men of the Renaissance, whatever their calling. The example of antiquity—and of Roman eulogies—taught that great men became immortal through either words or monuments. As Dante unforgettably writes in the *Inferno*, it is through fame that man can make himself eternal: "come l'uom s'etterna."[84] Not by chance, the taste for monumental tombs adorned with sculptures advanced in lockstep with the progress of Renaissance humanism.

Until the fifteenth century, nearly a hundred popes had been laid to rest beneath the floor or in stone chests and sarcophagi placed at random in or around the Basilica of St. Peter's, which was built above the apostle's simple shrine.[85] The tomb of Eugenius IV (1383–1447) in the church of S. Salvatore in Lauro inaugurates the tradition of using architecture—either a temple front or a triumphal arch—to frame a portrait statue of the pontiff accompanied by sculptures of the Madonna, angels, and saints. The erection of such a tomb for a pope or cardinal very often provided the impetus for the reconstruction of the apse or chapel in which it was placed.

The precedents that most interested Julius were those of his own family, monuments to which, indeed, he had personally attended in varying degrees. By the time of his election, the venerable church of S. Maria del Popolo, rebuilt in 1472, had evolved into a curial mausoleum for the Sistine papacy. Julius set Bramante to work on a choir for the church, already the resting place for five of his uncle's cardinals. The apse of SS. Apostoli served as the funerary chapel for the highest ecclesiastics of the Riario and della Rovere families. Sixtus IV's favorite nephew, Pietro Riario, had been the cardinal protector of the Basilica of SS. Apostoli until his premature death in 1474, only fourteen months after his election. Grief-stricken by this tragedy, Sixtus had the apse of the church restored and commissioned a grandiose tomb. At Sixtus's death in 1484, Cardinal Giuliano looked to Florence for suitable masters, eventually selecting the sculptors Antonio and Piero del Pollaiuolo to design and erect his uncle's tomb in the same church. Shortly before the work was finished some nine years later, Rodrigo Borgia was elected pope and Giuliano could not attend its dedication. These events no doubt influenced Julius II's resolution to project his own tomb without delay. Selecting Michelangelo over his two architects was perhaps a foregone conclusion, once Julius had seen his remarkable sepulchral statue for Cardinal Bilhères, the *Pietà*.

· · ·

AFTER A THOUSAND YEARS, ROME WAS ONCE AGAIN CALLED THE *Eternal City*.[86] The myth of Roman everlastingness had been given timeless voice in Virgil's *Aeneid*, only to shatter with the sack of Rome in 410. In Palestine, Jerome, translator of the Bible and lover of Latin literature, wept bitter tears at the news: "Who could believe that Rome, erected on the conquest of the whole world, would fall to the ground?"[87] Occurring only thirty years after Christianity's designation as the official imperial religion, the

collapse was blamed on the new and foreign faith by many unconverted pagans. In his parish in Hippo in North Africa, Augustine responded forcefully in his masterpiece, *The City of God,* demolishing the pagan culture of Rome and absolving Christianity.[88]

Though banished, the mystique of Rome was still alive a thousand years later. An insignificant event of 1498 may be taken as a sign of the times. A marble slab uncovered during an excavation in the Roman Forum, near the church of Santa Maria Nuova, bore the words URBIS AETERNAE. The discovery excited an outburst of civic pride, although stones with old inscriptions were as common as weeds.[89] What had kept the legend alive?

Augustine wrote to bury Rome and yet could not refrain from praising Romans. Insistently quoting Cicero and Virgil, even to refute them, ensured their survival. Throughout the Middle Ages, the *Aeneid* was the most beloved book in Latin, apart from Scripture, notwithstanding its subversiveness. The saintly writer Gregory of Tours (ca. 538–94) admitted as much, grumbling in his *Glory of the Martyrs,* "We ought not to relate its deceitful fables, lest we fall under sentence of eternal death."[90] It was Dante who finally undermined the old church fathers, boldly declaring that tumbledown, dirty, thirteenth-century Rome was the same "imperio senza fine" of which Virgil sang.[91] To underscore the point, Dante chose Virgil to shepherd him through the *Inferno.*

The *Divine Comedy* brings together the whole sprawling welter of medieval contradictions about Rome and declares them pages in a single story: the Rome of the *Aeneid* is the Rome of *Acts*; the Rome of the Caesars, the Rome of martyrs; the Rome of Minerva, the Rome of Mary; Rome, the Great Whore of Babylon (in *Revelation*), and Rome, the triumphant new Jerusalem. Far from far-fetched, Julius II's self-identification as a Christianized Julius Caesar, personifying *romanità* and *cristianità*, had solid foundations—admittedly not the Latin fathers, but definitely the national poets.

None of these things needed saying, of course; they were fully understood by both pontiff and sculptor during the discussions that resulted in the remarkable proposition that Michelangelo build for Julius II a papal mausoleum that would surpass in "beauty and pride, richness of ornamentation, and abundance of statuary, every ancient Imperial tomb."[92] In his contract, which is lost, Michelangelo promised to complete the tomb entirely within five years. Its huge dimensions precluded construction inside St. Peter's ancient basilica, in proximity to the apostle's tomb and surrounded by memorials of the greatest popes. A solution was needed and quickly found— by Michelangelo himself—at the basilica's very head.

In the absence of any Michelangelo drawings or letters from 1505, the outlines of his proposal must be pieced together from his biographers and a few other scattered sources. Condivi, the most informed, tells us that the pontiff would be laid to rest in a sepulchral chapel deep inside a massive structure with "four façades," that is, viewable from all sides, and rising three stories in terraced tiers. Access to the crypt would be through a door at ground level in the center of the front façade. The rectangular plan measured 12 x 18 braccia, a proportion of 2:3, which Condivi calls "a square and one-half." The front and rear façades would be more than 6 meters (20 feet) wide, and the two long sides more than 9 meters (30 feet) each, allowing for variations in the braccio standard.[93]

The effect, more imperial than papal, would be of a three-tiered pyramid teeming with statues. Catafalques of similar shape, like low ziggurats, appear on imperial *consecratio* coins from the second to the fourth centuries.[94] The coins commemorated the rite of consecration that transformed the deceased emperor, or his consort, into a divinity.[95] Other influences have been cited; evidently Michelangelo drew his ideas from a wide range of classical monuments, combining them in new and striking ways, just as he designed the *David*, which resembles no single model but parts of many.

The tomb of Julius would have greater sculpture than even the ancient Caesars, for it would be conceived by a sculptor whose like had never been known in Rome, neither for genius nor for ambition. The door marking the sepulchral chapel would be flanked by statues of slaves atop square plinths in front of the façade. The slaves comprised a series that was to continue around all four sides, alternating with terms—that is, square columns formed of half-length men—and niches with other sculptures, including richly figured bronze reliefs. The amazing spectacle would be "held together," as Condivi puts it, by an architectural cornice separating the ground floor from the second tier. Four great statues would command the corners of this elevation. Condivi names only the *Moses*; Vasari refers to a *St. Paul* and personifications of the Active Life and the Contemplative Life. The third and highest tier, some 6 meters (20 feet) above the ground, would display the pope's effigy in marble, reclining or sitting upright, between two angels.

A pyramid that rises in steps is a symbol of the soul's ascent toward God. Steps appear as benchmarks of intellectual development as early as Plato's *Symposium*, and as a passageway between heaven and earth at least from the time of Jacob's dream in the Old Testament.[96] From his early *Confessions* to the *City of God* of his maturity, and in innumerable discussions in between, Augustine

employs steps to demonstrate degrees of enlightenment and spiritual perfection.[97] Michelangelo's sculptures would visualize, in three monumental tiers, the Augustinian stages of the soul's progress from containment within the body toward its desired end, the eternal contemplation of the divine.

The tomb's ground level, which is the nearest and most clearly seen by us, is the level of mortality. Here the pontiff's body is preserved within the sanctuary, while the ranks of slaves on the tomb's exterior are exemplars of how the living body is ruled by the soul.[98] Michelangelo would complete only two slaves, some years later: the so-called *Rebellious Slave* and *Dying Slave.* Each is moved by a different state of soul.[99] Condivi calls these statues "Prisoners," and invokes the Neoplatonist repudiation of the body as the prison of the soul. But this harsh reading was neither Augustine's nor the young Michelangelo's. Augustine defends the unquestionable goodness and beauty of the body[100]— and so do Michelangelo's slaves, unforgettably. They are restrained by chains, *vincoli,* not as a punishment but as a sign of the body's submission to the soul's command. It was an ingenious solution, at once a metaphor for the union of body and soul, and, to those who would behold the tomb, the personal emblem of the deceased within, the cardinal of San Pietro in Vincoli.[101]

Augustine's concept of the ascent to God assigns a middle level to the departed soul, in which the human mind also partakes.[102] Accordingly, the tomb's second tier would be dominated by four great statues embodying ideas of the religious life, specifically Christian, but not exclusively. A symmetrical pairing of the prophet Moses and the apostle St. Paul was unprecedented and not adopted afterward in Christian art. Their most evident connection was of course as exemplars of the Old and New Law, respectively.[103] A deeper reading was proposed by Augustine. In considering one of his favorite problems, the extent to which God is knowable in this life, Augustine several times paired Moses and Paul as among the few who had experienced a foretaste of heaven in the instant they briefly stood face to face with God—Moses before a cloudy pillar; Paul, then called Saul, before a blazing light that blinded him for three days.[104]

Still more curious about the middle tier was the symmetry implied between the Scriptures and a pair of philosophical ideas, the Active Life and the Contemplative Life. The early church fathers identified two types of religious life on earth and named the wives of Jacob to personify them: Rachel, the contemplative life (often seen also as Faith, or *Fides*) and Leah, the active life (*Caritas*).[105] Michelangelo portrayed Rachel and Leah with these meanings for Julius's tomb, as it was finally executed in Condivi's time.[106]

Jacob, the son of the Old Testament patriarch Isaac, was commanded by his father to go to the land of his mother's brother, Laban, and there seek a wife. On his journey, Jacob dreamed: "and behold a ladder set up on the earth, and the top of it reached to heaven: and behold the angels of God ascending and descending on it" (Genesis 28:12–14). Jacob labored seven years for Laban, desiring to marry his daughter Rachel, but Laban tricked Jacob and gave him Leah, the eldest, as his wife. Jacob labored another seven years to marry Rachel, who bore him his son, Joseph. The moral of this story, for Augustine, was that the active life leads to the reward of the contemplative, "the toil of doing the work of righteousness precedes the delight of understanding the truth (which is in God)."[107] The idea of the necessity of both kinds of action would have been congenial to a warrior pope near the end of his life.

In Augustine's hierarchy, and Julius's plan for his tomb, the soul ascends in mystical steps that culminate in a *visio veritatis,* a mansion where the soul can rest in eternal contemplation of God.[108] Michelangelo was to visualize this invisible concept in a portrait sculpture of the pope, his tiara with three crowns the symbol of the papacy and of St. Peter. Two angels descended from Heaven to assist.

> One of these made a smiling face as though he were glad that the soul of the pope was received among the blessed spirits, the other a weeping one as though he were grieved that the world was deprived of such a man.[109]

Aflame with the desire "to build a mountain," as one Romantic poet put it, "above the Iron Pope, and a race of men to people it,"[110] Michelangelo hastened to Florence as soon as possible. Before departing, he met with Alidosi, recently promoted to the venerable bishopric of Pavia, to arrange the transfer of the pope's money.[111] He would need marble for at least forty statues, not to mention the mausoleum itself. Neither sculptor nor pontiff took pause at the pharaonic grandeur of the project or the impossibility of realizing it during the pope's own lifetime. Despite their age difference—Pope Julius was sixty; Michelangelo, thirty—and their similarly contentious temperaments, neither man could believe that anything he passionately wanted would be denied him.

In a letter of April 28, Alidosi instructed Alamanno Salviati to pay the artist a thousand Cameral ducats "in part payment for a tomb that he is obligated to make for his Beatitudine"—that is, the pope—"and to allow him to begin

purchasing the marble for said sepulcher."[112] Alidosi added that no security besides a signed receipt would be required of Michelangelo, as it was known that his personal means surpassed this sum. The pope had a reputation for parsimony, but in this circumstance he did not stint. The ultimate expense of the tomb was expected to approach ten thousand ducats, a king's ransom.

In closing, the bishop of Pavia delicately reminded Salviati of his responsibilities, pointing out that Salviati's recommendations of Michelangelo were the reason that Julius II was "content and at ease" in this affair. Michelangelo's chief credential, apart from his indisputable genius, was the extraordinary facility and promptness with which he had delivered the giant *David*.

Alidosi's letter was received in Florence on May 4. Three days later Michelangelo collected the money, but curiously, he did not depart at once for Carrara. Rather, he lingered until the end of June, when he redeposited six hundred large gold florins of the pope's remittance in his account at Santa Maria Nuova.[113] The two months gave him just enough time to make his excuses to Soderini, accept congratulations on his stupendous success in the Eternal City, and watch Leonardo paint the first strokes of his painting in the Great Council Hall.[114]

• • •

ONE DAY, AS MICHELANGELO STOOD ON A HIGH PRECIPICE LOOKING out at the vastness of the sea, he experienced a kind of delirium. Suddenly he was seized by a desire to carve the mountaintop into a giant colossus that would be visible from afar to seafarers. The impulse was so strong that he told Condivi about it five decades later. The urge came over him, he said, because of the rock and from his desire to emulate the ancients.[115]

The fantastical tomb that enthralled the pope had sealed his destiny as the greatest sculptor of all time. Now the *pietra viva,* living rock, of Carrara induced a dreamlike vision of competing with the colossal wonders of the pagan past. Perhaps he had in mind the Colossus of Rhodes, whose 30-meter (98-foot) height dominated the island and the view for miles in every direction until it was destroyed by an earthquake. Or perhaps he would best Dinocrates, the great Greek architect, who proposed to make Mount Athos into the likeness of Alexander the Great, holding a city in one hand and a vessel in the other from which the mountain waters would pour into the sea. The scheme was in his head and never left him. "He would certainly have

done it if he had had enough time or the project for which he had come had permitted. One day I heard him speak of this with great regret."[116] So Condivi sums it up, and Michelangelo confirmed, "This was a madness that came over me . . . but if I could have been sure of living four times longer than I have lived, I would have taken it on."[117]

Around this time, the Turkish sultan Bayezid II approached the geniuses of Florence, Michelangelo and Leonardo, regarding the construction of a bridge over the Bosphorus near Pera, on the Golden Horn. The bridge was to cross in a single span an arm of the sea more than 182 meters (200 yards) wide. Leonardo replied enthusiastically to the proposal, "I will erect it high as an arch so that a ship under full sail could sail underneath it." He made two sketches in his notebook, but his offer, impossible to construct with sixteenth-century engineering, was not taken up. The sultan approached Michelangelo "with most generous promises through the intermediary of certain Franciscan friars," and Michelangelo was sorely tempted.[118] He told this, too, to Condivi, and confirmed to his assistant, Calcagni, that indeed, he had gone so far as to build a model.[119] Again, it seems, the sultan balked. Leonardo's sketches were successfully realized in steel, however, in 2001, and today live on as a footbridge in Ås, Norway.[120]

While Michelangelo wandered the blindingly white quarries at the height of the summer heat and dreamed of besting the ancients, Leonardo set his sights on revamping the historical techniques of painting. The cartoon for the *Battle for the Standard* had been unveiled in February 1505; by June he was ready to start on the enormous expanse of wall. Only a few years earlier, in Milan, Leonardo had attempted to bend the time-honored techniques of fresco painting in *The Last Supper,* imbuing it with the sfumato effects he had achieved with oils on panel. Leonardo used a combination of techniques in *The Last Supper,* experimenting in situ. But all of them veered woefully off course. The painting, his masterpiece, had at once begun to deteriorate. For anyone less restless, *The Last Supper* would have sounded a cease and desist to further improvisations, especially as the scale of the new fresco was several times larger. Instead, as before, Leonardo pushed the *Battle for the Standard* into terra incognita. He pored over Pliny the Elder's articles in the *Natural History,* searching for a substitute to conventional, quick-drying fresco techniques. In one chapter Pliny describes the glorious achievements of still more ancient painters in encaustic, or molten wax. The technique of encaustic had not been practiced for hundreds of years, nor were there any step-by-step descriptions. Nevertheless, Leonardo seems to have seized upon a formula of wax and oil

paints as the best medium to convey the apocalyptic frenzy of battle, the *pazzia bestialissima*—utter bestial madness—as Leonardo himself defined it. Vasari describes what happened, "conceiving the wish to colour on the wall in oils, he made a composition of so gross an admixture, to act as a binder on the wall, that, going on to paint the said hall, it began to peel off in such a manner that in a short time he abandoned it, seeing it spoiling."[121] When the colors refused to dry, Leonardo built fires at the base of the wall, which only exacerbated the problem. Some areas dried too hard, others melted. By the early months of 1506, Leonardo's innovations had left him in despair.

At this time Leonardo, too, had a bizarre fantasy connected, it seems, with his intense investigation of the flight of birds, especially long-winged birds. He sketched them as they soared in flight and annotated the drawings with descriptions of the birds and, increasingly, with his plans for his own flying machines. He alluded to his impending plan to leap off the mountain of Ceceri near Florence. One of the notebook pages concerned with flight contains a mysterious fragment of a memoir: "This writing in such a distinct manner about the kite seems to be my destiny, because in the first recollection of my infancy, it seems to me that, while I was in my cradle, a kite came to me and opened my mouth with its tail, and struck me several times with its tail inside my lips." Thus he penned one of the most famous dreams in Western history, the object of a monographic study published in 1910 by Sigmund Freud.[122] Pliny, a constant source for Leonardo, reports in his *Natural History* that the kite (a common species of hawk in Italy), "by its manipulation of its tail taught the art of steermanship, nature demonstrating in the sky what was required in the deep."[123] Despite a grievous slip—confusing a kite with a vulture—Freud's interpretation became a classic case in the history of psychoanalysis. "In words which only too plainly recall a description of a sexual act," he writes, ". . . the situation in the phantasy, of a vulture opening the child's mouth and beating about inside it vigorously with its tail, corresponds to the idea of an act of *fellatio*." He proceeds to examine from different perspectives the ramifications of his own observation, before concluding that the above-referenced sexual act merely reenacts "a situation in which we all once felt comfortable—when we were still in our suckling days and took our mother's (or wet-nurse's) nipple into our mouth and sucked at it."[124]

• • •

THROUGH THE SUMMER AND AUTUMN OF 1505, MICHELANGELO worked feverishly, climbing to the high quarries in search of pristine blocks. Finally, on November 12, he signed off on a first shipment of two gigantic stones, each weighing fifteen *carrate*—about fifteen tons by today's measurements.[125] For the Carraresi, lowering chunks of the mountainside was a daily feat and an act of faith. Quarrymen with teams of oxen slowly dragged the behemoths inch by inch on log rollers and then finally up earthen ramps for loading onto beached boats. The anxious memories of shepherding *David* through the streets of Florence surely loomed in Michelangelo's head.

The shippers Domenico di Pargolo and Giovanni Antonio del Merlo promised to bring their small boats down the coast from Lavagna and have them in position in Avenza, Carrara's shallow harbor, before November 20. Each boat would transport one of the great blocks southward into the Tyrrhenian Sea, always keeping an eye on the shoreline. At Ostia, the flat-bottomed boats would turn inland at the mouth of the Tiber and follow the river some twelve miles and three additional days until reaching Rome. A few other stones made for a total cargo weight of about thirty-four tons. The undertaking was fraught with hazards that had not diminished appreciably since Tacitus's observation fifteen hundred years earlier, "Italy relies on external supplies, and the life of the Roman people is daily at the uncertain mercies of sea and storm."[126] If and when the laden boats arrived at the city's port of Ripa Grande, essentially a stretch of muddy riverside down by the Isola Tiburtina, Michelangelo was obligated to provide the laborers and lumber necessary to unload the cargo within two days, or pay a penalty for lateness.[127]

The first giant blocks were but the tip of the fantastic mountain he proposed to construct. On December 10 Michelangelo signed a contract with two Carraresi, Guido d'Antonio and Matteo di Cucciarello, to find and cut for him sixty additional *carrate* of marble in various sizes. "It is understood," the contract stipulated, "that the whole of the marble as above described, and especially the large blocks, shall be free from cracks and veins, and above all that they shall be white and in no way inferior to that quarried by me in person at Carrara."[128] Four "large stones" were specified: two weighing eight *carrate*—that is, about eight tons each—and two others weighing five *carrate* each. These would be the makings of four important sculptures somewhat smaller than the pair of giants shipped in November (for the statues of Moses and St. Paul). "The remainder of the marble may be of any size of two *carrate* or less each piece."[129] He agreed to pay two large gold ducats per *carrata*, except for the two largest blocks, for which he

would pay a total of thirty-five ducats, instead of thirty-two, as a premium for the rarity of a perfect block of such mammoth dimensions. The same contract also obliged the quarrymen to rough out the shapes of the blocks according to Michelangelo's instructions, which Cucciarello would receive in Florence within a month's time. The quality of the stone was the paramount issue, elaborated twice, "Again, the marbles described above must be living and strong and not dried-out, excavated at the Polvaccio quarry or some other place where the stone is living, comparable to those when they are white, pure, and beautiful."[130] It was unusual for sculptors to live in the quarries and choose their own marbles, but Michelangelo had suffered enough with inferior or dried-out blocks.

Marmo, the Italian word for marble, comes from the Greek marma-irein, meaning "to shine." Geologically speaking, marble is limestone transformed by the heat and pressure of the earth's crust into a medium-hard, crystalline rock. Cold to the touch, marble yields willingly to the sculptor's chisel. Over time, white statuary acquires an ivory patina remarkably evocative of the warmth of human flesh. As a building stone, marble was first used extensively by Pericles in the construction of the Parthenon in Athens about 438 B.C. The Roman emperor Augustus famously boasted that he had inherited a city of brick and was leaving one of marble. Ancient Rome imported precious polychrome marbles from every corner of the empire; many blocks, lost in accidents, have been salvaged from the Tiber mud. Tuscans take a mystical view of the stone's properties, endlessly praised in lore and legends. If there were any stories that Michelangelo had not yet heard, he learned them in these months from the lips of the Carraresi. Sculptors were the masters of la pietra viva—"the living stone."[131] Marble that was still attached to the mountain vein, or freshly quarried, was considered alive because porous stone retains moisture absorbed from the ground. Quarry sap makes the marble soft, sparkling, and easy to work. After exposure to the air, this calcium-soaked water evaporates, and the stone becomes drier and harder—cotto, Michelangelo calls it in his contract.

Michelangelo had cause for concern: traditions regarding the fragility of marble were recorded in the earliest dictionary of art terms ever compiled in Tuscany, or anywhere. "White marble," Filippo Baldinucci intoned in his Vocabolario toscano dell'arte del disegno (1681), "has such disdain towards every thing that is not white, that if touched by lime, it loses its whiteness and is tinged by spots; by oil, it becomes pallid; by red wine, it shows purple splotches; and if white marble by chance is washed

by chestnut sap, it turns black deep inside, and no chisel strokes would suffice to take away the stain."[132]

In the December 10 contract, Michelangelo also specified how the quarrymen would be paid in his absence, an ingenious system worked out through the Balducci bank in Lucca that allowed Michelangelo to stay in Rome while marble chunks continued flowing down the mountain like white lava. Leaving the shippers and quarrymen to do their work, he departed for Florence but did not tarry there, as the marble shipped in November might arrive in Rome at any moment, and he had much to do to prepare for it. On December 18 the *operai* of the Duomo met and resolved that the house being built for Michelangelo in the Borgo should be completed and then sublet to someone else, for "the said Apostles have not been carved, nor does it seem as if they either are being, or can be, carved."[133] On December 20 Michelangelo assigned power of attorney to his father, authorizing him to make deposits and withdrawals from his account.[134] Nine days later Michelangelo was again in Rome, for on that day he reopened his account with the Balducci bank with a cash deposit of seventy-three florins.[135]

As he waited anxiously for his marbles, a vineyard on the outskirts near Santa Maria Maggiore suddenly revealed a buried masterpiece, an ancient work described by Pliny as "preferable to all that the arts of painting and sculpture have produced."[136] It was the 14th of January when Julius II was informed by urgent messenger that "some excellent statues had been dug out of the ground in a vineyard near the Church of Santa Maria Maggiore." The pope wasted no time and sent a groom to Giuliano da Sangallo to instruct him to find out immediately what it was. Michelangelo happened to be at the Sangallo household and rode with his friend and his young son, Francesco, out to the site. They had scarcely dismounted and glanced at the marble figures, when Sangallo exclaimed, "It is the Laocoön of which Pliny speaks!" In his *Natural History,* Pliny the Elder describes a statue representing the death of the Trojan priest Laocoön at the hands of the Greek gods; the story of a father and his sons strangled by sea snakes was known to all from Virgil's *Aeneid.* The field laborers immediately resumed their digging to get the sculpture out. After looking it over very carefully, Francesco recalled in a memoir written sixty years later, the company went home to supper, "talking all the way of antiquity." Michelangelo anointed the Laocoön with his highest respect, calling it *il portento,* "the prodigy."[137] Within days, Isabella d'Este in Mantua had received word that "All Rome, cardinals and people, hasten by night and day to the *vigna:* it was like a Jubilee."[138] Julius

II quickly acquired it from the owner of the vineyard where it was found, and had a special niche constructed for it in the Belvedere. A tablet promising immortality to the happy man whose vineyard it was, Felice de Fredis, was placed inside the church of Ara Coeli on the Capitoline Hill. The tablet is still there, in the left transept.[139] For Michelangelo the unimaginable privilege of participating in the discovery of the Laocoön was a providential consecration of his ideas on the perfect union of the nude, the colossal, and the impassioned.[140]

· · ·

DEALING WITH DEPOSITS AND WITHDRAWALS WAS A CONSTANT preoccupation for Michelangelo, indeed a priority. Lodovico Buonarroti was proving invaluable as the executor of his fiscal affairs, diligently inquiring about good properties, attending to the time-consuming contracts, punctilious in keeping his son informed. Just before his return to Rome, Michelangelo had taken steps to acquire a farm called Capiteto, five miles to the south of Florence, using the 600 florins he had deposited from the marble money and 325 florins of his own savings.[141] The farm comprised a hilltop with arable land below it, vines, and fruit trees.[142] Situated in the parish of Santo Stefano near the town of Pozzolatico, Capiteto represented a safe investment. The papal commission had made possible Michelangelo's first acquisition of property, a significant moment in the restoration of the Buonarroti family's former status. Unaware that the transaction had closed on January 27, Michelangelo wrote Lodovico on the 31st to express his anxiety that the director (*Spedalingo*) of the Santa Maria Nuova bank might be capable of fraud.

> Most revered father, I learn from a letter of yours that the
> Spedalingo has not returned to Florence and consequently that
> you have not been able to settle up about the farm as you desired.
> I, too, am much worried about this, as I supposed you would have
> it by now. I'm wondering whether the Spedalingo did not go away
> on purpose, in order not to have to relinquish the income from it,
> and retain both the money and the farm. Keep me informed, for
> if this were so, I would take my money out of his hands and place
> it elsewhere.[143]

The letter was apparently his first since he left Florence. He goes on to express frustration that poor weather had delayed the marble's arrival in Rome.[144]

> As to my affairs here, all would be well if my marbles were to come, but as far as this goes I seem to be most unfortunate, for since I arrived here there have not been two days of fine weather. A barge, which had the greatest luck not to come to grief owing to the bad weather, managed to put in with some of them a few days ago; and then, when I had unloaded them, the river suddenly overflowed its banks and submerged them, so that as yet I haven't been able to begin anything; however, I'm making promises to the Pope and keeping him in a state of agreeable expectation so that he may not be angry with me, in the hope that the weather may clear up so that I can soon begin work—God willing.[145]

The events he describes are documented in the records of the Balducci bank, down to such details as pocket money and a visit to Giovanni Balducci's tailor so that he did not have to wear his sculptor's rags when calling on the pope.[146] While in Carrara, he had arranged to pay the shippers upon delivery: accordingly, on January 21 he withdrew twenty-one florins to pay for the "hire of a boatload of marbles" (*nolo di una barcata di marmi*).[147] As soon as the boats reached the Ripa port, the Tiber rose from all the rain and Michelangelo's beautiful marbles were covered in mud. The biggest blocks were cleaned as thoroughly as possible and dragged to dry land, soiled but safe. Evidently he raced to tell the pope the good news, because just three days later, on January 24, Julius II gave him another five hundred ducats, which he deposited.[148] This sum would have paid for laborers to haul the stones on carts to St. Peter's Square, which was the open space closest to the house the pope had given him as his workshop behind the church of Santa Caterina delle Cavallerotte.[149] But Michelangelo had other uses for the money. On the very same day, he withdrew twenty-one large gold ducats to purchase cloth from the Mouscron firm to which he had promised the *Bruges Madonna* but had not as yet delivered. It was a sizable sum to spend on cloth, unless, as seems probable, it was intended as stock in trade for his brothers in the wool business. On January 26 Michelangelo bought back a cache of marble he had left as security with Jacopo Galli on a loan of eighty ducats five years before. His old friend had died in the summer of the previous year.[150] He gave Galli's heirs only seventy-two ducats, however, because in the interim two of the

stones had been sold to Pietro Torrigiani, a transaction that surely chafed when Michelangelo learned of it.

In Florence the preceding December, Michelangelo had prepared designs to guide the Carraresi in roughing out the blocks for his statues. He needed those designs in Rome, as he told his father in the same letter.

> Please will you take all those drawings—that is, all those sheets I put into that bag I mentioned to you—and make a small parcel of them and send it to me by carrier. But see that they are carefully packed, so that they don't get wet, and take care when you pack them that not even the smallest of the sheets goes astray, and give the parcel into the charge of the carrier, because some of them are very important, and write and tell me by whom you are sending them and what I must pay him.[151]

These drawings were Michelangelo's first ideas for the tomb, containing studies for the *Moses,* perhaps, or the *Slaves.* All of them are lost, most likely destroyed by Michelangelo himself in one of his periodic purges to prevent his designs from falling into the wrong hands.

Secrecy is certainly his concern in the conclusion of the letter, worth reading as well for its commanding style. Repeating instructions is a practical technique, but everything Michelangelo writes has this quality of pouring out his desires in the order they occur to him. The letter's final sentence is a reprise of the first paragraph.

> As to Michele [a stonemason],[152] I wrote to him telling him to put that chest of mine in a safe place under cover and then to come here to Rome immediately, and on no account to fail to do this. I don't know what he has done. Please will you put him in mind of this. Also would you please put yourself to a little trouble over the following two things: that is, in having that chest of mine put under cover in a safe place; the other is that marble of Our Lady;[153] I want you to have it moved into the house, likewise, and not to let anyone see it. I am not sending you the money for these two things, because I think they're small items. But should you have to borrow it, please do so, because when my marbles arrive I shall soon be sending you money for this and for yourself.

I wrote asking you to find out from Bonifazio [Fazi] to whom in Lucca he had made payable the fifty ducats that I'm paying to Matteo Cucciarello at Carrara, and to add the agent's name in the unsealed letter I sent you, and to send it on to Carrara to the said Matteo, so that he may know to whom he has to go in Lucca for the said money. I assume you have done this. Please will you write and tell me also to whom Bonifazio made them payable in Lucca, so that I may know the name and can write to Matteo in Carrara and tell him to whom he has to go in Lucca for the said money. That's all. Don't send me anything except what I ask for—my clothes and shirts you and Giovan Simone can have. Pray God my affairs may go well; and see, in any case, that up to a thousand ducats are invested for me in land, as we agreed. On the thirty-first day of January 1506.

Your Michelangelo In Rome[154]

He was managing everything by himself and being pulled in too many directions. Contracting the construction of a papal mausoleum was nothing like being alone with his dreams and drawings, chisel and stone. Instead of working, he was writing letters, meeting contacts, arranging payments, obtaining permissions. It was a question of time. In Florence Michelangelo had immediate access to Soderini, Salviati, Machiavelli, anyone he needed to see. The Roman elite comprised a cast of thousands. Serving Julius gave him the right to wait for an audience. He had to be visible, accept invitations, defend his interests, compete for attention, play the courtier's game against others, particularly Bramante, who were used to it and infinitely better at it.

The marble shipments were arriving punctually, pouring in and stacking up outside St. Peter's. The spectacle was a daily reminder of his importance, lest his patron forget. Behind the old basilica, Bramante was attending to the perfection of the pontiff's residence. Michelangelo had a plan to see to his eternity. On February 20 Michelangelo paid 58 florins in cash for another delivery, and a further 50 florins to the Fazi company in Florence for remittance in Lucca to Matteo di Cucciarello, his Carrara supplier.[155] The young man had been given more than enough money to cover expenses, but continuous payouts of considerable size were unsettling. He was alarmed by his need to withdraw large amounts of cash for incidentals: 77½ florins at the end of January, 50 more on March 2.[156] When he was first in Rome and working on the *Pietà*, Jacopo Galli had quietly taken care of his affairs. His major

obligation had been his modest rent. Even the tricky logistics of moving the *David* from his studio to the piazza had been handled by experts. Now he was learning on the job how to manage workmen and furnish and equip a house to be his dormitory, sculpture studio, and general headquarters for a construction firm.

The Buonarroti household was rudderless in his absence, with the usual results. Letters soon arrived from Lodovico and Buonarroto pressuring him for money.[157] Begging him over a triviality, his father was merely testing the waters for his other sons' substantial request. Buonarroto wanted one of two alternatives: his brother's backing to launch a business or his help in finding him a position in Rome. Michelangelo pushed back firmly, pleading poverty as he always did: "A few days ago I wrote Lodovico and told him that I have four hundred large ducats worth of marble here and that I owe a hundred and forty ducats on it, so that I haven't got a *quattrino* [penny]. I'm telling you the same thing, so that you may see that for the time being I cannot help you."[158]

It was a manner of expressing himself—more a principle than a fact. Of the 1,600 Cameral ducats received from the pope (and another 60 large gold florins deposited lately), he had spent less than half: about 287 florins in Carrara, 108 florins more for marble in Rome, and 127½ on various expenses in Rome.[159] Lodovico knew that 600 florins of the pope's money were in his son's account in Florence. Michelangelo's Rome account was brimming over with 256⅙ Cameral ducats. It didn't matter in the slightest if he lied to his father—Lodovico responded in kind. The problem was, probably because of the constant stress he felt over money, he applied the tactic to Pope Julius. The costs that accrued when the blocks reached Rome, Michelangelo convinced himself, were above and beyond the funds provided. He began to ask Julius repeatedly, insistently, obsessively, for more money.

• • •

IN THE FIRST EUPHORIA OF MAKING PLANS, IT WAS EVIDENT THAT the most suitable place for the tomb would be in the apse behind the altar of St. Peter's. The foundations for a new choir had been laid a half-century earlier under Nicholas V, who noted in a papal bull of 1451 that the venerable basilica of Constantine was on the verge of collapse (*ut ruinam minetur*). The walls rose only a few feet, however, and modifications would be needed to

connect the mausoleum to the church. Julius asked how much this would cost, to which Michelangelo replied, "A hundred thousand scudi." The pontiff laughed, "Let it be two hundred thousand."[160] Thus encouraged, Michelangelo went off to Florence and Carrara in the latter half of 1505, convinced that his pyramid would join the holy cluster of shrines, fortifications, and cenotaphs atop the hill of Peter's martyrdom. In doing so, he gravely underestimated both the pope and his architect, Bramante.

Julius II had already seen, when he was but a twenty-eight-year-old cardinal, that the walls of the basilica were not inviolable as far as the della Rovere were concerned. His uncle Sixtus IV had immediately added his own funerary chapel at the head of the south aisle.[161] Nicholas V's vision of entirely rebuilding St. Peter's, beginning with the choir, was interrupted at his death in 1455, then revived under Paul II (1464–71), who engaged a young architect named Giuliano da Sangallo. Sixtus inherited these plans but declined to pursue them. His nephew Julius declared more than once his determination to remedy the oversight, but it was Bramante, not Sangallo, who had his ear.[162] The 1,100-year-old walls of the nave were noticeably listing to one side. With marvelous drawings and lavish flattery, Bramante enticed him with a grandiose redesign of the choir into a Cappella Julia at least as important as his uncle's Sistine Chapel.

The groundbreaking was scheduled for April 18, the Saturday after Easter. Michelangelo was a bystander to the preparations; Bramante was in charge of everything. The architect's vision was unifying and expansive—a massive rebuilding that entailed sacrificing the older structures and raising a new order from their dust. Unlike previous renewals, which began with a chapel or the choir, Bramante staked out four massive piers to lift a dome above the whole building. Eventually, the piers would have to come down.[163] The Milanese sculptor Caradosso was enlisted to prepare two gold and silver medals for Julius II to place in the foundation stone of the first pier on the south side. Profile portraits of the pope commanded the front of each medal; on the reverses, the inscription TEMPLI PETRI INSTAVRACIO (The Temple of Peter Restored) and a rendering of Bramante's building boldly announced the new St. Peter's. Neither the medals nor the pope's bull issued on the occasion contained any reference to the pontiff's prospective tomb.[164]

On Holy Saturday, April 11, 1506, the day between the Passion of Good Friday and the Resurrection of Easter, Michelangelo was invited to dinner with the pope. From his seat he could hear Julius say to a jeweler who was seated on one side and to his master of ceremonies on the other that he

did not wish to spend one baiocco more on small stones or on large ones. Presumably the pontiff was making a play of words on gems and blocks of marble, both of which are *pietra*. And perhaps he spoke loud enough to be overheard, diplomatically sending a message to his high-strung protégé. In any event, Michelangelo missed the irony—and the point. A kind of mania came over him, in much the same way as when the Magnifico had teased him about the satyr's perfect teeth. Before leaving the dinner, he waited for an opportunity to approach His Holiness to ask for reimbursement (as he saw it) of his latest expenses in unloading and carrying marbles from the Ripa to St. Peter's. Julius told him to come back on Monday, as the next day was Easter. Michelangelo did so punctually, only to be turned away at the door. Tuesday, Wednesday, Thursday, Michelangelo returned; each day he was not received. Finally on Friday, the day before the laying of the foundations for St. Peter's, he confronted the equerry, who apologized but said he had orders not to admit him. A bishop intervened in Michelangelo's defense, "You must not realize who this man is." "On the contrary," the man replied, "I do know him, but I am obliged to follow the orders of my superiors without inquiring further." Indignant, Michelangelo retorted, "You may tell the pope that from now on, if he wants me, he can look for me elsewhere."[165] Furious and humiliated, Michelangelo ordered his servants to sell his furnishings, jumped on a horse, and stormed out of Rome. He did not stop until he was at Poggibonsi, safely inside Florentine territory. When recounting these events to Condivi, Michelangelo was careful to detach himself from the circumstances that culminated in the demolition of the most sacred temple in Christendom.[166] Nevertheless, it was the gargantuan dimensions of the tomb that tripped the lever Bramante seized.

News of Michelangelo's flight sped through the Vatican like wildfire. The pope immediately dispatched five couriers to intercept him with strict orders to bring him back. They reached him about three hours after sunset.[167] Condivi writes, "But they had come upon him in a place where they could do him no violence, and as Michelangelo threatened to have them killed if they attempted anything, they resorted to entreaties; these being of no avail, they did get him to agree that at least he would answer the pope's letter, which they had presented to him, and that he would write specifically that they had caught up with him only in Florence, in order for the pope to understand that they had not been able to bring him back against his will. The tenor of the pope's letter was this: that, as soon as Michelangelo had seen the present letter, he was to return forthwith to Rome, under pain

of disfavor." Michelangelo answered that "he would never go back; that in return for his good and faithful service he did not deserve to be driven from the pope's presence like a villain; and that, since His Holiness no longer wished to pursue the tomb, he was freed from his obligation and did not wish to commit himself to anything else."[168]

As the first rays of morning broke, everyone who was anyone, with one major exception, made their way through the marbles littering St. Peter's Square for the groundbreaking. A chilling wind whistled through the city, fluttering capes and tarps alike. The pontiff was attended by his Curia, including Cardinal Giovanni de' Medici (accompanied by his cousin Giulio) and Cardinal Alessandro Farnese. All watched anxiously as Pope Julius II, wearing his heavy cope and tiara, lowered himself rung by rung down the ladder that descended to the base of the first pier. The papal master of ceremonies described the trough as "a chasm in the earth." There the pope laid his commemorative medals, while thundering to the company above not to come too close lest the earth give way.[169]

• • •

Vasari tells a famous story of how Giotto drew a circle to impress a pope. Word of Giotto's genius had spread far and wide until, finally, Benedict IX sent an emissary to bring the proof to Rome. The envoy found the artist in Florence and explained his mission, whereupon Giotto took a piece of paper, dipped his brush in ink, and traced a circle with a single stroke. Smiling, he turned and gave it to the man: "Here is your drawing." When the pope's envoy protested this jest, Giotto said, "It is enough and more." The skeptical messenger did as he was told, making his excuses, but the pontiff and his entire court marveled at the artist's excellence.[170]

Giotto's O was a symbol of perfection. Pythagoras, the archetypical mathematical philosopher, considered the sphere the ideal solid; the circle, the most perfect of plane figures.[171] Having no beginning and no end, circles represent the infinite, ergo the divine. Giotto and the pope knew such things by heart. Plato explained in the *Republic* that "knowledge of geometry was knowledge of the eternal."[172] Florentine artists and philosophers found a way to give this ancient wisdom a Christian spin. When the Neoplatonist Marsilio Ficino needed to demonstrate the immortality of the soul, he compared it to a "spiritual sphere."[173]

Replacing Gothic pinnacles with circles and squares was one of Brunelleschi's main concerns when he returned to Florence after studying Roman architecture.[174] About 1430 he designed the Pazzi Chapel in Michelangelo's parish of Santa Croce as a virtuoso display of circles inscribed in squares inscribed inside the larger circle of the whole chapel—rather like a sonata fragment of the Pantheon's symphony.[175] The primary decorations were round reliefs in polychrome terra-cotta—twelve apostles by Luca della Robbia, four Evangelists by Donatello, one in each of the dome's pendentives.

Both of these sculptors proceeded to produce Madonna reliefs for display in every possible corner of the city, sometimes in marble, almost always replicated in painted stucco or terra-cotta.[176] The tondo shape was an ideal surround for the Virgin and Child, at once a halo and a symbolic world receiving the Incarnation. Painters did not immediately adopt the format, for which there was a prior tradition of round panels presented to families in celebration of births. Fra Angelico painted the earliest Renaissance tondo, whose round shape seems deliberately symbolic of divinity. His *Adoration of the Magi* on a panel 137 centimeters (54 inches) in diameter remained unfinished at his death, but was completed soon afterward by Filippo Lippi and entered the collection of Lorenzo il Magnifico. Botticelli and Signorelli, particular favorites of the Medici court at the close of the century, often selected the tondo for their most ambitious paintings of the Madonna and Child, increasingly characterized by sumptuous costumes and growing numbers of attendant angels.

To our knowledge, Michelangelo addressed the tondo format only three times in his career—all within an arc of three or four years, making it complicated to reconstruct the sequence. It was probably during the second half of 1504, having just completed the *David,* that he started—then abandoned—a marble carving in relief of the Virgin and Child with the young St. John. The inspirations behind the unfinished marble appear to have been principally three: first, the anatomical and movement studies he was just then undertaking for the *Battle of Cascina;* second, a desire to experiment with Leonardo da Vinci's compact figure groups such as he had exhibited a year before at SS Annunziata; and third, as a fallback, Donatello's Madonna reliefs, which he knew so intimately that they seemed the fruits of his own imagination.

Vasari says the work was made for Taddeo Taddei and, though unfinished, was admired for its "excellence." The surface of the marble circle was left in radically different states of completion. At left, the Baptist's head is almost

invisibly ghostly, his hands enclosed in stone. Michelangelo's composition leads our eyes in a continuous movement corresponding to the tondo shape. The infant John proffers a fluttering goldfinch to his cousin, Jesus, who turns away violently, seeking shelter in his mother's arms. We suppose that the barely sculpted bird is a goldfinch because its symbolism of sacrifice and the Passion is the only explanation for the Child's response, which evokes Christ's prayer, "If it be possible, let this cup pass from me." Portents of Christ's Passion are traditional in the iconography of his infancy, but not the agony in the garden. Representing the Child as fearful is originality verging on the unorthodox. The only precedent, not surprisingly, is Michelangelo's own *Madonna of the Stairs*, his earliest marble. In his left hand the Child clutches an apple, symbol of Adam's Fall, which he came into the world to redeem. The Madonna turns toward the Baptist, her lips closed pensively as she extends her arm toward the infant John, as if to delay the prophetic message just a moment longer.[177]

Perhaps a year later, Michelangelo was thinking beyond the *Cascina* studies as he began a second marble tondo,[178] which would be acquired by Bartolomeo Pitti and inherited by Vasari's good friend Fra Miniato Pitti of Monte Oliveto, "a man with a rare knowledge in cosmography and many other sciences."[179] The three figures of the *Pitti Tondo*—Madonna, Child, and the young St. John the Baptist—are brought to different degrees of completion. Here the Madonna's sibylline pose is cool, aloof, superior. She is seated on a cornerstone, the symbol of her son. Her towering figure, which pushes past the circumference of the tondo, overshadows that of the infant John, who is barely glimpsed behind her. On her knee rests an open book of Scripture, which causes the Christ Child, robust like a little Hercules, to slump disconsolately as he reads. Mary knows the content and looks away, not offering the slightest comfort. In the *Pitti Tondo* Michelangelo self-identifies with the pain of prophecy and fate. He worked longer on this marble before abandoning it; even so, his chisel marks, parallel or cross-hatching, are clearly visible throughout. The straight lines that cancel the space behind the Madonna look almost like background shading, as though he were sculpting in pen and ink. This sculpture more than any other must have been in Vasari's mind when discussing the sculptor's art and his use of the *gradina*, the claw chisel, for passing over the figures, gently respecting the proportions of the "muscles and the folds" so that the "notches or teeth of the tool give the stone a wonderful grace."[180]

Lacking any documentation of commission, and considering their incomplete states, we can only conclude that he must have carved them for

himself, for purposes we have difficulty guessing. Despite their ideal shapes, the tondi are the antithesis of the *Pietà*, to which he gave two years to make it translucent, obliterating every trace of manual labor. In this he succeeded to such an extent that when it was done he felt a compulsion to sign his name. Not so with the two tondi, the raw stone of which is left exposed on every side, the sculptor's cuts and grooves a constant reminder that the figures were made by him. The comparison to drawing is inevitable because drawing is the medium most closely associated with the creative process. These round reliefs are figure studies preserved in stone. This is especially true of the earlier *Taddei Tondo*. The British Museum has a sheet with several sketches of John in pudgy profile, without the slightest interest in his face, which is exactly how the sculpture shows him.[181]

The *Pitti Tondo* is far more realized, and yet the virtuoso display of carving techniques makes the artist's presence still more vivid. Abandoning a composition so close to completion, so that its message is perfectly legible and all that remains is a final reading over, is a willful act. Circumstances did not prevent him from finishing these two sculptures. Rather, he deliberately broke off where he did and allowed their acquisition by personal friends. He had many opportunities to add the last touches, had he wished, but he chose to leave them rough, just as he did with his very first piece, the *Battle of the Centaurs*. Evidently, Michelangelo was intrigued to contemplate the aftermath of his own experience of eliciting beauty from obstinate rock.

Vasari explained the *nonfinito*, "unfinished," in Michelangelo's sculptures in Platonic terms, "... the works he envisioned were of such a nature that he found it impossible to express such grandiose and awesome conceptions with his hands, and he often abandoned his works, or rather ruined many of them ... for fear that he might seem less than perfect."[182] This reading seems right. Despite his hostility toward Leonardo da Vinci, including insults over his failure to cast an equestrian monument for Ludovico Sforza, Michelangelo was now seduced by the dark expression of *nonfinito*. Vasari's words for Leonardo hold true for both of them, "... he began many projects but never finished any of them, feeling that his hand could not reach artistic perfection in the works he conceived."[183] Michelangelo's paradoxical impulse in taking up the tondo format was to fill the circle with intimations of mortality.

• • •

JULIUS II PROCEEDED DELIBERATELY, AS BEFITS A *pontifex maximus* dealing with a recalcitrant soul. First he bade Sangallo to write his friend to calm down and return to work. That letter is lost, but Michelangelo's reply of May 2, 1506, is crystal clear: he did not repent at all. With incredible coolness, he begins, "Giuliano: I learn from your letter that the Pope has taken my departure badly, but that His Holiness is ready to do all that we were agreed upon, and that I am to return and not be worried about anything." He then proceeds to detail the mistreatment he has suffered, adding at the end of the long litany:

> But this was not the only reason for my departure; there was something else besides, which I do not want to write about—it is enough that I had cause to think that if I remained in Rome, my own tomb would be sooner made than the Pope's. This, then, was the reason for my sudden departure.[184]

This cryptic reference to a threat on his life is unexplained and is never mentioned again. It recalls the fear of violence that shortened his stay in Bologna ten years earlier, as soon as he finished his statues for San Domenico.

For his pains, Sangallo was given the task of conveying to the Holy Father the following set of conditions.

> Since you write on behalf of the Pope, you may read this letter to the Pope and inform His Holiness that I am more than ever ready to continue the work. But if it is indeed his wish to execute the Tomb, he should not trouble himself as to where I do it, provided that within five years it be walled into St. Peter's, on the site he chooses, and it shall be as beautiful as I have promised, for I am certain that if it is carried out, there will be nothing to equal it in the whole world.

> Therefore, if His Holiness wishes to proceed, let him place the sum agreed at my disposal here in Florence, whence I will write to him. I have quantities of marble on order at Carrara, which I will have sent here, and similarly I will send for the supplies I have in Rome. Even if it were to mean a considerable loss to me, I should not mind, if I could do the work here. And I would forward the pieces one by one, as they are completed, by which arrangement His Holiness would derive as much pleasure from them as if I were working

in Rome—nay, more, because he would see the finished things, without having any further bother about them. And for the said money and for the said work I will pledge myself as His Holiness directs and will give him here in Florence whatever security he shall demand. Be it what it may, Florence is my full and sufficient security. And I should add that there is no possibility of doing the said work for the same price in Rome, owing to the many facilities which exist here, but do not exist there; again I shall work better here and with greater zeal, as I shall not have so many things to think of. Meanwhile, my dearest Giuliano, I beg you to answer me as soon as possible. That's all.[185]

He need not have asked for a prompt response, since further entreaties arrived within days. His banker, Giovanni Balducci, with whom he shared the Sangallo letter, complimented him warmly, then begged him to come back to Rome without delay.[186] On May 10 Piero Rosselli, another Florentine who was working under Sangallo as the master mason in charge of patching and smoothing the Sistine Chapel ceiling for possible fresco paintings, wrote "fraternally," he said, of hearing the pope say that Sangallo would be sent to Florence to bring him back. Present at the same meeting was Bramante, who chimed in, "Holy Father, nothing will come of it, because I've had a lot to do with Michelangelo, and he's told me again and again that he doesn't want anything to do with the chapel, even though you wanted to give him that commission."[187] That was bad enough, Rosselli felt, but the next comments were worse. Having stuck the knife in the absent rebel, Bramante proceeded to give it a twist, adding confidentially, "I don't think he has the heart for it, because he hasn't worked much at figures, and especially because these figures must be high up and foreshortened, and this brings up problems which are completely different from those met in painting at ground level." At which Rosselli rebuked him soundly and assured the pope that Bramante had never spoken about the Sistine to Michelangelo. Indeed, everything he had said was a lie. Less commendable, from Michelangelo's perspective as he read this missive, was Rosselli's eager discussion of ceiling paintings and emphatic reassurance to Julius that Michelangelo could be counted on to return "whenever your Holiness wishes."[188]

Florence embraced Michelangelo's return. After all, there were the commissions still unfinished—the cartoon for the *Battle of the Cascina,* the bronze *David* for the French ambassador, and the Apostles for the Duomo—and

others eagerly awaited. The pope sent at least three letters between July and August, all addressed to the gonfaloniere, Piero Soderini. The first, dated July 8, two months after Michelangelo's arrival in Florence, reads, "Michelangelo, the sculptor who left us without reason and out of mere caprice, is, we understand, afraid of returning though we, knowing the humors of such men of genius, have nothing against him. Still, in order that he may dismiss any suspicions, we rely on your loyalty towards us that you will promise him in our name that if he returns he shall be neither hurt nor injured and that we will restore him to the same apostolic favor which he enjoyed before he left us."[189] At this point Michelangelo was—as Soderini put it—*terrified*.[190] Notwithstanding His Holiness's own assurances, Soderini was obliged to explain to Julius that Michelangelo would not take a step unless he had in hand a letter of safe conduct from Francesco Alidosi, cardinal of Pavia, the pope's closest confidant and the man who had overseen the initial transfer of one thousand ducats for the pope's tomb. Soderini emphasized that above all, they must deal very gently with Michelangelo lest they cause him to flee from Florence, as he had already attempted *twice*.[191] Meanwhile, the gonfaloniere turned for help to his brother, Francesco Soderini, cardinal of Volterra, asking him to guarantee Michelangelo's safety if and when he was persuaded to go to Rome.[192] Perhaps no artist in history had ever been treated so gingerly.

Michelangelo's fate was now in Soderini's hands, and he used these months to show his loyalty. Final touches were needed on the *Cascina* cartoon, which had lain idle for fourteen months. By an incredibly favorable turn of Fortune's wheel, however, within a month of his reentry, Leonardo abandoned the competition and left the city. None of his technical fixes had kept his painting from streaking the wall. The *Anghiari* was spoiled before it was finished. On May 30 the Signoria granted three months' leave so that Leonardo could travel to Milan, now under French rule and eager to employ him.[193] The permission entailed a heavy penalty, 150 gold ducats, should he fail to return on time. The French governor was able to extend the deadline several times until October, leaving Soderini to futile complaints of breach of contract.[194] Without its matching composition, the pressure was off of Michelangelo: he would not have to paint the *Cascina*.

Unfortunately, the cartoon survived less than twenty years before being destroyed by artists and souvenir hunters who cut the great expanse of paper into portable pieces. About 1540 the composition was recorded, without any of the vibrancy of the master's touch, in a monochrome painting by Aristotele da Sangallo, who had kept his copy drawings of the lost original.[195]

Benvenuto Cellini would praise the *Cascina* cartoon, calling it "The School of Art."[196] In a passage that recalls his earlier description of Masaccio's Brancacci Chapel, Vasari writes of the artists who came on pilgrimages to sketch from the cartoon where it was on view. Since the *Cascina* mural was intended for a public space, Michelangelo knowingly accepted the challenge to compete with Masaccio. By providing separate studies of monumental male nudes in self-consciously handsome postures, he established the curriculum for generations of imitators.[197] "Once they had examined these divine figures," Vasari concludes, "some of the people who saw them declared that no other genius, neither Michelangelo nor any other artist, could ever produce anything to equal the sublime qualities of this work of art."[198]

While Piero Soderini finessed the delicate lines of communication between the imperious pope and his mistrustful artist, he seized the window of opportunity to discuss with Michelangelo a new strategy to recoup the waning popularity of his government. Every day, as Soderini walked into the Palazzo della Signoria, at the left side of the entrance he passed by the *Gigante* that only Michelangelo had seen inside the mangled block of marble. The *David* was virtually the sole success of Soderini's tenure. He used the summer of 1506 to broach the prospect of a companion piece, apparently of Hercules, a hero long identified as emblematic of Florentine character. Because Michelangelo was resident in Florence, nothing survives in his letters about their discussions. In August, when the negotiations between pope and artist were heating up, Soderini wrote excitedly to Marchese Alberico Malaspina in Carrara to reserve a large marble for "a statue as great as any that exists."[199] The tone of the letter was intimate, addressing the marchese "like a dear brother," as Piero Soderini's wife, Argentina Malaspina, was related to the rulers of the independent, marble-rich state of Massa-Carrara. Soderini would continue to hold out hope for the project, writing to the marchese a year later and then several times in 1508.[200]

While waiting out his situation, Michelangelo had little choice but to turn his attention to the Apostle series he had done all he could to ignore since April 1503, when he promised to carve at least one statue a year.[201] Admittedly, the governing council of the Florence Cathedral lacked the artist's personal touch when dealing with the crusty Carraresi—twenty months passed before the arrival of the first block of marble in December 1504, which happened to be the time of Michelangelo's most intensive work on his mural cartoon. As a result, the block was consigned to a different sculptor, Andrea Ferrucci, who used it to carve a St. Andrew.[202] The wholly

understandable decision by the *operai* of the Duomo to involve other sculptors was of course the surest way to lose Michelangelo. By a remarkable coincidence, the *operai* did not receive the next shipment of blocks, three in all, until March 1506, that is, on the eve of Michelangelo's tumultuous flight. It was from one of these, scholars believe, that he now began to carve the *St. Matthew.*

A face half-trapped in stone is a terrible image, and indeed, Michelangelo's renown for *terribilità*—which connotes the possession of awesome force—begins here with this single unfinished apostle. Nothing about the figure alludes to its identity apart from a book, which remains embedded in the rough-cut rock like the rest of the body. Only the apostle's left knee projects sufficiently to raise the hope of breaking out. The body's anguished torque is Michelangelo's first response in art to the shocking revelation six months earlier of the Laocoön, which it strongly recalls on several levels. Michelangelo sculpted the *St. Matthew* frontally, from only one side of the block. Vasari compared the effect to a model that is immersed in a basin of water, then slowly raised so that one by one the limbs emerge.[203] The statue itself tells us, unmistakably, that it was conceived to be exactly as it is, *nonfinito.*

The *St. Matthew* is Michelangelo's earliest statement—before he cites it in his poetry—of the Platonic reasoning that the sculpted figure is captive in the block. In his *Enneads,* the gospel of Neoplatonism, translated by Ficino in 1492, the philosopher Plotinus describes how the sculptor of a statue "cuts away" until he "disengages beautiful lineaments in the marble." And he advises, almost biblically, "Do you this, too."[204] According to the same thought, the artist's idea of beauty descends from the Divine. Removing the excess stone was as much an intellectual task as a manual one, if not more so. Michelangelo sketched some apostle types, but none relates directly to the *St. Matthew.* One suspects that he disdained the traditional preparations of drawing and modeling in favor of cutting straight into the marble containing the captive soul yearning for release. The result is a kind of metaphor, perhaps unconscious, for the struggle of artistic creation. The only way Michelangelo could show us this was to leave the figure half-embedded in the rock.

• • •

For the first time in years Michelangelo had the freedom to tie up some lingering loose ends. That August he wrote to his banker friend Balducci for his advice as to the best route to ship the *Madonna* he had made for the Mouscrons in Bruges. He received the reply on August 14. Balducci had arranged everything. Francesco del Pugliese would collect the statue and take it to Viareggio. From the Tuscan port the statue would make the long sea journey past Gibraltar to Flanders. The costs would be reasonable; the shipping, the most conscientious available. All Michelangelo had to do was pay the bill at the Lucca office of the Fazi company. Though he kept the *Bruges Madonna* under lock and key, somehow the insatiably curious Umbrian Raphael had seen it. His new *Madonna del Cardellino* (Madonna of the Goldfinch) was a graceful compendium of motifs culled from Michelangelo—the Baptist from the *Taddei Tondo* and the Child standing upright from the *Madonna* statue he was finally sending away.

With Ghirlandaio and Filippino Lippi dead, and Botticelli in a permanent state of depression, Raphael found an affluent audience starved for works of the highest quality. Florentine mercantile society fell in love with his portrayals of the Madonna and Child and the Holy Family—and with him, personally, for his gentle character. The provincialism of his master Perugino had heretofore kept Raphael's genius under wraps. Leonardo taught him the power of unified, lucid compositions based on geometry, particularly the triangle and the circle. During Michelangelo's absence, Raphael's company was sought by everyone, including Michelangelo's valued friends Taddeo Taddei and Agnolo Doni. In fact, he was such a frequent guest at Taddei's home, where he would have had plenty of opportunities to study Michelangelo's tondo, that Raphael gave his patron two paintings as thanks for his many kindnesses, and painted the *Madonna del Cardellino* as a wedding gift for his friend Lorenzo Nasi, Taddei's cousin. In 1505, the Carrara year, Raphael painted the portraits of Doni and his wife, Maddalena. The out-of-towner whom Michelangelo had dismissed as a mere nuisance had grown up.

There is perhaps no better indicator of the nonlinearity of Michelangelo's thinking than the fact that at the same time as he was developing his expressive *nonfinito* in the *St. Matthew,* he painted a Holy Family that achieves in tempera on wood a technical perfection analogous to his *Pietà*. It was a tondo commissioned by his good friend Agnolo Doni—and the first panel painting he had ever finished. Doni's mansion in Corso dei Tintori, near Santa Croce, was filled with curiosities and paintings, as he was a man who "much delighted to have beautiful things both by ancient and by modern

craftsmen."[205] Naturally, he wanted a Michelangelo to go with his Raphaels. Perhaps Michelangelo cooperated for the chance to teach the upstart a lesson or two.

Though the *Doni Tondo* is not dated, Michelangelo most likely painted it during the relatively quiet months after his precipitous return in April 1506. Exquisitely detailed, the tondo has a pristine surface, its colors as smooth and polished as enamel. The Madonna anchors the pyramidal composition in the brilliant light of the foreground. She lifts the Christ Child to Joseph, whose bent right leg, swathed in a luminescent, satiny gold cloth, looms over the Virgin. All eyes are on the Christ Child, including those of St. John the Baptist, who hovers just on the other side of the divide between the Holy Family and six nude young men engaged in visual and verbal dialogue in the background. The youths are not bound, as in Michelangelo's proposal for the tomb. They bear a striking resemblance to the enigmatic nudes in the background of Signorelli's *Madonna and Child,* a Medici picture Michelangelo knew well. Perhaps they represent souls in paradise. If the *Doni Tondo* was in part a response to Raphael, it would explain the lofty flights of philosophical erudition. The picture is Michelangelo's most "symbolic" painting, redolent with plants, flowers, gestures, and glances crying out for interpretation, but mostly defying it.

Many classical sources have been proposed for the *Doni Tondo*, although none helps to elucidate it. Perhaps the most curious, because it is so pagan, is a medallion in the courtyard of the Palazzo Medici. It represents the infant Dionysus lifted on the shoulders of a satyr, not unlike the way Mary holds the infant Jesus. Michelangelo sent the finished painting to Agnolo's house via messenger, with a bill for seventy ducats. Agnolo, as Vasari tells it, despite knowing the picture was worth much more, gave the messenger forty and said it would suffice. Michelangelo swiftly sent the money back with a messenger and an ultimatum, "Either one hundred ducats or the picture." In the end, Agnolo paid double the original price to soothe Michelangelo's anger and keep his friendship.[206] Raphael, undeterred, continued to draw on Michelangelo's work, turning the anguish of his *St. Matthew* into a pious glance heavenward in a study drawn after Michelangelo once again left town.

When a second letter arrived from the pope in August, around the same time as Balducci's assurances about the *Bruges Madonna*, Soderini summoned Michelangelo and unleashed a white-hot scolding. "You have treated the pope in a manner the King of France would not have dared! The trifling with him must end now! We will not go to war with the pope because of

you, and we will not risk the safety of the State. Make arrangements to return to Rome."[207] Nevertheless, Michelangelo would not be moved. Soderini despaired in his reply to Rome: unless the pope offered guarantees, there was nothing he could do. Julius's third letter on this matter must have contained the protections Michelangelo desired, as he was finally willing to go. To further reassure him, Soderini granted the artist diplomatic immunity by naming him an official ambassador of the city. Anyone who caused him harm would have to reckon with the Republic of Florence. The gonfaloniere also gave him a special letter of recommendation to Francesco Alidosi, cardinal of Pavia. The letter was dated August 21.[208] Still Michelangelo was not eager to start the journey; this time it was just as well, because on August 27 the pope left Rome with twenty-four cardinals, five hundred heavily armed mounted soldiers, and an equally vast traveling court, determined to reclaim Perugia and Bologna for the Church.[209] While Julius waged war, Michelangelo instructed Lodovico to purchase more land in his name.[210]

• • •

THE TENUOUS PEACE OF THE FIRST THREE YEARS OF JULIUS'S pontificate belied his warlike nature. In truth, he was merely biding his time while paying the costs of his election and building a war chest. Uppermost in his mind was his desire to redeem the papal possessions usurped by Cesare Borgia and annexed by Venice. The Venetians had reclaimed three seaports—Ravenna, Cervia, and Rimini—and the inland town of Faenza. Julius announced that he intended to take control of all of them by force. The pope's favorite preacher, Egidio of Viterbo, an Augustinian friar, was among the most distinguished of Renaissance Platonists. As a young man he had been called to Rome by Raffaele Riario, cardinal-protector of his order, and by Fra Mariano, the prior general. Egidio incited Julius's dreams of conquest with heady prophecies of the resurrection of imperial splendor in a papal golden age, while Agostino Chigi, the trusted financial mastermind of Julius's inner circle, orchestrated the sale of indulgences.[211] Shrewdly and deliberately, Julius orchestrated every aspect of his building campaigns, tomb project, paintings, and ceremonial pageantry to convey the message that he was born to be— and had rightly assumed his God-given role as—the Christian Caesar.

Properly intimidated, the Venetians volunteered to cede some territory if the pope would restore to their ambassadors full access to the Holy See.

Permission granted, Venice for the moment was neutralized. To shore up his military strength, Julius sent his emissaries to seek men and arms from Ferrara, Siena, and Florence. From Florence he requested the services of Marcantonio Colonna, one of the best mercenaries in Italy, along with a hundred soldiers. The Florentine Signoria equivocated about the wisdom of pulling Colonna from their war with Pisa, not to mention the cost of fulfilling the pope's request. Though they did not deny the pope, they wanted to delay as long as possible. Machiavelli was directed to "explain to and assure his Holiness that, when once his enterprise is fairly under way, and his troops and those of his allies begin to assemble and to march, and have received all the other support which the Protonotary has told us of, he may depend upon it that our troops will not be the last, and more especially so as they are in the neighborhood."[212]

Louis XII, king of France, is said to have scoffed at the notion of a pope riding to war. But Julius was no ordinary pope. By August 1506 Julius II had collected sufficient funds, and assurances, and set forth from the Eternal City. Proceeding north at the head of a surprisingly small force of five hundred lances, with twenty-four cardinals in tow, the pontiff first set his sights on Perugia in Umbria and Bologna in Emilia, two former papal towns ruled by families against whom he harbored grudges. Machiavelli caught up with the pope's entourage at Nepi, just north of Rome, on August 28, 1506. His mission over the next two months was to keep the Florentines both in the pope's good graces and well informed, diligently sending dispatches filled with news as well as gossip. On September 6 he reported the extraordinary development that the despot of Perugia, Gianpaolo Baglioni, instead of fleeing, had come to Julius's camp in Orvieto to offer his personal escort to his city and 150 mounted soldiers for the pope's army. In front of the populace of Perugia, Baglioni knelt obediently before his august sovereign. In a famous passage in his *Discourses*, Machiavelli commented that the incident proved how difficult it is for a man to be perfectly wicked. Having his worst enemy in his hands, Baglioni "had not the spirit to be magnificently criminal, and murder or imprison Julius."[213] The city's legation was handed over to Cardinal Giovanni de' Medici.[214]

The fearsome pope seemed invincible and marched up the road to Cesena. In October, after occupying Forlì, Julius proceeded to Imola. Though still smarting from Julius's disregard for several of his requests for benefices and cardinalships, the French king reluctantly agreed to send six hundred lances and three thousand foot soldiers from Milan. The Florentines and the

duke of Ferrara also sent reinforcements for the pontifical army, whose next objective was Bologna. The first salvo of the attack was a papal bull against its ruler, Giovanni Bentivoglio, on October 10, 1506, calling on the faithful to plunder the excommunicate's goods. The news struck terror in the heart of Bentivoglio, who fled to Milan. The people of Bologna sent emissaries to the pope's camp pleading for mercy.

Just a few weeks after Michelangelo stormed back to Florence, the Dutch-born Catholic priest and humanist Desiderius Erasmus (1466–1536) set out from London bound for Bologna. In his charge were the sons of King Henry VII's physician, Giovanni Battista Boerio of Genoa; Erasmus was to serve as coordinator of the boys' studies.[215] The universities at Bologna and Padua were renowned throughout Europe for their classical studies. It was a journey Erasmus had longed to make, but limited funds had thwarted his plans until that moment. The party stopped in Paris for nearly two months, where Erasmus arranged for the publication of his Latin translations of Lucian and two plays by Euripides. Sometime in July they set out on the four-hundred-mile journey to Turin, where Erasmus would at last receive his doctorate of divinity on September 4, 1506. But Bologna still beckoned as the holy grail of scholarship. Erasmus and his young charges arrived about the end of September. His timing could not have been worse. Julius II was already on the march to reclaim the city as papal territory.

The peaceful haven of contemplative reflection Erasmus thought he would find in Bologna was suddenly filled with the threat of war. Erasmus took his charges and retreated to Florence.[216] On November 11, 1506, Julius rode triumphant in the rain through the gates of Bologna and was hailed as a liberator. Through sheer strategic genius he had reclaimed two of the Papal States without a fight. Erasmus returned to Bologna in time to witness the warrior pope's procession through the muddy streets, surrounded by his cardinals, flowers strewn in his path. Thirty-one triumphal arches had been planned but were cut back to thirteen, in part because of the weather and in part because of a certain nervousness about the proximity of hostile French forces.[217] "I could not but contrast with a quiet sigh such triumphs as these with the majesty of the apostles, who trusted to their heavenly teaching to convert the world." Only a week later, he wrote, "Here in Italy, studies are chilled, while wars are hot. Pope Julius fights, conquers, triumphs, and in fact plays the part of Julius to perfection."[218] He promised himself that he would return home as soon as possible. Nevertheless he remained in Bologna for more than a year, until December 1507.

Within a year of the pope's death in 1513, a scathing indictment entitled *Julius Excluded from Heaven* appeared anonymously.[219] Erasmus never admitted to authoring the book, though it is widely attributed to his pen. In it, he skewers the pope, using Julius's own bullying tactics. He depicts the pope trying to force St. Peter to allow him to enter heaven. "Tell me who you are," says St. Peter. "Stop this nonsense, if you know what's good for you; for your information, I am Julius, the famous Ligurian; and unless you've completely forgotten your alphabet, I'm sure you recognize these two letters, P.M." "I suppose they stand for Pestis Maxima," retorts St. Peter.[220]

No sooner had the pope accomplished his mission than the gonfaloniere received a letter from Francesco Alidosi, cardinal of Pavia, saying that the Florentine Council would do His Holiness a great favor if they would at once send Michelangelo to Bologna, where he would find only the most welcome reception. A week later Michelangelo was on his way, in his hand an astonishing letter from Soderini to his brother, the cardinal of Volterra, "We can assure you that Michelangelo is a distinguished man; the first of his art in Italy, indeed perhaps the whole world. We cannot recommend him to you sufficiently urgently: kind words and gentle treatment can gain anything from him. It is only necessary to let him see that he is loved, and is favorably thought of, and he will produce astonishing works. He has here now made the design for a picture, which will be quite an extraordinary work; he is likewise occupied with twelve apostles, each nine feet high, which will turn out a beautiful thing. Once again I commend him to you. Michelangelo comes relying on our given word."[221]

On November 21 a fearful Michelangelo rode into Bologna. "I was forced to go there with a rope round my neck to beg [the pope's] pardon," he later wrote to Giovan Francesco Fattucci, chaplain of the Florentine cathedral, an intimate friend.[222] His first stop was the cathedral of San Petronio to hear mass, where he was quickly recognized by the pope's equerries. They took him directly to Julius, who was dining in the Palazzo de' Sedici. "When he saw Michelangelo in his presence, he said to him with an angry look on his face, 'You were supposed to come to us, and you have waited for us to come to you.' . . . Michelangelo knelt down and loudly begged his forgiveness, pleading that he had erred not out of wickedness but out of indignation, as he could not bear to be turned away as he was. The pope remained with his head bowed and a disturbed expression on his face, answering nothing, when a monsignor, sent by Cardinal Soderini to exonerate and recommend Michelangelo, wanted to intervene and said, 'Your Holiness must disregard his offense, because he

offended through ignorance. Painters, outside of their art, are all like that.' To which the pope answered angrily, 'You, not We, are saying insulting things about him. You are the ignoramus and the wretch, not he. Get out of my sight and go to the devil.' . . . The pope, having thus vented most of his wrath upon the bishop, called Michelangelo closer, pardoned him, and enjoined him not to leave Bologna until he had given him another commission."[223]

• • •

JULIUS WANTED TO COMMEMORATE HIS VICTORY, AND THE REESTAB-lishment of papal government, with a monumental bronze statue, a seated figure three times life size to be prominently placed in a niche above the central portal of San Petronio.[224] The pope's first question to the artist who had turned on his heels in a spat over pride and money was, how much will it cost? Michelangelo protested that bronze was not his forte, not to mention the many things that could go awry with the casting. But finally he answered that he thought he could manage it for a thousand ducats. The pope ordered him to "cast it over and over again till it succeeds; and I will give you enough to satisfy your wishes."[225]

With his wayward artist once again firmly in his grasp, the pope set to work surveying the old medieval wall on the northern periphery of the city. The victory at Bologna would be short-lived unless he fortified his defenses. Julius himself led the team of engineers, architects, and papal and government officials to determine the best site. They selected the Porta Galliera, the city's northernmost gate, for its accessibility, sweeping view of the surrounding countryside, and access to water. Curiously, it was the same site selected by Julius's predecessors for previous papal fortresses, all of which had been leveled at the earliest opportunity by the townspeople. Preparatory work began just after the Feast of the Epiphany in January 1507.[226] On February 20 the cornerstone was consecrated in a solemn ceremony.[227]

Michelangelo, now ordered by the pope not to leave Bologna without his permission, immersed himself in clay, using as his studio the Stanza del Pavaglione behind the cathedral. He needed help. This statue would rise to 4.3 meters (14 feet) in height. It was the both the largest and the costliest operation he had ever attempted—and bronze was a medium in which he did not feel comfortable. He sent to Florence for three skilled workmen—Lapo d'Antonio, Lodovico di Guglielmo Lotto, and Piero d'Argenta.[228]

By mid-December the three were in Bologna, all living and working with Michelangelo day in and day out. Lapo was a sculptor who had long worked at the Opera del Duomo; Lodovico, an expert in bronze who trained as a youth in Pollaiuolo's workshop; and Piero d'Argenta, his most faithful assistant.[229] They all slept in a single bed in the grimy room Michelangelo rented.[230]

When not working on the bronze, he appears to have spent the vast majority of his time on his correspondence with Buonarroto, which he sent in care of the wool shop of Lorenzo di Filippo Strozzi. No aspect of his family's affairs was too small or great to escape his personal attention. A small farm in Settignano had caught his eye and he was keen to see the deal closed. The adjoining property was available and he asked his father to look into it. Baroncello Baroncelli, one of their cousins of good family, needed a favor, which seems to have involved a highly placed patron, to judge from Michelangelo's hesitation, "I have made full enquiries and the matter is much more serious than you indicated."[231] His brother Giovansimone, chronically unable to find his way, wanted money to invest in a shop; failing that, Giovansimone asked if he could come and stay with him. Michelangelo told him the money might be available in four months and not to come to Bologna in the meantime.

Buonarroto had been approached by Piero Aldobrandini, a Florentine nobleman who wanted Michelangelo to make him a bronze dagger.[232] Daggers were must-have accoutrements for the well heeled, their blades engraved with intricate patterns indicative of the region of their owner, then gilded. In his letter of December 19, 1506, Michelangelo protests that daggers are not his profession; his time is totally occupied with the bronze. However, he was loath to alienate anyone so influential and quickly relented, assuring Buonarroto that he would find the best solution for Aldobrandini to have his dagger within a month. Michelangelo entrusted the project to the best armor maker in Bologna, who said he could have it done within a week, a false promise, as it turned out, because the pope's entourage created a sudden spike in the demand for weapons that kept every craftsman in Bologna working overtime.

The mountain of clay rose higher and higher, and by late January it was nearing completion. Lapo and Lodovico did not last long enough to see it; after a rocky start, their relations with their master broke down completely when Michelangelo accused Lapo of attempting to cheat him over a purchase of a large quantity of wax. Michelangelo was indifferent to their departure, but worried about the lies they would tell about him at home.[233] He wrote his father, chiding him for taking sides with these enemies, who were claiming to

have done all the work, or at least half of it, which wasn't true. Worse, Lapo imagined himself on equal terms with his master, "and having already made much ado and begun to boast about the Pope's favours, he was amazed that I should send him packing like a cur. I regret the seven ducats he had of me, but when I return I shall certainly make him give them back."[234]

Michelangelo's letters to Buonarroto are full of the hope that he will have the bronze cast by Lent and be able to return to Florence. Even the friendly intimacy he had enjoyed with the pope in Rome now seemed restored, as evidenced by a story he later relayed to Condivi. The pope came to inspect his progress on the colossal seated figure. As befits a pope, Michelangelo had fashioned the right hand in an attitude of benediction, but "was in doubt as to what to do with the left hand" and so he asked Julius if he would like a book in that hand. "What book? A sword!" Julius declared. "Because I for my part know nothing of letters." Then, joking and smiling, he asked Michelangelo, "This statue of yours, is it giving the benediction or a curse?" To which Michelangelo rejoined, "It is admonishing the Bolognese to behave themselves."[235]

Whether it concerned this visit from the pope or another one about the same time, Michelangelo wrote glowingly to Buonarroto on February 1, 1507, about the pope's pleasure in the statue in at least two letters that dealt with the same topics, a practice that was not uncommon, given the uncertainties of delivery. "On Friday afternoon at two o'clock, Pope Julius came to the premises where I'm working and stayed to watch me at work for about half an hour; then he gave me his blessing and went away. He was evidently pleased with what I am doing. For this I think we must thank God above all, and this I beg you to do and to pray for me."[236]

Julius's belligerence was paying off. All of the major powers with their feet on the Italian peninsula—France, Spain, and the Germans—now had to consider the papacy a military force to be reckoned with. He was a crafty negotiator, not inspiring trust in his allies because of his conviction of serving, ultimately, a higher calling. Venice, the gateway to the eastern Mediterranean, with its expansionist aspirations to the terra firma, was a constant thorn in his side. Under different circumstances, the pope might have used Bologna as his base of operations for further consolidation of papal territories in the Romagna, but he could not ignore the nearby threat of French troops, led by their king, who made no secret of his desire to install a French pontiff on Julius's throne.[237] The friendship that had sustained him during the Borgia papacy was by now forgotten. Despite the ease with which he had overawed the despot of Perugia, Julius was loath to try such tactics with King Louis,

who might well take him prisoner. No, it was far better to return to the safety of Rome, replenish his treasury, and plan the next move.

Besides, the former Borgia holdings were restive that winter since receiving word of Cesare's dramatic escape from prison in Spain. On December 3, after recovering from serious injuries sustained in a leap from a rope, the thirty-two-year old suddenly reappeared, "like a ghost," witnesses said, in Pamplona. The small kingdom of Navarre was ruled by his wife's brother, who immediately placed the famous Cesare in command of his armies. His sister, Lucrezia Borgia, trembled with joy upon receiving the news in Ferrara. Four days after his arrival, the duke sat down to write letters to Italy—to Lucrezia, Francesco Gonzaga, and Ippolito d'Este. To make his intentions perfectly clear, he signed the letters, "Cesar Borgia de Francia, duca di Romagna."[238]

On February 22, 1507, two days after laying the foundation stone for his citadel, Julius hurriedly departed Bologna, leaving one thousand ducats for the bronze in the bank of Messer Antonmaria da Lignano.[239] Hastening south by way of the Marches (to avoid passing the French camp), he made only a simple entry into Urbino, lacking the time for full pomp and circumstance. After crossing the Apennines on the Via Cassia, well south of Florence, Julius salvaged his wounded pride at Orte with a processional entry that that must have been the most spectacular ever witnessed by the denizens of that small town near Orvieto.[240]

Good news finally arrived from Spain. His nemesis, Cesare Borgia, was dead. As captain-general of Navarre, Il Valentino had brought siege against the rebellious castle of Viana. Late on the miserable night of March 11, an enemy detachment led by the French count de Beaumont succeeded in supplying the town with provisions under cover of darkness. A skirmish broke out on the detachment's return to camp. Aroused by the din, and enraged at his embarrassment, Cesare sprang into his battle dress and galloped off in pursuit. To the amazement of all observers, he rode alone into the enemy's rear guard, meting out death and destruction on every side. Seeing the unidentified knight without support, the enemy's best men returned for vengeance. They had no idea as to the identity of their valiant, if reckless, assailant. Cesare Borgia died quickly under a flood of blows. De Beaumont wept when he learned of the prize denied him. The furious duke had not allowed himself to be captured alive. Some asked whether it was suicide.[241]

Flush with victory, Julius II entered Rome on March 28, Palm Sunday. He brushed aside the suggestion (from Paride de' Grassi, his master of ceremonies) that the festiveness of his procession be tempered in respect for

the Lenten season. Pointedly noting that he had not set foot in Rome since August, Julius replied that the Roman populace should be allowed to acclaim his reappearance after such a long absence. A medal was struck in honor of the event, inserting CAESAR between JULIUS and II. The reverse is inscribed with the Scripture, BLESSED IS HE THAT COMETH IN THE NAME OF THE LORD. The streets were covered with cloths, the flanking houses with pictured tapestries, and triumphal arches set up for the pope and his train to ride through. The arch in Via dei Banchi was inscribed with Caesar's famous boast, VENI, VIDI, VICI.[242]

Only two days earlier, Michelangelo had written Buonarroto, "My affairs here are going well, thank God, and I hope within a month to cast my figure. So pray God that the thing turns out well, so that I may come home, for I am prepared to do what I've promised you." Though Michelangelo was in Bologna, he still held the family purse. Both brothers entreated him repeatedly for financial help to invest in their own businesses. In letter after letter Michelangelo empathized with, and even encouraged, their ambitions, but urged patience, as "his world could shatter at any moment."[243] Meanwhile, he continued to purchase real estate near Florence with his father acting as his agent.[244]

The dagger was finally delivered in March 1507 and sent to Aldobrandini, only to be rejected because the blade was too long.[245] Incensed at the news, Michelangelo dashed off his response: "He sent me a paper pattern of it in a letter and wrote me that I should make it exactly to measure. This I did, so if he wanted a dagger, he should not have sent me the measurements of a rapier."[246] By the end of the month, though, Michelangelo's outrage had done an about-face. On March 31, 1507, he coolly wrote Buonarroto, "I am delighted that he didn't want it and that he wasn't pleased with it; perhaps because it is not its fate to be worn at his belt, and particularly because I hear that if he doesn't want it, someone else does—namely Filippo Strozzi. Therefore, if you see that he likes it, go and make him a present of it, as from yourself, and do not say anything to him about cost."[247] Buonarroto was a member of the Strozzi household; Michelangelo perhaps meant the gift to further his brother's career. But Buonarroto apparently did not grasp the tactic and sold the dagger to Strozzi for less than it had cost Michelangelo to make. After all, in Buonarroto's experience, when had Michelangelo ever done anything without being compensated? But Michelangelo had worked for the rich long enough to understand that at times you have to spend a little to gain a lot. Michelangelo chided him, saying, "I am sorry you behaved in such a stingy manner over such a small thing with Filippo Strozzi; but as it's done, it can't be undone."[248]

Whatever Michelangelo had learned about casting bronze, he knew for sure that the process was fickle enough that he did not dare to tackle it without help. He wrote to Angelo Manfidi, herald of the Florentine Signoria and a good friend, begging him to release Maestro Bernardino of Milan from his position as superintendent of the gunnery of the Republic so that he could help him. No reply came from the herald. Several weeks went by, but Bernardino still had not shown up. Michelangelo assumed that Bernardino was afraid to come lest he be stricken with the plague that had broken out in several places in and around Bologna. He wrote to Buonarroto, asking him to explain the situation to the herald and say that because he couldn't wait any longer, he had hired a Frenchman to help him. Bernardino arrived near the end of May. On June 20 Michelangelo wrote excitedly to Buonarroto, "It is not yet cast, but we shall cast it without fail this Saturday; and in a few days I think I shall be home, if it turns out well, as I anticipate."[249]

Julius's directive to "cast it over and over again"[250] and Michelangelo's apprehensions about the process both proved prophetic. The first casting yielded merely a figure to the waist, as only half the metal had melted. "I shall have to have the furnace taken down to extract it," an exasperated Michelangelo wrote to Buonarroto on July 6. He laid the blame firmly at Bernardino's feet, "I could have believed that Maestro Bernardino could cast without fire, so great was my faith in him; nevertheless, it is not that he is not a good craftsman, nor that he did not put his heart into it, but he who tries may fail. And he has indeed failed to my loss and to his own also, because he has so disgraced himself that he can no longer hold up his head in Bologna."[251]

In Rome the papal court waited anxiously to hear whether the second casting had met with the same fate. Michelangelo made no secret of his progress, detailing successes and setbacks as they unfolded in copious letters from Bologna written not only to his family but also to Giuliano da Sangallo in Rome, Granacci in Florence, and his friends in the Signoria. On July 10 he wrote with tempered optimism that a second casting had been made, but that "the casing is so hot that it cannot yet be uncovered. Next week I shall know for certain and will inform you."[252] The frustrations he had vented only a few days before had evidently been soothed as he added, "Maestro Bernardino left here yesterday. If he should say anything to you, be nice to him, and leave it at that."[253] By early August anticipation turned to joy. Michelangelo wrote with amazement on August 2, 1507, to Buonarroto, "The further I uncovered my figure the better I found it had turned out."[254] Now greatly encouraged, Michelangelo calculated that six weeks would be

needed to clean the figure, and urged Buonarroto and Giovansimone to be patient just a little longer. *Nonfinito* did not apply to a public portrait; the bronze would have to be thoroughly cleaned, tooled, and burnished before Michelangelo pronounced it *finito*.[255]

Michelangelo was equally elated that there would be no more sapping of his finances. On August 10, 1507, he breathed a sigh of relief, "It is true there is a great deal of work to do," he wrote Buonarroto. "I can rest assured that I have no more risks to run, nor undue expenses to meet, as my only obligation is to hand over the finished work where it stands."[256] The bronze would not be hurried. At the end of September he chided Buonarroto for not writing, "I have not had any letters from you now for over a month. . . . I do not often write to you, as I haven't time, as there has been more and more to be done in connection with this undertaking of mine, so that if it were not for my great application, I should be here for another six months. However I expect to have finished by All Saints [Day] or very nearly, applying myself as I do, so that I can scarcely snatch the time to eat."[257] All Saints' Day came and went.

Michelangelo heard the rumors that he would not and could not finish the project. "I do nothing but work day and night and have endured and am enduring such fatigue that if I had to do the work over again I do not believe I should survive, because it has been a tremendous undertaking and had it been in anyone else's hands it would have been a disaster," he wrote on November 10, 1507. "But I think someone's prayers must have helped me and kept me well, because the whole of Bologna was of the opinion that I should never finish it. No one has believed, either before or since it was cast, that I could ever cast it. Let it suffice that I have brought it to a successful conclusion." Throughout the storm, he clung to a dream of returning to the marble stacked in St. Peter's Square. With each writing, he anticipated that he would be finished within a few weeks. But he was finding that with bronze, as with marble, the process of perfecting the surface obeyed its own inexorable logic.[258]

Just before Christmas, with the finish line in clear sight, Michelangelo gave Buonarroto a letter to the cardinal of Pavia, "As soon as you have received it go to Sangallo and see whether he has the means to send it safely. And if Sangallo is not in Florence, or cannot send it, write a covering letter and send it to Giovanni Balducci and ask him on my behalf to send it to Pavia, that is to say, to the said Cardinal, and tell Giovanni that I shall be in Rome this Lent and commend me to him. Commend me also to Sangallo and tell him that I have his business in mind and that I shall soon be home."[259]

The letter pleaded with Alidosi for permission to leave the city. In reply, the pope ordered him to remain in Bologna until the statue was safely installed. Elevating a dead weight of several unevenly distributed tons up to a ledge higher than the central door of San Petronio was no small matter. There was also the correct angle of the sculpture to be considered. Michelangelo's presence was clearly indispensable. Nevertheless, his patience unraveled over the delay. "Now they dilly-dally with me and do nothing about it," he complained to Buonarroto on February 13, 1508. The fear with which the pope had held him in check was forgotten. His statue was a triumph; he needed to be in Rome, not Bologna. "I will wait and see until the end of this week," he continued, "and if they give no further instructions, I shall come away whatever happens, without paying any attention to my orders."[260]

Eight days later, on February 21, the colossal statue of the pope "in full pontificals, with the triple tiara on his head, raising the right hand to bless, and holding the keys of St Peter in the left,"[261] was unveiled above the façade of San Petronio to the amazement of a huge crowd. Julius wanted his statue to be a show of force—and a political statement. Under the circumstances, the analogy to the Roman practice of erecting statues in conquered cities was perhaps inevitable, even intentional.[262] San Petronio was the center of the city's religious function, and also the largest area of public assembly. Since Carolingian times and through the Middle Ages, bishops had issued public statements of the law in front of their cathedral *sub portico*.[263] Through the awesome proxy of this sculpture, the Roman popes would preside over every event, festival, and procession taking place in the open piazza or entering the temple. But Julius's message was also contemporary. The commission to Michelangelo involved the figuration of *libertas ecclesiastica*, which had nothing to do with either the city motto of Bologna, *Libertas*, or "ecclesiastical freedom."[264] It conveyed instead the Church's direct government of a city, apart from certain municipal rights of self-administration. Sixtus IV had granted *libertas ecclesiastica* to the citizens of Ascoli Piceno, in the Papal States, in 1482. As cardinal-bishop of Bologna, Giuliano della Rovere inscribed the phrase on a portrait medal issued about 1488.[265] The huge bronze was a proclamation of the Church's resumption of power, this time in perpetuum. Michelangelo departed for Florence immediately after the unveiling.

Many years later Michelangelo lamented in a letter to his good friend Giovanni Francesco Fattucci, chaplain of Santa Maria del Fiore and the pope's emissary, that the bronze had been so costly that when all was said and done he had cleared only 4½ ducats for himself. His ledgers tell a different story,

though the time, effort, and mental anguish he expended on the project must have made his compensation feel like pocket change. In early March 1508 Michelangelo authorized his father to withdraw 750 florins from his account at Santa Maria Nuova to purchase several houses on the Via Ghibellina in Santa Croce. They were destined to become the family's ancestral home, not Michelangelo's place of residence, as he was already on his way back to Rome. A few days later his father granted his now thirty-three-year-old son legal independence.

•••

HE WAS BACK IN ROME BY MARCH 27, DEPOSITING NEARLY FIVE hundred ducats from Julius as further payment for the tomb and ordering more marble to add to the stacks piled up in St. Peter's Square. At the same time, he enlisted his old friend Granacci to recruit assistants for him from Florence, and he began to make small but systematic withdrawals for household items in preparation for their arrival. But the assistants were not coming to help with the tomb. Julius, now thoroughly convinced that there was nothing Michelangelo could not do, had other plans for his temperamental prodigy. Whiffs of their negotiations float through the letters Michelangelo wrote in the last months of his Bologna stay. On May 10 Michelangelo signed the contract to decorate the ceiling of the Sistine Chapel, accepting from Cardinal Alidosi a down payment of five hundred ducats. His intention was to work simultaneously on the pope's two projects.[266]

The area around his workshop was teeming with construction sites, largely directed by Bramante. Still savoring the taste of victory, Pope Julius had ignited the boom upon his return from Bologna with a bull offering tax concessions to anyone who invested in building projects. Suddenly every cardinal, banker, and ambassador wanted a palace of his own. Julius and Bramante scoured texts by Tacitus, Suetonius, and Pliny the Younger, drinking in their descriptions of imperial villas, monuments, and civic buildings. The new Rome of which they dreamed would surpass the glory of the ancients and boldly announce the new world order to which all else had been prelude.

While Bramante orchestrated the pharaonic building campaign, Julius set out to eradicate the lingering Borgia presence. Even the dead had to go. Julius ordered that the tomb of Alexander VI be opened and his remains

shipped back to Spain. Like father like son, Cesare's remains would not long rest in peace either. His battered body was first buried beneath the altar of the church of Santa Maria in Viana. The inscription read, "Here lies in little earth one who was feared by all, who held peace and war in his hand." But the tomb was opened in 1527 under orders from the local bishop, who was incensed that such a sinner was being honored inside a church. The body was reburied in unconsecrated ground, where, the bishop declared, it could be "trampled by men and beasts." There Cesare lay until 1945, when workmen inadvertently dug up his remains. The last few bones were respectfully placed in a silver coffin and taken inside the town hall, whence the city officials began to petition the Catholic Church to allow their "Captain of the Navarre Army" to be reinterred in sacred ground. For more than fifty years they sent petitions. Finally, permission was granted, and on March 11, 2007, one day before the 500th anniversary of Cesare's death, his relics were solemnly restored to their original resting place inside the church of Santa Maria.[267]

Unable to live a minute longer with the sight of Alexander's mistress parading across the walls as the Madonna, Julius moved upstairs in the Vatican at the end of 1507, and sent for a star-studded cast of painters. Four public rooms on the second floor dated from the time of Nicholas V, a half-century earlier. Though small in size—destined to be Julius's library and study—they contained various frescoes by such luminaries as Piero della Francesca and Pietro Signorelli. Now, on Bramante's advice, a new team of excellent painters was assembled, led by Pietro Perugino and three young but promising artists, Giovanni Antonio Bazzi, Bartolomeo Suardi, nicknamed Bramantino ("Little Bramante") in honor of his master, and the Venetian Lorenzo Lotto. Toward the end of 1508, when most of the rooms were already frescoed, Bramante brought in a new talent, Raphael Sanzio, to execute the library.[268] When Julius laid eyes on his painting in the Stanza della Segnatura, he fired the painters who had nearly finished the new decorations for his private quarters and ordered Raphael to redo their works as he saw fit. The painting that had so stunned Julius is today called *The School of Athens*. In it, Raphael created a visual anthology of classical philosophy that included many recognizable portraits in the crowd of erudites. We see his self-portrait as a golden-haired youth of extraordinary beauty, Bramante as Euclid holding class in geometry, Leonardo as Plato exhorting Aristotle to lift his gaze upward. Michelangelo's portrait is the most like him, down to his negligent dress. He appears in the center foreground as Heraclitus, the melancholy philosopher, slumped over a makeshift table, alone in his thoughts.

NOTES

IN THE BEGINNING

1 The triumphal Arch of Septimius Severus was erected in A.D. 203.

2 Pietrangeli 1979, p. 58, lists the livestock sold at market on Thursdays and Fridays according to F. Martinelli's 1660 guidebook, *Roma ricercata nel suo sito*.

3 Four lines of a poem by Michelangelo. Author's translation based on Saslow 1991, poem 21, and C. Gilbert 1980, p. 19.

4 Pope Paul III Farnese cleared the road through the Forum in honor of the visit of Charles V in 1536; additional work was done in preparation for the Jubilee pilgrims in 1550.

5 da Varagine 1969, pp. 322–23; Forbes 1899, p. 68.

6 Vasari-Milanesi 1906, vol. 3, p. 7. Gentile da Fabriano was buried in this church, though no trace remains of his tomb.

7 According to Armellini 1891, pp. 150–52, the mosaic was destroyed around 1615.

8 Kerrigan and Braden 1991, p. 104: "The doctrine restated throughout the commentaries and treatises of Ficino is the religious meaning of contemplative ascent, and this he [Ficino] drew mostly from the rational mysticism of Plotinus."

9 The inscription was altered later. See Morey 1915, p. 22. Kindly translated by Monsignor John Azzopardi. The inscription is apparently a Christian elaboration of *ad astra per aspera*, "to the stars through difficulties," a classical expression that combined two passages from Virgil's *Aeneid*: *itur ad astra* (Book IX, line 641) and *ardua pennis astra sequi* (Book XII, lines 892–93).

10 Don Miniato Pitti, letter, October 10, 1563, to Vasari, in Vasari 1941, Letter CDXVIII, pp. 17–19.

11 This famous quip is told in Bargellini 1960, pp. 241–42.

12 Bargellini 1960, pp. 240–41. Field 1988, p. 19, draws an interesting distinction between the anti-Medici "faction" of older families, often magnates who had passed the peak of their prosperity and wanted political power to dominate the rest of the population, and the Medici "party" in the modern sense, "a group that attempts to appeal to all segments of the population—even if objectively its appeal was narrowed by its benefits to a certain class" (and family). Field cites Dale Kent's *The Rise of the Medici*, 1978, pp. 148–49: the final Medici victory resulted in the "virtual liquidation of the magnates as a genuine social category."

13 Ewart 1899, pp. 180–81, translated from Vespasiano.

14 This was the failed "del Poggio" putsch of 1466, which Gutkind 1938, p. 139, calls the beginning of the House of Medici. See Field 1988, pp. 20–21. It was a party revolt, designed to replace Piero.

15 Don Miniato Pitti was the son of Girolamo Pitti, not Bartolomeo, as is almost always claimed. For the correction, see Rosen 2003, p. 7.

16 Don Miniato Pitti was twice almost elected general of the Olivetan order. He died in 1566.

17 Vasari was painting ceilings and walls in the Palazzo della Signoria and had almost finished the second edition of his *Lives of the Artists*. The chapter on Michelangelo was greatly expanded over the first edition of 1550.

18 Don Miniato Pitti, letter, October 10, 1563, to Vasari, in Vasari 1941, Letter CDXVIII, pp. 17–19. I am grateful to Fra Bernardo Maria of San Miniato al Monte for confirming that Santa Maria Nova was the Olivetan church in Rome at this date. Michelangelo's scruffy chestnut horse is cited in the inventory taken after his death of his house in Macello de' Corvi.

19 The annual Easter festivity of Florence, the *Scoppio del Carro*, owes its origin to Pazzo de' Pazzi, who so distinguished himself during the crusade of 1099 that he was given fragments of the tomb of Christ in Jerusalem. Every year the spark struck off these relics is used to light the *colombina*, the "little dove," which in turn ignites the spectacular exploding fireworks on a special carriage in the cathedral square.

20 Vespasiano da Bisticci 1963, p. 286.

21 Gardner 1920, p. 279.

22 He called out the Florentine battle cry *Popolo e Libertà*. Landucci 1927, p. 16.

23 *Picchia ancora una volta!* Landucci 1927, p. 19.

24 *Mes.ser Jacopo nuota in Arno.* Landucci 1927, p. 19.
25 Machiavelli 1960, p. 367.
26 Ibid.
27 Condivi-Holroyd 1911, p. 5.
28 Brucker 1975, p. 91, regarding the importance of family status.
29 Hatfield 2002, p. 201; Symonds 1928, pp. 2–3, traces the family to a Bernardo who died in 1228. Bernardo is also the earliest ancestor named in Filippo Buonarroti's "Descrizione genealogica della nobile famiglia dei Buonarroti," published in an appendix to Anton Francesco Gori's 1746 edition of Condivi.
30 Condivi-Wohl 1976, p. 5; Condivi-Nencioni 1998, p. 7.
31 Vasari 1550/1986, vol. 2, p. 881. Vasari recognized, however, that he was nobly born.
32 The personage painted by Raphael supposedly represents Heraclitus, the pessimistic philosopher. Although the identification is sometimes doubted, it is confirmed in the analogous portrayal of Michelangelo in the *Michelangelo and Poetry* designed by Cristofano Allori and painted by Zanobio Rosi for the Galleria of the Casa Buonarroti, Florence, 1615–21. Michelangelo would not have objected to being compared to a philosopher admired by the Platonists.
33 Paolo Giovio compiled a brief outline of his life in a manuscript ca. 1527; though unpublished, Michelangelo must have seen it.
34 Buonarrota di Simone, who died in the plague of 1348, was a consul in the Wool Guild. *Carteggio indiretto,* vol. 1, p. xi.
35 The most complete account of the family's offices is provided in the *Carteggio indiretto,* vol. 1, pp. x–xii.
36 Dante, *Inferno,* 96:15.
37 Michele di Ridolfo painted a famous allegory of Fortune, with a female figure seated on a wheel, based on a design ascribed to Michelangelo.
38 Kristeller 1979, p. 60, notes that Petrarch wrote an extremely influential treatise on the remedies of good and bad fortune, adding, "The recurrent theme in Alberti's moral writings is the victory of virtue over fortune, and Ficino restates the same view, adding a Neoplatonic note by basing moral virtue on the life of contemplation."
39 Spini 1964, p. 115, gives 1373 as year of death. Michelangelo's descendant Filippo Buonarroti lists many such civic offices held by his ancestors in his useful "Descrizione genealogica della nobile famiglia dei Buonarroti."
40 Ewart 1899, p. 155.
41 Quoted in Brucker 1975, p. 85.
42 Ibid., pp. 114–15.
43 For family tax arrears see Hatfield 2002, pp. 207–11. By contrast, "Medici loans could and did rescue those in tax arrears," in Field 1988, p. 23, citing research of A. Molho, "Cosimo de'

44 The *catasto,* civic wealth tax, of 1427 says the "Buonarota di Simone" house was near San Jacopo dei Fossi, which is the church nearest Piazza dei Peruzzi.
45 See Brucker 1975, p. 93: Economic decline was often the prelude to a family's descent in the social hierarchy, for it was usually followed by a loss of political influence.
46 Hatfield 2002, p. 205. His father, Lionardo di Buonarrota di Simone, had filled the same office in 1424 (Condivi 1746, p. 105).
47 Hatfield 2002, p. 205.
48 Manetti 2006, pp. 21–23.
49 Michelangelo's date of birth was written down by Condivi and has never been disputed in any other source. As to his place of birth, Michelangelo specified only that he was born in the Casentino mountains while his father was serving as *podestà* of Chiusi and Caprese. As an antediluvian Florentine, Michelangelo was interested in his father's dignity, less so in the accident of his birth away from home. The two towns are sixteen kilometers apart; Chiusi clings to the slope below La Verna, in the Arno valley, while Caprese overlooks the Tiber River, on the other side of a ridge. Geographically speaking, therefore, only Chiusi is located in the Casentino region. For Manetti (Manetti 2006, pp. 55–56) this fact proves that Michelangelo was born in Chiusi. In the papers of the Casa Buonarroti Archive is a page, apparently not noticed until 1875, that is labeled a copy of Lodovico's personal record of Michelangelo's birth on March 25, 1475, in Caprese. The authenticity of this document, which appears from the script to date no earlier than the seventeenth century, is disputed by adherents of Chiusi as his place of birth, but considered determinative by adherents of Caprese, which astutely changed its name to Caprese Michelangelo in 1910. Michelangelo never expressed interest in either of the two towns, nor visited them, so far as is known.
50 Vasari-Bondanella 1998, p. 415.
51 Gaye 1839–40, vol. 2, pp. 253–55. Michele was a year older than Lionardo, according to the *catasto* of 1427: "Lionardo et Michele di Buonarota di Simone" (Gonfalone c.) "una chasa posta nel popolo di S. iachopo tralle fosse. Lionardo d'anni 35, Michele 36, Donna Alessandra (di Lionardo) 18, grossa, Lisa di Lionardo 4." There was also a Michele di Simone di Buonarrota in the Trecento.
52 The Lent of St. Michael (August 15–September 29) is a period of forty days honoring Mary and St. Michael the Archangel. It begins on the Feast of the Assumption and ends on the Feast of the Archangels.
53 Manetti 2006, pp. 21–22.

54 Grimm 1900, vol. 1, p. 84, relates this story. The local traditions were recorded in 1875 during the deliberations over the designation of Caprese as Michelangelo's birthplace. Partisans of Chiusi claimed that the birth took place along the road between the towns.

55 Campbell 2002, p. 596: "By 1550, when Giorgio Vasari produced his *Lives of the Artists,* Michelangelo came to epitomize the conception of a divine artist . . ."

56 April 14, 1548: *Carteggio,* vol. 4, doc. MCVII, pp. 296–97. This letter contains the earliest reference to a "book" in which Lodovico Buonarroti recorded his family's births, deaths, and history; this "libro de' ricordi" appears to have been lost during the eighteenth century. Milanesi notes that Vasari uses the word *natività* when discussing Michelangelo's "horoscope" (Vasari-Milanesi 1906, vol. 7, p. 137, note 1).

57 Recently, scholars have pointed out that Michelangelo either fudged his horoscope or Condivi made an elementary error calculating it. Lippincott 1989, pp. 228–32, was the first to notice that Condivi's reading of the conjunction of Mercury and Venus is correct for 1474, not 1475. She also notes that Michelangelo's contemporaries, among them Ficino, had precise records of the planetary configurations of these years. Riggs 1995, p. 99, noted that Michelangelo's corrected chart for 1475 indicates that rather than being prefigured by the conducive alignment of the planets, Michelangelo's success would be achieved only through unceasing hard work fueled by ambition.

58 Seznec 1972, p. 49, "Astra inclinant; non necessitant." With this reservation, astrology continued into the Christian epoch as the foundation of profane culture and the underlying principle of all science. See Kristeller 1965, pp. 58, 60: Pico della Mirandola made a strenuous attack against astrology that was actually a defense of human freedom; the arguments that he uses show very clearly that his attitude was prompted by moral and religious as well as scientific considerations.

59 Vasari-Bondanella 1998, p. 415.

60 Hatfield 2002, p. 205.

61 Condivi-Wohl 1976, p. 7; Condivi-Nencioni 1998, pp. 8–9.

62 Vasari-Bondanella 1998, p. 415.

63 Machiavelli 1960, p. 169.

64 Among the Florentines who were imprisoned in the Stinche were the chronicler Giovanni Villani, the historian Giovanni Cavalcanti, and the master artist Benvenuto Cellini, incarcerated in 1557 after his conviction for sodomy. The Stinche was demolished in 1833 and replaced by a theater, today called the Teatro Verdi; some ancient cells still exist in the basement. Wolfgang 1960, p. 149.

65 Poliziano, *Detti Piacevoli,* online at http://www.intratext.com/IXT/ITA1849/_P3K.HTM.

66 Leon Battista Alberti, *Della Famiglia,* 1433–41, quoted in Braudel 1981, p. 580.

67 He mentions her only once. In 1554 he wrote to his nephew Lionardo that if he were to have a daughter, he should call her Francesca "after our mother." See *Letters*-Ramsden, vol. 2, Letter 386.

68 Lionardo, 1473–1510? His date of death is not known.

69 Buonarroto, 1477–1528.

70 Giovan Simone, 1479–1548.

71 Sigismondo, 1481–1555.

72 February 1544: letter from Michelangelo in Rome to Luigi del Riccio in Rome. *Carteggio,* vol. 4, doc. MXVIII.

73 Condivi-Wohl 1976, p. 9; Condivi-Nencioni 1998, p. 9. See Vasari-Bondanella 1998, p. 416.

74 Vasari 1550/1986, vol. 2, p. 881.

75 Gori, cited in Clément 1882, p. 7.

76 von Holst 1974, p. 12.

77 von Holst 1974, p. 42.

78 Vasari-Bondanella 1998, p. 481.

79 Condivi-Nencioni 1998, p. 9, as translated by Symonds, in Symonds 1928, p. 7.

80 Vasari-Bondanella 1998, pp. 416–17.

81 Roscoe 1846, pp. 295–97, Appendix XXVIII.

82 Cadogan 1993, note 13.

83 Ibid., pp. 30–31.

84 Vasari-Milanesi 1906, vol. 7, p. 150. English translation in E. L. Seeley, *Stories of the Italian Artists from Vasari* (London, 1906), p. 279 (online).

85 This famous report has generally been dated to the mid-1480s. In Nelson, Arasse, and De Vecchi 2004, p. 95, Jonathan Katz Nelson proposes to connect it with the commission to paint altarpieces for the Certosa of Pavia, 1493.

86 Translation adapted from Baxandall 1972, p. 26.

87 See Grimm 1900, vol. 1, p. 87.

88 Ruskin 1945, p. 20.

89 Vasari-Milanesi 1906, vol. 7, p. 140.

90 Condivi-Wohl 1976, pp. 9–10; Condivi-Nencioni 1998, pp. 7–8.

91 Vasari-Bondanella 1998, p. 417.

92 Condivi-Wohl 1976, pp. 9–10; Condivi-Nencioni 1998, p. 7.

93 Condivi-Wohl 1976, pp. 9–10; Condivi-Nencioni 1998, p. 8.

94 Vasari-Milanesi 1906, vol. 7, p. 141.

95 Vasari-Bondanella 1998, p. 288. In 1999 a painting of *The Temptation of Saint Anthony,* based on the Schongauer engraving, was exhibited in Florence with an attribution to the Ghirlandaio workshop proposed by Michael Hirst (*Giovinezza,* no. 45). Everett Fahy was cited in favor of an attribution to Michelangelo's own hand. As this book goes to press, the painting has been acquired as an original by the Kimbell Art Museum and Keith Christiansen has published research in support (2009). See Vasari-Bondanella 1998, p. 418.

96 Sixty years later he told Condivi to write that Ghirlandaio had envied it. Condivi-Wohl 1976, p. 10; Condivi-Nencioni 1998, p. 10.

THE GARDEN OF THE MEDICI

1 See C. Elam, "Il Giardino delle Sculture di Lorenzo de' Medici," in Barocchi 1992, p. 162, for a thorough study of the location of the garden, including the probable date of acquisition, ca. 1470. Elam also clears up the confusion with the adjacent garden belonging to Lorenzo's wife, Clarissa Orsini.

2 Vasari-Milanesi 1906, vol. 7, p. 256. J. D. Draper (Draper 1999, p. 63) sums up the arguments and concludes that the garden of San Marco was an academy, as Vasari calls it, in its original Greek sense of a place of reunion for kindred spirits dedicated to contemplation and thought.

3 Hauser 1957, vol. 1, p. 115.

4 The artists mentioned in Vasari or elsewhere as having studied at the garden of San Marco include: Michelangelo, Granacci, Rustici, Torrigiano, Niccolò di Jacopo Soggi, Lorenzo di Credi, Bugiardini, Baccio di Montelupo, Andrea Sansovino.

5 Anonimo Fiorentino 1968, p. 119.

6 Pedretti 1992, p. 234.

7 The date is based on Condivi's report that Michelangelo was "between fifteen and sixteen" when he entered the house of the Magnifico. See Condivi-Wohl 1976, p. 13.

8 Ghirlandaio's name refers to his father's trade of making ornamental hair garlands, *ghirlandi*.

9 Vasari-Milanesi 1906, vol. 4, p. 259.

10 Vasari-Bondanella 1998, p. 419.

11 Leon Battista Alberti, *Della Famiglia*, 1433–41, in Braudel 1981, pp. 578–80.

12 Vasari-Bondanella 1998, p. 481.

13 Vasari 1550/1986, p. 883.

14 Calcagni writes as a marginal note to Condivi (dictated by Michelangelo), "He never left his studies for the lyre or for improvising songs (singing)." Procacci 1966, p. 284, and Elam, in Condivi-Nencioni 1998, p. 8, agree that Piero de' Medici is in question here, but Michelangelo has mistaken it for a reference to himself so he hastens to correct it.

15 Condivi-Wohl 1976, p. 12.

16 Grimm 1900, vol. 1, p. 109.

17 Brinton 1925, p. 146.

18 See *Encyclopedia Britannica*, 1911, for an eloquent essay on the Medici dynasty.

19 Guicciardini, *History of Florence*, as quoted in translation in Gardner 1920, p. 91.

20 Machiavelli 1960, p. 407, translated from "si vedeva in lui essere due persone diverse, quasi con impossibile congiunzione aggiunte." Lorenzo was the supreme discovery of an age enchanted by *personalità* and individualism; see Kristeller 1990, p. 65.

21 This reverie of the Florentine hills stems from Hallam 1837; quoted in Brinton 1925, p. 199.

22 Hauser 1957, vol. 2, p. 45.

23 Kristeller 1990, p. 90.

24 A date of 1463 is also possible. See Field 1988, pp. 3–17.

25 Kristeller 1990, pp. 90–93. See Ficino chapter in Copenhaver and Schmitt 1992, p. 186. Ficino, who had taught Poliziano philosophy, tutored Lorenzo's nephew, Lorenzo di Pierfrancesco de' Medici, who later commissioned Botticelli to paint works of Platonic inspiration.

26 Poliziano letter in *Opera*, 1563, 157, translated in Mazzini and Martini 2004, n.p.

27 Hibbert 1979, p. 158.

28 de Roover 1999, p. 80: "Tommaso Portinari was the captain who steered the Bruges branch onto the rocks by lending large sums to Charles the Bold."

29 "vir ad omnia summa natus," from Poliziano's eulogy after Lorenzo de' Medici's death, in Godman 1998, p. 18, note 58.

30 "quanto alla mercanzia, infelicissimo," in Machiavelli 1960, p. 405.

31 For Lorenzo's misappropriation of public funds see de Roover 1999, pp. 366–67.

32 Pico, *On the Dignity of Man*, p. 4, quoted in Kerrigan and Braden 1991, p. 119.

33 Pico, *On the Dignity of Man*, p. 5, quoted in Kerrigan and Braden 1991, p. 119.

34 In 1487 he nominated Tomás de Torquemada as Grand Inquisitor of Spain.

35 In 1486, while en route to Rome to publish his 900 theses, Pico stopped over in Arezzo and became embroiled in a love affair with Margherita, wife of Giuliano di Mariotto de' Medici, one of Lorenzo de' Medici's cousins. Dougherty 2008, p. 212.

36 Barzun 2001, p. 59.

37 Guidi 1998, p. 126.

38 Ridolfi 1981, p. 48.

39 Condivi-Wohl 1976, p. 12.

40 Ibid., pp. 11–12, is the main source for this faun story and dialogue.

41 The *Faun* is lost and no exact record of its appearance is preserved. A marble *Faun* in the Bargello Museum, inv. n. 124, was long considered to be the young Michelangelo's original, but the attribution fell from favor in the nineteenth century. The work has been untraced since World War II; a plaster cast in the Casa Buonarroti was illustrated and discussed by C. L. Frommel in *Giovinezza*, pp. 226–27.

42 Vasari-Bondanella 1998, pp. 419–20.

43 Machiavelli 1960, p. 407, a tame translation of the Italian, "ancora che fusse nelle cose veneree maravigliosamente involto."

44 Tragically, the Signorelli *Court of Pan* (ex-Kaiser Friedrich Museum) perished in the catastrophe of the *Flakturm* in Berlin in 1945.

45 Condivi-Wohl 1976, p. 12.

46 Ibid.

47 Popular reaction against the building of Cosimo's palace is vividly described in Cavalcanti 1838–39, vol. 2, pp. 210–12. See also Kent 1978 and Field 1988.

48 The statues are exhibited in the Uffizi.

49 "Enter my breast, breathe into me as high / a strain as that which vanquished Marsyas / the time you drew him from his body's sheath." Dante, *Paradiso*, Canto I, verses 19–21, in Dante 1986.

50 The Palazzo Medici collections are documented in the inventory drawn up after Lorenzo's death in 1492. This inventory has been published several times, beginning with Müntz 1888. See also Alsop 1982, pp. 395–409; Kent 2004, passim.

51 Vasari-Bondanella 1998, p. 420.

52 Condivi-Holroyd 1911, p. 10.

53 Ibid.

54 Condivi-Wohl 1976, p. 13.

55 Field 1988, p. 25: "Humanists in Florence also promoted values that seem more particularly linked with the Medici regime." In Bracciolini 1538, p. 68, Poggio Bracciolini described the Florentine nobles as those from good families, with great wealth, and eligible for public office. He argued that the Florentine nobility was "nobility of virtue."

56 According to Vasari-Bondanella 1998, p. 416, Granacci showed him drawings by Ghirlandaio.

57 He was no doubt impressed as well by the ancient Greeks' ambivalence toward the illusory art of painting. See the admirable unraveling of this intricate issue in Kristeller 1951, pp. 501–2.

58 Vasari-Milanesi 1906, vol. 7, p. 141; English translation from E. L. Seeley, *Stories of the Italian Artists from Vasari*, London, 1906, p. 281 (online).

59 Vasari-Bondanella 1998, p. 107.

60 Berenson 1958, p. 49.

61 Saslow 1991, poem 172, "Costei pur si delibra," ca. 1542–46.

62 Vasari-Bondanella 1998, p. 27.

63 Barolsky 1997, p. 109.

64 Vasari-Bondanella 1998, p. 477.

65 Vasari 1550/1986, p. 883.

66 Vasari-Bondanella 1998, p. 421.

67 Symonds 2002, p. 31; source cited as Benvenuto Cellini, *Memoirs of Cellini*, Book I, chapter XIII.

68 Condivi-Wohl 1976, p. 108.

69 Ibid., p. 13.

70 Vasari-Bondanella 1998, p. 420.

71 Ficino 1489/1989, p. 371.

72 For Michelangelo's horoscope as charted under Ficino's system, see Lippincott 1989 and Riggs 1995.

73 Riggs 1995, pp. 111–12.

74 Ibid., p. 115.

75 Ibid.

76 Ibid., p. 120.

77 Condivi-Wohl 1976, p. 15.

78 Ibid., p. 13.

79 Garin 2001, p. 335.

80 Ibid., p. 336.

81 Augustine, *Confessions*, vol. 6, pp. 4, 6. Galatians 4:24, II Cor. 3:6. See Gilson 1955, p. 590.

82 Petrarch 1971, pp. 6, 72, "the rank scum that pursues the mechanic arts." Lodovico, lacking money, was keen for his family to retain the appearance of its honorable past.

83 Dante *Purgatorio*, Canto XI, ll, 94–96.

84 Filippo Villani, *Liber de origine civitatis Florentiae et eisudem famosis civibus*, 1400–1405, a volume of encomiastic bios; translation in Baxandall 1972, p. 71.

85 "Learned" as well as "skilled." Doris 1997, p. 144.

86 Ibid.

87 Vasari-Bondanella 1998, p. 36.

88 Manetti 1957, p. 178.

89 Bertoldo's room in the Palazzo Medici is described in the Lorenzo de' Medici inventory in 1492 as filled with paraphernalia of all kinds such as mattresses, easels, a nude bronze statue with a broken arm, and two "perspectival paintings of the Duomo and Palazzo Signoria," which seemingly correspond to famous lost paintings by Brunelleschi.

90 *Cammina!*

91 Vasari-Milanesi 1906, vol. 7, p. 278.

92 Ibid., vol. 2, pp. 425–26.

93 Clark 1984, p. 59.

94 Today it is in the Lille Museum.

95 Vasari-Bondanella 1998, pp. 420–21. Vasari comments rather generously, "in this work Michelangelo, as a young man at this same time who wanted to imitate Donatello's style, acquitted himself so well that it seems to have been done by Donatello himself, except that it contains more grace and a better sense of design."

96 He is wholly contained within her profile. The shroud motif is explicit and seems deliberately linked to her womb, evoking the Christian mystery that finds parallels between womb and tomb.

97 Donatello included a relief of similarly rounded boys, with cupid's wings, in a triumphal procession on Goliath's helmet in his *David*, as if suggesting a connection between earthly love and sin.

98 The Child's prominent upper body tends to direct our attention away from his insubstantial legs.

99 A *Resting Hercules* was in the collection of Cardinal Francesco Piccolomini in Rome at the end of the sixteenth century; a drawing of it is included in an album composed and compiled around 1490 by an artist close to Ghirlandaio, if not by Ghirlandaio himself. If the so-called Codex Escurialensis (28-II-12, Library of the Royal Monastery of San Lorenzo de El Escorial) is not the album described as Ghirlandaio's by Vasari, it was probably one similar to it. See Bober and Rubinstein 1986, p. 165, no. 130, *Hercules Resting*.

100 *Giovinezza*, p. 71. Weil-Garris Brandt notes the view that the Madonna's psychological detachment is related to ancient funeral reliefs.

Donatello portrayed a protective Madonna in the marble relief known as the *Madonna of the Clouds*, which belonged to Lorenzo de' Medici. There are also grounds for comparison with Donatello's *Madonna dei Pazzi*.

101 Schaff 1888, section 76 (Girolamo Savonarola).
102 Brinton 1925, p. 212.
103 Ridolfi 1981, p. 50.
104 Ibid., p. 67.
105 Ibid., p. 57, with historical sources.
106 Ibid., p. 59. Ridolfi rightly separates this event from the visit of five citizens sent by Lorenzo to dissuade Savonarola from further prophecies.
107 Guicciardini 1984, p. 83.
108 Ridolfi 1981, p. 67. After reporting Lorenzo's attempt to influence him with church donations, Savonarola announced in public that a preacher must be like a good dog, which, although the thief throws him a bone, does not cease to bark. The example plays on the analogy between Dominican and *Domine cane*, i.e., "God's dog."
109 Hibbert 1979, p. 144.
110 Tateo 1981, p. 63.
111 Ibid., p. 63.
112 Brinton 1925, p. 206. Lorenzo evokes Poggio's natural beauty in his delightful poem "L'Ambra."
113 Though not documented, Bertoldo's involvement is convincingly argued by Draper in *Giovinezza*, pp. 272–75.
114 Medri 1992, pp. 47–58.
115 Kent 1992, pp. 248–49, from a letter dated December 29, 1491, of Bartolommeo Zeffi to Piero Guicciardini.
116 Draper in *Giovinezza*, p. 59.
117 Parronchi 1966, pp. 41ff.
118 Condivi-Wohl 1976, pp. 14–15.
119 Juren 1974, pp. 27ff. As summarized by Hirst and Dunkerton 1994, p. 78, note 30. Poliziano's *Giostra di Giuliano*, left unfinished after the Pazzi assassinations of 1478, recommends the subject of the Centaurs and Lapiths. See Seznec 1972, p. 114.
120 This is also the theme of Pollaiuolo's *Battle of the Nudes* engraving, certainly a conceptual source.
121 Pico calls the realm of matter the *mondo sotterraneo* ("underground world")—quoted in Panofsky 1972, p. 134.
122 Bronze, 45 x 99 cm. Museo Nazionale del Bargello, inv. Bronzi 1879, n. 258. See Avery 1970, p. 151. Bertoldo's design in turn was based on a badly damaged Roman sarcophagus that still survives in the Camposanto at Pisa.
123 Vasari speaks of Michelangelo's genius at disguising his sources. Vasari-Milanesi 1906, vol. 7, p. 277. "Michelangelo was a man of tenacious and profound memory, so that, on seeing the works of others only once, he remembered them perfectly and could avail himself of them in such a manner that scarcely

anyone has ever noticed it." Translated in Panofsky 1972, p. 171.
124 de Tolnay, *Michelangelo*, 1975, pp. 98–99.
125 Condivi-Wohl 1976, p. 15.
126 Careggi holds a central place in the lore of Renaissance Platonism because it is there that the conversation that Ficino transcribed in his commentary on Plato's *Symposium* is supposed to have taken place. The mythologizing of the "Platonic academy" is the subject of two lengthy interventions by James Hankins: Hankins 1990 and Hankins 1991.
127 Field 1988, pp. 3–4, for a description of Cosimo's final philosophical preparations. After Cosimo's death in 1464 the humanist Donato Acciaiuoli was chosen to compose the decree naming him *pater patriae*.
128 Landucci 1927, p. 53, entry for April 5, 1492.
129 Ibid., p. 54, entry for April 8, 1492.
130 Poliziano wrote afterward a moving account of Lorenzo's last hours.
131 The story was told first in the Latin biography of Savonarola by Giovan Francesco Pico, the philosopher's nephew. About this story William Roscoe (Roscoe 1881, p. 549) commented: "being contradictory to the account left by Politiano, written before the motives for misrepresentation existed, is rendered deserving of notice only by the necessity of its refutation."

THE GENERATIONS

1 Ranke 1853, vol. 1, p. 62; Schaff 1888, section 56, "Leo X."
2 Carlo de' Medici (1428?–1492), the natural son of Cosimo il Vecchio and Maddalena, a Circassian slave, had achieved the ranks of protonotary and canon of the cathedral of Florence, and provost of St. Stefano, Prato, but not bishop or cardinal.
3 Landucci 1927, p. 52.
4 Hibbert 1979, p. 204.
5 The portrait by the miniaturist Gherardo di Giovanni was included in a decorated manuscript of Homer, 1488–89, that was dedicated to Piero. In Barocchi 1992, cat. 21, Andrea De Marchi affirms that the attribution was confirmed by Everett Fahy.
6 Grimm 1900, vol. 1, p. 121. Piero and Alfonsina were married on May 22, 1488.
7 Ventrone 1994, vol. 1, pp. 423–24.
8 Brinton 1925, p. 206.
9 Roscoe 1881, p. 334.
10 Hibbert 1979, p 182.
11 Roscoe 1881, p. 335, translates this letter of April 12, 1491; the original Latin appears on pp. 477–78.
12 Guicciardini 1984, p. 36.
13 Hibbert 1979, p. 181.
14 Savonarola, translated in Gardner 1920, pp. 113–15 : "I saw then in the year 1492, the night before the

last sermon which I gave that Advent in Santa
Reparata, a hand in Heaven with a sword, upon
which was written: 'The sword of the Lord upon
the earth, soon and speedily'; . . . and suddenly
it seemed that all the air grew dark with clouds,
and that it rained down swords and hail with
great thunder and lightning and fire; and there
came upon the earth pestilence and famine and
great tribulation."

15 July 25, 1492.

16 August 11, 1492.

17 Gill 2003, p. 196.

18 Guicciardini 1984, p. 10. For the pope's
shameless nepotism, see p. 19.

19 Condivi-Wohl 1976, p. 15.

20 See Panofsky 1972, p. 196, for a summary of
Ficino's views on melancholy.

21 Aristotle posed this question in his *Problemata
Physica XXX.* Though the author of this work
is now considered to be the "pseudo-Aristotle,"
most probably Theophrastos, he was considered
genuine in the Renaissance. See Cantimori in
Hay 1967, p. 148: "To the humanist, melancholy
was the particular affliction of genius." Souls
"born under Saturn" were ruled by the
melancholic temperament. It was the first
appearance of a lifelong alternation between
prodigious exertion and black depression.
Within a few years, Michelangelo would wear
his "melancholy" like a badge of honor.

22 Lionardo entered the convent of S. Caterina in
Pisa on July 4, 1491, and made his profession of
faith one year later. *Carteggio indiretto,* vol. 1, p.
xxviii. There is no evidence, but it is probable
that his vocation in 1491 was inspired by
Savonarola's preaching. Savonarola's followers
were openly opposed to the Medici regime.

23 Condivi-Wohl 1976, p. 17.

24 His real name was Antonio Benci (ca. 1431
Florence 1498 Rome). "Pollaiuolo"—which
means "chicken vendor"—was his father's
trade. Vasari, a tireless compiler of workshop
tradition, states as a fact that his knowledge
gained from dissections is displayed in the
Battle of the Nudes engraving. See Vasari-
Milanesi 1906, vol. 1, p. 533. Physicians could
obtain license to dissect unclaimed bodies
for teaching and research purposes. Sixtus
IV issued a papal brief in 1482 that permitted
dissections in certain hospitals.

25 By 1500, Johannes of Frankfurt had published a
woodcut copy of the *Battle of the Nudes.* Dürer
is known to have drawn copies of Pollaiuolo's
figures. See Evans 1986, pp. 109–16.

26 Poliziano wrote a treatise *De Ira* (On Anger),
dedicated to Lorenzo de' Medici. See Langdale
2002, pp. 35, 57, note 16, for more references.

27 Modern scholarship has identified the prior,
who is not named in the early sources. See
Giovinezza, p. 439.

28 Giovanni Boccaccio (1313–75). Bargellini 1960,
p. 263.

29 See Weiss 1988, p. 38. Marsili was the devoted
friend of Petrarch (1304–74), the "poet
laureate of their century," according to his
contemporary Chaucer. Petrarch died, it is said,
with his head resting on a tome of Virgil.

30 Garin 1989, vol. 1, p. 83.

31 St. Augustine, *On Christian Doctrine,* 12:18. Also
dear to humanist hearts was how Augustine
exhorted his readers, "We must learn to correct
texts." In 13:19, he writes, "We must endeavour
to learn those languages from which the
Scriptures are translated into Latin."

32 Kristeller 1979, pp. 188–89. The subtitle, *On
the Immortality of the Soul,* has illustrious
precedents in the identical titles of works by
Plotinus and Augustine. See the Introduction
by M.J.B. Allen and J. Hankins in Ficino 2001,
pp. vii–xvii, for an admirable essay (worthily
dedicated to the memory of Paul Oskar
Kristeller) on Ficino's life and works.

33 Out of respect for Fra Mariano, Lorenzo
undertook the rebuilding of the Augustinian
convent of San Gallo, only a few steps from
Piazza San Marco.

34 Ridolfi 1981, pp. 62–65.

35 Piero is not generally credited with this
contribution; however, see Capretti 1991, pp. 7,
16. The vestibule was designed by Simone del
Pollaiuolo, called Cronaca, in 1491; the vault
was designed by Cronaca and Giuliano da
Sangallo in 1493.

36 Botticelli's *Bardi Altarpiece,* ca. 1485, was
removed by the family in the seventeenth
century.

37 Vasari 1550/1986, vol. 2, pp. 333–34, 398–99.
Vasari tells the story in his lives of both
Brunelleschi and Donatello, and in both
editions of his book.

38 It is perhaps noteworthy that one of his
friends from the garden, Baccio da Montelupo,
specialized in wooden crucifixes.

39 Translation of Pindar in Hamilton 1942, pp.
97–98.

40 Umberto Baldini tells the story in *Giovinezza,* p.
290.

41 Lisner 1980, p. 817.

42 Edited by Giovanni Bottari.

43 After its discovery in 1962, the crucifix was
displayed in the Casa Buonarroti until its
transfer to the sacristy of Santo Spirito in 2004.
For an introduction to the copious bibliography
the crucifix has elicited, including some dissent
over the attribution, see Lisner 1980, pp. 812–19.

44 St. Augustine, *Enarrationes in Psalmos* 44.3. The
concept of the ideal of beauty was a mainstay
of Neoplatonism. Plotinus in the *Enneads,* V. 8,
maintains the superiority of the interior vision
over any reproduction of the real.

45 Psalm 45:2. As a statement traditionally
attributed to David, some readers have wished
to read it as a reference to his intimate friend
Jonathan. See O'Connell 1978, p. 219, note

15: Augustine faced an exegetical problem, "whereas Psalm 44:3 speaks prophetically of Christ as *speciosus prae filiis hominum,* 'more beautiful than the sons of men,' Isaiah 53:2 seems equally clear in the contradictory sense: 'We saw him, and he had neither beauty nor comeliness [*neque speciem neque decorum*].'" O'Connell cites where Augustine confronts these two texts in an attempt to reconcile them.

46 Pico della Mirandola 1956, p. 3.

47 Elkins 1984, pp. 180–81: it is "impossible to gauge the extent of Michelangelo's knowledge of dissection," as most of the visible musculature appears based on observation, not dissection.

48 Augustine's source is *The Book of Wisdom,* 11:21: "Thou hast ordered all things in measure and number and weight."

49 170 x 170 cm (70 x 70 in.). Lisner 1964, pp. 7ff. See Spike 1996, p. 67, for Piero Sanpaolesi's analysis of Brunelleschi's geometrical scheme for his panel of the *Sacrifice of Isaac* submitted for the Baptistery doors.

50 135 x 135 cm (53½ x 53½ in.).

51 Leonardo's *Study of Human Proportion in the Manner of Vitruvius* is in the Gallerie dell'Accademia, Venice. See Martin Kemp's entry, with illustration, in Levenson 1991, pp. 276–77.

52 Pico della Mirandola, *Heptaplus,* or *Discourse on the Seven Days of Creation,* 1489, quoted in Steinberg 1983, p. 144. Seznec 1972, pp. 64–70: Medieval manuscripts were abundantly illustrated by figures of man as a microcosm of the universe.

53 Steinberg 1983, p. 131. Carved wooden crucifixes were usually draped with loincloths of fabric soaked in plaster. In the Trecento no sexual members were carved, an observance maintained in Brunelleschi's *Crucifix.*

54 Augustine 1953, p. 263: "Divine providence is at hand to show that the beauty of the human form is not evil, because it exhibits manifest traces of the primal numbers." Augustine provided a justification for expressing divinity through geometry, and also nudity.

55 Hamilton 1942, p. 117.

56 Clark 1969, p. 126.

57 Panofsky 1972, p. 134. See also pp. 182–84.

58 Augustine's *The Trinity* starts with the thesis that our souls are hungry for that vision (I, 16–20), and concludes that the central identity of man, when considered as created to God's image, is soul, specifically the contemplative soul, candidate for the bliss to be found only in that ultimate vision of God (XIV, 24–26). Augustine, *City of God,* X, xvi: "For that vision of God is a vision of such great beauty, worthy of such great love . . . that Plotinus does not hesitate to call that man most miserable who fails of it, endowed (though he be) with a wealth of whatever other goods."

59 Chastel 1964, pp. 295–96.

60 Ficino, quoted in Brinton 1925, p. 200.

61 Ficino, *Opera,* p. 618, quoted in Chastel 1964, p. 299, note 21.

62 Hamilton 1942, p. 105, paraphrasing a tale recounted by Aulus Gellius, a literary gossip who lived in the late second century.

63 Rocke 1998, pp. 224–25.

64 Ibid., p. 201.

65 Chastel 1964, p. 298.

66 Rocke 1998, pp. 139, 201.

67 Ibid., p. 139.

68 Condivi-Wohl 1976, p. 15.

69 Michael Hirst first suggested that the *Hercules* might have been a commission from Piero de' Medici: see Elam 1993, pp. 59–61. The confirmation was found and published by Francesco Caglioti, who discovered that Michelangelo was allowed to reclaim possession in August 1495 because it had never been paid for; see Caglioti 2000, pp. 262–65.

70 Vasari 1568, vol. 7, p. 341. At Fontainebleau, the statue stood in the garden, where it is dimly visible in old engravings made before its disappearance sometime after 1713.

71 The problem of its appearance has engaged many scholars; for a summary and new proposals, see Joannides 1977, pp. 550ff., and Joannides 1981, "A Supplement to Michelangelo's Lost Hercules," pp. 20–23.

72 Chastel 1996, pp. 188–89; Highet 1985, pp. 520–21.

73 Landucci 1927, pp. 55–56.

74 Cadogan 1993, p. 176 and p. 338 for original document. Ghirlandaio died of *febre pestilenziale* (plague) on January 11, 1494. His death was recorded by the Compagnia di San Paolo.

75 Condivi-Wohl 1976, p. 15; Condivi-Nencioni 1998, p. 14.

76 Condivi-Holroyd 1911, p. 13. Condivi-Nencioni 1998, p. 14.

77 Condivi-Wohl 1976, pp. 15-17; Condivi-Nencioni 1998, p. 12.

78 Michelangelo complained to his pupil Tiberio Calcagni, who made a marginal note, that he had never said to Condivi that Piero had taken his father's place but lacked his father's grace (Condivi-Wohl 1976, p. 15). For Calcagni notes, see Elam, in Condivi-Nencioni 1998, pp. xxi, 14.

79 Guicciardini 1984, p. 32.

80 Ridolfi 1981, pp. 107–8.

81 Guicciardini 1984, p. 21.

82 1485. See Shearman 1975, p. 17.

83 Lorenzo must have had an important library: Ficino would bequeath to him his personal copy of Plato's *Dialogues* in Greek; Landino dedicated to him his famous *Commentary on Dante's Divine Comedy,* 1481. See Shearman 1975, p. 15.

84 To judge from the inventories published by John Shearman, Botticelli was their favorite artist. See Shearman 1975, pp. 17–18. The

Primavera and *Minerva and the Centaur* are both found in the room adjacent to Lorenzo's in the Casa Vecchia. *Minerva and the Centaur* is titled *Camilla and a Satyr* in the 1498 inventory.

85 The literature is vast. Two of the most influential studies are Gombrich 1945, pp.7ff, and Wind 1958, pp. 113–27. Ficino 1996, letter 78.

86 Ficino 1996, letter 78.

87 Gardner 1920, p. 94.

88 Landucci 1927, p. 56 and note 1.

89 Some sources say that Piero ordered them to remain in their properties outside the city: Lorenzo at Cafaggiolo, Giovanni at Castello. See Pieraccini 1924–25, vol. 1, pp. 345, 353; *Carteggio*, vol. 1, p. 353; Hibbert 1979, p. 185.

90 Calì 1989, p. 98.

91 Guicciardini 1984, p. 44.

92 He was so described by the Venetian ambassador Contarini: Okey 1905, p. 194.

93 Guicciardini 1984, pp. 48–49.

94 Ibid., p. 49; Guicciardini calls Charles's illness a pox.

95 See Ridolfi 1981, p. 117, for this description of the sermon.

96 Genesis 6:17.

97 Poliziano died in a house attached to Clarice de' Medici's garden on Piazza San Marco. See Elam, "Lorenzo de' Medici's Sculpture Garden," 1992, p. 51.

98 There was a claim from a young man. Today, syphilis is suspected.

99 Condivi-Wohl 1976, pp. 17–18.

100 Ibid., pp. 17–18, 127, note 24: Bernardo Dovizi da Bibbiena was also tutor and later chancellor of Piero's brother Giovanni de' Medici, who upon his election as Leo X named him cardinal of Santa Maria in Portico.

101 It has been suggested by James Beck and others that the dreamer was in fact Michelangelo, not Cardiere.

102 Elam, "Lorenzo de' Medici's Sculpture Garden," 1992, p. 58.

103 *Giovinezza*, p. 440.

104 Condivi-Wohl 1976, p. 18.

105 In addition to his own distinctions, including literary, Giovan Francesco Aldrovandi was an ancestor of the erudite author Ulisse Aldrovandi (1522–1605). For the most recent biography, see Ciammitti 1999, pp. 139–141.

106 Condivi-Wohl 1976, p. 18.

107 Johannes Wilde, in Wilde 1978, pp. 1–16, mentions the poet Annibale Caro as a possible editor. In 1554 Condivi married Caro's niece.

108 Condivi-Wohl 1976, p. 18.

109 Gill 2003, p. 124.

110 October 4–9. Landucci 1927, p. 58.

111 Ibid.

112 Guicciardini 1984, p. 57.

113 Brinton 1925, p. 221.

114 Jacopo Nardi, *L'Historie della Città di Firenze*, 1582, vol. 1, quoted in Brinton 1925, p. 223.

115 Machiavelli 1999, chapter 12.

116 Landucci 1927, p. 5.

117 Ibid., pp. 60–61.

118 Guicciardini 1984, p. 59.

119 Condivi-Wohl 1976, p. 18.

120 The persistent myth that the Palazzo Medici was pillaged was invented by Piero de' Medici for political and private purposes when he reached Venice on November 18. See Grote 1980, pp. 131–38. On the other hand, Raymond de Roover writes that the mob seized and burned most of the Medici bank's account books. See de Roover 1999, p. 81.

121 Landucci 1927, p. 62.

122 Ibid., p. 56, note 1. Deliberation of November 9, "contra justiciam et omne debitum, et ad instantiam tirannorum, fuerunt relegati."

123 Elam, "Lorenzo de' Medici's Sculpture Garden," 1992, p. 52, for contemporary Bolognese sources.

124 Gardner 1920, p. 117.

125 Landucci 1927, p. 66.

126 Grote 1980, p. 132. Some of the gems and gold medals had in fact been sequestered by the Signoria, but there was no need to tell that to the king.

127 The prophecy was made by Camilla Rucellai in 1491 and referred, to be precise, to when Pico would "put on the Dominican habit" and therefore not necessarily to his death. Pico's nephew is the source of the story: Picus 1557, p. 8; Ridolfi 1981, p. 148; Pater 1960, pp. 24–40, for a most romantic account of the story; Gardner 1920, p. 110.

128 Gardner 1920, p. 110.

129 Condivi-Wohl 1976, p. 19.

130 Ciammitti 1999, p. 139.

131 Condivi-Wohl 1976, p. 19.

132 Ibid.

133 Luchs 1978, p. 225.

134 Wölfflin 1968, p. 17.

135 Lisner 1967, pp. 79–80.

136 Longsworth 2002, p. 79.

137 This was the view of Johannes Wilde, but many scholars have doubted its attribution. See Goldscheider 1964, p. 9; Emiliani 1999, p. 136.

138 The three statues are first cited by Leandro Alberti in his 1535 book on the tomb. See Goldscheider 1964, p. 9; Emiliani 1999, p. 134.

139 Robertson 1983, p. 660. The most detailed source was the *Chronicles* of Archbishop Antoninus of Florence (1389–1459), conveniently reprinted in 1491.

140 Guicciardini 1984, p. 69.

141 Ibid.

142 After negotiating a treaty with his erstwhile comrade-in-arms Ludovico Sforza, Charles VIII finally made it back to Grenoble in October.

143 Landucci 1927, p. 91.

144 That is, "failed fugitives."

145 Landucci 1927, p. 93.

146 Ibid., pp. 97–98.
147 Ibid., p. 103.
148 Guicciardini 1984, p. 83.
149 *Arrabbiati*, the "angry ones"; *Palleschi*, named for the seven balls on the Medici coat of arms.
150 Elam, "Lorenzo de' Medici's Sculpture Garden," 1992, p. 52.
151 Gilbert 1949, pp. 101–31.
152 Oberhuber 1982, pp. 15–16.
153 It is now in the Uffizi.
154 The altarpiece was removed from the church in 1529, after the Medici regained control of Florence. In his biography of Filippino Lippi, Vasari says that Lorenzo and Giovanni di Pierfrancesco are portrayed without specifying the figures. All subsequent portraits of them were derived from this altarpiece; the tendency nowadays is to identify Giovanni, reputedly the more handsome, with the prince who respectfully removes his crown—perhaps in reference to the brothers' renunciation of their Medici name in favor of the modest Popolano. If so, this altarpiece becomes a kind of public manifesto of that event.
155 Today the *Inferno* miniatures on parchment (1485–1500) are divided between the Biblioteca Vaticana and the Kupferstichkabinett in Berlin.
156 In Vasari's first edition of 1550 (p. 883), he writes only that Michelangelo carved the statue in the garden of San Marco and that it was acquired by Baldassare del Milanese, who took it to Rome, buried it in a vineyard to age it as an antique, and sold it for a great price. Condivi (Condivi-Wohl 1976, p. 19) writes that Lorenzo di Pierfrancesco saw the completed *Cupid* in Michelangelo's studio and suggested that the sculptor make it appear to have been buried. It was then taken to Rome by an unnamed middleman, who lied to Michelangelo and Lorenzo about the price received from the cardinal di San Giorgio. In 1568 Vasari (Vasari-Bondanella 1998, p. 423) published a much fuller account in which the middleman Baldassare del Milanese first showed the *Cupid* to Lorenzo di Pierfrancesco, who then proposed the plot. Vasari leaves open the possibility that the story may have unfolded slightly differently. Unlike Condivi, he is well aware of the *Cupid*'s subsequent travels.

SACRED AND PROFANE LOVE

1 Gregorovius 1903, p. 95.
2 July 2, 1496: letter from Michelangelo in Rome to Lorenzo di Pierfrancesco de' Medici in Florence. *Letters*-Ramsden, vol. 1, Letter 1; *Carteggio*, vol. 1, doc. I.
3 For Del Milanese, see N. Baldini, D. Lodico, and A. M. Piras in *Giovinezza*, pp. 153–55.
4 Raffaele Riario was elevated to the cardinalate by his uncle Sixtus IV in December 1477. He was assigned the titular church of San Giorgio ad Velum Aureum (San Giorgio in Velabro) and was called the cardinal of San Giorgio.
5 Rowland 1998, pp. 33–40.
6 Brown 1986, pp. 235–38. The *Apollo Belvedere* was rediscovered in 1489.
7 *Giovinezza*, p. 153. Riario's palace later passed to the Altemps family and today is a museum of classical antiquities.
8 Breisach 1967, p. 175.
9 Hirst and Dunkerton 1994, p. 38. Innocent VIII was the father of sixteen children. After 1517 Riario's palace became the papal chancellery and was known as Palazzo della Cancelleria.
10 Letter from Count Antonio Maria da Mirandola to Isabella d'Este, June 27, 1496. See Bober and Rubenstein 1986, p. 258, note 2.
11 *Giovinezza*, p. 443; Frey, *Michelagniolo Buonarroti*, 1907, p. 137.
12 Roman power was largely concentrated in the hands of the relatives of past and present pontiffs. Cardinal Ascanio Maria Sforza was Cardinal Riario's brother-in-law and the uncle of Caterina Sforza.
13 By 1488 Baldassare Balducci had obtained the office of *cassiere* in Jacopo Galli's bank. See *Giovinezza*, pp. 159–61.
14 Botticelli painted frescoes, now lost, in Lorenzo di Pierfrancesco's country residences at Trebbio (1495) and Castello (1497).
15 Ridolfi 1981, p. 224.
16 Ibid., p. 250.
17 Wilde 2008, p. 153.
18 Ranke 1853, vol. 1, p. 35. Paolo Capello was the Venetian ambassador to the Holy See.
19 Landucci, cited in Ridolfi 1981, p. 280.
20 Ridolfi 1981, p. 248.
21 Savonarola's sermon is quoted in McClintock 1889, p. 386.
22 Savonarola preached on Amos 4:1 on February 28, 1496. See Ridolfi 1981, p. 231.
23 Ridolfi 1981, p. 239.
24 Amos 4:11.
25 The document is dated July 18, 1496. See Hirst and Dunkerton 1994, p. 31.
26 Hirst 1981, p. 581; *Giovinezza*, p. 153.
27 Norton 1957, p. 251.
28 Lodovico's annual pay was deduced by Rab Hatfield in Hatfield 2002, p. 16, note 58, and p. 147. Though Michelangelo told Condivi that Lorenzo gave his father a job that paid eight scudi a month, in fact the pay was closer to two.
29 July 1, 1497: letter from Michelangelo in Rome to his father in Florence. *Letters*-Ramsden, vol. 1, Letter 2; *Carteggio*, vol. 1, doc. II.
30 Condivi-Nencioni 1998, p. 19. Translation based on Pope-Hennessy 1985, p. 307.
31 Vasari-Bondanella 1998, p. 424.
32 Percy Bysshe Shelley, quoted in Symonds 1928, p. 39. Symonds adds, "If Michelangelo meant to carve a Bacchus, he failed; if he meant to imitate a physically desirable young man in a state of drunkenness, he succeeded."

33 The *Bacchus* is comparable in its treatment of the nude to the many classical statues of the beautiful Antinous in the guise of Bacchus, for example, that in the Farnese collection, Museo Archeologico, Naples.

34 The sculpture is cited in Jacopo Galli's courtyard in 1506.

35 This is the drawing *Garden of the Casa Galli* by Maerten van Heemskerck, 1532–35. The *Bacchus* was sold to Grand Duke Francesco de' Medici in 1572 for 240 ducats and taken to Florence. In 1873 the statue was transferred from the Uffizi collections to the Bargello Museum.

36 Though Condivi claims that Galli commissioned the *Bacchus*, the conclusion seems inescapable that it was first declined by the cardinal.

37 Michelangelo was already mortified by the *Cupid* scandal. He confided as much to Tiberio Calcagni while going over Condivi's book, "And moreover, he said he had begged the Cardinal not to speak about it [the *Cupid*] and that he had made an error to speak about it." Elam in Condivi-Nencioni 1998, pp. xxi and 18.

38 Guicciardini 1984, p. 116.

39 Ridolfi 1981, p. 277.

40 Brucker 1975, p. 203.

41 November 17, 1496; Landucci 1927, p. 113.

42 March 27, 1497; Landucci 1927, p. 117.

43 Curiously, Landucci does not mention it.

44 Ridolfi 1981, p. 236, cites a letter of Piero Capponi, March 10, 1496, acknowledging Savonarola's contributions to the city but urging that he accede to the pope's commandants. The pontiff's past censures, Capponi notes, caused "great damage to our city, most of all to our merchants."

45 Bernardo del Nero was gonfaloniere for March and April 1497; he was then executed for conspiracy to return the Medici to power. See Machiavelli 1891, p. 102.

46 April 28, 1497; Landucci 1927, p. 118.

47 May 4, 1497; Ibid., pp. 118–19.

48 May 24, 1497; Ibid., p. 121.

49 June 11, 1497; Ibid., p. 122.

50 June 18, 1497; June 19, 1497; June 20, 1497; Ibid., pp. 122–23.

51 Brucker 1975, p. 270.

52 July 1, 1497: letter from Michelangelo in Rome to his father in Florence. *Letters*-Ramsden, vol. 1, Letter 2; *Carteggio*, vol. 1, doc. II.

53 August 19, 1497: letter from Michelangelo in Rome to his father in Florence. *Letters*-Ramsden, vol. 1, Letter 3; *Carteggio*, vol. 1, doc. III.

54 Hatfield 2002, p. 7.

55 Ulisse Aldrovandi, "Delle Statue Antiche, che per tutta Roma, in diversi luoghi & case si vaggono," in Lucio Mauro, *Le Antichita della Citta di Roma* (Venice, 1556), p. 173, and in Howard 2001, pp. 83, note 8, 104.

56 Weil-Garris Brandt 1996, pp. 644–59. In 2009 the Republic of France lent *Cupid* to the Metropolitan Museum of Art for a period of ten years. Initial doubts as to its authenticity are likely to recede now that it has been cleaned and put on public view. Many observers, even supporters, have pointed out distortions in the figure's anatomy, e.g., the very long legs. Rather than weaknesses, such departures from realistic proportion are characteristic of Michelangelo.

57 Hirst and Dunkerton 1994, p. 61, provisionally attribute three anonymous paintings to d'Argenta. Agosti and Hirst 1996, p. 684, cite Pablo de Céspedes, a Spanish artist in Rome in the 1570s, as stating, "Some say it is by a certain Pedro de Argento."

58 Hatfield 2002, p. 5.

59 Ibid.

60 Hirst and Dunkerton 1994, pp. 37–45, present a convincing defense.

61 A further solid point on its behalf is the iconography in which the ancillary youths seem to receive unwarranted emphasis in comparison to the Madonna and Child, much like the rowdy boys in the *Madonna of the Stairs*. The two angels at right read a scroll that would traditionally belong to the Baptist, while the Child strains to reach a copy of the Scriptures that his Mother holds up so that the angels may read it. This is evidently an original variation on the "not-yet" theme, in which the Virgin stops the Child from embracing the symbols of his Passion. Steinberg 1983, p. 124.

62 Hatfield 2002, pp. 208, 212.

63 August 19, 1497: letter from Michelangelo in Rome to his father in Florence. *Letters*-Ramsden, vol. 1, Letter 3; *Carteggio*, vol. 1, doc. III, pp. 4–5.

64 Ibid.

65 *Lettere*-Milanesi, August 19, 1497: letter from Michelangelo in Rome to his father in Florence. *Letters*-Ramsden, vol. 1, Letter 3; *Carteggio*, vol. 1, doc. III and p. 359, note 1. Consiglio d'Antonio Cisti, a merchant, was the husband of Lodovico's sister, and thus Michelangelo's uncle on his father's side. Lodovico was in debt to him for 90 florins. Contrary to his son's advice, Lodovico reached an agreement that allowed Consiglio to attach his account in the Monte della Pietà bank. The debt was repaid by 1502.

66 October 1497–March 1498, letter from Michelangelo in Rome to his brother Buonarroto in Florence. *Letters*-Ramsden, vol. 1, Letter 43; *Carteggio*, I, doc. IV, p. 6.

67 *Lettere*-Milanesi, pp. 613–14; Hirst 1985, p. 154.

68 Hatfield 2002, pp. 5–11, for his banking transactions of 1497–98.

69 January 13, 1498, letter of Piero d'Argenta from Rome to Michelangelo's brother Buonarroto in Florence, *Carteggio*, vol. 1, doc. I, p. 1.

70 Ibid.

71 January 6, 1498; Landucci 1927, p. 129.

72 Scigliano 2005, p. 77.

73 See Hirst 1985, p. 155 and Appendix A, doc. 7. "E addi 26 (March) ducati trenta volse per rendere a Piero de' Medici. . . ."

74 Hirst 1985, p. 155, notes 23 and 24, suggests that the delay was caused by a dispute over payment of the *gabella,* or customs tax, on marble based upon Cardinal de Sassoferrato's letter from Rome dated April 7, 1498, requesting the passage of the material "mediante el conveniente prezo da pagarsi per dicto nostro."
75 Hirst 1985, p. 155.
76 Hatfield 2002, p. 8, doc. R20. He made another payment on February 21, 1500 (doc. R57).
77 Holt 1958, p. 3, publishes an English translation of the contract for the *Pietà. Contratti,* pp. 5–6.
78 Landucci 1927, p. 125.
79 Bradford 1976, p. 72.
80 Ibid., p. 71.
81 Ibid.
82 Guicciardini 1984, p. 127.
83 February 27, 1498; Landucci 1927, pp. 130–31.
84 Masters 1999, p. 62.
85 Letter to Ricciardo Becchi, in Viroli 2000, pp. 29–30.
86 Savonarola 1898, p. 326.
87 March 28, 1498; Landucci 1927, p. 134.
88 April 7, 1498; Ibid., p. 135.
89 April 19, 1498; Ibid., p. 138.
90 May 19, 1498; Ibid., p. 142.
91 May 22, 1498; Ibid., p. 142.
92 Danny Bloom, Rome, Italy, letter to the *Guardian,* in response to "Whatever happened to Laszlo Toth, the man who smashed Michelangelo's Pieta in 1972?" http://www.guardian.co.uk/notesandqueries/query/0,5753,-2565,00.html.
93 Quoted in Sagoff 1978, p. 458.
94 Goldscheider 1964, p. 10.
95 Sagoff 1978, p. 463.
96 Vlastos 1973, p. 27.
97 Freedberg 1989, p. 420.
98 Waldman 2004, p. 380.
99 Condivi-Wohl 1976, pp. 24–27.
100 Steinberg 1997, p. 127.
101 Clark 1984, p. 241.
102 Posèq 1999, p. 92.
103 Wölfflin 1968, p. 41.
104 Repetti, quoted in Scigliano 2005, p. 75.
105 Scigliano 2005, p. 78.
106 Pope-Hennessy 1985, vol. 3, p. 8.
107 Clark 1984, p. 242.
108 "The Making of The Pieta" by Irving Stone, http://avemaria.bravepages.com/articles/jul/pieta.html.
109 Gregorovius, quoted in Schaff 1888, vol. 6, section 54, "Pope Alexander VI—Borgia. 1492–1503."
110 Bradford 1976, p. 77.
111 Pastor 1901, p. 63.
112 July 13, 1499; Landucci 1927, p. 158.
113 There are no documents in support of the story that Leonardo da Vinci planned or contributed to the decorations for the king's entrance. Cloulas 1993, p. 110.
114 Nicholl 2004, pp. 321–22.

115 Paolo Giovio is the source. See Bramly 1994, p. 307.
116 Bradford 1976, p. 108.
117 Nicholl 2004, p. 322.
118 See Bradford 1976, p. 105, for a discussion of all the Papal States involved, including Pesaro and Cesena.
119 Bradford 1976, p. 107.
120 The translation is adapted from Saslow 1991, poem no. 10, p. 78. Saslow follows the traditional dating of this poem to ca. 1512 and the papacy of Julius II. However, Ciulich and Ragionieri 2002, cat. 2, convincingly date the poem earlier, ca. 1497, based on the youthful style of the handwriting. The references to the papacy as likely apply to that of Alexander VI, including the final verse, which reflects the sermons of Savonarola in its contrast between poverty, which is pleasing to God, and luxury, which suffocates the spirit.
121 Hatfield 2002, pp. 8–9.
122 Ibid., p. 10.
123 Bradford 1976, p. 110.

DAVID

1 He used this signature for the poem transcribed on pp. 121–22; the original manuscript is in the Casa Buonarroti (Archives, XIII, 110).
2 February 14, 1500: letter from Lodovico in Florence to Michelangelo in Rome. *Carteggio,* vol. 1, doc. V.
3 Ibid.
4 Ibid.
5 Hatfield 2002, p. 12, docs. R69–70.
6 Bull 1995, p. 44. The prescription continues: "I went for a few days eating only sops of bread, chicken and egg, and I took by the mouth a little cassia, and I made a poultice of thyme, which I put in a pan with rose oil, and camomile oil, and when the poultice was ready I applied it to the front of my body, and in a few days was well again: However, be careful, as this is dangerous. May Christ keep you from all harm . . ."
7 *Carteggio,* vol. 1, doc. VI. The letter is addressed *Domino* [to Sir] *Michelagniolo di Lodovico Bonarroti in Roma.*
8 Ibid.
9 Fagiolo and Madonna 1984, p. 34.
10 Burchard 1883–85, vol. 2, pp. 591–93, quoted in Schaff 1888, section 54.
11 Burckhardt 1914, p. 115.
12 Roscoe 1846, vol. 1, p. 171.
13 Breisach 1967, p. 227.
14 Ibid., p. 228.
15 Ibid., p. 232.
16 Ibid., p. 238.
17 Ibid. Johann Burchard was the papal master of ceremonies.
18 Bradford 1976, pp. 114–15.
19 Vasari-Milanesi 1906, vol. 7, p. 152.

20　Hirst and Dunkerton 1994, p. 78, note 26. Michelangelo carved his signature on a diagonal strap that crosses the Virgin's chest; similar kinds of straps were employed in Florence for supporting a child: see de Tolnay 1943–60, vol. 1, p. 91, and Shearman 1992, p. 237, with some examples. See Juren 1974, pp. 27–30, for a discussion of Poliziano's observation of the usage of the imperfect on an antique fragment on his visit to Rome (with Piero de' Medici) in 1488, and his subsequent written résumé of its significance one year later. Juren also draws attention to its classical antecedents and Poliziano's recognition of a relevant passage in Pliny's *Natural History*, for whom the usage of the imperfect showed that art was something begun and never finished, or, alternatively, a sign of modesty on the part of the artist. We find Andrea Sansovino following Michelangelo's use of the imperfect on his two della Rovere tombs in Santa Maria del Popolo not many years later.

21　On February 28 Michelangelo paid six months' rent on his house to Fabrizio Pugligate Vanoso: Mancusi-Ungaro 1971, p. 148; cited in *Giovinezza*, p. 161, note 110.

22　Hatfield 2002, p. 61, lists a deposit on July 3 of 230 ducati, 40 bolognini, received from Donato Ghinucci & Co., presumably as final payment for the *Pietà*.

23　This assistant is mentioned in Lodovico's letter of December 19: "Buonarroto also told me about that young man that you had with you down there, namely Piero di Giannotto" (*Carteggio*, vol. 1, doc. VI). He is assumed to be Piero d'Argenta, who had been assisting Michelangelo since 1497.

24　Hirst 1981, p. 583.

25　Ibid.; Hatfield 2002, doc. R67.

26　Hirst 1981, p. 583.

27　Hatfield 2002, p. 13, doubts Michelangelo would have refunded the money in full for a painting as close to being finished as the London *Pietà*.

28　Hirst and Dunkerton 1994, pp. 57–71. The subsequent history of the chapel is discussed with documentation in Nagel 1994, pp. 164–67. A certain Maestro Andrea made an altarpiece of the *Pietà*, which was installed on June 18, 1502. As early as October 23, 1506, this chapel "della Pietà" will be cited as belonging to Fiammetta, the famous courtesan connected with Cesare Borgia, whose house stood in the nearby piazza. Many prostitutes were known to attend masses at S. Agostino; see Nagel 1994, p. 166, note 25. The chapel dedication was changed in 1603 when the rights were transferred to Ermete Cavalletti and his family, and Maestro Andrea's *Pietà* was replaced by Caravaggio's *Madonna of Loreto*; see Spike 2001, p. 149. Caravaggio's painting was thus placed above an altar traditionally frequented by prostitutes.

29　Nagel 1994, pp. 164–67.

30　Hirst and Dunkerton 1994, pp. 80–81.

31　Hochmann 1995, p. 111.

32　Hatfield 2002, doc. R27.

33　On January 26, 1506, Michelangelo paid Galli's heirs 72 large ducats and reacquired the stones. The difference of 8 large ducats from the original 80 large ducats resulted from Galli's sale of two pieces of marble to Piero Torrigiani.

34　Hatfield 2002, doc. R76.

35　Vasari-Milanesi 1906, vol. 7, p. 153.

36　*Contratti*, doc. II, May 22, 1501, p. 7.

37　Ibid., doc. III, June 5, 19, 25, 1501, pp. 8–11.

38　Ibid., p. 10.

39　Torrigiani's contract of May 1501 is cited by A. Darr in *The Grove Dictionary of Art*, edited by Jane Turner, 1996.

40　The pope's secretary, Cardinal Adriano Castelesi, engaged Torrigiani to sculpt the *cantoria* and various marble tombs and altars, 1500–1502, in the Church of San Giacomo degli Spagnoli in Piazza Navona in Rome.

41　Parks 1975, p. 561.

42　Condivi-Wohl 1976, p. 28.

43　Holt 1958, vol. 2, p. 4.

44　Sergio Bertelli, in Scalini 2001, p. 54.

45　Landucci 1927, p. 178.

46　Ibid., pp. 178–79.

47　Ibid., p. 179.

48　Ibid.

49　Ibid., p. 180.

50　Ibid.

51　Guicciardini, *Storie fiorentine*, ch. XXI, translated in Najemy 2006, p. 403.

52　Nicholl 2004, p. 330.

53　Ibid., p. 332, for a discussion of these events as reported by Vasari.

54　Letter from Fra Pietro Novellara to Isabella d'Este dated Florence, April 14, 1501: Nicholl 2004, p. 337.

55　Ibid.

56　Vasari-Milanesi 1906, vol. 4, p. 38; Nicholl 2004, p. 332.

57　Letter from Fra Pietro Novellara to Isabella d'Este dated Florence, April 14, 1501: Nicholl 2004, p. 337.

58　Gaye 1839–40, vol. 2, p. 52.

59　Ibid., p. 54.

60　Bradford 1976, p. 157.

61　Ibid.

62　Ibid., p. 162.

63　Ibid., pp. 161–62.

64　Nicholl 2004, p. 344. The notebook is at the Institut de France, Paris, MS 2182.

65　Bradford 1976, p. 177.

66　Letter from Machiavelli to the Council of Ten; see Bradford 1976, p. 178.

67　Bradford 1976, pp. 178–79.

68　Landucci 1927, June 26, 1502, p. 196.

69　Ibid., August 26, 1502, p. 199.

70　Parks 1975, p. 564, note 16.

71　Gaye 1839–40, vol. 2, p. 52.

72　Ibid., p. 54.

73 Rubenstein 1986, p. 257.
74 Gill 2003, p. 226.
75 Vasari 1568, vol. 7, pp. 153–57.
76 Seymour 1974, p. 26.
77 Ibid., pp. 37–38.
78 Scigliano 2005, p. 99.
79 Pope-Hennessy, *Italian High Renaissance,* 1970, p. 12.
80 Condivi-Wohl 1976, p. 7.
81 Vasari 1568, vol. 7, pp. 153–57.
82 Condivi-Wohl 1976, p. 28. Condivi writes that Piero Soderini, *suo grande amico,* sought him for this task.
83 Seymour 1974, p. 7.
84 Petrarch, from the *Canzoniere.*
85 Seymour 1974, p. 5, for comments on these lines.
86 Hirst 2000, p. 488.
87 Ibid.
88 Gaye 1839–40, vol. 2, pp. 59–60.
89 Lorenzo di Pierfrancesco de' Medici died during the night of May 19, 1503: Baldini 2003, p. 281, note 31.
90 Gill 2003, p. 259.
91 Masters 1999, p. 85.
92 Ibid., p. 94.
93 Ibid., p. 95.
94 Landucci 1927, p. 206.
95 Kelly 1986, p. 255.
96 Information in *Handschriften des Mittelalters* 2007. The find was made by Dr. Armin Schlechter and released to Reuters on January 15, 2008.
97 He was to receive keys to the *sale pape et atigue habitationem* (the chamber of the pope and other adjacent rooms). Bambach 2005, pp. 34–43, note 48, cites the document of October 24, 1503, in the Archivio di Stato, Florence, with additional bibliography.
98 Seymour 1974, p. 151.
99 Ibid.
100 Ibid., p. 149.
101 Vasari-Bondanella 1998, p. 427.
102 *Trattato,* quoted in Summers 1981, p. 376.
103 Ibid., pp. 300, 322.
104 Gaye 1839–40, vol. 2, p. 462.
105 Landucci 1927, p. 214.
106 Ibid.
107 According to Parks 1975, p. 565, the significance of the stoning cannot be determined: "That the *David* was stoned during the first night of its transport to the Piazza de' Signori has been attributed to the antagonism of Medici adherents (Hartt, de Tolnay); or oppositely to pro-Republican forces who resented removal of the *Judith* (Klein and Zerner). And other possibilities exist: that of *piagnoni* offended by its nudity; and of simple vandalism, devoid of any ideological basis."
108 Pope-Hennessy 1985, p. 310.
109 Parks 1975, p. 569, note 43: The sling and the tree stump were gilded at the same time. See Frey 1909, pt. C, docs. 189, 190, and especially 192.

THE VIZIER

1 Hatfield 2002, p. 38, not including assets or possessions.
2 Condivi-Wohl 1976, p. 28; Condivi-Nencioni 1998, p. 22.
3 Saslow 1991, poem 1.
4 The British Museum, London (1859-9-15-496), pen and brown ink. The sonnet lines are on the verso, which is illustrated and discussed in Chapman 2005, p. 73.
5 The British Museum, London (1859-6-25-564), pen and brown ink. The sonnet lines are on the verso, which contains a sketch of the Madonna and Child in the *Bruges Madonna,* and several variations on the infant Baptist in the *Taddei Tondo,* and is illustrated and discussed in Chapman 2005, p. 91.
6 Saslow 1991, poem 2.
7 Wilde 1944, p. 66.
8 Ibid.
9 Ibid., p. 67.
10 Nelson, Arasse, and De Vecchi, 2004, p. 323.
11 Quoted in Wilde 1944, p. 78.
12 Ibid. See Frey 1909, doc. 154.
13 Seymour 1974, pp. 152–53. This was the opinion expressed by Michelangelo di Viviano, the goldsmith and father of Baccio Bandinelli.
14 Masters 1999, pp. 114–15.
15 Ibid.
16 Ibid., p. 86.
17 Vasari-Bondanella 1998, p. 286.
18 Grimm 1900, vol. 1, p. 254.
19 The young man's spirits were buoyant. The acclaim bestowed on the *David* had recently been publicly renewed with a civic ceremony of inauguration on September 8, which was noted by Landucci ("E a dì 8 di settenbre 1504, fu fornito el gigante in Piazza, e scoperto di tutto").
20 Listri 2003, p. 45.
21 Masters 1999, pp. 130–31.
22 Nicholl 2004, p. 359.
23 Masters 1999, p. 137.
24 In the autumn of 1504 Machiavelli wrote the *Decennali in terza rima* and dedicated them to Alamanno Salviati; it is probable that he had the work printed about the end of that year or the beginning of the next, under the care of his colleague in the Chancellery, Ser Agostino di Matteo. The title of this extremely rare little volume is *Nicolai Malclavelli Florentini Compendium Rerum Decennii in Italiam Gestarum ad Viros Florentions, incipit feliciter.* It bears neither the printer's name nor the place or date.
25 Nicholl 2004, p. 388. Leonardo was back in Florence by the end of November.
26 Clark 1956 and 1984, p. 59.
27 Anonimo Fiorentino 1968, pp. 124–25. The Corsini were one of Florence's noble families.
28 Condivi-Wohl 1976, p. 97.

29 Birke 1992, inv. 123.
30 An effect that influenced Giulio Romano's Sala dei Gigante, 1526–34, in the Palazzo del Tè, Mantua.
31 Chapman 2005, nos. 13 and 14 (recto and verso), in the British Museum; see ibid., fig. 28, for the Uffizi drawing.
32 Chapman 2005, nos. 9 and 10 (recto and verso), in the Teylers Museum, Haarlem, and the famous Seated Nude Twisting Around, no. 11, in the British Museum.
33 Golzio 1936, pp. 9–10.
34 Ibid. The letter is dated October 1, 1504.
35 Francesco Maria della Rovere was the nephew of Julius II. In 1501, when he was ten years old, he succeeded his father, Giovanni, in the office of prefetto of Rome. In 1504, with the pope's approval, he was adopted as son and heir, with rights of succession, by Guidobaldo da Montefeltro, duke of Urbino.
36 Vasari-Bondanella 1998, p. 307.
37 Vasari-Milanesi 1906, vol. 4, p. 321.
38 See Golzio 1936, pp. 11–13, for Raphael's contract of December 12, 1505, to paint the Coronation of the Virgin for the Franciscan church of Monteluce in Perugia.
39 The letter by Baldassare Castiglione to his mother, Aloisia, is transcribed in Castiglione 1969, sub datem July 7, 1504.
40 Vasari-Bondanella 1998, p. 307.
41 Leonardo da Vinci drawing of David, now in the Royal Library at Windsor Castle.
42 Raphael, back view of the David, British Museum.
43 Pope-Hennessy, Raphael, 1970, p. 184.
44 Hamlin 1946, p. 223.
45 Ibid., p. 224.
46 The unusual iconography of the Bruges Madonna thus constitutes an unexpected argument in favor of the unproven and perhaps unprovable hypothesis that Michelangelo may have conceived it in connection with the Piccolomini Altar, which stands outside the Piccolomini Library in the Siena Cathedral. Only Michelangelo, perhaps, would have attempted to persuade the pope's heirs to change their instructions in order to facilitate his vision of a plan dominated by his contribution of a central sculpture. See Mancusi-Ungaro 1971, for the inconclusive documentary evidence.
47 Wölfflin 1968, p. 42. See Ziegler 1995, p. 32.
48 Hall 2005, pp. 21–23, proposes a connection between Michelangelo's aloof Madonnas and the haughtily beautiful "stony woman" in Dante's four Rime petrose.
49 He noted it in his daily journal of his travels in the Netherlands.
50 This military information is found on the "Canadians at War" Web site, http://www. forces.gc.ca/dhh/collections/caw/engraph/home_e.asp?cat=7.
51 Hamalainen 2007.

52 Gaye 1839–40, vol. 2, pp. 92–93, includes several valuable notices in relation to the project: on October 31, 1504, the bookbinder Bartolomeo di Sandro received seven lire for fourteen sheets of Bolognese royal paper for the cartoon of Michaelangelo; the bookbinder Bernardo di Salvadore, five lire for gluing it together; in December the workmen who had stretched the paper on the frame were paid; there is also the account of the apothecary for the wax and turpentine in which the paper that was to serve as windows was steeped. The paper "fogli reali Bolognese" and a papermaker to glue the sheets together, and the use of a room in the Spedale dei Tintori near Sant Onofrio were granted by the city. Nearly two reams of royal folio paper were employed for Leonardo's cartoon, and eighty-eight pounds of flour were consumed for paste to attach the paper to the lining. See also Morozzi 1988–89, p. 320; Bambach, 1999, pp. 105–33.
53 Hatfield 2007, p. 43, cites this document.
54 See Nicholl 2004, p. 379.
55 No doubt it didn't help that Perugino was working on the Santissima Annunziata commission altarpiece promised by Leonardo but never begun.
56 Vasari-Milanesi 1906, vol. 3, p. 585. Vasari tells this story in his biography of Perugino (omitted from Vasari-Bondanella). Vasari also claims that Perugino unsuccessfully appealed to the Council of Eight for a judgment against Michelangelo, but no trace of his petition has ever come to light.
57 Vasari-Bondanella 1998, p. 296.
58 Masters 1999, p. 139. The Great Council Hall was made ready for Leonardo's work on March 14. On April 30 the painter received another payment. Exactly where in the Great Council Hall Leonardo placed his work is a bone of contention, as all remnants were covered over in the 1550s when Grand Duke Cosimo I de' Medici ordered the remodeling of the aging hall.
59 The passage in Leonardo's Madrid Notebook (II, 2 a) is translated in Bramly 1994, pp. 347–48.
60 Vasari-Milanesi 1906, vol. 4, p. 21. See also Manca 1996, pp. 143, 149, 157–58 (extensive bibliography).
61 Vasari-Bondanella 1998, p. 286.
62 Manca 1996, p. 154.
63 Ibid., p. 149. See also Bambach Cappel 1991, pp. 72–95.
64 Ephesians 4:26, Revised Standard Version.
65 Gaye 1839–40, vol. 2, p. 93, cites the down payment, which, unusually, gives his names and patronyms going back to his grandfather, i.e., "Michelangelo di Lodovico di Lionardo di Buonarroti Simoni." See also Hirst 1991, p. 762.
66 Amy 2000, p. 495, documents that the block of marble was taken in January 1505 from the Opera del Duomo to "Michelangelo's house,

that is, the house then being erected for the artist in Borgo Pinti." The stone was later worked by Andrea Ferrucci.

67 Hatfield 2002, p. 38.

68 Ibid.

69 Condivi-Wohl 1976, pp. 28–29.

70 Hirst 1991, p. 762.

71 Condivi-Wohl 1976, pp. 28–29; Vasari-Bondanella 1998, pp. 431–32.

72 Vasari had the same opinion; see Vasari 1976, vol. 4, pp. 144, 146–47. The relevant passage in Francesco Sangallo's 1567 letter to Vincenzo Borghini is quoted in Carteggio, vol. 1, p. 365.

73 Hatfield 2002, pp. 18ff; Hirst 1991, p. 762.

74 Hirst 1991, p. 762.

75 Hatfield 2002, pp. 18ff. On March 27 he received 60 large gold florins from Jacopo Rucellai on the orders of the pope, which he deposited in the bank of his old friend Baldassare Balducci. A month later, he emptied his account on the eve of his departure from Rome and journey to Carrara to obtain marbles.

76 Paride de' Grassi (Latin: Paris de Grassis) succeeded Burchard as Maestro delle Ceremonie della Cappella Papale on May 26, 1504. See Frati 1886, sub annum.

77 Giuliano was in Savona in May 1496.

78 Villa La Magliana and the Palazzo Penitenzieri. Caroline Elam, et al., "Sangallo, da," Grove Art Online at oxfordartonline.com

79 Machiavelli went personally to call on Alidosi in his chambers. In his letter of November 23, 1503, to the Council of Ten, he writes "questa mattina ne andai alle camera di messer Francesco di Castel del Rio, ch'è il primo che sia appresso ad questo Pontefice." Machiavelli 1964, p. 672. See Hirst 1991, p. 763, note 29.

80 Some of the nephews are depicted in a fresco painted in the Latin Hall of Sixtus IV's Vatican Library by Melozzo da Forlì (1438–94). It represents Sixtus IV appointing Bartolomeo Platina the first prefect of the Vatican Library, ca. 1477 (later transferred to canvas and now held in the Pinacoteca Vaticana). Platina, kneeling in the center, receives the investiture and points his right index finger at an inscription composed by him that exalts the enterprises of Sixtus IV in the city of Rome. Sixtus IV is seated on his throne on the right, among his cardinal nephews and lay nephews. The apostolic pronotary Raffaele Riario is on his right, the future pope Julius II (pontiff from 1503 to 1513), Giuliano della Rovere, stands before him, and Girolamo Riario and Giovanni della Rovere are behind Platina.

81 Rowland 1998, p. 107.

82 Rowe and Satkowski 2002, pp. 35–41.

83 Frommel 1976, p. 51, notes that the Belvedere foundation medal compares Bramante's plan to Nero's Cortile.

84 Dante 1954, p. 138.

85 See Creighton 1903, vol. 5, p. 90.

86 Pratt 1965, pp. 35–36.

87 Jerome describes the devastation of the Empire around 406 in the preface to the third book of his Commentary on Ezekiel, 410–14; this translation in Robinson 1906, vol. 1, p. 45.

88 Pratt 1965, p. 32.

89 Santa Maria Nova was built ca. 850 on the ruins of the Temple of Venus and Rome by Emperor Hadrian, A.D. 121–41; see Pratt 1965, pp. 33, 35.

90 Gregory of Tours 1988, p. 19.

91 Dante, Convivio, iv, 4; Virgil, Aeneid, Bk. 1, 275–79.

92 Vasari-Bondanella 1998, p. 432; Vasari-Milanesi 1906, vol. 7, p. 164.

93 The metric equivalent of a Florentine braccio ("arm's length") has been variously estimated at between 45 and 58 centimeters; in any event, the proportions remain 2:3.

94 Funerary coins issued between A.D. 141 and 306; Frazer 1975, p. 53.

95 The Renaissance mistakenly interpreted these images as imperial mausoleums; in fact, they were funeral pyres for the cremation of the emperor's body (or a surrogate wax image of the deceased); Frazer 1975, p. 53.

96 Jacob's vision of a "ladder" is generally considered a less accurate translation for "staircase"; Houtman 1977, pp. 337–38.

97 This concept inspired Longfellow's poem "The Ladder of Saint Augustine," which includes this stanza:

The mighty pyramids of stone
That wedge-like cleave the desert airs,
When nearer seen, and better known,
Are but gigantic flights of stairs.

98 Fitzgerald and Cavadini 1999, p. 23: Augustine wrote "De Animae Quantitate" (On the Greatness of the Soul) in Rome after his baptism, probably in 388. The dialogue begins with six questions: origin of the soul; its quality; its quantity or greatness; the reason for its union with the body; the result of that union; and the result of its separation from the body (quant.1.1). He defines the soul in highly Platonic language as "a certain substance partaking in reason and suited to rule the body" (13.22).

99 In Condivi-Wohl 1976, p. 33, Condivi states confusedly that the Prisoners, as he calls them, represent the Liberal Arts, although in fact they lack any identification as such. Nevertheless, his may be a reference to Augustine (20.34), who states that in his view, "the soul has brought with it all the arts and that what we call learning is merely remembering." Or he may have based his assumption on the personification of the liberal arts as lithe young women on Sixtus IV's tomb in St. Peter's. See Stinger 1998, p. 147.

100 Augustine, City of God, 22.24.2; see Fitzgerald and Cavadini 1999, p. 26.

101 Nicholas Temple essay in Wyke 2006, p. 119. The church preserves the chains that held St. Peter during his imprisonment under Herod.

Panofsky 1972, p. 196, points out that *vinculum*, which means both "link" and "fetter," was the Neoplatonic expression for the principle that binds the soul to the material body.

102 Fitzgerald and Cavadini 1999, p. 885.

103 Apart from specifically Pauline programs, St. Paul is usually represented alongside St. Peter, his fellow apostle, martyr, and patron saint of Rome.

104 Augustine, *Genesi ad litteram*, 12.27.55; 12.28.56; *Epistula* 147.13.32; see Fitzgerald and Cavadini 1999, p. 885. The Florentine Neoplatonists, especially Pico della Mirandola, were enthralled by this pairing of mystical seers; see Panofsky 1972, p. 140.

105 Genesis 29:31; see de Tolnay 1964, p. 73.

106 Condivi-Wohl 1976, p. 79, cites Dante's descriptions in the *Purgatorio*.

107 Augustine, *contra Faustum*, xxii, 52, among other citations.

108 Shanzer 1984, p. 360; Augustine, "De Animae Quantitate " (PL 32, 1073ff.), cited in Fitzgerald and Cavadini 1999, p. 376.

109 Condivi-Wohl 1976, p. 33.

110 Kelly 2002, p. 2, points to this line from Rainer Maria Rilke's poem "Of One Who Listened to the Stones."

111 Hatfield 2002, docs. R87, 88: On April 28 Michelangelo deposited with Baldassare Balducci in Rome 55 ducati, 7 bolognini in cash, arranging to withdraw them in Florence from Bonifazio Fazi & Co. to pay for his travel to Carrara.

112 Hirst 1991, p. 762; Hatfield 2002, pp. 19, 39. See also Beck 1990, pp. 63–77.

113 Hirst, 1991, p. 762; Hatfield 2002, pp. 19, 39.

114 Soderini evidently still held out hope for the *Cascina* because in August he paid a "rope maker" to work on the cartoon.

115 Condivi Wohl 1976, pp. 29–30.

116 Ibid.

117 Elam 1998, p. 493.

118 Condivi-Wohl 1976, p. 37.

119 Elam 1998, p. 493.

120 The Leonardo Bridge Project, www. leonardobridgeproject.org

121 Vasari 2006, p. 240.

122 Freud 1999, pp. 33–34.

123 Beck 1993, p. 187.

124 Freud 1999, pp. 33–34.

125 A *carrata* was equivalent to the maximum load a pair of oxen could pull in a wagon over level ground: see Scigliano 2005, p. 161. The stones and their weights are described in the contract in *Contratti*, doc. XV, November 12, 1505, pp. 35–36, ". . . triginta quatuor carratas marmorum, inter quas sunt due figure que sunt 15 carrate" ("thirty-four cartloads of marble, among which there are two figures weighing fifteen cartloads").

126 Tacitus, *Annals* (3.54).

127 *Contratti*, doc. XV, November 12. 1505, p. 36.

128 Ibid., doc. XVI, December 10, 1505, pp, 37–39.

129 Ibid.

130 Ibid., doc. XVI, November 12, 1505, p. 37.

131 Scigliano 2005, pp. 25, 28–29.

132 Baldinucci 1681, p. 90.

133 Amy 2002, p. 493, points out that this deliberation reflected the Opera's acceptance of delays, rather than a cancellation.

134 Hatfield 2002, p. 39.

135 Ibid., p. 19, doc. R89.

136 Pliny the Elder, *The Natural History*, XXXVI, 37.

137 Klaczko 1903, p. 95.

138 Letter from Sabadino degli Arienti in Rome to Isabella d'Este in Mantua; see Klaczko 1903, p. 94.

139 The tablet reads: OB PROPRIAS VIRTUTES ET REPERTUM LAOOCHONTIS DIVINUM SIMULACRUM; see Klaczko 1903, p. 94.

140 Ibid., pp. 93–96.

141 Hatfield 2002, p. 39.

142 *Letters*-Ramsden, vol. 1, pp. 235–36.

143 *Carteggio*, vol. 1, doc. VII.

144 Hirst 1991, p. 764.

145 *Carteggio*, vol. 1, doc. VII.

146 Hatfield 2002, doc. R97.

147 Ibid., doc. R91.

148 Hatfield 2002, p. 19; Hirst 1991, Appendix A, doc. 14. The church no longer exists.

149 Hatfield 2002, p. 10, Hirst 1991, p. 761.

150 Hatfield 2002, p. 20, note 10. "M. Iacopo apparently died between 13 June and 1 July 1505."

151 *Carteggio*, vol. 1, doc. VII.

152 Scigliano 2005, p. 163. Michele di Piero di Pippo, called Battaglino da Settignano. He was a *scarpellino* (stonemason), employed to do the initial blocking out of figures under a sculptor's instructions.

153 Presumably the *Bruges Madonna*, which was not shipped, however, until August 1506.

154 *Carteggio*, vol. 1, doc. VII.

155 Hatfield 2002, p. 20, docs. R98, R101.

156 Ibid., docs. R95, R100.

157 Letter of February or March 1506, from Michelangelo in Rome to his brother Buonarroto in Florence. *Letters*-Ramsden, vol. 1, no. 7, p. 13 (Buonarroti Archives Mil. lxxvii).

158 Ibid.

159 Hatfield 2002, pp. 18–20.

160 Condivi-Wohl 1976, p. 34.

161 Frommel 1977, 30–33.

162 Tronzo 2005, pp. 67–75.

163 Ibid., p. 74.

164 Weiss 1965, p. 170; Frommel 1976, pp. 94, 100.

165 Condivi-Wohl 1976, p. 35.

166 In 1510 Bramante laid the foundations for the piers of a new nave in St. Peter's, which necessitated the destruction of large parts of the transept and half of the nave of the basilica begun by Constantine in 324.

167 Michelangelo's recollection in a letter of October 1542, as translated in Symonds 1928, p. 101.

168 Condivi-Wohl 1976, p. 35.
169 Scotti 2006, pp. 8–10.
170 Vasari-Bondanella 1998, p. 23.
171 Celenza 1999, pp. 667–711, notes 52, 53.
172 Plato, *The Republic*, Book VII, in the dialogue between Socrates and Glaucon.
173 Celenza 1999, p. 683, note 101.
174 Brunelleschi moved to suppress Gothic ornaments in his renovation of San Lorenzo, the Medici church in Florence. Ruda 1978, pp. 358–61: A clause in the 1434 chapel program stipulates that any new altarpiece was required to be "a square panel without canopies, honourably painted." See Spike 1997, pp. 38–39.
175 Joost-Gaugier 1998, "The Iconography of Sacred Space," p. 30.
176 Pope-Hennessy, *Luca della Robbia*, 1980, p. 60: Donatello conceived a style of relief that resembled a painting with a modeled surface.
177 Steinberg 1983, p. 124, calls this gesture the "not-yet" motif.
178 For the provenance of the *Pitti Tondo* and the Pitti family's connections with Michelangelo, see Wallace 1992, pp. 68–70; Rosen 2003, pp. 4–24.
179 Vasari-Milanesi 1906, vol. 7, p. 151.
180 Vasari 1960, p. 152.
181 BM 1887-5-2-117; reproduced in Chapman 2005, p. 90, no. 13 verso.
182 Vasari-Bondanella 1998, p. 472.
183 Ibid., p. 287.
184 *Letters*-Ramsden, vol. 1, no. 8, p. 15.
185 *Carteggio*, vol. 1, doc. IX.
186 Ibid.
187 *Carteggio*, vol. 1, doc. X, p. 16. See Scigliano 2005, pp. 165–66; Condivi-Wohl 1976, p. 131, note 54.
188 *Carteggio*, vol. 1, doc. X. See Condivi-Wohl 1976, p. 131, note 54; Scigliano 2005, pp. 165–66.
189 Symonds 1928, p. 114. See Wittkower and Wittkower 1969, p. 39.
190 Gaye 1839–40, vol. 2, no. XXIX, p. 83.
191 Ibid.
192 Ibid., p. 84. See Grimm 1900, vol. 1, p. 279.
193 Nicholl 2004, p. 403.
194 October 9, 1506, Soderini complains to the French in Milan; Gaye 1839–40, vol. 2, pp. 87–88.
195 The Sangallo copy is at Holkham Hall.
196 Cellini 1903, p. 23.
197 He also created the style of anatomical studies that came to be called "academies": S. J. Freedberg, quoted in Gere 1979, p. 24.
198 Vasari-Bondanella 1998, p. 431.
199 Scigliano 2005, p. 321, note 9, cites Soderini's letter of August 7, 1506.
200 In these later letters, Soderini mentions Michelangelo and pleads for patience until the pope frees the artist to spend more time in Florence.
201 Amy 2000, p. 494, notes there is no evidence that Michelangelo was ever paid the monthly salary of two florins stipulated in the contract of April 1503; Amy also points out the contradictory references in the sources and in Michelangelo's own draft letter of December 1523 regarding the date of his *St. Matthew*.
202 Ferrucci's statue is in the Florence cathedral.
203 Vasari-Milanesi 1906, vol. 7, pp. 272–73; Cellini confirms that Michelangelo cut in from only one side of the block.
204 Plotinus, *Enneads*, I.6.
205 Vasari-Bondanella 1998, p. 429.
206 Ibid., p. 430.
207 Grimm 1900, vol. 1, p. 280; Condivi-Wohl 1976, p. 37.
208 Soderini letter, August 21, 1506.
209 See Grimm 1900, vol. 1, p. 281.
210 Hatfield 2002, p. 64.
211 Graham-Dixon 1999, p. 205.
212 Instructions given to Machiavelli, sent to Rome. See Machiavelli 1882, for August 25, 1506.
213 Machiavelli, *Discourses*, Book I, Chapter XXVII.
214 Roscoe 1846, vol. 1, p. 220.
215 Giovanni and Bernardo Boerio. Erasmus praised them as intellectually mature for their age; Erasmus 1901, Epistles 194 and 195, June 1506.
216 On November 4 he wrote letters from Florence to Servatius Rogerus and others; Erasmus 1901, Epistle 200.
217 Christine Shaw in Gosman, MacDonald, and Vanderjagt 2005, p. 57. For the military campaign of Julius II, see Frati 1886.
218 Erasmus to Jerome Busleiden, Provost of Aire, Royal Councillor, November 17, 1506, in Erasmus 1901, Epistle 202.
219 Wren, Wren, and Carter 1994, pp. 49–51.
220 Ibid., pp. 48–51; Tatham 1895, pp. 642–46.
221 Grimm 1900, vol. 1, p. 292. The original letter was first published in Gaye 1839–40, vol. 2, pp. 91–92.
222 *Carteggio*, vol. 3, doc. DXVI; Condivi-Wohl 1976, p. 131, note 52; Symonds 1928, pp. 121–22; Gouwens and Reiss 2005, p. 191.
223 Condivi-Wohl 1976, pp. 37–38.
224 Ibid., p. 131, note. 53.
225 Letter from Michelangelo in Florence to Giovanni Francesco Fattucci in Rome, late December 1523, in *Carteggio*, vol. 3, doc. DXVI. See Symonds 1928, p. 120.
226 Tuttle 1982, pp. 189–201.
227 Ibid.
228 Letter from Michelangelo in Bologna to his father Lodovico in Florence, February 8, 1507, in *Carteggio*, vol. 1, doc. XVI.
229 Hirst 2005; Symonds 1911 and 2002, p. 189.
230 Letter from Michelangelo in Bologna to his brother Buonarroto in Florence, December 19, 1506, in *Carteggio*, vol. 1, doc. XI.
231 Letter from Michelangelo in Bologna to his brother Buonarroto in Florence, February 1, 1507, in *Carteggio*, vol. 1, doc. XIV.
232 Wallace 1997, pp. 22–26.
233 "I must also inform you how on Friday morning I dismissed Lapo and Lodovico, who have been assisting me here. Lapo I sent

packing because he is a deceitful good-for-nothing fellow, who did not do what I wanted. Lodovico, however, is not so bad, and I would have kept him on for another two months. But Lapo, so that he might not be the only one in disgrace, influenced him in such a fashion that they have both gone off. I am telling you this, not because I take any account of them, for they are not worth three *quattrini* between them, but in order that Lodovico may not be alarmed about it, if they go talking to him. Tell him on no account to listen to them. And if you yourself want to know more about them, go to Messer Angelo, Herald to the Signoria, because I have written and told him about the whole affair, and he, of his kindness, will explain it to you." *Letters*-Ramsden, p. 22. Letter from Michelangelo in Bologna to his brother Buonarroto in Florence, February 1, 1507, in *Carteggio*, vol. 1, doc. XIV.

234 Scigliano 2005, p. 171, translation of Michelangelo's letter to Lodovico, February 8.

235 Condivi-Wohl 1976, page 38.

236 *Letters*-Ramsden, vol. 1, p. 22. Letter from Michelangelo in Bologna to his brother Buonarroto in Florence, February 1, 1507, in *Carteggio*, vol. 1, doc. XIV.

237 The Cardinal d'Amboise. See Christine Shaw in Gosman, MacDonald, and Vanderjagt 2005, p. 56.

238 Bradford 1976, p. 282.

239 Tuttle 1982, p. 192; Grimm 1900, vol. 1, pp. 189–201.

240 Paride de' Grassi thought Orte unsuitably small for the event. See Christine Shaw in Gosman, MacDonald, and Vanderjagt 2005, p. 58.

241 Bradford 1976, p. 286; Sabatini 1912, p. 193.

242 Sanuto 1879–1903, vol. 7, col. 64. See Christine Shaw in Gosman, MacDonald, and Vanderjagt 2005, p. 57.

243 Letter from Michelangelo in Bologna to his brother Buonarroto in Florence, December 19, 1506, in *Carteggio*, vol. 1, doc. XII.

244 On January 8, 1507, Lodovico bought a small farm near their own villa at Settignano: Hatfield 2002, doc. Pr2.

245 Wallace 1997, pp. 22–26.

246 Letter from Michelangelo in Bologna to his brother Buonarroto in Florence, March 26, 1507, in *Carteggio*, vol. 1, doc. XX.

247 Letter from Michelangelo in Bologna to his brother Buonarroto in Florence, March 31, 1507, in *Carteggio*, vol. 1, doc. XXII.

248 Wallace 1997, pp. 22–26.

249 Letter from Michelangelo in Bologna to his brother Buonarroto in Florence, June 20, 1507, in *Carteggio*, vol. 1, doc. XXIX.

250 Letter from Michelangelo in Florence to Giovanni Francesco Fattucci in Rome, late December 1523, in *Carteggio*, vol. 3, doc. DXVI.

251 Letter from Michelangelo in Bologna to his brother Buonarroto in Florence, July 6, 1507, in *Carteggio*, vol. 2, doc. XXXI.

252 Letter from Michelangelo in Bologna to his brother Buonarroto in Florence, July 10, 1507, in *Carteggio*, vol. 1, doc. XXXII.

253 Ibid.

254 Letter from Michelangelo in Bologna to his brother Buonarroto in Florence, August 2, 1507, in *Carteggio*, vol. 1, doc. XXXIV.

255 Letter from Michelangelo in Bologna to his brother Buonarroto in Florence, July 10, 1507, in *Carteggio*, vol. 1, doc. XXXII; letter from Michelangelo in Bologna to his brother Buonarroto in Florence, August 2, 1507, in *Carteggio*, vol. 1, doc. XXXIV.

256 Letter from Michelangelo in Bologna to his brother Buonarroto in Florence, August 10, 1507, in *Carteggio*, vol. 1, doc. XXXVI.

257 Letter from Michelangelo in Bologna to his brother Buonarroto in Florence, September 21, 1507, in *Carteggio*, vol. 1, doc. XXXVII.

258 Letter from Michelangelo in Bologna to his brother Buonarroto in Florence, November 10, 1507, in *Carteggio*, vol. 1, doc. XL.

259 Letter from Michelangelo in Bologna to his brother Buonarroto in Florence, September 21, 1507, in *Carteggio*, vol. 1, doc. XXXVII.

260 Letter from Michelangelo in Bologna to his brother Buonarroto in Florence, February 13, 1508, in *Carteggio*, vol. 1, doc. XLIV.

261 Symonds 1928, pp. 125–26.

262 The statue was a symbol of conquest as far as the citizens were concerned. In December 1511, as soon as the papal legate had fled the city and the Bentivoglio family had retaken the government, the sculpture was thrown to the ground, and its bronze melted down and cast into a giant cannon known derisively as La Giulia.

263 Bornstein 1988, p. 41.

264 Weiss 1965, p. 164.

265 Ibid.

266 Letter from Michelangelo in Bologna to his brother Buonarroto in Florence, December 21, 1507, in *Carteggio*, vol. 1, doc. XLI; letter from Michelangelo in Bologna to his brother Buonarroto in Florence, January 5, 1508, in *Carteggio*, vol. 1, doc. XLIII; letter from Michelangelo in Bologna to his brother Buonarroto in Florence, February 13, 1508, in *Carteggio*, vol. 1, doc. XLIV. For the payment, see Hatfield 2002, p. 23; *Ricordi*, pp. 1–2.

267 The deposition was covered in the international news. Most of these particulars appeared in "The Rehabilitation of Cesare Borgia," *The Daily Telegraph*, Jan 23, 2007: http://www.telegraph.co.uk/news/worldnews/1540315/The-rehabilitation-of-Cesare-Borgia.html; see also "Cesare Borgia" in Wikipedia: http://en.wikipedia.org/wiki/Cesare_Borgia. Hersey 1993, pp. 90–91.

BIBLIOGRAPHY

FREQUENTLY CITED SOURCES

Carteggio. Michelangelo Buonarroti. *Il carteggio di Michelangelo*. Edited by Giovanni Poggi (original editor), Paola Barocchi, and Renzo Ristori. 5 vols. Florence, 1965–83.

Carteggio indiretto. Michelangelo Buonarroti. *Il carteggio indiretto di Michelangelo*. Edited by Paola Barocchi, Kathleen Loach Bramanti, and Renzo Ristori. 5 vols. Florence, 1988–97.

Contratti. Lucilla Bardeschi Ciulich, ed. *I contratti di Michelangelo*. Florence, 2005.

Lettere-Milanesi. Michelangelo Buonarroti. *Le lettere di Michelangelo Buonarroti, pubblicate coi ricordi ed i contratti artistici*. Edited by Gaetano Milanesi. Florence, 1875.

Letters-Ramsden. Michelangelo Buonarroti. *The Letters of Michelangelo,* translated from the original Tuscan. Edited and annotated by E. H. Ramsden. 2 vols. Palo Alto, Calif.: Stanford University Press, 1963.

Ricordi. Michelangelo Buonarroti. *I ricordi di Michelangelo*. Edited by Lucilla Bardeschi Ciulich and Paola Barocchi. Florence, 1970.

Condivi-Holroyd 1911. Charles Holroyd. *Michelangelo Buonarroti, with Translations of the Life of the Master by His Scholar Ascanio Condivi and Three Dialogues from the Portuguese by Francisco d'Ollanda*. London: Duckworth and Co., 1911.

Condivi-Wohl 1976. Ascanio Condivi. *The Life of Michelangelo* (1553). Translated by Alice Sedgwick, edited by Helmut Wohl. Baton Rouge, LA: Louisiana State University Press, 1976.

Condivi-Nencioni 1998. Ascanio Condivi. *Vita di Michelangelo Buonarroti* (1553). Edited by Giovanni Nencioni. Florence, 1998.

Vasari 1550/1986. Giorgio Vasari. *Le Vite de' più eccellenti architetti, pittori, et scultori italiani, da Cimabue, insino a' tempi nostri*. Florence: Torrentino, 1550; L. Luciano Bellosi and A. Rossi, eds. 2 vols. Turin: Einaudi, 1986.

Vasari-Milanesi 1906. Vasari, Giorgio. *Le opere di Giorgio Vasari, con nuove annotazioni e commenti*. Edited by Gaetano Milanesi. 9 vols. Florence, 1906. Reprints. 1981, et al.

Vasari-Bondanella 1998. Vasari, Giorgio. *The Lives of the Artists*. Translated by Julia Conaway Bondanella and Peter Bondanella. Oxford and New York: Oxford University Press, 1998.

Giovinezza. Kathleen Weil-Garris Brandt, Cristina Acidini Luchinat, James David Draper, and Nicholas Penny, eds. *Giovinezza di Michelangelo*. Exhibition catalogue. Florence and Milan: Artificio Skira, 1999.

...

Ackerman 1961. James Ackerman. *The Architecture of Michelangelo*. London: Zwemmer, 1961.

——— 1986. *The Architecture of Michelangelo*. 2nd ed. Chicago: University of Chicago Press, 1986.

Agosti and Hirst 1996. Giovanni Agosti and Michael Hirst. "Michelangelo, Piero d'Argenta and the 'Stigmatization of St. Francis.'" *Burlington Magazine* 138, no. 1123 (October 1996): 683–84.

Alberti 1535. Leandro Alberti. *De divi Dominici obitu et sepultura*. 1535.

Alexander 1984. Sidney Alexander. *Nicodemus: The Roman Years of Michelangelo, 1534–1564*. Athens, Ohio: Ohio University Press, 1984.

Alsop 1982. Joseph Alsop. *The Rare Art Traditions: The History of Art Collecting and Its Linked Phenomena Wherever These Have Appeared*. New York: Harper & Row, 1982.

Ames-Lewis 1981. Francis Ames-Lewis. *Drawings in Early Renaissance Italy*. New Haven: Yale University Press, 1981.

Amy 2000. Michaël J. Amy. "The Dating of Michelangelo's St Matthew." *Burlington Magazine* 142, no. 1169 (August 2000): 493–96.

D'Ancona, Pinna, and Cardellini 1964. P. D'Ancona, A. Pinna, I. Cardellini, et al. *Michelangelo: Architettura Pittura Scultura*. Milan: Bramante, 1964.

Androsov and Baldini 2000. Sergej Androsov and Umberto Baldini. *L'adolescente dell' Hermitage e la sagrestia nuova di Michelangelo.* Exhibition catalogue. Florence, 2000.

Angela 2005. Piero Angela. *Michelangelo in compagnia di un genio.* DVD, 2005.

Anonimo Fiorentino 1968. Anonimo Fiorentino. *L'anonimo magliabechiano.* Edited by Annamaria Ficarra. Naples, 1968.

d'Aquisgrana 1988. Alfredo Reumont d'Aquisgrana, compiler. *Tavole cronologiche e sincrone della Storia fiorentina.* Florence: Cassa di Risparmio, 1988.

Argan 1993. Giulio Carlo Argan. *Michelangelo: Architect.* New York: Harry N. Abrams, 1993.

Armellini 1891. Mariano Armellini. *Le Chiese di Roma dal secolo IV al XIX.* Rome: Tipografia Vaticana, 1891.

Augustine 1953. *Augustine: Earlier Writings.* Edited by J. H. S. Burleigh. Philadelphia: Westminster Press, 1953.

———— **1955.** *Augustine: Later Works.* Edited by J. Burnaby. Philadelphia: Westminster Press, 1955.

Avery 1970. Charles Avery. *Florentine Renaissance Sculpture.* London: John Murray, 1970.

Bacarelu 1979. G. Bacarelu. *Schede manoscritte della Sopraintendenza del beni artistici e storici della provincia di Firenze.* Florence, 1979.

Balas 1983. Edith Balas. "Michelangelo's Florentine Slaves and the S. Lorenzo Façade." *Art Bulletin* 65, no. 4 (December 1983): 665–71.

Baldini 1973. Umberto Baldini. *L'opera completa di Michelangelo scultore.* Milan: Rizzoli Editore, 1973.

———— **1982.** *The Complete Sculpture of Michelangelo.* London: Thames & Hudson, 1982.

Baldini 2003. N. Baldini. "In the Shadow of Lorenzo the Magnificent. The Role of Lorenzo and Giovanni di Pierfrancesco de' Medici." In *In the Light of Apollo. Italian Renaissance and Greece,* edited by M. Gregori, vol. 1, pp. 277–82. Exhibition catalogue. Milan: Silvana, 2003.

Baldini, Lodico, and Piras 1999. N. Baldini, D. Lodico, and A. M. Piras. "Michelangelo a Roma. I rapporti con la famiglia Galli e con Baldassare del Milanese." In *Giovinezza di Michelangelo,* edited by Kathleen Weil-Garris Brandt, et al., pp. 149–62. Exhibition catalogue. Florence and Milan: Artificio Skira, 1999.

Baldinucci 1681. Filippo Baldinucci. *Vocabolario toscano dell'arte del disegno.* Florence, 1681.

Bambach 1983. Carmen C. Bambach. "A Note on Michelangelo's Cartoon for the Sistine Ceiling: Haman." *Art Bulletin* 65, no. 4 (December 1983): 661–65.

———— **1999.** "The Purchases of Cartoon Paper for Leonardo's *Battle of Anghiari* and Michel-angelo's *Battle of Cascina.*" *Villa I Tatti Studies: Essays in the Renaissance* 8 (1999): 105–33.

———— **2005.** "In the Footsteps of Leonardo." *Apollo* 162, no. 521 (July 2005): 34–43.

Bambach Cappel 1990. Carmen Bambach Cappel. Review of Michael Hirst's Michelangelo and His Drawings. *Art Bulletin* 72, no. 3 (September 1990): 493–98.

———— **1991.** "Leonardo, Tagliente, and Dürer: 'La scienza del far di groppi.'" *Achademia Leonardi Vinci* 4 (1991): 72–95.

Bargellini 1960. Piero Bargellini. *Florence: An Appreciation of Her Beauty.* Florence, 1960.

Barnes 1998. Bernadine Barnes. *Michelangelo's Last Judgment: The Renaissance Response.* Berkeley, Los Angeles, and London: University of California Press, 1998.

Barocchi 1962. Paola Barocchi. *Michelangelo e la sua scuola: I disegni di Casa Buonarroti e degli Uffizi.* 2 vols. Florence, 1962.

Barocchi 1971. Paola Barocchi, ed. *Scritti d'arte del Cinquecento.* 3 vols. Milan and Naples: R. Ricciardi, 1971.

———— **1992.** *Il Giardino di San Marco: Maestri e compagni del giovane Michelangelo.* Exhibition catalogue. Florence: Casa Buonarroti, 1992.

Barolsky 1997. Paul Barolsky. *Michelangelo's Nose: A Myth and Its Maker.* University Park, Pa.: Pennsylvania State University Press, 1997.

Bartz and König 1998. Gabriele Bartz and Eberhard König. *Michelangelo.* Cologne: Könemann, 1998.

Barzun 2001. Jacques Barzun. *From Dawn to Decadence: 500 Years of Western Cultural Life, 1500 to the Present.* New York: HarperCollins, 2001.

Battisti 1967. Eugenio Battisti. "The Meaning of Classical Models in the Sculpture of Michelangelo." In: *Stil und Überlieferung in der Kunst des Abendlandes.* Vol. 2, pp. 73–78. Berlin: Mann, 1967.

Baxandall. Michael Baxandall. *Giotto and the Orators: Humanist Observers of Painting in Italy and the Discovery of Pictorial Compositions, 1350–1450.* Oxford: Clarendon Press, 1971.

———— **1972.** *Painting and Experience in Fifteenth-Century Italy: A Primer in the Social History of Pictorial Style.* Oxford: Oxford University Press, 1972.

Beck 1974. James Beck. *Michelangelo: A Lesson in Anatomy.* New York: Viking, 1974; London: Phaidon, 1975.

———— **1988.** "The Final Layer: 'L'ultima mano' on Michelangelo's Sistine Ceiling." *Art Bulletin* 70, no. 3 (September 1988): 502–3.

———— **1990.** "Cardinal Alidosi, Michelangelo, and the Sistine Ceiling." *Artibus et Historiae* 11, no. 22 (1990), pp. 63–77.

———— **1993.** "The Dream of Leonardo da Vinci." *Artibus et Historiae* 14, no. 27 (1993): 185–98.

———— **1993** I sogni di Leonardo. Florence: *Giunti,* 1993.

Becker 1964. Marvin H. Becker. "An Affluent Ancestor of Michelangelo." *Medievalia et Humanistica* 16 (1964): 105.

Bell 1995. Daniel Orth Bell. "New Identifications in Raphael's School of Athens." *Art Bulletin* 77, no. 4 (December 1995): 638–46.

Bellini 1980–81. Paolo Bellini, ed. *Incisori italiani del Cinquecento dalla Raccolta di Stampe della Biblioteca Civica di Monza.* Monza, Italy, 1980–81.

Bellonci 1939. Maria Bellonci. *Lucrezia Borgia.* 1939. 5th ed. London: Phoenix Press, 2003.

Benedetti and Zander 1990. Sandro Benedetti and Giuseppe Zander. *L'Arte in Roma nel secolo XVI.* Vol. 1, *L'Architettura.* Storia di Roma 29. Bologna, 1990.

Benini 1985. Mirella Benini. *Ceramica del Seicento.* Novara, Italy, 1985.

Benkard 1933. Ernst Benkard. *Michelangelos Madonna an der Treppe.* Berlin, 1933.

Berenson 1896. Bernard Berenson. *Florentine Painters of the Renaissance.* New York: G. P. Putnam's Sons, 1896.

————1958. *The Italian Painters of the Renaissance.* London: Phaidon, 1958.

Berti, Cecchi, and Natali 1985. Luciano Berti, Alessandro Cecchi, and Antonio Natali. *Michelangelo: i disegni di Casa Buonarroti.* Florence: Cantini Edizioni d'arte, 1985.

Berti and Baldini 1991. Luciano Berti and Umberto Baldini. *Filippino Lippi.* 2nd ed. Florence, 1991.

Birke 1992. Veronika Birke. *Italian Drawings 1350–1800: Masterworks from the Albertina.* Translated by John T. Spike. Vienna; Alexandria, Va: Art Services International, 1992.

Bober and Rubinstein 1986. Phyllis P. Bober and Ruth Rubinstein. *Renaissance Artists and Antique Sculpture: A Handbook of Sources.* London and New York: Harvey Miller Publishers and Oxford University Press, 1986.

Bober, Rubinstein, and Woodford 1991. Phyllis Pray Bober, Ruth Rubinstein, and Susan Woodford. *Renaissance Artists and Antique Sculpture: A Handbook of Sources.* Rev. ed. London: Harvey Miller Publication, 1991.

Boeck 1959. Wilhelm Boeck. "Michelangelos Bronze-David und die Pulsky-Statuette im Louvre." *Mitteilungen des Kunsthistorischen Instituts in Florenz* 8 (1957–59): 131ff.

Bornstein 1988. Christine Verzár Bornstein. *Portals and Politics in the Early Italian City-State: The Sculpture of Nicholaus in Context.* Parma, 1988.

Boroli and Broggi 1985. Marcella Boroli and Silvia Broggi. *Il mobile del Rinascimento—Italia.* Novara, Italy: De Agostini, 1985.

Boström 1995. Antonia Boström. "Daniele da Volterra and the Equestrian Monument to Henry II of France." *Burlington Magazine* 137, no. 1113 (December 1995): 809–20.

Bracciolini 1538. Poggio Bracciolini. *De nobilitate.* In *Opera omnia.* Vol. 1. 1538.

Bradford 1976. Sarah Bradford. *Cesare Borgia: His Life and Times.* 2nd ed. New York: Macmillan; London: Weidenfeld & Nicholson, 1976.

Bramly 1994. Serge Bramly. *Leonardo: The Artist and the Man.* London: Penguin, 1994.

Brandi 1967. Cesare Brandi. "Forma e compiutezza in Michelangelo." In: *Stil und Überlieferung in der Kunst des Abendlandes.* Vol. 2, pp. 89–95. Berlin: Mann, 1967.

Braudel 1981. Fernand Braudel. *The Structures of Everyday Life: The Limits of the Possible.* Translated by Siân Reynolds. New York: Harper & Row, 1981.

Breisach 1967. Ernst Breisach. *Caterina Sforza: A Renaissance Virago.* Chicago: University of Chicago Press, 1967.

Brinton 1925. Selwyn Brinton. *The Golden Age of the Medici* (Cosimo, Piero, Lorenzo de' Medici) 1434–1494. London: Methuen & Co., 1925; Boston: Small, Maynard & Co., 1926.

Brown 1986. Deborah Brown. "The Apollo Belvedere and the Garden of Giuliano della Rovere at SS. Apostoli." *Journal of the Warburg and Courtauld Institutes* 49 (1986): 235–38.

Brown 1998. David Alan Brown. *Leonardo da Vinci: Origins of a Genius.* New Haven: Yale University Press, 1998.

Brucker 1975. Gene A. Brucker. *Renaissance Florence.* Huntington, N.Y.: R. E. Krieger, 1975.

Brugnoli. M. V. Brugnoli. *Michelangelo.* Milan: Giunti-Martello, 1978.

Bull 1995. George Anthony Bull. *Michelangelo: A Biography.* New York: Viking, 1995.

Bullard 1990. Melissa M. Bullard. "Marsilio Ficino and the Medici: The Inner Dimensions of Patronage." In *Christianity and the Renaissance: Images and Imagination in the Quattrocento,* edited by T. Verdon and J. Henderson, pp. 467–92. Syracuse, N.Y.: Syracuse University Press, 1990,

Burchard 1883–85. Johann Burchard. *Diarium sive rerum urbanarum commentarii, 1483–1506.* Edited by L. Thuasne. 3 vols. Paris: Ernest Leroux, 1883–85.

Burckhardt 1914. Jacob Burckhardt. *The Civilisation of the Renaissance in Italy.* Translated by S.G.C. Middlemore. London: George Allen & Unwin Ltd.; New York: The Macmillan Company, 1914.

Butters 1985. H. C. Butters. *Governors and Government in Early Sixteenth-Century Florence, 1502–1519.* Oxford: Clarendon Press, 1985.

Buzzegoli 1987. Ezio Buzzegoli. "Michelangelo as a Colourist, Revealed in the Conservation of the Doni Tondo." *Apollo* 126, no. 310 (1987): 405–8.

Cadogan 1993. Jean. K. Cadogan. "Michelangelo in the Workshop of Domenico Ghirlandaio." *Burlington Magazine* 135 (1993): 30–31.

Cagliotti 1996. Francesco Cagliotti. "Il David bronzeo di Michelangelo (e Benedetto da Rovezzano): il problema dei pagamenti." In *Ad Alessandro Conti (1946-1994),* edited by F. Cagliotti, M. Fileti Mazza, and U. Parrini, in *Quaderni del Seminario di Storia della Critica d'Arte* 6 (1996): 87–132.

———2000. Donatello e i Medici. Storia del David e della Giudita. 2 vols. Florence: Olschki, 2000.

Calì 1989. M. Calì. "La 'Calunnia' del Botticelli e il Savonarola." *Arte Documento* 3 (1989): 88–99.

Campbell 2002. Stephen Campbell. "'Fare una Cosa Morta Parer Viva': Michelangelo, Rosso, and the (Un)Divinity of Art." *Art Bulletin* 84, no. 4 (December 2002): 596–620.

Camesasca 1966. Ettore Camesasca. *The Complete Paintings of Michelangelo.* London: Weidenfeld & Nicholson, 1966.

Campi 1994. Emidio Campi. *Michelangelo e Vittoria Colonna: Un dialogo artistico-teologico ispirato da Bernardino Ochino e altri saggi di storia della Riforma.* Turin, 1994.

Capretti 1991. Elena Capretti. *The Building Complex of Santo Spirito.* Florence, 1991.

Castiglione 1967. Baldassar Castiglione. *The Book of the Courtier.* Translated by George Bull. London: Penguin Classics, 1967.

———1969. *Lettere inedite e rare.* Edited by Guglielmo Gorni. Milan and Naples: Ricardo Ricciardi, 1969.

Cavalcanti 1838–39. Giovanni Cavalcanti. *Istorie fiorentine.* Florence, 1838–39.

Celenza 1999. Christopher S. Celenza. "Pythagoras in the Renaissance: The Case of Marsilio Ficino." *Renaissance Quarterly* 52, no. 3 (Autumn 1999): 667–711.

Cellini 1903. Benvenuto Cellini. *La vita di Benvenuto Cellini scritta da lui medesimo.* Edited by B. Bianchi. Florence, 1903.

———1910. *The Autobiography of Benvenuto Cellini.* Translated by John Addington Symonds. New York: P. F. Collier and Son, 1910.

Chapman 2005. Hugo Chapman. *Michelangelo Drawings: Closer to the Master.* Exhibition catalogue. London: British Museum Press, 2005.

Chastel 1961. André Chastel. *The Genius of Leonardo da Vinci.* New York: Orion Press, 1961.

———1964. *Arte e umanesimo a Firenze al tempo di Lorenzo il Magnifico.*Turin: Einaudi, 1964.

———1996. *Marsile Ficin et l'Art.* Geneva: Droz, 1996.

Chastel 1988. André Chastel et al. *Les Carrache et les décors profanes.* Actes du colloque organisé par l'École française de Rome (2–4 octobre 1986). Collection de l'École française de Rome, no. 106. Rome, 1988.

Cherubini 1979. G. Cherubini. "La mezzadria toscana delle origini." In *Contadini e proprietari nella Toscana moderna. Atti del Convegno di Studi in oniore di Giorgio Giorgetti. Vol. 1, Dal Medioevo all'età moderna,* pp. 131–52. Florence, 1979.

Chiarini, Darr, and Giannini 2002. Marco Chiarini, Alan P. Darr, and Cristina Giannini, eds. *L'ombra del genio. Michelangelo e l'arte a Firenze, 1537–1631.* Exhibition catalogue. Milan: Skira, 2002.

Chong, Pegazzano, and Zikos 2004. Alan Chong, Donatella Pegazzano, and Dimitrios Zikos. *Bindo Altoviti tra Rafaello e Cellini. Ritratto di un banchiere del rinascimento.* Exhibition catalogue. Milan: Skira, 2004.

Ciammitti 1999. Luisa Ciammitti. "Note biografiche su Giovan Francesco Aldrovandi." In *Giovinezza di Michelangelo,* edited by Kathleen Weil-Garris Brandt, et al., pp. 139–41. Exhibition catalogue. Florence and Milan: Artificio Skira, 1999.

Ciulich 1983. Lucilla Bardeschi Ciulich. "Nuovi documenti su Michelangelo architetto maggiore di San Pietro." *Rinascimento,* 2nd series, 23 (1983): 174.

Ciulich and Ragionieri 2001. Lucilla Bardeschi Ciulich and Pina Ragionieri, eds. *Vita di Michelangelo.* Exhibition catalogue. Florence: Casa Buonarroti, 2001.

———2002. Michelangelo: Grafia e Biografia. *Disegni e autografi del Maestro.* Exhibition catalogue. Florence: Mandragora, 2002.

Clark 1935. Kenneth Clark. *A Catalogue of the Drawings of Leonardo da Vinci in the Collection of His Majesty the King at Windsor Castle.* 2 vols. Cambridge: Cambridge University Press, 1935.

———1956 and 1984. *The Nude: A Study in Ideal Form.* New York: Pantheon Books, 1956; Princeton: Princeton University Press, 1984.

———1961. *Leonardo da Vinci.* 1939. 3rd ed. London, 1961.

———1964. "Michelangelo pittore." *Apollo* 80 (1964): 436–45.

———1968. *The Drawings of Leonardo da Vinci in the Collection of Her Majesty the Queen at Windsor Castle.* 3 vols. 2nd ed. Revised with assistance of Carlo Pedretti. London: Phaidon, 1968.

———1969. *Civilization.* New York: Harper & Row, 1969.

Clément 1882. Charles Clément. *Michelangelo.* Translated by Jean Paul Richter. New York: Scribner & Welford; London: Sampson Low, Marston, Searle, and Rivington, 1882.

Clements 1961. Robert J. Clements. *Michelangelo's Theory of Art.* New York: Gramercy, 1961.

Cloulas 1993. Ivan Cloulas. *Giulio II.* Rome, 1993.

Collazio 1992. Pietro A. Collazio. *De duello Davidis et Goliae.* Milan: Pizzi, 1992.

Colombo 1981. S. Colombo. *L'arte del legno e del mobile in Italia.* Busto Arsizio, Italy, 1981.

Condivi 1553. Ascanio Condivi. *Vita di Michelangelo Buonarroti.* Rome: Antonio Blado, 1553.

————— 1746. *Vita di Michelagnolo Buonarroti.* Edited by Anton Francesco Gori. 2nd ed. Florence: G. Albizzini, 1746.

Connolly 2004. Sean Connolly. *Michelangelo.* Florence: McRae Books, 2004.

Copenhaver and Schmitt 1992. Brian P. Copenhaver and Charles B. Schmitt. *Renaissance Philosophy.* Oxford: Oxford University Press, 1992.

Corti 1964. Gino Corti. "Una ricordanza di Giovan Battista Figiovanni." *Paragone* 15, no. 175 (1964): 24–31.

Corti 1981. Laura Corti, et al. *Giorgio Vasari: Principi, letterati e artisti nelle carte di Giorgio Vasari: La Toscana nel '500.* Florence: Edam, 1981.

Coughlin 1966. R. Coughlin. *The World of Michelangelo: 1474-1564.* London: Time-Life International, 1966.

Cox-Rearick 1984. Janet Cox-Rearick. *Dynasty and Destiny in Medici Art: Pontormo, Leo X, and the Two Cosimos.* Princeton: Princeton University Press, 1984.

Creighton 1903. Mandell Creighton. *A History of the Papacy: From the Great Schism to the Sack of Rome.* 6 vols. London: Longmans, Green, and Co., 1903.

Cropper 1983. Elizabeth Cropper. Review of David Summers's *Michelangelo and the Language of Art. Art Bulletin* 65, no. 1 (March 1983): 157–62.

Crowe and Cavalcaselle 1864. Joseph A. Crowe and Giovanni Battista Cavalcaselle. *A New History of Painting in Italy.* London: John Murray, 1864.

Dal Poggetto 1979. Paolo Dal Poggetto. *I disegni murali di Michelangelo e della sua scuola nella Sagrestia Nuova di San Lorenzo.* Florence: Centro Di, 1979.

Dante 1954. Dante Alighieri. *The Inferno: Dante's Immortal Drama of a Journey Through Hell.* Translated by John Ciardi. New York: Signet, 1954.

————— 1986. *The Divine Comedy.* Translated by Mark Musa. New York: Penguin, 1986.

da Varagine 1969. Jacopo da Varagine. *The Golden Legend.* New York, 1969.

Del Pania 1980. L. Del Pania. *Le epidemie nella storia demografica italiana.* Turin, 1980.

de Roover 1999. Raymond de Roover. *The Rise and Decline of the Medici Bank, 1397-1494.* Cambridge: Harvard University Press, 1963. Reprint. Frederick, Md.: Beard Books, 1999.

de Tolnay 1943-60. Charles de Tolnay. *Michelangelo.* 5 vols. Princeton: Princeton University Press, 1943–60.

————— 1964. *The Art and Thought of Michelangelo.* Translated by Nan Buranelli. New York: Pantheon, 1964.

————— 1966. "Michel Ange et la Casa Buonarroti à Florence. Nouvelles recherches." *Gazette des Beaux-Arts* 67 (1966): 193–204.

————— 1975. *I disegni di Michelangelo nelle collezioni italiani.* Exhibition catalogue. Florence: Centro Di, 1975.

————— 1975. *Michelangelo: Sculptor, Painter, Architect.* Princeton: Princeton University Press, 1975.

————— 1975-80. *Corpus dei disegni di Michelangelo.* 4 vols. Novara, Italy: Istituto Geografico De Agostini, 1975–80.

De Vecchi 1992. Pierluigi De Vecchi. *La Cappella Sistina: La volta restaurata: il trionfo del colore.* Novara, Italy, 1992.

Doglio 1983. Mariangela M. Doglio, ed. *Leonardo e gli spettacoli del suo tempo.* Exhibition Catalogue. Milan: Electa, 1983.

Dorez 1918. Léon Dorez. *Nouvelles recherches sur Michel-Ange et son entourage.* Paris: Bibliothèque de l'École des Chartes, 1918.

Doris 1997. Carl Doris. "Benedetto da Maiano: Il ritratti commemorativo di Giotto." Paper presented at conference, Santa Maria del Fiore: The Cathedral and Its Sculpture, Florence, Villa I Tatti, June 5–6, 1997.

Dotson 1979. Esther G. Dotson. "An Augustinian Interpretation of Michelangelo's Sistine Ceiling, Part I." *Art Bulletin* 61, no. 2 (June 1979): 223–56.

Dougherty 2008. M. V. Dougherty, ed. *Pico della Mirandola: New Essays.* Cambridge: Cambridge University Press, 2008.

Draper 1992. James David Draper. *Bertoldo di Giovanni, Sculptor of the Medici Household: Critical Reappraisal and Catalogue Raisonné.* Columbia, Mo., and London: University of Missouri Press, 1992.

————— 1999. "Bertoldo e Michelangelo." In *Giovinezza di Michelangelo,* edited by Kathleen Weil-Garris Brandt, et al., pp. 57–63. Exhibition catalogue. Florence and Milan: Artificio Skira, 1999.

Duruy 1883. Victor Duruy. *History of Rome and of the Roman People.* Vol. 8. Boston: Dana Estes and Charles E. Lauriat, 1883.

Ekserdjian 1987. David Ekserdjian. "The Sistine Ceiling and the Critics." *Apollo* 126, no. 310 (1987): 401–4.

Elam 1979. Caroline Elam. "The Site and Early Building History of Michelangelo's New Sacristy." *Mitteilungen des Kunsthistorischen Institutes in Florenz* 23 (1979): 155–86.

————— 1992. "Il Giardino delle Sculture di Lorenzo de' Medici." In *Il Giardino di San Marco,* edited by Paola Barocchi, pp. 157–74. Florence: Casa Buonarroti, 1992.

————— 1992. "Lorenzo de' Medici's Sculpture Garden." *Mitteilungen des Kunsthistorischen Institutes in Florenz* 36 (1992): 41–84.

————— 1993. "Art in the Service of Liberty—Battista della Palla, Art Agent for Francis I." *I Tatti Studies: Essays in the Renaissance* 5 (1993): 33–109.

————— 1998. "Chè ultima mano!": Tiberio Calcagni's Marginal Annotations to Condivi's Life of Michelangelo." *Renaissance Quarterly* 51, no. 2 (Summer 1998): 475–97.

Elam n.d. Caroline Elam, et al. "Sangallo, da." Grove Art Online at www.oxfordartonline.com.

Elkins 1984. James Elkins. "Michelangelo and the Human Form: His Knowledge and Use of Anatomy." *Art History* 7 (1984): 176–86.

Emiliani 1999. Andrea Emiliani. "Michelangelo a Bologna." In *Giovinezza di Michelangelo*, edited by Kathleen Weil-Garris Brandt, et al., pp. 127–37. Exhibition catalogue. Florence and Milan: Artificio Skira, 1999.

Erasmus 1901. Desiderius Erasmus. *The Epistles of Erasmus, from His Earliest Letters to His Fifty-first Year, Arranged in Order of Time.* Translated by Francis Morgan Nichols. London: Longmans, Green, and Co., 1901.

Ettlinger 1965. Leopold D. Ettlinger. *The Sistine Chapel before Michelangelo: Religious Imagery and Papal Primacy.* Oxford: Clarendon Press, 1965.

Evans 1986. Mark Evans. "Pollaiuolo, Dürer and the Master IAM van Zwolle." *Print Quarterly* 3, no. 2 (1986): 109–13.

Ewart 1899. K. Dorothea Ewart. *Cosimo de' Medici.* Cambridge: Cambridge University Press, 1899.

Fagiolo and Madonna 1984. M. Fagiolo and M. L. Madonna, eds. *Roma 1300–1875: L'arte degli anni santi.* Exhibition catalogue. Milan, 1984.

Falletti 2004. Franca Falletti. Michelangelo's David: A Masterpiece Restored. Florence: Giunti 2004.

Faludy 1970. George Faludy. *Erasmus.* New York: Stein & Day, 1970.

Farinella and Ragionieri 2007. Vincenzo Farinella and Pina Ragionieri. *Michelangelo: La Leda e la Seconda Repubblica fiorentina.* Cinisello Balsamo, Italy: Silvano, 2007.

Fehl 1971. Philipp Fehl. "Michelangelo's Crucifixion of St. Peter: Notes on the Identification of the Locale of the Action." *Art Bulletin* 53, no. 3 (September 1971): 327–43.

Ferrara and Quinterio 1984. Miranda Ferrara and Francesco Quinterio. *Michelozzo di Bartolomeo.* Florence: Salimbeni, 1984.

Ficino 1489/1989. Marsilio Ficino. *De Vita Libri Tres (Three Books on Life).* 1489. Translated by Carol V. Kaske and John R. Clarke. Tempe, Ariz.: The Renaissance Society of America, 1989.

———— **1996.** *Meditations on the Soul: Selected Letters of Marsilio Ficino.* Translated by the School of Economic Science, London. Rochester, Vt.: Inner Traditions International, 1996.

———— **2001.** *Platonic Theology.* The I Tatti Renaissance Library, edited by James Hankins, vol. 1, books I–IV, translated by Michael J. B. Allen. Cambridge: Harvard University Press, 2001.

Field 1988. Arthur Field. *The Origins of the Platonic Academy of Florence.* Princeton: Princeton University Press, 1988.

Fischer 1990. Chris Fischer. *Fra Bartolommeo: Master Draughtsman of the High Renaissance.* Exhibition catalogue. Rotterdam: Museum Boymans-Van Beuningen, 1990.

Fitzgerald and Cavadini 1999. Allan Fitzgerald and John C. Cavadini, eds. *Augustine Through the Ages: An Encyclopedia.* Grand Rapids, Mich.: Eerdmans, 1999.

Fleming, Honour, and Pevsner 1970. John Fleming, Hugh Honour, and Nikolaus Pevsner. *The Penguin Dictionary of Architecture.* 2nd ed. London: Penguin, 1970.

Forbes 1899. S. Russell Forbes. *Rambles in Rome.* London, 1899.

Forcellino 2002. Antonio Forcellino. *Michelangelo Buonarroti: storia di una passione eretica.* Milan: Einaudi, 2002.

———— **2005.** *Michelangelo: una vita inquieta.* Rome: Laterza, 2005.

Frati 1886. Luigi Frati, ed. *Le due spedizioni militari di Giulio II: tratte dal diario di Paride Grassi Bolognese.* Bologna, 1886.

Frazer 1975. Alfred Frazer. "A Numismatic Source for Michelangelo's First Design for the Tomb of Julius II." *Art Bulletin* 57, no. 1 (March 1975): 53–57.

Freedberg 1971. S. J. Freedberg. *Painting of the High Renaissance in Rome and Florence.* 2 vols. Cambridge: Harvard University Press, 1971; New York: Harper & Row, 1972.

Freedberg 1989. David Freedberg. *The Power of Images: Studies in the History and Theory of Response.* Chicago: University of Chicago Press, 1989.

Freemantle 1992. Richard Fremantle. *God and Money: Florence and the Medici in the Renaissance.* Florence, 1992.

Freud 1999. Sigmund Freud. *Leonardo da Vinci: A Memory of His Childhood.* 1910. London: Routledge, 1999.

Frey 1907. Karl Frey. *Die Briefe des Michelagniolo Buonarotti.* Berlin, 1907.

———— **1907.** *Michelagniolo Buonarroti. Quellen und Forschungen zu seiner Geschichte und Kunst.* Vol. 1, Michelagniolos Jugendjahre. Berlin: Curtius, 1907.

———— **1909.** "Studien zu Michelagniolo Buonarroti und zur Kunst seiner Zeit." *Jahrbuch der königlich preuszischen Kunstsammlungen* 30 (1909): 103–80.

Frommel 1976. Christoph Luitpold Frommel. "Die Peterskirche unter Papst Julius II. Im Licht neuer Dokumente." *Römisches Jahrbuch für Kunstgeschichte* 16 (1976): 57–136.

———— **1977.** "Capella Julia: Die Grabkapelle Papst Julius' II. in Neu-St. Peter." *Zeitschrift für Kunstgeschichte* 40 (1977): 26–62.

———— **1986.** "Papal Policy: The Planning of Rome during the Renaissance." *Journal of Interdisciplinary History* 17, no. 1 (1986): 39–65.

———— 1992. "Jacobo Gallo als Förderer der Künste: Das Grabmal seines Vaters in S. Lorenzo in Damso und Michelangelos erste römische Jahre." In *Kotinos: Festschrift für Erika Simon*, edited by H. Froning, T. Hölscher, and H. Mielsch, pp. 450–60. Mainz: von Zabern, 1992.

Frosini 2005. Fabio Frosini, ed. *Leonardo e Pico. Analogie, contatti, confronti. Atti de convegno di Mirandola, 10 maggio 2003*. Florence: Olschki, 2005.

Galleschi 1993. Riccardo Galleschi. *Baccio da Montelupo: Scultore e architetto del Cinquecento Firenze*. Florence, 1993.

Gardner 1920. Edmund G. Gardner. *The Story of Florence*. London: J. M. Dent & Co., 1920.

Garin 1938. Eugenio Garin. "La 'Dignitas hominis' e la letteratura patristica." *La Rinascita* 1, no. 4 (1938): 102–46.

———— 1965. "Il pensiero." In *Michelangelo Artista Pensatore Scrittore*. Novara, Italy: Istituto Geografico De Agostini, 1965, pp. 529–41.

———— 1989. "La biblioteca di S. Marco." In *La chiesa e il convento di S. Marco a Firenze*, edited by T. Centi, O.P., vol. 1, pp. 79–148. Florence: Giunti, 1989.

———— 2001. *La cultura filsofica del Rinascimento italiano*, 2001. Ricerche e documenti. Milan: Bompiani, 2001.

Gaye 1839–40. G. Gaye. *Carteggio inedito d'artisti dei secoli XIV, XV, XVI*. 3 vols. Florence, 1839–40.

Gengaro 1961. Maria Luisa Gengaro. "Maestro e scolaro: Bertoldo di Giovanni e Michelangelo." *Commentari* 12 (1961): 52–56.

Gentili 2004. Giancarlo Gentili, ed. *Proposta per Michelangelo Giovane, Un Crocifisso in legno di tiglio*. Exhibition catalogue. Turin: Allemandi, 2004.

Gere 1979. J. A. Gere, et al. *Drawings by Michelangelo from the British Museum*. Exhibition catalogue. New York: The Pierpont Morgan Library, 1979.

Giacometti 1986. Massimo Giacometti, ed. *La Cappella Sistina: I primi restauri: la scoperta del colore*. Novara, Italy, 1986.

Gilbert 1980. Creighton Gilbert, trans., Robert Linscott, ed. *Complete Poems and Selected Letters of Michelangelo*. Princeton: Princeton University Press, 1980.

———— 1988. Creighton Gilbert. *L'Arte del Quattrocento nelle testimonianze coeve*. Florence, 1988.

———— 1994. *Michelangelo On and Off the Sistine Ceiling*. New York: George Braziller, 1994.

Gilbert 1949. Felix Gilbert. "Bernardo Rucellai and the Orti Oricellari: A Study on the Origin of Modern Political Thought." *Journal of the Warburg and Courtauld Institutes* 12 (1949): 101–31.

———— 1980. *The Pope, His Banker, and Venice*. Cambridge: Harvard University Press, 1980.

Gill 2003. Anton Gill. *Il Gigante: Michelangelo, Florence, and the David, 1492–1504*. New York: Thomas Dunne Books, 2003.

Gilson 1955. Étienne Gilson. *History of Christian Philosophy in the Middle Ages*. New York: Random House, 1955.

Girardi 1974. Enzo N. Girardi, ed. *Studi su Michelangiolo Scrittore*. Florence: Olschki, 1974.

Gobbi 1980. G. Gobbi. *La villa fiorentina. Elementi stonci e critici per una lettura*. Florence, 1980.

Godman 1998. Peter Godman. *From Poliziano to Machiavelli: Florentine Humanism in the High Renaissance*. Princeton: Princeton University Press, 1998.

Goethe 1816 17/1982. Johann Wolfgang von Goethe. *Italian Journey 1786-1788*. 1816–17. Translated by W. H. Auden and Elizabeth Mayer. San Francisco: North Point Press, 1982.

Goldscheider 1940. Ludwig Goldscheider, ed. *Michelangelo: Die Skulpturen*. London: Phaidon, 1940.

———— 1964. *Michelangelo: Paintings, Sculptures, Architecture*. Complete Edition. London: Phaidon, 1964.

Goldthwaite 1980. Richard A. Goldthwaite. *The Building of Renaissance Florence: An Economic and Social History*. Baltimore and London: Johns Hopkins University Press, 1980.

———— 1993. *Wealth and the Demand for Art in Italy, 1300–1600*. Baltimore and London: Johns Hopkins University Press, 1993.

Golzio 1936. V. Golzio. *Raffaello nei documenti, nelle testimonianze dei contemporanei e nella letteratura del suo secolo*. Vatican City, 1936.

Gombrich 1945. Ernst H. Gombrich. "Botticelli's Mythologies: A Study in the Neoplatonic Symbolism of His Circle." *Journal of the Warburg and Courtauld Institutes* 8 (1945): 7–60.

———— 1960. "The Early Medici as Patrons of Art: A Survey of Primary Sources." In *Italian Renaissance Studies: A Tribute to the Late Cecilia M. Ady*, edited by E. F. Jacobs, pp. 279–311. London: Faber & Faber, 1960.

———— 2000. "Sleeper Awake! A Literary Parallel to Michelangelo's Drawing of the Dream of Human Life." In *Festschrift fur Konrad Oberhuber*. Milan: Electa, 2000.

González-Palacios 1982. Alvar González-Palacios. "Avvio allo studio del mobile italiano." *Storia dell'arte italiana*. Vol. 1. Turin, 1982.

Gosman, MacDonald, and Vanderjagt 2005. Martin Gosman, Alasdair A. MacDonald, Arie Johan Vanderjagt, eds. *Princes and Princely Culture 1450–1650*. Vol. 2. Leiden, the Netherlands: Brill, 2005.

Gotti 1875. Aurelio Gotti. *Vita di Michelangelo Buonarroti: narrata con l'aiuto di nuovi documenti*. 2 vols. Florence, 1875.

Gouwens and Reiss 2005. Kenneth Gouwens and Sheryl E. Reiss, eds. *The Pontificate of Clement VII: History, Politics, Culture.* Aldershot, U.K.: Ashgate Publishing, 2005.

Graham-Dixon 1999. Andrew Graham-Dixon. *Renaissance.* Berkeley: University of California Press, 1999.

Gregorovius 1903. Ferdinand Gregorovius. *Lucretia Borgia: According to Original Documents and Correspondence of Her Day.* Translated by John Leslie Garner. New York and London: D. Appleton and Company, 1903.

Gregory of Tours 1988. Gregory of Tours. *Glory of the Martyrs.* Translated by Raymond Van Dam. Liverpool: Liverpool University Press, 1988.

Griffo 1985. Massimo Griffo. *Il mobile del Seicento.* Novara, Italy: De Agostini, 1985.

Grimm 1900. Herman Grimm. *Life of Michael Angelo.* Translated by Fanny Elizabeth Bunnett. 2 vols. Boston: Little, Brown & Company, 1900.

Grote 1980. Andreas Grote, et al. *Il Tesoro di Lorenzo il Magnifico: Repertorio delle gemme e dei vasi.* Florence, 1980.

Guicciardini 1984. Francesco Guicciardini. *The History of Italy.* Translated by Sydney Alexander. Princeton: Princeton University Press, 1984.

Guidi 1998. Remo L. Guidi. *Il dibattito sull'uomo nel Quattrocento.* Rome, 1998.

Gulazzi 1984. Enzo Gualazzi. *Vita di Raffaello da Urbino.* Milan: Rusconi, 1984.

Gutkind 1938. Curt S. Gutkind. *Cosimo de' Medici, Pater Patriae, 1389–1464.* Oxford: Clarendon Press, 1938.

——— **1940.** Cosimo de' Medici il Vecchio. Florence, 1940.

Hall 2005. James Hall. Michelangelo and the Reinvention of the Human Body. New York: Farrar, Straus and Giroux, 2005.

Hall 1973. Michael Hall. "Reconsiderations of Sculpture by Leonardo da Vinci: A Bronze Statuette in the J. B. Speed Art Museum, MCMLXXIII." *J.B. Speed Art Museum Bulletin* 29 (November 1973).

Hallam 1837. Henry Hallam. *Introduction to the Literature of Europe in the Fifteenth, Sixteenth, and Seventeenth Centuries.* Vol. 1. London, 1837.

Hamalainen 2007. Aloysia Hamalainen. "Greatest Art Theft in the History of the World," International Society of Appraisers National Capital Area Chapter, May 2007. Online at www.isancac.org/ValuesMay2007.pdf.

Hamilton 1942. Edith Hamilton. *The Greek Way.* 1930. Reprint. New York: W. W. Norton & Company, 1942.

Hamlin 1946. Gladys E. Hamlin. "European Art Collections and the War." *College Art Journal* 5, no. 3 (March 1946): 219–28.

Hankins 1990. James Hankins. "Cosimo de' Medici and the 'Platonic Academy.'" *Journal of the Warburg and Courtauld Institutes* 53 (1990): 144–62.

——— **1991.** "The Myth of the Platonic Academy of Florence." *Renaissance Quarterly* 44, no. 3 (Autumn 1991): 429–75.

Hartt 1987. Frederick Hartt. Il *David di Michelangelo: La scoperta del modello originale.* Milan: Arnoldo Mondadori, 1987.

Hartt and Finn 1975. Frederick Hartt and David Finn. *Michelangelo's Three Pietàs: A Photographic Study by David Finn.* New York: H. N. Abrams, 1975.

Haskell and Penny 1981. F. Haskell and N. Penny. *Taste and the Antique: The Lure of Classical Sculpture 1500–1900.* New Haven and London: Yale University Press, 1981.

Hatfield 2002. Rab Hatfield. *The Wealth of Michelangelo.* Rome: Edizioni di Storia e Letteratura, 2002.

——— **2007.** *Finding Leonardo: The Case for Recovering the Battle of Anghiari.* Florence: The Florentine Press, 2007.

Hauser 1957. Arnold Hauser. *The Social History of Art.* 4 vols. New York: Vintage, 1957.

Hay 1967. Denys Hay, ed. *The Age of the Renaissance.* London: Thames & Hudson, 1967.

Hegarty 1996. Melinda Hegarty. "Laurentian Patronage in the Palazzo Vecchio: The Frescoes of the Sala dei Gigli." *Art Bulletin* 78, no. 2 (June 1996): 265–85.

Hernández Perera 1957. Jesús Hernández Perera. *Escultores florentinos en España.* Madrid, 1957.

Hersey 1993. George L. Hersey. *High Renaissance Art in St. Peter's and the Vatican: An Interpretive Guide.* Chicago: University of Chicago Press, 1993.

Heusinger and Mancinelli 1973. Lutz Heusinger and Fabrizio Mancinelli. *All the Frescoes of the Sistine Chapel.* Florence: Scala, 1973.

Heydenreich 1951. Ludwig H. Heydenreich. *Leonardo da Vinci: The Scientist.* Exhibition catalogue. New York: International Business Machines Corporation, 1951.

——— **1996.** *Architecture in Italy, 1400–1500.* Revised by Paul Davies. New Haven: Yale University Press, 1996.

Hibbard 1974. Howard Hibbard. *Michelangelo.* New York: Harper & Row, 1974.

——— **1975/1978.** H. Hibbard. *Michelangelo: Painter, Sculptor, Architect.* London: Allen Lane The Penguin Press, 1975; New York: The Vendome Press, 1978.

Hibbert 1979. Christopher Hibbert. *The Rise and Fall of the House of Medici.* London: Penguin, 1979.

Highet 1985. Gilbert Highet. *The Classical Tradition: Greek and Roman Influences on Western Literature.* Oxford and New York: Oxford University Press, 1985.

Hirst 1981. Michael Hirst. "Michelangelo in Rome: an altar-piece and the 'Bacchus.'" *Burlington Magazine* 123, no. 943 (October 1981): 581–93.
————— 1985. "Michelangelo, Carrara, and the Marble for the Cardinal's Pietà." *Burlington Magazine* 127, no. 984 (March 1985): 154–59.
————— 1986. "A Note on Michelangelo and the S. Lorenzo Façade." *Art Bulletin* 68, no. 2 (June 1986): 323–26.
————— 1988. *Michelangelo Draftsman.* Exhibition catalogue. Milan: Olivetti, 1988.
————— 1989. *Michel-Ange Dessinateur.* Exhibition catalogue. Paris: Ed. de la Réunion des Musées Nationaux, 1989.
————— 1991. "Michelangelo in 1505." *Burlington Magazine* 133, no. 1064 (November 1991): 760–66.
————— 1996. "Michelangelo and His First Biographers." *Proceedings of the British Academy* 94 (1996): 63–84.
————— 2000. "Michelangelo in Florence: 'David' in 1503 and 'Hercules' in 1506." *Burlington Magazine* 142, no. 1169 (August 2000): 487–92.
Hirst and Dunkerton 1994. Michael Hirst and Jill Dunkerton. *The Young Michelangelo: The Artist In Rome 1496–1501* (Hirst); *Michelangelo as a Painter on Panel* (Dunkerton). Exhibition catalogue. London: National Gallery Publications, 1994.
Hochmann 1995. M. Hochmann, "La collezione di dipinti di palazzo Farnese di Roma secondo l'inventario del 1644." In *I Farnese: arte e collezionismo,* edited by Lucia Fornari Schianchi and Nicola Spinosa, pp. 108–21. Milan: Electa, 1995.
Hodson 1999. Rupert Hodson. *MichelAngelo: Sculptor.* London: Philip Wilson Publishers, 1999.
Holt 1958. Elizabeth Gilmore Holt. *A Documentary History of Art.* Vol. 2, Michelangelo and the Mannerists, The Baroque and the Eighteenth Century. Garden City, NY: Doubleday, 1958
Hood 1987. William Hood. "The State of Research in Italian Renaissance Art." *Art Bulletin* 69, no. 2 (June 1987): 174–86.
Houtman 1977. C. Houtman. "What Did Jacob See in His Dream at Bethel?: Some Remarks on Genesis XXVIII 10-22." *Vetus Testamentum* 27, Fasc. 3 (July 1977): 337–51.
Howard 2001. Seymour Howard. "Eros, Empathy, Expectation, and Breasts of Michelangelo (A Prolegomenon on Polymorphism and Creativity)." *Artibus et Historiae* 22, no. 44 (2001): 79–118.
Jameson 1868. Anna Jameson. *Memoirs of the Early Italian Painters, and of the Progress of Painting in Italy: From Cimabue to Bassano.* London: John Murray, 1868.
Janson 1963. H. W. Janson. *The Sculpture of Donatello.* Princeton: Princeton University Press, 1963.
Januszczak 1991. Waldemar Januszczak. *Sayonara Michelangelo: The Sistine Chapel Restored and Repackaged.* Reading, Mass.: Addison Wesley, 1991.
Joannides 1978. Paul Joannides. Review of Charles de Tolnay's *Disegni di Michelangelo nelle collezioni italiani. Art Bulletin* 60, no. 1 (March 1978): 174–77.
————— 1981. Review of Charles de Tolnay's *Corpus dei disegni di Michelangelo. Art Bulletin* 63, no. 4 (December 1981): 679–87.
————— 1981. "A supplement to Michelangelo's Lost Hercules." *Burlington Magazine* 123, no 934 (1981): 20–23.
————— 1996. *Michelangelo and His Influence: Drawings From Windsor Castle.* Washington, D. C.: National Gallery of Art, 1996.
————— 2003. *Michel-Ange: Élèves et copistes. Dessins italiens du Musée du Louvre.* Paris: Réunion des Musées Nationaux, 2003.
————— 2003. "Michelangelo's 'Cupid': A Correction." *Burlington Magazine* 145, no. 1205 (August 2003): 579–80.
Joost-Gaugier 1998. Christiane L. Joost-Gaugier. "The Iconography of Sacred Space: A Suggested Reading of the Meaning of the Roman Pantheon." *Artibus et Historiae* 19, no. 38 (1998): 21–42.
————— 1998. "Ptolemy and Strabo and Their Conversation with Appelles and Protogenes: Cosmography and Painting in Raphael's School of Athens." *Renaissance Quarterly* 51, no. 3 (Autumn 1998): 761–87.
Juren 1974. Vladimir Juren. "Fecit-faciebat." *Revue de l'art* 26 (1974): 27–30.
Kelly 1986. J.N.D. Kelly. *The Oxford Dictionary of Popes.* Oxford: Oxford University Press, 1986.
Kelly 2002. Robert L. Kelly. "In Search of Michelangelo's Tomb for Julius II." Ph.D. diss, School of Architecture, McGill University, 2002.
Kent 1978. Dale Kent. *The Rise of the Medici: Faction in Florence, 1426–1434.* Oxford and New York: Oxford University Press, 1978.
Kent 1992. F. W. Kent. "Bertoldo 'sculptore' and Lorenzo de' Medici." *Burlington Magazine* 134 (April 1992): 248–49.
————— 2004. *Lorenzo de' Medici and the Art of Magnificence.* Baltimore: Johns Hopkins University Press, 2004.
Kerrigan and Braden 1991. William Kerrigan and Gordon Braden. *The Idea of the Renaissance.* Baltimore: Johns Hopkins University Press, 1991.
King 2003. Ross King. *Michelangelo and the Pope's Ceiling.* New York: Penguin, 2003.
Klaczko 1903. Julian Klaczko. *Rome and the Renaissance: The Pontificate of Julius II.* Translated by John Dennie. New York and London: G. P. Putnam's Sons, 1903.

Klibansky 1943. Raymond Klibansky. "Plato's Parmenides in the Middle Ages and the Renaissance: A Chapter in the History of Platonic Studies." *Medieval and Renaissance Studies* 1 (1941–43): 281–330.

Knapp 1906. Fritz Knapp. *Michelangelo: Des Meisters Werke.* Stuttgart and Leipzig, 1906.

Krautheimer 1980. Richard Krautheimer. *Rome: Profile of a City, 312–1308.* Princeton: Princeton University Press, 1980.

Kristeller 1944. Paul Oskar Kristeller. "Augustine and the Early Renaissance." *The Review of Religion* 8, no. 4 (1944): 339–58.

———1951. "The Modern System of the Arts: A Study in the History of Aesthetics, Part I." *Journal of the History of Ideas* 12, no. 4 (October 1951): 496–527.

———1965. *Renaissance Thought II: Papers on Humanism and the Arts.* New York: Harper & Row, 1965.

———1969. "Per la biografia di Marsilio Ficino." In *Studies in Renaissance Thought and Letters*, pp. 213–19. Rome, 1969.

———1979. *Renaissance Thought and Its Sources.* New York: Columbia University Press, 1979.

———1990. *Renaissance Thought and Art: Collected Essays.* Princeton: Princeton University Press, 1990.

Kustodieva 2003. Tatiana Kustodieva, et al. *Leonardo: La Madonna Litta dall'Ermitage di San Pietroburgo.* Exhibition catalogue. Rome: De Luca Editori d'arte, 2003.

Landucci 1883. Luca Landucci. *Diario fiorentino dal 1450 al 1516 di Luca Landucci continuato da un anonimo fino al 1542.* Edited by I. Del Badia. Florence: Sansoni, 1883.

———1927. *A Florentine Diary from 1450 to 1516 by Luca Landucci, continued by an anonymous writer till 1542 with notes by Iodoco Del Badia.* Translated from the Italian by Alice de Rosen Jervis. London and New York, 1927.

Langdale 2002. Shelley R. Langdale. *Battle of the Nudes: Pollaiuolo's Renaissance Masterpiece.* Exhibition catalogue. Cleveland: Cleveland Museum of Art, 2002.

Lavin and Lavin 2000. Irving Lavin and Marilyn Aronberg Lavin. *Liturgia d'Amore: Immagini del Cantico dei Cantici nell'arte di Cimabue, Michelangelo e Rembrandt.* Modena, Italy: Franco Cosimo Panini, 2000.

Leathes 1902. Stanley Leathes. *Cambridge Modern History.* Vol 1. Cambridge: Cambridge University Press, 1902.

Le Mollé 1998. Roland Le Mollé. *Giorgio Vasari: L'uomo dei Medici.* Milan: Rusconi, 1998.

Leonardi 1995. Corrado Leonardi. *Michelangelo: l'Urbino, il Taruga.* Città di Castello, Italy: Petruzzi, 1995.

Levenson 1991. J. A. Levenson, ed. *Circa 1492: Art in the Age of Exploration.* Exhibition Catalogue. New Haven: Yale University Press, 1991.

Levine 1974. Saul Levine. "The Location of Michelangelo's David: The Meeting of January 25, 1504." *Art Bulletin* 56 (1974): 31–49.

———1984. "Michelangelo's marble David and the lost bronze David: The Drawings." *Artibus et Historiae* 5, no. 9 (1984): 91–120.

Liebert 1977. Robert S. Liebert. "Michelangelo's Mutilation of the Florence Pietà: A Psychoanalytic Inquiry." *Art Bulletin* 59, no. 1 (1977): 47–54.

———1983. *Michelangelo: A Psychoanalytic Study of His Life and Images.* New Haven: Yale University Press, 1983.

Lippincott 1989. Kristen Lippincott. "When Was Michelangelo born?" *Journal of the Warburg and Courtauld Institutes* 52 (1989): 228–32.

Lisner 1963. Margrit Lisner. "D. Kruzifixus Michelangelos im Kloster S. Spirito in Florenz. *Kunstchronik* 16 (1963): 1–2.

———1964. "Michelangelos Kruzifix aus S. Spirito in Florenz." *Münchner Jahrbuch der bildenden Kunst* 15 (1964): 7ff.

———1967. "Das Quattrocento und Michelangelo." In *Stil und Überlieferung in der Kunst des Abendlandes.* Vol. 2, pp. 78–89. Berlin: Mann, 1967.

———1980. "The Crucifix from Santo Spirito and the Crucifixes of Taddeo Curradi." *Burlington Magazine* 122, no. 933 (December 1980): 812–19.

Listri 2003. P. F. Listri. *La sfida universale: 1503–1504, Leonardo, Michelangelo e le battaglie di Anghiari e Cascina.* Florence: Scramasax, 2003.

Litofino 2000. Giancarlo Litofino. *Il mito del Giudizio Universale nella Cappella Sistina.* Lodi, Italy: Mamma Editore, 2000.

Longsworth 2002. Ellen L. Longsworth. "Michelangelo and the Eye of the Beholder: The Early Bologna Sculptures." *Artibus et Historiae* 23, no. 46 (2002): 77–82.

Luchs 1978. Alison Luchs. "Michelangelo's Bologna Angel: 'Counterfeiting' the Tuscan Duecento." *Burlington Magazine* 120 (April 1978): 222–25.

McClintock 1889. John McClintock. *Cyclopaedia of Biblical, Theological, and Ecclesiastical Literature.* 12 vols. New York: Harper & Brothers, 1889.

MacCurdy 1938. Edward MacCurdy, ed. and trans. *The Notebooks of Leonardo da Vinci.* 2 vols. London: Jonathan Cape, 1938.

Machiavelli 1882. Niccolò Machiavelli. *The Historical, Political, and Diplomatic Writings of Niccolò Machiavelli.* Translated by Christian E. Detmold. Vol. 4, Diplomatic Missions 1506–1527. Boston: James R. Osgood and Company, 1882.

———1891. *Il Principe*. Edited by Laurence Arthur Burd. Oxford: Clarendon Press, 1891.

———1960. *History of Florence and of the Affairs of Italy: From the Earliest Times to the Death of Lorenzo the Magnificent*. Washington, D.C., and London: M. Walter Dunne, 1901. Reprint. New York: Harper Torchbook, 1960.

———1964. *Legazioni e commissarie*. Edited by S. Bertelli. Milan, 1964.

———1999. *The Prince*. Translated by George Bull. Introduction by Anthony Grafton. London: Penguin, 1999.

Mallett 1967. Michael Mallett. *The Florentine Galleys in the Fifteenth Century*. Oxford: Clarendon Press, 1967.

Manca 1996. Joseph Manca. "The Gothic Leonardo: Towards a Reassessment of the Renaissance." *Artibus et Historiae* 17, no. 34 (1996): 121–58.

Mancinelli and De Strobel. Fabrizio Mancinelli and Anna Maria De Strobel. *Michelangelo: Le Lunette e le vele della Cappella Sistina: Liber Generationis Jesu Christi*. Rome, 1992.

Mancini 1896. G. Mancini. "Vite d'artisti di Giovanni Battista Gelli." *Archivio storico italiano* 17, series 5 (1896): 32–62.

Mancusi-Ungaro 1971. Harold Mancusi-Ungaro, Jr. *Michelangelo: The Bruges Madonna and the Piccolomini Altar*. New Haven and London: Yale University Press, 1971.

Manetti 2006. Andrea Manetti. *Michelangelo nasce in Casentino*. Storia delle contese tra Chiusi e Caprese. Florence: Polistampa, 2006.

Manetti 1957. Antonio Manetti. *Vita di Filippo Brunelleschi*. Ca. 1480. Excerpted and translated in Elizabeth Gilmore Holt. A Documentary History of Art. Vol. 1, The Middle Ages and the Renaissance. Garden City, NY: Doubleday, 1957.

———1970. *The Life of Brunelleschi*. Critical edition by Howard Saalman. University Park, Pa.: Pennsylvania State University Press, 1970.

Marani 1989. Pietro C. Marani. *Leonardo: Catalogo completo dei dipinti*. Florence, 1989.

———2001. *Il Genio e le Passioni: Leonardo e il Cenacolo*. Exhibition catalogue. Milan: Skira, 2001.

Marmuji 1984. Caterina Marmugi, ed. *Raffaello a Firenze: Dipinti e disegni delle collezioni fiorentine*. Exhibition catalogue. Florence: Electa, 1984.

Marongiu 2002. Marcella Marongiu, ed. *Il mito di Ganimede prima e dopo Michelangelo*. Exhibition catalogue. Florence: Mondragora, 2002.

Martines 1963. L. Martines. *The Social World of the Florentine Humanists, 1390–1460*. Princeton: Princeton University Press, 1963.

Masters 1999. Roger D. Masters. *Fortune Is a River: Leonardo da Vinci and Niccolò Machiavelli's Magnificent Dream to Change the Course of Florentine History*. New York: Plume, 1999.

Mazzini and Martini 2004. Donata Mazzini and Simone Martini. *Villa Medici a Fiesole: Leon Battista Alberti e il prototipo di villa rinascimentale*. Florence: Centro Di, 2004.

Medri 1992. Litta Maria Medri. *Il mito di Lorenzo il Magnifico nelle decorazioni della Villa di Poggio a Caiano*. Exhibition catalogue. Florence, 1992.

Meller 1965. Peter Meller. "Aggiornamenti bibliografici." In *Michelangelo Artista Pensatore Scrittore*, pp. 597–605. Novara, Italy: Istituto Geografico De Agostini, 1965.

Meyer zur Capellen 1996. Jürg Meyer zur Capellen. *Raphael in Florence*. London, 1996.

Millon and Smyth 1988. Henry A. Millon and Craig Hugh Smyth. *Michelangelo Architect: The Façade of San Lorenzo and the Drum and Dome of St. Peter's*. Exhibition catalogue. Milan: Olivetti, 1988.

Monti 1977. Paolo Monti, ed. *La Pietà Rondanini di Michelangelo Buonarroti*. Milan: Peppi Battaglini, 1977.

Morey 1915. Charles Rufus Morey. *Lost Mosaics and Frescoes of Rome of the Mediaeval Period*. Princeton: Princeton University Press, 1915.

Morozzi 1988–89. Luisa Morozzi. "La 'Battaglia di Cascina' di Michelangelo: Nuova ipotesi sulla data di commissione." *Prospettiva*, nos. 53–56 (April 1988–January 1989): 320–24.

Müntz 1888. Eugène Müntz. *Les collections des Médicis au quinzième siècle*. Paris, 1888.

Murray 1984. Linda Murray. *Michelangelo: His Life, Work and Times*. London: Thames & Hudson, 1984.

Museo del Bargello n.d. *Michelangelo's Bacchus*. Florence: Museo del Bargello, n.d.

———n.d. *Michelangelo's Works*. Florence: Museo del Bargello, n.d.

Nagel 1994. Alexander Nagel. "Michelangelo's London 'Entombment' and the Church of S. Agostino in Rome." *Burlington Magazine* 136 (1994): 164–67.

Najemy 2006. John M. Najemy. *A History of Florence, 1200–1575*. Malden, Mass.: Blackwell Publishing, 2006.

Nardi 1582. Jacopo Nardi. *L'Historie della Città di Firenze*. Vol. 1. Lyons: Appresso T. Ancelin, 1582.

Nardini 1971. Bruno Nardini. *Michelangiolo: la vita e l'opera*. Florence: Giunti, 1971.

———1977. *Michelangelo: His Life and Works*. London: Collins 1977.

Natali 1980. Antonio Natali. *L'Umanesimo di Michelozzo*. Florence, 1980.

Nelson, Arasse, and De Vecchi 2004. Jonathan Katz Nelson, Daniel Arasse, and Pierluigi De Vecchi, eds. *Botticelli and Filippino Lippi: Passion and Grace in Fifteenth-Century Florentine Painting*. Exhibition catalogue. Milan: Electa, 2004.

Neufeld 1966. Gunther Neufeld. "Michelangelo's Times of Day: A Study of Their Genesis." *Art Bulletin* 48, nos. 3–4 (September–December 1966): 273–84.

Nicholl 2004. Charles Nicholl. *Leonardo da Vinci: Flights of the Mind.* A Biography. London: Penguin, 2004.

Norton 1957. Paul F. Norton. "The Lost Sleeping Cupid of Michelangelo." *Art Bulletin* 39, no. 4 (December 1957): 251–57.

Oberhuber 1967. Konrad Oberhuber. "Raphael und Michelangelo." In *Stil und Überlieferung in der Kunst des Abendlandes.* Vol. 2, pp. 156–64. Berlin: Mann, 1967.

———— 1982. *Raffaello.* Milan: A. Mondadori, 1982.

O'Connell 1978. Robert J. O'Connell, SJ. *Art and the Christian Intelligence in St. Augustine.* Cambridge: Harvard University Press, 1978.

Okey 1905. Thomas Okey. *The Story of Venice.* London: J. M. Dent, 1905.

O'Malley 1986. John O'Malley. "The Theology behind Michelangelo's Ceiling." In *La Cappella Sistina.* Edited by Massimo Giacometti. Novara, Italy, 1986.

Osti 1999. Ornella Francisci Osti, ed. *Mosaics of Friendship: Studies in Art and History for Eve Borsook.* Florence: Centro Di, 1999.

Pagano and Ranieri 1989. Sergio M. Pagano and Concetta Ranieri. *Nuovi Documenti su Vittoria Colonna e Reginald Pole.* Vatican City: Archivio Vaticano, 1989.

Paliaga 2007. Franco Paliaga. *L'equivoco della Gioconda: la presunta Monna Lisa di Leonardo.* Pisa: Felici, 2007.

Panofsky 1937. Erwin Panofsky. "The First Two Projects of Michelangelo's Tomb of Julius II." *Art Bulletin* 19, no. 4 (December 1937): 561–79.

———— 1972. *Studies in Iconology: Humanistic Themes in the Art of the Renaissance.* New York: Harper & Row, 1972.

Papini 1964. Giovanni Papini. *Vita di Michelangelo nella vita del suo tempo.* Milan, 1964.

Park 1980. K. Park. "The Readers at the Florentine Studio According to the Fiscal Records (1357–1380, 1413–1446)." *Rinascimento,* 2nd series, 20 (1980): 249–310.

Parks 1975. N. Randolph Parks. "The Placement of Michelangelo's David: A Review of the Documents." *Art Bulletin* 57, no. 4 (December 1975): 560–70.

Parronchi 1964. Alessandro Parronchi. "Michelangelo al tempo dei lavori di San Lorenzo in una 'ricordanza' del Figiovanni." *Paragone* 15, no. 175 (1964): 9–24.

———— 1966. "Titulus Crucis." *Antichità* viva 4 (1966): 41ff.

———— 1967. "Il 'Cupido dormente' di Michelangelo." In *Stil und Überlieferung in der Kunst des Abendlandes.* Vol. 2, pp. 121–25. Berlin: Mann, 1967.

———— 1981. *Opere giovanili di Michelangelo.* Vol. 3, *Miscellanea michelangiolesca.* Florence: Olschki, 1981.

———— 2003. *Opere Giovanili di Michelangelo.* Vol. 6, *Con o senza Michelangelo.* Florence: Olschki, 2003.

Parronchini 1962. Alessandro Parronchini. "Il modello michelangiolesco del 'David' bronzeo per Pietro di Roano." *Arte ant. e moderna* 18 (1962): 170–80.

Partridge, Mancinelli, and Colalucci 2000. Loren Partridge, Fabrizio Mancinelli, and Gianluigi Colalucci. *Michelangelo: The Last Judgment: A Glorious Restoration.* Foreword by Francesco Buranelli. New York: Harry N. Abrams, 2000.

Pastor 1901. Ludwig von Pastor. *The History of the Popes, from the Close of the Middle Ages; Drawn from the Secret Archives of the Vatican and Other Original Sources.* 2nd ed. Vol. 6 (of 40). London: Kegan Paul, Trench, Trübner, & Co., 1901.

———— 1944–60. *Storia dei Papi.* 20 vols. Rome, 1944–60.

Pater 1873. Walter Pater. *Studies in the History of the Renaissance.* London: Macmillan and Co., 1873.

———— 1960. *The Renaissance: Studies in Art and Poetry.* New York: Modern Library, ca. 1960. First published as *Studies in the History of the Renaissance.*

———— 1968. *Michelangelo.* Tokyo: Kodansha International, 1968.

Pedretti 1981. Carlo Pedretti. *Leonardo da Vinci: Nature Studies from the Royal Library at Windsor Castle.* Exhibition catalogue. New York: Harcourt Brace Jovanovich, 1981.

———— 1992. "L'era nuova con Leonardo." In *1492: un anno fra due ere.* Florence, 1992.

Petrarch 1971. Petrarch. *Epistolae familiares,* III. Translated by David Thompson. In *Petrarch: A Humanist among Princes. An Anthology of Petrarch's Letters and of Selections from His Other Works.* Edited and in part translated by David Thompson. New York: Harper & Row, 1971.

Pfeiffer 1966. Heinrich Pfeiffer. "On the Meaning of a Late Michelangelo Drawing." *Art Bulletin* 48, no. 2 (June 1966): 226–27.

Pico della Mirandola 1496/1956. Giovanni Pico della Mirandola. *Oration on the Dignity of Man [1496].* Translated by A. Robert Caponigri. South Bend, Ind.: Gateway Editions, 1956.

Picus 1557. I. F. Picus, *Ioannis Pici . . . Vita.* In *Opere di Giovanni Pico.* Venice: Scoto, 1557.

Pieraccini 1924–25. G. Pieraccini. *La stirpe dei Medici di Cafaggiolo.* 3 vols. Florence: Nardini Editore, 1924–25.

Pietrangeli 1979. Carlo Pietrangeli, ed. *Guide Rionali di Roma.* Vol. 10, *Rione X, Campitelli,* parte III. Rome, 1979.

Pirina 1985. Caterina Pirina. "Michelangelo and the Music and Mathematics of His Time." *Art Bulletin* 67, no. 2 (September 1985): 368–82.

Poggi 1906. Giovanni Poggi. "Della prima partenza di Michelangelo Buonarotti da Firenze." *Rivista d'Arte* 4 (1906): 33–37.

—— **1988.** *Il Duomo di Firenze: Documenti sulla decorazione della chiesa e del campanile tratti dall'Archivio dell'Opera.* Vol. 2. Edited by Margaret Haines. Florence, 1988.

Polizzotto 1994. Lorenzo Polizzotto. *The Elect Nation: The Savonarolan Movement in Florence, 1494-1545.* Oxford: Clarendon Press, 1994.

Pomilio 1978. Mario Pomilio. *L'opera completa di Leonardo pittore.* Milan, 1978.

Pope-Hennessy 1956. John Pope-Hennessy. "Michelangelo's Cupid: The End of a Chapter." *Burlington Magazine* 98, no. 644 (November 1956): 403–11.

—— **1970.** *Raphael.* New York: Harper & Row, 1970.

—— **1970 and 1985.** *Introduction to Italian Sculpture.* Vol. 3, Italian High Renaissance & Baroque Sculpture. London: Phaidon, 1970, 1985.

—— **1980.** *Luca della Robbia.* Ithaca, N.Y.: Cornell University Press, 1980.

—— **1980.** *The Study and Criticism of Italian Sculpture.* New York: The Metropolitan Museum of Art; Princeton: Princeton University Press, 1980.

Popham 1945. Arthur E. Popham. *The Drawings of Leonardo da Vinci.* New York: Reynal & Hitchcock, 1945.

Popham and Wilde 1949. Arthur E. Popham and Johannes Wilde. *The Italian Drawings of the XV and XVI Centuries in the Collection of His Majesty the King at Windsor Castle.* London: Phaidon, 1949.

Posèq 1999. Avigdor W. G. Posèq. "Aspects of Laterality in Michelangelo." *Artibus et Historiae* 20, no. 40 (1999): 89–112.

Pratt 1965. Kenneth J. Pratt. "Rome as Eternal." *Journal of the History of Ideas* 26, no. 1 (1965): 25–44.

Procacci 1966. Ugo Procacci. "Postille contemporanee in un exemplare della vita di Michelangiolo del Condivi." In *Atti del Convegno di Studi Michelangioleschi,* pp. 279–94. Rome, 1966.

Quasimodo and Camesca. S. Quasimodo and E. Camesca. *L'opera completa di Michelangelo pittore.* Milan, 1977.

Ragionieri 2000. Pina Ragionieri. *I bozzetti michelangeleschi.* Exhibition catalogue. Florence: Casa Buonarroti, 2000.

—— **2001.** *Michelangelo: Drawings and Other Treasures from the Casa Buonarroti, Florence.* Exhibition catalogue. Atlanta: High Museum of Art, 2001.

—— **2004.** *Michelangelo: sei Capolavori.* Exhibition catalogue. Spoleto, Italy: Soft & Light, 2004.

—— **2005.** *Michelangelo e le due Cleopatra.* Exhibition catalogue. Rapallo, 2005.

Ragionieri 2005. Pina Ragionieri, ed. *Vittoria Colonna e Michelangelo.* Exhibition catalogue. Florence: Mandragora, 2005.

Ranke 1853. Leopold Ranke. *The History of the Popes.* 3 vols. London, 1853.

Rapetti 2001. Caterina Rapetti. *Michelangelo, Carrara e i maestri di cavar marmi.* Florence: All'Insegna del Giglio, 2001.

Rasponi 1994. Simonetta Rasponi. *Michelangelo: Architetto, Pittore, Scultore.* Milan: Fabbri, 1994.

Ratzinger 2006. Joseph Ratzinger (Pope Benedict XVI). *Dare bellezza per la gloria di Dio. Discorso alla Cappella musicale pontificia Sistina.* Vatican City: Città Ideale, 2006.

Redig de Campos 1946. D. Redig de Campos. *Raffaello e Michelangelo: studi di storia e d'arte.* Rome: G. Bardi, 1946.

Ridolfi 1981. Roberto Ridolfi. *Vita di Girolamo Savonarola.* Florence, 1981.

Riggs 1995. Don Riggs. "Was Michelangelo Born under Saturn?" *The Sixteenth Century Journal* 26, no. 1 (Spring 1995): 99–121.

Rilke 1963. Rainer Maria Rilke. *Stories of God.* 1900. New York: W. W. Norton & Company, 1963.

Risaliti and Vossilla 2007. Sergio Risaliti and Francesco Vossilla. *Il Bacco di Michelangelo: Il dio della spensieratezza e della condanna.* Florence: Maschietto, 2007.

Roberts 1988. Jane Roberts. *A Dictionary of Michelangelo's Watermarks.* Exhibition catalogue. Milan: Olivetti, 1988.

Robertson 1983. David A. Robertson. "Michelangelo's Saint Proculus 'Reconstructed.'" *Art Bulletin* 65, no. 4 (December 1983): 658–60.

Robinson 1906. James Harvey Robinson. *Readings in European History: A Collection of Extracts from the Sources Chosen with the Purpose of Illustrating the Progress of Culture in Western Europe since the German Invasions.* 2 vols. Boston: Ginn & Company, 1906.

Rocke 1998. Michael Rocke. *Forbidden Friendships: Homosexuality and Male Culture in Renaissance Florence.* New York and Oxford: Oxford University Press, 1998.

Roscoe 1846. William Roscoe. *The Life and Pontificate of Leo X.* 2 vols. London: H. G. Bohn, 1846.

—— **1881.** *The Life of Lorenzo de' Medici: Called the Magnificent.* London, 1881.

Rosen 2003. Mark Rosen. "Don Miniato Pitti and the Second Life of a Scientist's Tools in Cinquecento Florence." *Nuncius* 18, no. 1 (2003): 3–24.

Rowe and Satkowski 2002. Colin Rowe and Leon Satkowski. *Italian Architecture of the 16th century.* Princeton: Princeton University Press, 2002.

Rowland 1998. Ingrid D. Rowland. *The Culture of the High Renaissance: Ancients and Moderns in Sixteenth-Century Rome.* Cambridge: Cambridge University Press, 1998.

Rubinstein 1986. Ruth Rubenstein. "Michelangelo's Lost Sleeping Cupid and Fetti's Vertumnus and Pomona." *Journal of the Warburg and Courtauld Institutes* 49 (1986): 257–59.

Ruda 1978. Jeffrey Ruda. "A 1434 Building Programme for San Lorenzo in Florence." *Burlington Magazine* 120 (1978): 358–61.

Rufini 1965. E. Rufini. *Michelangelo e la colonia fiorentina a Roma.* Naples, 1965.

Ruskin 1945. John Ruskin. *Mornings in Florence: Being Simple Studies in Christian Art for English Travellers.* 1877. Reprint. Florence, 1945.

Saalman 1978. Howard Saalman. "Michelangelo at St. Peter's: The Arberino Correspondence." *Art Bulletin* 60, no. 3 (September 1978): 483–93.

Sabatini 1912. Rafael Sabatini. *The Life of Cesare Borgia of France: Duke of Valentinois and Romagna, Prince of Andria and Venafri, Count of Dyois, Lord of Piombino, Camerino and Urbino, Gonfalonier and Captain-General of Holy Church. A History and Some Criticisms.* New York: Brentano's, 1912.

Sagoff 1978. Mark Sagoff. "On Restoring and Reproducing Art." *The Journal of Philosophy* 75, no. 9 (September 1978): 453–70.

Sala 2001. Charles Sala. *Michelangelo: Scultore, pittore, architetto.* Genoa: Keybook, 2001.

Salmi 1996. Mario Salmi, ed. *Michelangelo, Artista Pensatore Scrittore.* Novara, Italy, 1996.

Sanuto 1879–1903. Marino Sanuto. *I Diarii di Marino Sanuto.* Rinaldo Fulin, et al., eds. 58 volumes. 1879–1903.

Saslow 1991. James M. Saslow. *The Poetry of Michelangelo: An Annotated Translation.* New Haven: Yale University Press, 1991.

Savonarola 1898. Girolamo Savonarola. *Scelte di prediche e scritti di fra Girolamo Savonarola.* Edited by Pasquale Villari and Eugenio Casanova. Florence, 1898.

Scalini 2001. Mario Scalini, ed. *Giovanni delle Bande Nere.* Florence: Banca Toscana, 2001.

Scavizzi 1981. G. Scavizzi. *Arte e architettura sacra: Chronache e documenti sulla controversia tra riformati e cattolici (1500–1550).* Reggio Calabria and Rome, 1981.

Schaff 1888. Philip Schaff. *History of the Christian Church.* Vol. 6, *The Middle Ages. A.D. 1294–1517.* New York: Charles Scribner's Sons, 1888. Online at archive.org.

———— **1985.** *History of the Christian Church.* 8 vols. Peabody, Mass.: Hendrickson Publishers, 1985.

Schianchi and Spinosa 1995. Lucia Fornari Schianchi and Nicola Spinosa. *I Farnese: Arte e Collezionismo.* Exhibition catalogue. Milan: Electa, 1995.

Scigliano 2005. Eric Scigliano. *Michelangelo's Mountain: The Quest for Perfection in the Marble Quarries of Carrara.* New York: Free Press, 2005.

Scotti 2006. R. A. Scotti. *Basilica: The Splendor and the Scandal: Building St. Peter's.* New York: Viking, 2006.

Secret 1964. F. Secret. "Le cardinal Gilles de Viterbe." In *Les Kabbalistes chrétiens de la Renaissance,* pp. 106–26. Paris: Dunod, 1964.

Seymour 1967. Charles Seymour, Jr. "Homo magnus et albus. The Quattrocento Background for Michelangelo's David of 1501–04." In: *Stil und Überlieferung in der Kunst des Abendlandes.* Vol. 2, pp. 96–105. Berlin: Mann, 1967.

———— **1974.** *Michelangelo's David: A Search for Identity.* New York: W. W. Norton & Company, 1974.

Seymour 1972 and 1995. Charles Seymour, Jr., ed. *Michelangelo: The Sistine Chapel Ceiling.* New York: W. W. Norton & Company, 1972, 1995.

Seznec 1972. Jean Seznec. *The Survival of the Pagan Gods: The Mythological Tradition and Its Place in Renaissance Humanism and Art.* Translated by Barbara F. Sessions. Princeton: Princeton University Press, 1972.

Shanzer 1984. Danuta Shanzer. "The Death of Boethius and the 'Consolation of Philosophy.'" *Hermes* 112, no. 3 (1984): 352–66.

Shearman 1975. John Shearman. "The Collections of the Younger Branch of the Medici." *Burlington Magazine* 117, no. 862 (January 1975): 12–27.

Shell and Sironi 1991. Janice Shell and Grazioso Sironi. "Salaì and Leonardo's Legacy." *Burlington Magazine* 133, no. 1055 (1991): 95–108.

Shrimplin-Evangelidis 1989. Valerie Shrimplin-Evangelidis. "Michelangelo and Nicodemism: The Florentine Pietà." *Art Bulletin* 71, no. 1 (March 1989): 58–66.

Sisi 1985. Carlo Sisi, ed. *Michelangelo e i maestri del Quattrocento.* Exhibition catalogue. Florence, 1985.

Sobotik 1982. K. Sobotik. "Michelangelo's Lost 'Noli me Tangere.'" *Dayton Art Institute Bulletin* 38 (1982): 5–8.

Spike 1996. John T. Spike. *Masaccio.* New York: Abbeville Press, 1996.

———— **1997.** *Fra Angelico.* New York: Abbeville Press, 1997.

———— **2001.** *Caravaggio.* New York and London: Abbeville Press, 2001.

———— **2010.** *Caravaggio.* 2nd rev. ed. New York and London: Abbeville Press, 2010.

Spini 1964. G. Spini. "Politicità di Michelangelo." *Rivista storica italiana* 76, no. 3 (1964): 557–600.

Stechow 1966. Wolfgang Stechow. *Northern Renaissance Art 1400–1600: Sources and Documents.* Englewood Cliffs, N.J.: Prentice Hall, 1966.

Steinberg 1983. Leo Steinberg. *The Sexuality of Christ in Renaissance Art and in Modern Oblivion.* New York: Pantheon, 1983.

———1989. "Michelangelo's Florentine Pietà: The Missing Leg Twenty Years After." *Art Bulletin* 71, no. 3 (September 1989): 480–505.

———1997. *The Sexuality of Christ in Renaissance Art and in Modern Oblivion.* 2nd ed., rev. and exp. Chicago: University of Chicago Press, 1997.

Stinger 1998. Charles L. Stinger. *The Renaissance in Rome.* Bloomingon: Indiana University Press, 1998.

Stone 1961. Irving Stone. *The Agony and the Ecstasy.* New York: Doubleday & Company, 1961.

Stone 1904. Jean Mary Stone. *Reformation and Renaissance (circa 1377–1610).* London: Duckworth and Co., 1904.

Suida 1929. Wilhelm Suida. *Leonardo und sein Kreis.* Munich, 1929.

Sullivan 1998. Michael Sullivan, trans. *Michelangelo: Love Sonnets and Madrigals to Tommaso de' Cavalieri.* London: Peter Owen, 1998.

Summers 1972. David Summers. "Michelangelo on Architecture." *Art Bulletin* 54, no. 2 (June 1972): 146–57.

———1981. *Michelangelo and the Language of Art.* Princeton: Princeton University Press, 1981.

Symonds 1911 and 2002. John Addington Symonds. *The Life of Michelangelo Buonarroti, Based on Studies in the Archives of the Buonarroti Family at Florence.* 2 vols. 3rd ed. London: Macmillan and Co.; New York: Charles Scribner's Sons, 1911. Reprint. Introduction by Creighton Gilbert. Philadelphia: University of Pennsylvania Press, 2002.

———1928. *The Life of Michelangelo Buonarroti, Based on Studies in the Archives of the Buonarroti Family at Florence.* New York: Modern Library, 1928.

Sypher 1963. Wylie Sypher, ed. *Art History. An Anthology of Modern Criticism.* New York: Vintage, 1963.

Talamo 1984. Emilia Anna Talamo. "La Controriforma interpreta la Sistina di Michelangelo." *Storia dell'Arte,* no. 50 (1984): 7–26.

Tampieri 1997. R. Tampieri, ed. *La biblioteca dell'Istituto Nazionale di Studi sul Rinascimento.* Carte Poggi. Florence, 1997.

Tarchiani 1930. N. Tarchiani. *Il palazzo Medici-Riccardi ed il Museo Mediceo.* Firenze, 1930.

Tateo 1981. Francesco Tateo. *Lorenzo de' Medici e Angelo Poliziano.* Bari, Italy. Laterza, 1981.

Tatham 1895. Edward H. R. Tatham. "Erasmus in Italy." *The English Historical Review* 10, no. 40 (October 1895): 642–46.

Tronzo 2005. William Tronzo, ed. *St. Peter's in the Vatican.* Cambridge: Cambridge University Press, 2005.

Tuena 2001. Filippo Tuena. *La Grande Ombra.* Rome: Fazi Editore, 2001.

Tuttle 1982. Richard J. Tuttle. "Against Fortifications: The Defense of Renaissance Bologna." *The Journal of the Society of Architectural Historians* 41, no. 3 (October 1982): 189–201.

Valentiner 1956. W. R. Valentiner. "Il cupido dormiente di Michelangelo." *Commentari* 7 (1956): 236ff.

———1958. "Michelangelo's 'Cupid' for Jacopo Gallo." *Art Quarterly* 21 (Autumn 1958): 257–64.

Various authors 1993. *I disegni di Michelangelo.* 2 vols. Exhibition catalogue. Florence: Casa Buonarroti, 1993.

Vasari 1568. Giorgio Vasari. *Le vite de' più eccellenti Pittori e Architettori, scritte da M. Giorgio Vasari Pittore e Architetto aretino, di nuovo dal medesimo riviste et ampliate con i ritratti loro et con l'aggiunta delle vite de' vivi et de' morti dall'anno 1550 infino al 1567.* 3 vols. Florence: Giunti, 1568.

———1938. *Il libro delle ricordanze di Giorgio Vasari.* Edited by Alessandro del Vita. Arezzo, Italy, 1938.

———1938. *Lo Zibaldone di Giorgio Vasari.* Edited by Alessandro del Vita. Arezzo, Italy, 1938.

———1941. *Il Carteggio di Giorgio Vasari dal 1563 al 1565.* Edited by Karl Frey. Italian edition edited by Alessandro del Vita. Rome: Reale Istituto d'Archeologia e Storia dell'Arte, 1941.

———1960. *Vasari on Technique.* Edited by Baldwin Brown and Louisa Maclehose. London: J. M. Dent, 1907. Reprint, New York: Dover Publications, 1960.

———1962. *La vita di Michelangelo nelle redazioni del 1550 e del 1568.* Edited by Paola Barocchi. 2 vols. Milan and Naples, 1962.

———1976. *Le vite de' più eccellenti pittori scultori e architettori: nelle redazioni del 1550 e 1568.* Edited by Rosanna Bettarini and Paola Barocchi. 6 vols. Florence: Studio per edizioni Scelte, 1976.

———2006. *The Lives of the Most Excellent Painters, Sculptors, and Architects.* Translated by Gaston du C. de Vere. New York: Modern Library, 2006.

Ventrone 1994. Paola Ventrone. "L'eccezione e la regola: le rappresentazioni del 1439 nella tradizione fiorentina delle feste di quartiere." In *Firenze e il Concilio del 1439,* edited by Paolo Viti. Vol. 1, pp. 389–408. Florence, 1994.

Verdon 2005. Timothy Verdon. *Michelangelo teologo: Fede e creatività tra Rinascimento e Controriforma.* Milan: Ancora, 2005.

Verspohl 1981. Franz-Joachim Verspohl. "Michelangelo und Macchiavelli. Der David auf der Piazza della Signoria in Florenz." *Städel-Jahrbuch* 7 (1981): 204–46.

Vespasiano da Bisticci 1963. Vespasiano da Bisticci. *Renaissance Princes, Popes, and Prelates: The Vespasiano Memoirs, Lives of Illustrious Men of the XVth Century.* Translated by William George and Emily Waters. Introduction by Myron P. Gilmore. New York: Harper & Row, 1963.

Vezzosi 1983. Alessandro Vezzosi, ed. *Leonardo e il leonardismo a Napoli e a Roma.* Exhibition catalogue. Florence: Giunti, 1983.

Viroli 2000. Maurizio Viroli. *Niccolò's Smile: A Biography of Machiavelli.* Translated by Antony Shugaar. New York: Farrar, Straus and Giroux, 2000.

Vlastos 1973. Gregory Vlastos. *Platonic Studies.* 2nd ed. Princeton: Princeton University Press, 1973.

Vliegenthart 1976. Adrian W. Vliegenthart. *La Galleria Buonarotti. Michelangelo e Michelangelo il Giovane.* Florence, 1976.

von Holst 1967. Christian von Holst. "Michelangelo in dem Werkstatt Botticellis." *Pantheon* 25 (1967): 329–35.

——— *1974. Francesco Granacci.* Munich: Bruckmann, 1974.

Waldman 2004. Louis A. Waldman. *Baccio Bandinelli and Art at the Medici Court: A Corpus of Early Modern Sources.* Darby, Pa.: Diane Publishing, 2004.

Wallace 1987. William E. Wallace. "Michelangelo's Assistants in the Sistine Chapel." in *Gazette des Beaux-Arts* 110 (December 1987): 203–16.

——— 1992. "Bank Records Relating to Michelangelo's Medici Commissions at San Lorenzo: 1520–33." *Rivista d'Arte* 44 (1992): 3–27.

——— 1992. "How Did Michelangelo Become a Sculptor?" In *The Genius of the Sculptor in Michelangelo's Work,* pp. 151–67. Exhibition catalogue. Montreal: Musée des Beaux-Arts, 1992.

——— 1992. "In and Out of Florence between 1500 and 1508." In *Leonardo, Michelangelo, and Raphael in Renaissance Florence from 1500 to 1508,* edited by Serafina Hager, pp. 54–88. Washington, D.C.: Georgetown University Press, 1992.

——— 1994. "Miscellanea Curositae Michelangelae: A Steep Tariff, a Half Dozen Horses, and Yards of Taffeta." *Renaissance Quarterly* 47, no. 2 (1994): 330–50.

——— 1997. "Manoeuvring for patronage: Michelangelo's Dagger." *Renaissance Studies* 11, no. 1 (1997): 22–26.

Wallace 1999. William E. Wallace, ed. *Michelangelo: Selected Readings.* New York and London: Garland Publishing, 1999.

Weil-Garris Brandt 1992. Kathleen Weil-Garris Brandt. "The Nurse of Settignano: Michelangelo's Beginnings as a Sculptor." In *The Genius of the Sculptor in Michelangelo's Work,* pp. 21–40. Exhibition catalogue. Montreal: Musée des Beaux-Arts, 1992.

——— 1996. "A Marble in Manhattan: The Case for Michelangelo." *Burlington Magazine* 138, no. 1123 (October 1996): 644–59.

——— 1997. "More on Michelangelo and the Manhattan Marble." *Burlington Magazine* 139, no. 1131 (1997): 400–404.

——— 1999. "Sogni di un Cupido dormiente smarrito." In *Giovinezza di Michelangelo,* edited by Kathleen Weil-Garris Brandt, et al., pp. 315–17. Exhibition catalogue. Florence and Milan: Artificio Skira, 1999.

Weiss 1965. Roberto Weiss. "The Medals of Pope Julius II (1503–1513)." *Journal of the Warburg and Courtauld Institutes* 28 (1965): 163–82.

——— 1988. *The Renaissance Discovery of Classical Antiquity.* 2nd ed. Oxford and New York: Blackwell, 1988.

Whitehouse and Rocke 1934. J. Howard Whitehouse and Colin Rocke. *The Master: A Study of Michelangelo.* Oxford: Oxford University Press, 1934.

Wilde 1944. Johannes Wilde. "The Hall of the Great Council of Florence." *Journal of the Warburg and Courtauld Institutes* 7 (1944): 65-81.

——— 1953. *Italian Drawings in the Department of Prints and Drawings in the British Museum.* London: The British Museum Press, 1953.

——— 1978. *Michelangelo.* Oxford: Clarendon Press, 1978.

Wilde 2008. Oscar Wilde. *The Picture of Dorian Gray.* San Francisco: Ignatius Press, 2008.

Wind 1944. Edgar Wind. "Sante Pagnini and Michelangelo: A Study in the Succession of Savonarola." *Gazette des Beaux-Arts* 26 (1944): 211–46.

——— 1951. "Typology in the Sistine Ceiling: A Critical Statement." *Art Bulletin* 33 (1951): 41–47.

——— 1954. "The Revival of Origen." In *Studies in Art and Literature for Belle da Costa Greene,* edited by Dorothy Miner, pp. 412–24. Princeton: Princeton University Press, 1954.

——— 1960. "Maccabean Histories in the Sistine Ceiling." In *Italian Renaissance Studies: A Tribute to the Late Cecilia M. Ady,* edited by E. F. Jacobs, pp. 312–27. London: Faber & Faber, 1960.

Winters 2002. Laurie Winters. *Leonardo da Vinci and the Splendor of Poland: A History of Collecting and Patronage.* Exhibition catalogue. Milwaukee: Milwaukee Art Museum, 2002.

Wittkower 1978. Rudolf Wittkower. *Idea and Image: Studies in the Italian Renaissance.* London: Thames & Hudson, 1978.

Wittkower and Wittkower 1969. Rudolf Wittkower and Margot Wittkower. *Born Under Saturn: The Character and Conduct of Artists: A Documented History from Antiquity to the French Revolution.* New York and London: W. W. Norton & Company, 1969.

Wohl 1991. Helmut Wohl. "Two Cinquecento Puzzles." *Antichità Viva* 30, no. 6 (1991): 42–48.

Wölfflin 1891. Heinrich Wölfflin. *Die Jugendwerke des Michelangelo.* Munich, 1891.

————1968. Classic Art: An Introduction to the Italian Renaissance. Translated by Peter and Linda Murray. London: Phaidon, 1968.

Wolfgang 1960. Marvin E. Wolfgang. "A Florentine Prison: Le Carceri delle Stinche." *Studies in the Renaissance* 7 (1960): 148–66.

Wren, Wren, and Carter 1994. Linnea Holmer Wren, David J. Wren, and Janine M. Carter. *Perspectives on Western Art*. Boulder, Colo.: Westview Press, 1994.

Wyke 2006. Maria Wyke, ed., *Julius Caesar in Western Culture*. Malden, Mass.: Blackwell Publishing, 2006.

Ziegler 1995. Joanna E. Ziegler. "Michelangelo and the Medieval Pietà: The Sculpture of Devotion or the Art of Sculpture?" *Gesta* 34, no. 1 (1995): 28–36.

INDEX

Note: Michelangelo is referred to as M in this index.
Art works cited are by Michelangelo unless otherwise noted.

PHOTO CREDITS

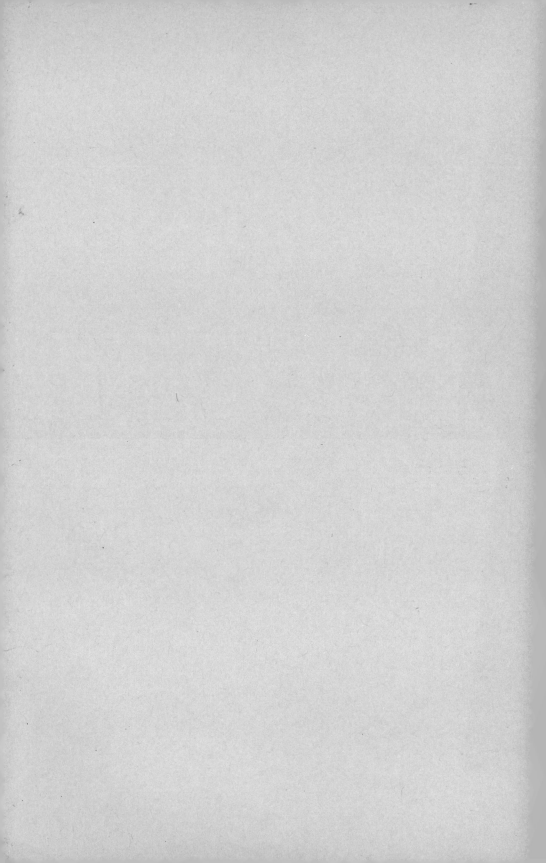